kid size The Material World of Childhood

kid size

The Material World of Childhood

Skira editore / Vitra Design Museum

Front Cover
Photo: Enzo Sellerio

Back Cover
Photo: Hilmar Pabel

Other cover photos:
p. 15, p. 68, p. 73, p. 127, p. 132,
p.140, p. 226, p. 227, p. 249,
p. 257, p. 270, p. 287, p. 292,
p. 299

Design
Marcello Francone

Layout and typesetting
Susan Gerhardt, Gabriele Miccichè

kid size The Material World of Childhood

Kunsthal Rotterdam,
The Netherlands
28 June 1997–
28 September 1997
Vitra Design Museum,
Weil am Rhein
Spring/summer 1998
Further venues in Great
Britain, Italy, Germany,
Switzerland, Scandinavia

Exhibition

Concept
Alexander von Vegesack,
Vitra Design Museum
Jutta Oldiges, Vitra Design
Museum
Lucy Bullivant, Guest
Curator

Organisation
Jutta Oldiges, Lucy Bullivant
Carina Villinger, Helena
Bullivant

Assistance
Barbara Fehlbaum, Thorsten
Romanus, Frank Ubik,
Andreas Nutz, Serge
Mauduit, Mathias Schwartz-
Clauss, Sixta Quaßdorf,
Theresa Simon, Philippa
Thomas, Eleanor Curtis

*Organisation Kunsthal
Rotterdam*
Wim Pijbes

Design
Dieter Thiel

Public relations
Gabriella Gianoli

Exhibition video
Play me
Concept: Lucy Bullivant
Producer: Helena
Bullivant, Fierce Bird
Films Ltd
Archive Researcher:
Kathy Manners
Video Editor:
Lol Gellor

Catalogue

General editors
Alexander von Vegesack,
Jutta Oldiges, Lucy Bullivant

Editors
Jane Havell, Peter Sidler

Editorial assistants
Theresa Simon, Carina
Villinger, Andreas Nutz

*Translators for the English
edition*
Tobias Kommerell (from
German, pp. 86–95, 110–17,
128–39, 146–53, 174–81,
202–9), Joseph Spooner
(from German, pp. 10–11,
24–35, 96–109, 118–27),
David Tabbat (from Italian,
pp. 68–88, 210–21), Jenny
Marsh (from German, pp.
35–39), Ian Hinchliffe (from
Swedish, pp. 196–201)

*Translator for the German
edition*
Regina Winter

Exhibition sponsors

IKEA~Stiftung

Wybert Lörrach elmex® Forschung

habitat

MIGROS
Kulturprozent

COMMERZBANK
FILIALE LÖRRACH

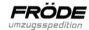 Dresdner Bank

FRÖDE
umzugsspedition

Dr. h. c. Georg H. Endress,
Endress + Hauser (Int.) Holding,
Reinach/Switzerland

British Council, London

Swedish Embassy, Bonn

Mondriaan Stichting, Amsterdam

Stichting VSB Fonds, Utrecht

Acknowledgements

The Vitra Design Museum and the Curators would like to express their gratitude to the following people and institutions for advice and assistance in the preparation of the exhibition:

Eileen Adams, London
Massimo Alvito, Florence
T. J. Baumgartner, Pacific Decor, Beijing
Günter Beltzig, Hohenwart
Wei Benli, Urumqi
J. S. Bhandari, Delhi
Isabell Brauer, Munich
The British Council (offices worldwide)
The Dessai family, Moers
Peter Ellenberg, Freiburg
Julia Engelhardt, AKG London
Barbara Fehlbaum, Basel
Stina Forsström, Stockholm
Chris Galea and Roger Watts, Focus on Kids, London
Stephanie Guha, Zürich
Denise Hagströmer, London
Wolfgang Jaede, Freiburg
Sally Kevill-Davies, London
Isamu Kinoshita, Department of Landscape Architecture, Chiba University
Ursula Klockgeter, Dreieich
Gerhard Kubik, Vienna
Franco La Cecla, Paris
Lismari Marbe, IKEA, Hofheim-Wallau
Noreen Marshall, Bethnal Green Museum of Childhood, London
Vedran Mimica, Amsterdam
Luca Molinari, Skira, Milan
Erwin Moser, Schweizerisch-Chinesische Gesellschaft, Basel
Yuko Ochi, Kanagawa
Rikuko Okuda, The International Association

for the Child's Right to Play Japan, Nagoya
Wim Pijbes, Kunsthal Rotterdam
Shi Qiaoying, Beijing
Giulia Reali, Florence
Alexandra Reinhold, Berlin
Sammler Journal, Munich
Mike Scaife, School of Cognitive and Computing Studies, Sussex University
Karin Schulte, Weißenhof-Institut, Stuttgart
Annemarie Seiler-Baldinger, Basel
Kelly Shannon, Denver
Joost Siedhoff, Ottobrun
Takaaki Sonoda, Institute of Advanced Material Study, Kyushu University
Sherri Steel, York Castle Museum
Jacqueline Vodoz and Bruno Danese, Milan
Heidemarie Waninger, Oranienburg
Florence Weiss, Basel
Liu Wenhua, Jinan
Cornelia Will, Velbert
Tina Wodiunig, Zürich

Lucy Bullivant would further like to thank Alexander von Vegesack for his sound judgement in initiating this project, and for painstakingly ensuring its realisation through the generous support of all the sponsors; all her collaborators at Vitra Design Museum and at Skira editore spa for their staying power, cooperation and good humour; Ben Weaver, Andrea Rose and Inger Kehlenbach for their kind help in carrying forward project work; and Helena Bullivant, Dargan and Pat Bullivant, Jane

Havell, Theresa Simon, Philippa Thomas, Eleanor Curtis, Kathy Manners, Tobias Kommerell, Ed Annink and Ineke Hans for their invaluable support, advice, enthusiasm and encouragement during its preparation.

Lenders

We would like to thank the following lenders for their generous support:

Anthologie Quartett, Bad Essen
Art & Form, Turin
Günter Beltzig, Hohenwart
Privatsammlung Hubertus Brörmann, Bohmte
Casala Werke, Lauenau
Combi, Saitama
Designvertrieb, Berlin
Nanna Ditzel, Copenhagen
DMD, Voorburg
Peter W. Ellenberg, Freiburg
Burkhard Engesser, Basel
Eurolounge, London
Rouge Ekkehard Fahr, Munich
Barbara Fehlbaum, Basel
Focke Museum, Bremen
Ole Gjerlov-Knudsen, Gilleleje
Glasgow Museums
Kenneth Grange/Pentagram, London
Emil Guhl, Stein am Rhein
Habit, Körten-Engeldorf
Historisches Museum Basel
Udo Horstmann, Zug
IKEA, Älmhult
Indianermuseum, Zürich
Dominic Jones, Worthington
Judith and Riaz Jurney, New York City
Gunter König, Hamburg
Källemo, Värnamo
Kinderlübke, Burkhard Lübke, Gütersloh
Kathrin Kremser, Darmstadt
Gerhard Kubik, Vienna
Stephen Kuester, Bloxham
Kunstindustrimuseet, Oslo
Simon Maidment, London
Moya A. Malamusi, Museum of Ethnographic Objects, Malawi, Africa
Mob-Design Gmbh, Leverkusen

Museum Der Kulturen, Basel
Museum Für Angewandte Kunst, Cologne
Museum Kindertagesstätten In Deutschland – Kita Museum, Potsdam
Museum of Welsh Life, Cardiff
Nationaal School Museum, Rotterdam
Nordiska Museet, Stockholm
Verner Panton, Basel
Pcd Ltd, Tavistock
Terri Pecora, Milan
Roberti Rattan, Milan
Alexandra Reinhold, Berlin
Annemarie Seiler-Baldinger, Basel
Schweizerisches Sportmuseum, Basel
Stedelijk Museum, Amsterdam
Stevenson Brothers, Ashford
Stokke Gmbh, Lübeck
Studio Böhm, Gelnhausen
Maria Teresa Sucre, Caracas
Tecta/Stuhlmuseum Burg Beverungen, Lauenförde
Technische Universität Delft
Toys 'R' Us, Weil am Rhein
Johannes Trüstedt, Munich
Alexander von Vegesack, Collection
Vienna Collection, Schrems
Vitra Design Museum Collection
Vs Vereinigte Spezialmöbelfabriken, Tauberbischofsheim
Jacqueline Vodoz & Bruno Danese, Milan
Florence Weiss, Basel
Thomas Wendtland, Hamburg
Wilkhahn, Bad Münder
Wybert, Lörrach
Xs Möbel für Kinder/ Holzwerkstatt Biiraboom, Kernen im Remstal
York Castle Museum, York
Zentrum für Außergewöhnliche Museen, Munich

Play me, a video
Archive material by kind permission of:

Massimo Alvito, Florence
Archive Films, London and New York
COI Footage file, London
Educational & Television Films, London
Institut für den Wissenschaftlichen Film, Göttingen
Professor Dr. Gerhard Kubik, University of Vienna
Katherine Mapes, London
Professor Dr. Frank Baumgärtel, Göttingen
Television South West, Plymouth
Thirteen/WNET, New York

Contents

Foreword

A continual source of confusion among the classic furniture designs that fill the Vitra Design Museum shelves (whose organising principles are technical innovation, material and design) are those items that have their origin in another world, are built on a different scale, in different colours and in different forms. Their very function seems to be subordinate to other criteria. Yet everyone feels instinctively drawn to these objects, for they inspire fascination and bring back personal reminiscences.

This direct and personal entrée to the subject of children's furniture was the stimulus behind our decision to dedicate an exhibition exclusively to it. We soon discovered that the way in which children's furniture varies between past and present and from culture to culture paints a very precise picture of the relationship between adults' conceptions and children's needs. In order to clarify our own critical standpoint, as a point of departure for our deliberations we formulated the provocative working title "From Cot to TV" and posed the question: are parents in the western world primarily interested in bringing up their children in safety, or can their concern be construed as a practical and appropriate way of aiding and promoting a child's development?

There are a plethora of changing traditions and a similarly large number of assumptions about what the optimal outward requirements are for a child's spiritual and physical development. In the end, our relationship to the world is not static; it builds up from childhood onwards through cultural experience, comparisons and realisations. The purpose of this exhibition and catalogue is to facilitate an insight into the different manifestations of this process, and to speak directly to those bringing up children and designing objects for them. In a wide-ranging collection of essays, we have attempted to consider the most important aspects of the theme from all standpoints from the practical experience of Günther Belzig, who is both a father and a designer for children, to Florence Weiss's striking descriptions of a tribe's social prototypes in Papua New Guinea.

Lucy Bullivant, guest curator from London, and Jutta Oldiges, curator for the Vitra Design Museum, have been responsible for the exhibition and the catalogue during a three-year gestation, and have overcome many difficulties. I should like to thank them both wholeheartedly for their unconditional commitment and great stamina. It was very fortunate that both had such excellent support: Carina

Villinger helped with the co-ordination of the project here in Weil am Rhein, and Jane Havell took care of the catalogue in London. Barbara Fehlbaum and Thorsten Romanus also made substantial contributions to the exhibition. We would also like to thank those who have lent items for the exhibition, and in particular we would like to thank the Basle Museum der Kulturen, whose generous contribution of a whole series of marvellous objects was not tied up in red tape. The wide-ranging views and insights of the authors in the catalogue sometimes personal, sometimes academic in tone have painted a fascinating picture of the meaning and context of the world of children; we are grateful to them, as well as to the translators and the editor Peter Sidler.

For a time, lack of funding endangered extensive research, catalogue, exhibition and even the project itself – until committed sponsors were suddenly found, above all IKEA, the IKEA Foundation and the firm Wybert, as well as Habitat, Migros, the Commerzbank Lörrach, the Dresdner Bank, Fröde, Dr. h. c. Georg H. Endress, the Mondriaan Foundation and the VSB Fonds Foundation. We are especially grateful to them, and would be delighted to think that the confidence they have invested in our work has paid off for them, too. Last of all, I would like to thank those who have visited the exhibition, and the readers of this catalogue for their interest. I hope the exhibition gives you much pleasure and interesting insights into the huge and fascinating world of children.

Alexander von Vegesack

Lucy Bullivant

The Currencies of Childhood

"Within us, still within us, always within us, childhood is a state of mind" Bachelard 1960

"Our children are the living messages to a time we will not see" Postman 1982

1
Child's articulated playtower, designed by Humphrey Kelsey, 1996, medium density fibreboard sealed with matt lacquer. He aimed to create a design giving control to the child and free of any parental preconceptions of what child's play should involve. He left the wood uncoloured, on the basis that as a result it would be sensed as an "adult" object, and therefore more exciting to play with.

"Kid size: the material world of childhood", the exhibition that this publication accompanies, aims to explore and critically illuminate the changing relationship between adults and children as expressed by their immediate, everyday material environments in societies in and beyond the Western world. Cross-cultural patterns of adult provision are traced through a geographically far-reaching selection of furniture and other daily artefacts that offers clues about the range of adult attitudes towards the child's role and identity.

Contextual images showing activities and objects in use, and a video about children's play with footage from the 1920s to the present day, are woven into the layout. These offer glimpses of the material world of childhood that build up a global perspective of the developing child's response to its environment and closest relationships.

This neglected and emotive theme draws on social history, psychology and anthropology to help shed light on its many facets. The mental tools and constructs previously used to lay bare the meaning of furniture are inadequate to this task. The applied art connoisseurship of much furniture history which might fascinate with its details of materials and production techniques does not offer significant value in this field. Being lucid about function in relation to children in global cultures requires an interdisciplinary approach. Furthermore, it requires that we examine closely our adult definitions of the word function, and give it a more synergetic relationship with the word "context".

The furniture and artefacts that help constitute the material world of childhood, irrespective of their culture or period, are potent carriers of meaning. Many contexts are considered territories for this project, spanning those as disparate as the Biedermeier nursery, work-orientated Shaker communities, a Iatmul house in Papua New Guinea or the collective space of a Chinese kindergarten. Conspicuous by their presence (or relative absence), and originating from hand as well as industrialised production, furniture and artefacts for children communicate messages about adults' attitudes towards the child's physical and psychological development; intimacy and order in the family; control; autonomy and personal territory; learning, and above all,

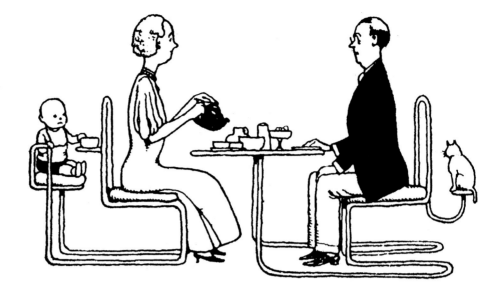

2
Cartoon by Heath Robinson
showing family seated on
all-in-one tubular steel
furniture, How to live in a
flat, Hutchinson, 1936, p. 30.

14

the role of play. There is much to be gleaned from observing the hand of the child itself, constantly at work creatively appropriating from its habitat, irrespective of the level of tangible adult provision. It is the play between the two that engages us.

The exhibits are grouped into five overlapping themes: patterns of sleeping; basic functions; play forms; mobility; formal and informal learning. In each thematic section, the selection cuts a broad swathe through many periods and cultures in and beyond the Western world, including Africa, India, Indonesia, Papua New Guinea, and North and South America, in order to illuminate links between them.

The material world of childhood is a dense and demanding one of which to make sense. We all occupied its nucleus once upon a time, and now it seems that the parallel worlds of the adults are sealed over its real depth. Our memories have put a gloss on the pictures we retain. In considering this world, we are reliant on the scant historical coverage of this area; for clues, we search for adequate methods to unravel what we see and hear. Designs for children express "assumptions about the nature of childhood", as Adrian Forty puts it.[1] In order to try to make sense of adults' material provision for children, it is important to be aware that childhood is socially constructed. The historian Carolyn Steedman explains the potent dualism that, historically, children have been both the repositories of adults' desires, and social beings, living in social worlds and networks of social and economic relationships as well as in the adult imagination.[2] This question of adult projection and desire is an intricate one to consider, for "our capacity to sentimentalise, identify with, project on to, and reify children is almost infinite".[3]

The title "Kid size" is intentionally somewhat of a provocative contradiction. For one thing, the material world of childhood is not synonymous with the informally used noun "kid": it is not small or otherwise diminu-

1 Forty 1986, p. 67.
2 Steedman 1995, p. ix.
3 Jordanova 1990, quoted in Steedman 1995, p. 6.

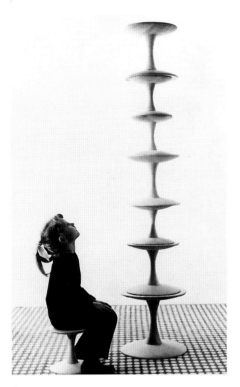

3
Trisserne children's stools, Nanna Ditzel, 1962, Oregon pine, manuf. Kolds Savvaerk, Kerteminde, Denmark (now by Trip Trip, in stained hevea), intended for active use in play, as well as furniture.

tive, so perhaps we should have placed a question mark after it. "Kid size", pertaining to matters that adults often pejoratively describe as being "kid's stuff", does not offer a simple, elementary, easy, or single perspective: it is a vast, rich and disordered matrix of relationships between ideas, objects and human beings, fragmented by time, place and individual psychologies. Children are seen as microcosmic emblems of the adult human condition. This has not always everywhere been the case. Now, ambivalence about the notion of freedom in relation to children reflects contemporary ambivalence about the fragility and psychodynamics of personal identity and of relationships in general. As late as the eighteenth century, 75 per cent of all children christened in the Western world were dead before the age of five. Infant mortality prevented the investment of much emotional attachment. At the end of the twentieth century, changing gender roles and forms of living together that increasingly coexist with non-familial relationships, have brought new challenges for socialisation. In this climate, "the importance of the child is increasing," as the sociologist Ulrich Beck puts it. "The child acquires a monopoly on practical companionship, on an expression of feelings in a biological give and take that otherwise is becoming increasingly uncommon and doubtful."[4]

One feature of the contemporary, constructed identity of the child stems directly from this focus: the creation of the baby as fashion accessory/alternative self. The author Will Self has described the 1990s as having seen unparalleled commodification of the baby, a phenomenon requiring the acquisition of fashionable accessories, largely clothes that are scaled-down versions of adults'. He suggests that this reduction in the baby's status "from person-of-the-future, to handbag-of-now" is "a darkly ironic counterpoint" to the other things happening to it. This focus, he suggests, is also a de-focus away from the problematic identity of the grown-up-as-parent.[5]

These complex projections are just one manifestation of the reality that, for a myriad of social reasons, childhood appears more and more contracted, visibly so in the Lilliputian world of American child beauty contests. Traditional practices, like the Japanese tradition of dressing little girls attending kindergarten in full formal dress for festivals, remind us that presenting children as miniature adults is not new but dates back to medieval times. For many centuries, when children came out of swaddling bands they immediately adopted the dress of their parents. This practice was applied up until the seventeeth century.

In non-industrial societies, furniture, accessories and toys are not huge, tangible support systems. Where they exist, equivalents may or may not be temporal, but much more likely to be created directly from an indigenous context, and limited to natural materials and low-technology methods of making. This is often a process in which the child plays a leading role, and

4 Beck 1992, p. 118
5 Self 1996, p. 12

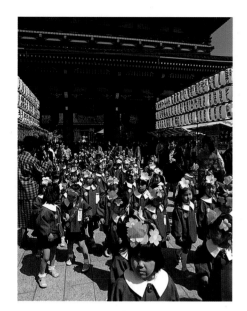

4
Japanese infant girls from
a local kindergarten with
cherry blossom headdresses
at the Hana-Matsuri flower
festival, Kannon temple,
Japan.

in which parents have fewer expectations about the fulfilment of their off-spring's perceived material needs. In the West, children's products invari-ably extend adult values into the child's world, reflecting a multitude of de-sires to support, enable, protect and control. This process can be discerned by observing various themes, some with long histories. They include minia-turisation in scale; mimetic and role-play objects; symbolism that is signif-icant for what it tells us about adult attitudes towards the child and its role in the family; formal restraint as well as its opposite, flexible multi-functionality.

In a catch-all consumerist world fuelled by constant novelty and media-tized, sequestrated experience, genuinely child-friendly environmental de-signs, with true flexibility of use (the totally adult-free object), are thin on the ground. Perhaps the reality is that the essential ingredients of play do not need to be designed, but just assembled. Miniaturisation of adult de-signs, in the sense of exact replication on a smaller scale, feeds the idea of emulation, association and transfer of ideas, and understandably central psychological notions like personal territory. Miniaturisation is just one facet of a huge wave of aspirations and intentions concerning children. Adults love to attribute to children their own idiosyncratic foibles, pre-sumably to make themselves feel a little taller in the world.

The fixed, static impression of the child as a miniature adult, endowed nat-urally with naive innocence, is part of the inheritance of the sixteenth and seventeenth centuries, involving beliefs in the absolute goodness of child-hood, and the nineteenth century Victorian romanticization of children. In the twentieth century, by contrast, there has been social ambivalence aris-ing from the widespread acceptance of two synergetic factors: "the needs of infants and small children are not variable; they are inherent and unalter-able. It is necessary to think all the time of the developing child."[6]

Miniaturisation historically seems to have been regarded as a natural course of affairs to a designer or furniture-maker in the Western world who, al-though he had access to textiles, was not able to rely on the pliability of plastic and other man-made materials. Slow production cycles for children's products, largely due to stringent testing to meet safety standards, and a rel-ative lack of commercial interest in this area, have limited the accessibility of new designs. Many children's furniture items from the twentieth centu-ry have been designed as one-offs, exercises in design virtuosity, using the latest materials and technologies of the day applied on a small scale, and sustained by public demand. They were literally scaled-down embodiments of avant-garde design ideals. If an avant-garde designer engaged with the wider creative implications of designing for children, his or her work might extend to new typologies like nappy changing tables (designed by Pierre Chareau or Alma Buscher) or by more traditional objects such as buggies and wheelbarrows (part of Gerrit Rietveld's body of work). Children's fur-

6 Winnicott 1957, p. 179.

5
RCP2 chair in adult and child's versions, designed by Jane Atfield, recycled plastic, 1994.

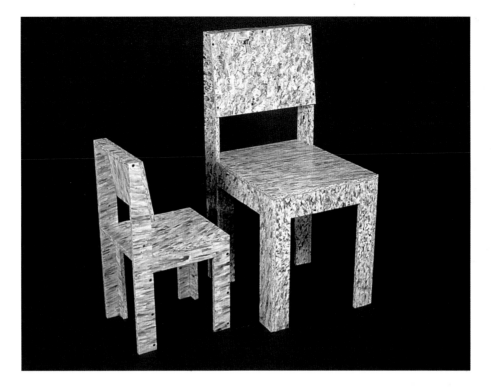

7 Rowland 1988, p. 154. In 1924, Marcel Breuer's small table and chair sets, Alma Buscher's ship building blocks and children's beds for the Weimar children's home, and Hirschfeld-Mack's colour-mixed spinning tops were in major demand.
8 The Astley Cooper chair, dating from the mid-nineteenth century and named after a famous English surgeon, was "invented" to prevent children developing bad posture while eating. It was not, however, universally approved of by the medical profession of the day.
9 Object shown in the 1995 exhibition "Behind the Nursery Door: Growing Up in a Great House", in the permanent collection of Burghley House, Stamford, Lincolnshire.

niture and toys were among the most successful products of the carpentry workshop at the Weimar Bauhaus, for instance, in the early 1920s, selling both to individual buyers and progressive educational establishments.[7]

One drawback of historic miniaturised furniture is that in some cases it bedevils interpretation of use. Even museum curators express doubts about some older pieces in their collections, which appear to be made for children, but are mostly scaled-down versions of sofas, chairs or other domestic furniture, which were made by craftsmen of the day as samples.

Corrective furniture made specifically for children, such as deportment chairs, reveal specific adult notions and priorities about the health and development of children in specific times and cultures.[8] The acquisition of graceful deportment was considered an essential part of a child's education in eighteenth- and nineteenth-century England, denoting good breeding and self-discipline. To this end children were subjected from the earliest age to an astonishing variety of corrective devices, including a board placed across the shoulder blades with ends looped through the child's crooked elbows. The effect was often increased by tying a violin string tightly around the shoulders, which would then bite into the child's flesh if it slouched.[9]

Applying subjective perspectives to taste and appropriateness, we may judge a highly decorative, gaudy or whimsical contemporary design object for a child, even one that might be physically detrimental, to be desirable for peer group reasons, until later awareness causes us to revise our opinions. Its symbolism may be enough to give it the reassurance of value. Our attitudes towards symbolism – and the mental imagery that reinforces meaning – are inherited from childhood. Symbolism in objects for children may not draw on these archetypes in the most directly appealing way, precisely

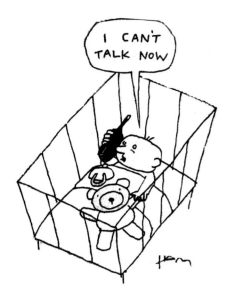

6
Cartoon by 'Ham' (Ham
Khan), The Observer,
London, 27 April 1997.

18

because adults' tastes often get in the way of a more empathetically elemental approach, although designers spend far more time considering such challenges in their work for children than in the past. The introduction of anthropomorphised animal elements in design for children, which became common at the end of the nineteenth century, served to reinforce adults' attribution of qualities of innocence and virtue to childhood, and to differentiate children's needs from those of adults at a time before psychoanalytical ideas about the nature of childhood began to make an impact.[10] The symbolism discernible in traditional designs for children underlines the strength of the values of the head of the family, perhaps someone of regal status or otherwise a person of property, rather than a more prosaic use. Handing down family artefacts that might display or take the form of symbols in the modern family, with its broadening spectrum of variations, is not so common.[11] Another kind of symbol-sharing exists for adult and child alike. While globally and niche-marketed branded clothes and goods are the norm, children increasingly appropriate and recycle symbols from society themselves, using them just as adults do as badges to mark out their cultural connections in a fragmented world.

Play furniture, like other furniture types in the slowly proliferating array of typologies within the history of children's furniture, transcends perceived boundaries between furniture and toy. Its qualities of flexibility and open-endedness in use can be saving graces against the ephemeral value ascribed by the developing child. Detlef Mertins, writing about the role of toys in cultural modernity, explains that industrialisation caused simplicity and directness in toy-making to be lost in the nineteenth century, to be replaced by "models progressively less active". "Children's creative mimetic play – becoming a horse, a baker, or a windmill – was displaced into spectatorship."[12] He quotes Walter Benjamin, writing in Kulturgeschichte des Spielzeugs, who noted that "the oldest toys – balls, rings, kites – had initially been cult-instruments, more 'play-equipment' than 'toys'."[13]

"Imitation is properly at home in play, not in the toy," wrote Benjamin.[14] As other contributors to this publication underline, objects are applied to the serious work of play which in childhood stems not from outer compulsion but from inner necessity.

Goethe thought that children found it difficult to distinguish between human artefacts and natural objects. The daily round of introjection and projection, making and destroying castles in the sandpit, or improvising hideouts (ironically miming the adult world, a cross-cultural activity) in an endless game of bricolage serves to dramatise actively the inner world of fantasy in order to maintain psychic equilibrium, to ground the child's sense of identity. Let us be clear, the purpose of life in childhood is not to grow up, but to play, something adults are prone to envy.

All play objects play psychological roles, but it is beyond the scope of this

10 Forty 1986, p. 71.
11 The offspring of the ancient Greeks were laid in cradles shaped like winnowing baskets, symbolising newly harvested grain. The traditional wood for the cradle is birch, the tree of inception, which drives away evil spirits. See Wright 1962, p. 171.
12 Mertins 1993, p. 7.
13 Benjamin 1977, pp. 113–17.
14 Ibid., p. 117.

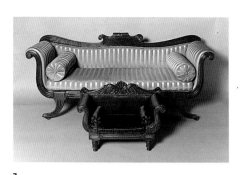

7
Mahogany sofa with sabre legs, c. 1820; miniature sofa, c. 1835, English. Collection Geffrye Museum, London.

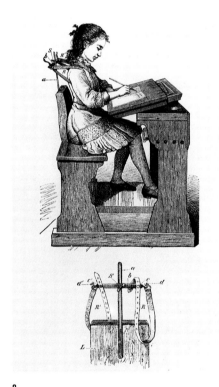

8
"A new halter device to keep school children sitting up straight", woodcut, c. 1890, German.

15 Mead 1949.

text to pursue the complex contributions made by design towards the building and awareness of gender identity. It should be enough to say that the elements of narrowly programmed designs – which, in the words of the anthropologist Margaret Mead, "create and maintain artificial occupational divisions and personality expectations for each sex that limit the humanity of other sex"[15] – have to be understood within the cultural context and the web of particular social relationships where they are used.

To meet the almost impossibly tall order of designing for the youngest members of society, adult needs might meet children's needs halfway, but there are no rules except awareness of the human nature of the child and its context. This is truly only possible in a one-off design, where the child's individual temperament and physiology can be closely attended to (fundamental in design for physically or mentally disadvantaged children). The reality is that a competent designer is able to sense patterns and make observations before commiting a creative act. Ergonomic soundness is relative. Once an object for a child is designed, freedom of use is a quality that can only partially be built into its form; it has be provided by the carer, and perhaps even the object's use supervised. Furthermore, it is not easy to make educational designs so that in their use the child can feel empowered to devise its own programme – just as designing for the fluid and mutable medium of the Internet requires a more humble, less controlling or behaviourist design sensibility. It involves the idea that a design might not be finished, and may be completely reassembled by the user. This kind of sensibility in design for formal learning environments is not widely applied. Perhaps the environmental designs for children's museums offer a richer scope for informal, non-consumerist, open design programmes.

Media attention and a focus on safety issues have meant more parental control, dependency upon experts and "good" advice about childcare. Awareness of the cultural contexts in which the child is reared, as perhaps the studies of cultures beyond the Western world in this volume may help to illuminate, involves a sense of the relative autonomy of the child and its carers in relation to societal norms. The introduction of the nursery was a double-edged phenomenon: a room set aside for the discipline and education of the young. By the early twentieth century, rooms and furnishing had distinguished numerous stages in a child's tastes and activities, from the nursery to adolescence to independence. The nursery was and is a repository of beliefs. Even if it becomes a zone totally free of adults, their intentions are still there – embodied in the objects found there, enclosed by memories of the safety gate.

Attempts to address the notion of giving control to the child (as opposed to consumer choice) through the design of furniture and toys, divorced of any adult preconceptions of what child's play should involve, have produced many modular designs and multi-use assemblages, many dating from

9
An advertisement from 1929
for the Jaeger Meccano
jerseys, with distinctive
chequerboard patterns, sold
exclusively to the "Meccano
Boys", members of the
world-wide, Boys Scouts-
style Meccano club. This
was founded to foster
identification with the
construction set company
Meccano, set up by inventor
Frank Hornby in Liverpool
in 1907.

the 1960s. A recent playtower by young English designer Humphrey Kelsey, based on lengthy studies of his eighteen-month-old son and his friends, deliberately aims to be ambiguous, and free of adult references such as bright colours and prescribed patterns of play. It animates the processes of revealing and concealing through a range of containment, methods of disassembly and of physical interaction. Unlike many pedagogically approved designs, the applications of this personal environment/repository are not age-related.

Just as an entire global economy has now developed around children, so children continue to develop trading economies of their own, imposing their presence. While children in many cultures do not act as commercial producers of artefacts intended to equip them with the means to negotiate the adult world, what they actually use, play with and benefit from is often improvised on the spur of the moment.

Beliefs in the importance of simplicity and directness, as in toy-making, have been overcome by other adult beliefs in consumer choice, in novelties and stimulating consumption. Less is more and play furniture can be self-made, customised, and above all used in ways often not envisaged by the designer or other adult provider. Historically, improvisation has been a major adult activity in creating home-grown support objects (and toys like dolls' houses) for children which could not be justified economically due to the ephemerality of their need. Examples of home-made artefacts in nineteenth-century rural Ireland, for instance, include "running stools" for children learning to walk, using wheels made of old cotton reels, and settle beds that doubled up as playpens.[16] An etching by the artist Daniel Maclise shows the cramped conditions of a single-storey house, with animals wandering around, and a small child confined amongst the legs of a sugan chair, laid on its back for the purpose. It is clear why so few of these fragile objects have survived, except as memories or depictions.

Children's artefacts and environments are invariably designed to fulfill the needs, and even satisfy the fantasies, of adults. Why is living with good design, or what passes for it, incompatible with living with children? Because good design is invariably static, ordered and of value, and children need to move through and disorder their environments, each time as if afresh, in line with their constant state of development. Adults like to relate, to feel extended and exalted through status symbols. By contrast, the child is constantly in a very distinct form of development, and does not for a long time accept the identity of external objects but, like a good artist, questions their reality. Children use objects in the world around them as symbols to express feelings and thoughts which otherwise would be unacceptable both to themselves and to the group in which they are living.

Adults use similar means within the larger terrain of society. A high percentage of the world's children live in cities. The organisation of the con-

16 Irish Country Furniture, 1700–1950.

10
Model family compound made by a child, Pern, Mongolia.

11
"My children, we were once children", illustration by Albert Hendschel to the poetry of Heinrich Heine, mid 19th century.

temporary industrialised city limits the laissez-faire nature of children's play outside the home. City planning is adult-oriented in a way that frequently does not embrace human difference, leaving the world of the child to be widely perceived as a spineless sphere of the socially weak.[17] Electronic tagging, a technology developed to keep track of criminals, has now been adapted for use in retail centres for children, so that individuals of all ages may soon have computer chips on their shoulders. Once, children used to play "tag"!

The importance of access to the kind of heterogeneous social space that enables us a degree of psychic balance as human beings is without doubt. Ralph Waldo Emerson wanted both "rural strength and religion" for his children as well as "city facility and polish", but with chagrin he sensed this to be an impossibility.[18] So, too, for the average urban dweller; while the macrocosmic problems of cities continue to rumble on, there is a strong impulse to consider, as curious observers, the identities of the home and the school as they affect their communities of inhabitants, spaces made by adults to contain their closest relationships.

Just as societies differ greatly in their orientation towards autonomy or dependence, furniture per se, in its role as definer of territory, is often far less common. In cultures like the South American Yequana, the Manus of New Guinea, the Mbuti in Africa and the Iatmul in Papua New Guinea, children own objects more closely geared to specific lifestyles, like the interactive vehicle of the sling, the personal food basket or canoe – equipment used autonomously – while toys are self-made. Cross-cultural influences have shown remote societies' awareness of their respective patterns of provision. In the industrialised West the sling is widely used for carrying babies around for the first few months of their lives – a more secure, intimate and interactive solution that the buggy or pram, and one that takes up less space, and is designed in a range of forms to suit individual body types.

17 See Sennett 1990.
18 Quoted in Ward 1978.

12
Low technology interactive
exhibit at the Children's
Museum of Manhattan, New
York City, 1996.

13
Children make a tented
hideout in the garden,
England.

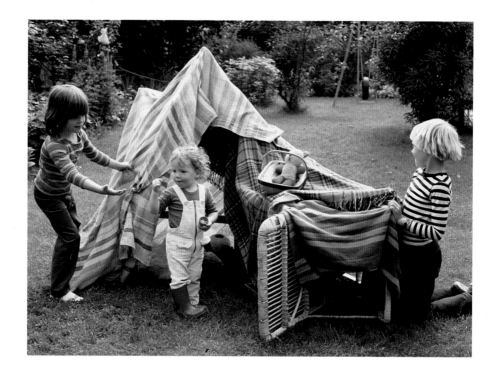

22

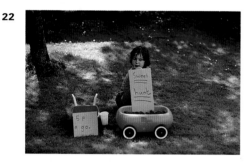

14
The game of trading,
England, 1984.

An element of anthropological enquiry within Western society, making the all-too-familiar strange, might act to lighten some of our psychic mists. With a degree of innocence, perhaps, prompted by a desire to uncover meaning rather than a puritan philosophy of denial, the British writer Norman Douglas wrote, just after the Second World War (a time of enforced utility, but high ideals for the future): "if you want to know what children can do, you must stop giving them things."[19]

19 Ibid.

15
Resourceful play with a
cardboard box, England.

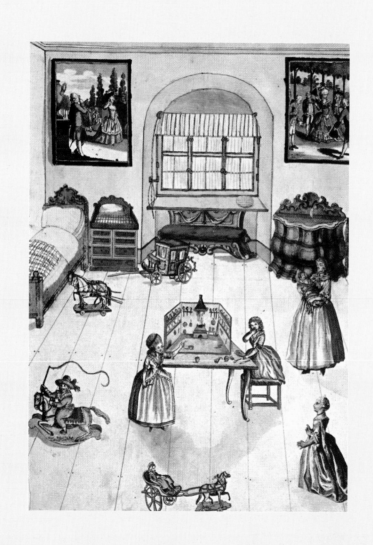

Ingeborg Weber-Kellermann

Die Kinderstube, 1991

Reprinted from Die Kinderstube,
Insel Verlag, Frankfurt am Main
and Leipzig 1991.

1
A child's room, picture book
with coloured engravings,
Augsburg 1740.

2
Sixteenth-century woodcut
of patrician family life.

A Cultural History of the Children's Room

The cultural indicators of a child's living arrangements are a gauge of society's attitude towards its children at any particular time. Linguistically, the basic meaning of the word *wohnen*, to live, is to be content; its other derivatives *gewöhnen* (to become accustomed to), *Wonne* (bliss) and *Wunsch* (wish) also fall within this emotional ambit. However, the meaning of *wohnen* originally amounted only to finding shelter under a roof, and for households in the past this entailed the whole family's living together and pulling together on the domestic front, old and young, all and sundry, as well as a band of servants. There was no question of giving a room over specially to children.

The main image in a legal and social context was therefore that of the extended family, the ganze *Haus* (whole house) as it is called in the Lutheran bible. The family group lived together under one roof and managed the means of production, which were held in common – rather like a workshop, a shop, a commercial enterprise, or a farm. The extended family was not necessarily restricted to blood relations, but could include maids, labourers, errand boys, journeymen, apprentices and servants; they might all live together as a social and commercial community where the number of household members was not important. The *Hausvater* (head of the household) was his family's legal representative in the municipality. This family structure was not restricted to the wealthy; ordinary people also organised their daily lives along such patriarchal lines. The son of a provincial eighteenth-century baker and smallholder with 11 children relates that owing to rising costs his father's debts were equal to the value of his house and the parcels of land belonging to it. In order to support his family honestly and "to create among his children an atmosphere of homeliness, simple living and probity, he availed himself of a simple . . . method . . . My father introduced for the whole household a system of duties and tasks, which were divided up among the children. With every passing year, each child proceeded to a higher level. This brought perfect order to the household. Each child knew, for the most part, from the moment it got up in the morning, what he or she had to do for the whole day. In this way, you became accustomed to

the tasks that had been assigned, and force, threats and parental admonishments were unnecesary. A mere wave of the hand was sufficient to see each child engaging willingly in its work. One good consequence of this system was that the higher levels of tasks were seen as a worthwhile mark of distinction, and you looked forward to the following year because you were moving up a level."[1]

In the old system of a patriarchally ordered family structure, children had no place of their own: only their physical upbringing was assured, as can be seen in a sixteenth-century woodcut showing the eight children of a patrician family.[2] One of the children sits in the background, certainly confined to its child's chair and probably on the potty; a second teeters in a baby-walker that protects it from knocks and falls; in the foreground, two children feed themselves unaided with wooden spoons from a long-handled basin fixed on a framework so that it cannot tip over; a somewhat older boy in a smock with a feather in his cap rides on a hobby-horse and is apparently pulling his brother along in his baby-walker, like a cart; a small girl in plaits greets her father, while her sister makes herself useful with a little basket, and the mother has taken the youngest child out of the cradle to breast-feed it. An older female relation sits spinning in the midground, keeping half an eye on the children, but in fact they are all protected somehow – even the infant will be tied in firmly when it is returned to the cradle.

Yet in this picture we miss any real sense of care for the children or their imaginations. The mother's attention is firmly on the father, who is dressed to go out and comes into the room only briefly, gesturing imperiously for quiet. The domineering bearing of the Hausvater clearly conveys something about the family system; he exercised control over the home in legal and economic matters, as well as those relating to the children's upbringing, and took responsibility for its members. In this way, a patriarchal–authoritarian system developed, taking the "father of the people" as its power model, and in religious terms overreaching itself in the concept of the devout nature of the relationship between the believer and God being reflected in that between the child and the father. The royal court itself can be understood as an expanded version of the control exercised by the king over his personal household.[3]

Generally speaking, contemporary painting reflects the same picture of the position of the child in society, at all socio-economic levels. In the famous depiction of a baptism by Jan Steen (1626–79) we see two boys with a ewer of wine, the older one pouring from it into the smaller one's mouth: no one is paying them the slightest attention. Only the smallest child in the basket and the two-year-old wearing a protective hat and tied to its mother's apron strings have the pleasure of any attention from the three chatting women.

This attitude towards children is typical for the time up to 1800. Small children are apparently confined to their child chairs, from beneath which potties could

26

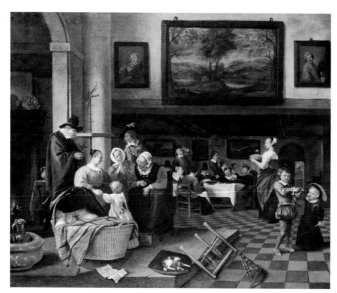

3
Jan Steen (1626–79),
children's behaviour
at a christening celebration.

1 Schad 1828, pp. 9ff.
2 Scheidig 1955, p. 121.
3 Weber-Kellermann 1984, pp. 74ff.

be pulled out; they may play with rattles or be amused by older siblings.[4] They are protected from danger in many ways: they move around in baby-walkers or, as infants, are bound in their cradles, but they do not experience any adult interest in them as children. This is particularly apparent in an anonymous north German painting of c. 1700. It shows what might be deemed a "children's room", going by the number of children depicted. In the foreground on both sides two small children sleep, one in a cradle, the other confined to a child's chair, where it is safe without needing adult attention. The woman nearby is doing elaborate needlework, and the spinning wheel on top of the open cupboard suggests that the room is mainly used for women's tasks. Although there are six children, they are not the main protagonists, and there is not a toy to be seen. A young woman is teaching a toddler in the customary protective hat to walk on a rein; a rather older nanny on the left in the foreground, although in the throes of teaching the child kneeling in front of her how to read, has broken off and removed her glasses. An older girl, kneeling against the wall as a punishment, has apparently given further cause for chastisement and is about to be struck with a

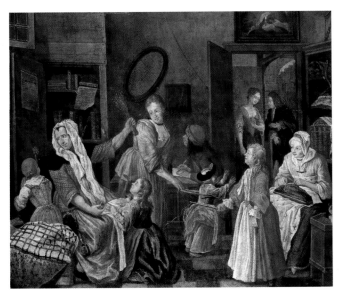

4
Unknown artist, caring for and bringing up children, c. 1700.

switch. This attracts the attention of all those in the room, including the young ones. Even a boy of about five, still dressed in girl's clothes and holding a whip in his right hand, seems extremely interested in this punishment. In the background, a man is busy writing at a desk, and through the open door we see the lady of the house engaged in a suggestive exchange with a cavalier.

There is nothing here indicating any particular affection, or any idea of a child's world in the later sense. Children grow into the adult world with beatings, and their furniture is designed with, at most, their physical protection in mind, not to facilitate the blossoming of their potential. By today's standards of thinking, these were not child-friendly surroundings. On the other hand, within a household there were clearly several people to bring children up: aunts, grandparents, maids and nannies.

These conditions were altered noticeably by the changes afforded by the French Revolution of 1789, and later by the processes of the so-called Industrial Revolution around 1800.

Up to that point, the guilds had determined the nature of commercial life in the cities. Their rules for the multi-part system of production and trade enterprises were strict; women had a definite role to play in the businesses, into which the children grew gradually, playing and learning. Apprentices, journeymen and domestic maids were part of a communal commercial association, living and working under the same roof. Children were enlisted to help out and run errands, and gradually grew into their fathers' professions. However, at the same time, they could play unattended in the house, garden or street, and no one expressly stipulated how they should behave. There was no children's room in a crafts-

4 Weber-Kellermann 1989, p. 29.

man's house – at the very most, the children might have their own communal bedroom.

Although children of high social standing apparently had lovely toys, as the picture by Mettenleitner (1750–1825) shows, they played under the watchful eyes of adults. This did not mean, however, that the adults' interest was directed towards them; rather, it represented a physical proximity that went hand-in-hand with emotional distance.

In his autobiography, the dramatist Franz Grillparzer (1791–1872) described the feelings of a child in a children's room in an old apartment block in Vienna – the antithesis of a homely place and more akin to a sort of chamber of horrors in which the children's four beds seemed completely lost.[5] The only light entering the room came through glass panes in the door, and close by was a wood store inhabited by rats, which filled the children with fear and indescribable horror. How cultivated parents (their father was a lawyer) could allot their children such quarters is completely incomprehensible today. If one of the principal goals of bringing up a child is, as I believe, the avoidance of fear, then these parents had absolutely no idea what they were doing.

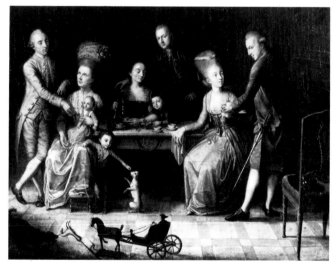

28

5
Jakob Johann Mettenleitner (1750–1825), children at play in a family setting, c. 1780.

But perhaps lack of attention towards children's feelings was typical for that period, which Ariès denoted as the time "of small adults".[6] He is particularly concerned with the childhood of the French Dauphin, later King Louis XIII, which was described in great detail by his personal physician, and which Ariès recounts under the chapter heading "From Shamelessness to Innocence". However, it contains no discussion either of an upbringing appropriate for a child, or a children's room. The "small adults" metaphor was still in evidence a hundred years later: the engravings of Daniel Chodowiecki (1726–1801) show boys suffering in frock coats and girls in corsets. In addition, the small children wear protective hats to keep them safe from the worst accidents, but receive no guidance pitched at their own level.

This all changed gradually with the turn of the nineteenth century. One outcome for workers and managers of the Industrial Revolution – a process of many phases, stemming from technological and organisational changes in the way factories were run and businesses managed – was the separation of the home and workplace (the countryside was an exception). This may be regarded as the decisive social change of the modern period – the breaking up of Luther's "whole house", the household. Instead, the middle-class nuclear family developed as the dominant social unit, and it was generally made up simply of only two generations. The French Revolution endorsed this unit, and its concomitant concept of the rights of the individual personality. The structure of family relationships changed: the father left the apartment to go to work elsewhere, while the mother's concerns were directed totally towards housekeeping and looking after the children.

5 Grillparzer, pp. 3f.
6 Ariès 1975.

This meant at the same time both a reduction in the possibilities open to women and the opening up of new areas of activity. Totally new dispositions came about in the way people lived and interacted on a day-to-day basis, and so at the beginning of the nineteenth century a middle-class culture unfolded that looked in upon itself – the growing spirit of Biedermeier contentment.

Karl Gutzkow (1811–78) sensitively described this previously unknown attitude towards life in a family: "Order and cultivation spread everywhere a feeling of warmth and homeliness which, in addition to the first meaning that springs to mind, includes a sense of warm-heartedness: the lady's small worktable by the window; the sewing basket with its small rolls of thread, blue English needle-papers and colourfully lacquered stars for winding silk thread around, the thimble, the scissors and sewing cushion set up on the table; nearby, the piano with sheet music; hyacinths being hothoused under glass by the window; a bird in a beautiful brass cage; a carpet on the floor that muffles every step; copper engravings on the walls; everything that is required only occasionally moved to distant rooms; meetings of family members characterised by moderation and deference; no screaming, rushing or running; guests received with composure; in the evenings, the round table lit by the lamp; the water boiling for tea; the sense of order in giving and taking; the spiritual need to relate . . . the placing of all these chords next to each other creates a harmony, something moral, which takes, shapes and ennobles every man."[7]

The separation of work and home areas that was taking place in city life was accompanied by a separation of public and private life. The father stood for one of these spheres; the mother and housewife for the other. Behind closed doors, the apartment became the true site of family life.

At the same time the roles of the sexes changed, and the growing emotionalisation of the family, associated with Biedermeier, touched particularly on the wife and children. Care for the family's interior space was the wife's responsibility, and she sought and found compensation for her isolation in the cycle of *kirche, kuche, kinder* (church, kitchen, children). But little had changed in the hierarchy of middle-class family life; it still ran according to conservative patriarchal rules, with an unemancipated woman confined to the home, and the children brought up in the traditional authoritarian manner. This restriction to the inner realm of the family, however, brought with it an emotional fulfilment for women, and a new relationship to the world of children. Now there was a "children's room", and a huge increase in the number of toys – especially at Christmas, which became a bourgeois feast of presents for children.[8] With attention now being paid to children's wants, needs, interests and whims, the children's room changed from a simple dormitory to a play world. An example of this new family spirit is the picture-book representation of a children's room by Johann Michael Voltz (1784–1858), which appeared in a children's pic-

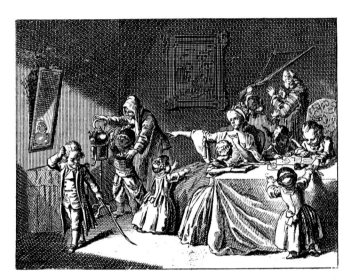

6
Daniel Chodowiecki (1726–1801), "small adults" in frock-coats, corsets and protective hats.

7 Gutzkow 1852, pp. 245ff.
8 Weber-Kellermann 1987, pp. 98ff.

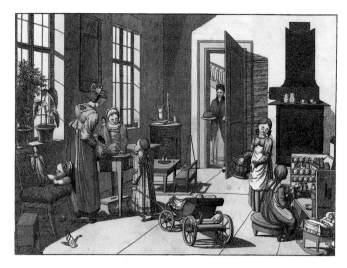

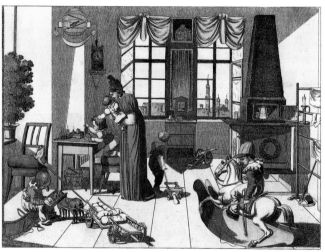

7
Michael Voltz (1784–1858),
a room for girls, a room for
boys, c. 1820.

ture book with other scenes from family life.[9] Going by the women's, girls' and dolls' clothing, we are in the first decades of the nineteenth century. The fire in the corner stove crackles cosily, warming drinks for the children's tea; a woman, perhaps their mother, is bringing in a cake. We see five girls of different ages, all contentedly playing with dolls and dolls' kitchens. Not only do they have cradles and carriages for their grown-up and baby dolls, they also have small furniture for themselves – tables, benches and stools designed to suit a child's stature.

The situation for the boys is no less cosy. The right-hand side of their picture is dominated by the male arena of war: under the window a cannon stands threatening, and in the foreground a proud boy with sabre and whip rides on a magnificent rocking horse. The situation is more peaceful on the other side of the picture. A small boy sits on the step in front of the window, lovingly feeding his two toy horses which are pulling an little cart laden with sacks of flour. There is also quite a small boy busy playing with a pull-along cart, while his brother builds a model village on the play table. The smallest boy, on his mother's arm, would very much like to join in. Practically hidden in the corner we can see a children's bench; apart from that, there is no children's furniture in this picture. However, on the stove there is a cocoa pot similar to that in the girls' room.

The frequent reprinting of these pictures up to the present time can hardly be attributed to their artistic merits. It is rather because they show the milieu of the children's room – a playroom in seemingly almost classical harmony, a make-believe world furnished in a friendly manner, in which adults play a supportive but not a commanding role. Even in the bourgeois society of the period, setting up nurseries as play paradises was certainly not an everyday occurrence, and such playrooms can hardly have been very common. It was already an achievement if a child had its own play corner in the living room – like the girl in the Hillebrandt painting, who holds her doll up proudly to view. Her dolls' kitchen is set up to be child-sized, and has a child's chair in front of it. These are signs of a completely new level of adult care and understanding, a transformation of the children's chairs of earlier periods which were designed principally to ensure safety and confinement.

Voltz's lovely, much published pictures should not lull us into thinking that such playrooms were common. The reminiscences of Felix Eberty (1812–84) of his childhood in Berlin show how different the children's room in an upper-class house of the Biedermeier period was to the rest of the home: "The second floor was inhabited by my parents. They had a very comfortable room with three windows, one of them with a bevelled glass partition for flowers. A large curtain cov-

9 Voltz 1983.

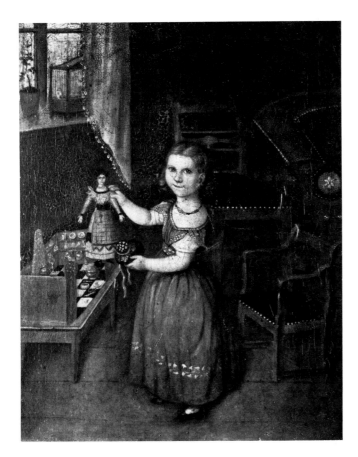

8
Johann Heinrich Hillebrandt
(born 1804), a small girl with
her doll and dolls' kitchen,
1832.

ered a wide opening to the adjoining alcove that served as their bedchamber. From the alcove you reached another small chamber, which served as a dining room. The servants' room led off this into the kitchen, which in turn gave on to a corridor (from which opened all sorts of storage and wall cupboards), and on to the wing on the courtyard that ran parallel with the front of the house, where the spacious, friendly children's room was."[10]

So the children's windows looked on to the courtyard, and their room lay far away from the living rooms, beyond the kitchen and the servants' quarters. We can hardly suppose that they would have liked staying there during the day, and that they would not rather have felt attracted to the adults' rooms. This same situation is vividly captured by Adalbert Stifter (1805–68): "My father had two children, myself, the first-born son, and a daughter, who was two years younger than me. We each had a small room in the apartment, in which we had to dedicate ourselves to our tasks, which were laid down for us even as children, and in which we slept. Mother kept an eye on us, and occasionally allowed us to come into their room and amuse ourselves with games."[11]

The children's room was definitely not always a play paradise, but rather a room for keeping sleeping children safe. "Our children's room was in a space under the gables, on the same level as the attic. A staircase led down to the central block level, where the smoking rooms were."[12] This description by Otto von Corvin (1812–86), the son of an officer and post office director, who came from the small Masurian town of Gumbinnen and grew up in thoroughly upper-class circles, makes one think immediately of that unwelcome exhortation "Go up to your room!", which would drive children out of the familial world of the living room to the spartan spaces that belonged to them.

I have not as yet touched on the different ways in which children's rooms were fitted out. Let it only be said that their invention in the Biedermeier period did not generally mean the glorious setting for children we see in the Voltz picture, but it did indicate a new understanding of children as an autonomous social group and is evidence of changed perceptions in bourgeois society of how children should be brought up. The spirit of this upbringing, occupying the space between the physical world of adults and the imaginary world of children, was articulated in a universally valid manner by Ellen Key (1849–1926) in her classic work, The Century of the Child: "During precisely that time when true development proceeds in touching, tasting, biting and feeling, etc., children are continually hearing the cry 'Leave that alone!' So to suit a child's temperament as well as to develop its strength, a large, colourful children's room is the most important thing of all, decorated with pretty lithographs, woodcuts and such

10 Eberty 1925, pp. 112ff.
11 Stifter, p. 1.
12 Corvin 1880, p. 16.

like, and full of plenty of space to move around. But if a child is inside with its parents and starts getting up to a lot of nonsense, then a short rebuke is the right means to teach it how to respect the grown-up world, in which someone else's will rules; a world in which a child should certainly create space for itself, but should also learn that any space it occupies for itself also has its limits! . . .

"Play can promote familiarity between parents and children, and can teach the former how to become better acquainted with the latter. But allowing children to turn all rooms into their own play space, and allowing them to demand continually that adults should be occupied with them is one of the most dangerous forms of mollycoddling in the present day. For it makes children accustomed to egotism and psychological dependence, and in any case entails an everlasting process of being brought up, which deadens a child's personality. The fact that children were at home in their own room, but outside it encountered the fixed boundary of their parents' habits and intentions, work and rest, commands and desires, meant that children were formerly a stronger and more respectful group than the youth of today."[13]

Ellen Key was writing in the twentieth century, yet a hundred years earlier the pedagogue Johannes Struve had similarly called for a healthy, child-friendly room for young people: "The [children's room] is usually the worst in the house, where neither sunlight nor moonlight can enter, while the best room in the house is decorated for empty display to look glamorous during occasional visits. It is considered acceptable to undertake all kinds of dirty and wet tasks in the children's room. Curtains are put up in front of all the doors and windows. The children's room should be the family's prettiest and most spacious room and provide unhindered entry for light and air."[14]

If the Biedermeier period was characterised by the contentment of the more-or-less self-satisfied middle class, then the determining elements of late nineteenth-century society looked different. Victory in the 1870–71 Franco–Prussian war flooded the country with billions of Reichsmarks; one consequence was the setting up of joint-stock companies, banks and huge business concerns, raising morale in a period of rapid industrial expansion. Incapable of creating a new style, the new rich began to use ideas from the past. In the spirit of historicism, dining rooms were decked out in old German style, salons in rococo, and bedrooms in baroque. The new furniture industry produced furnishings with "style" stuck on, and it became fashionable to have new reproductions, not inherited antiques.

Where did children live in this world of plush portières and carved wooden whatnots? They had their room near their parents' bedroom; the nanny often slept with the girls. Remarkably, however, a certain coolness infiltrated the former Biedermeier cosiness. The intimacy of the mother–child relationship became ossified in bourgeois rituals. The nanny, thrust between children and mother, often developed a more natural friendship with her charges than their mother did, distanced from them as she increasingly became in her role as a lady.

13 Key 1978, pp. 129ff., 169ff.
14 Struve 1781, p. 64.

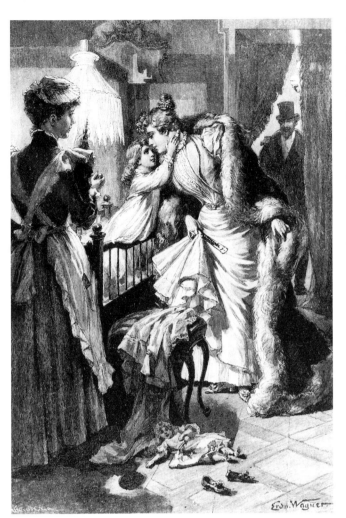

9
Erdmann Wagner
(1842–1917), parents going
out for the evening, while
the maid stays in with the
child, 1895.

Alice Herdan-Zuckmayer, the spoilt child of well-to-do parents in Vienna around 1900, felt much closer to the maid and the cook that to her refined mother. But in the children's room, her fantasy world came into being: "My room was long and wide, and there was a great deal of space between the table in the middle and the furniture that was by the walls. The room had four narrow windows, and underneath the windows were stored the big dolls' furniture, the dolls' house, the box of building blocks and the railway, above which there was, on a dainty table, an evergreen Alpine garden. My big white bed was ranged along the opposite wall, and above the tall curved headboard rose up the powerful watchtower: the crenellated, tiled, light blue stove.

"The bed stood right against the wall so that, if fear came knocking at night, you could press your back against the wall and look danger in the face. The mattresses were soft – only poor people had hard beds and hard bread – and if fate so decreed, a horsehair would occasionally poke through the sheet, which I would pluck out and make a wish: I would wish that I was lying in a meadow on real hay. The blanket was light blue, decorated with many colourful flowers; it was quilted, and seemed almost to be made of silk, because you had to wait until you were grown up to have a quilt with real silk. On top of the blanket there was a small, light eiderdown, covered with fine cambric. You could even see the light blue of the bolster, where the strong material of its cover was interrupted by lace insets. The most important thing however in the whole bed, was the small pillow, which lay on top of the big bolster."[15]

We are provided with another example of a children's room in a wealthy home at around the time of the First World War by Thomas Mann (1875–1955) in Doctor Faustus, where he writes about three girls who are being looked after by a young lady, a skilled nursery school teacher: "The light room where they grew up, where their beds stood, and where Ines [their mother] visited them whenever permitted by the demands made on her by the home and by her concern to appear soignée, was the very model of a children's paradise in the home, just as you see in books, with its fairy-tale frieze running round the walls, its likewise fairy-tale Lilliputian furniture, its colourful linoleum floor covering, and a whole world of well ordered toys – teddy bears, lambs on wheels, jack-in-the-boxes, Käthe Kruse dolls and railways – on the shelves around the walls."[16]

Although it is conceived ironically, what is envisaged here is a complete children's environment, which does not seem to be enlivened by the presence or mischief-making of any children. This was not the normal state of affairs.

Descriptions of the way people lived in the nineteenth and twentieth centuries show us that the middle-class children's room was a great privilege of the upper

15 Herdan-Zuckmayer 1973, pp. 32f.
16 Mann 1952, p. 447.

strata of society; even in those circumstances, it should not always be construed as an ideal playroom or personal space for children. Rather, it represented a combined bedroom and playroom for several brothers and sisters, usually furnished with discarded, inherited or leftover furniture. After the First World War, increasing urbanisation and incipient financial crisis meant that the setting-up of children's rooms remained the prerogative of an upper class that was ever shrinking in numbers.

With the fewer children of the nuclear family, the reduction in size of rented accommodation in cities, and the gradual disappearance of maids and nannies, the old children's rooms became rarer and rarer. The middle classes in the city, impoverished by inflation, attempted to uphold their prestige by maintaining a dining room and a smoking room, but not necessarily a children's room. Children often had to content themselves with niches for sleeping in, or corners to play in. I remember feeling indescribable happiness at the age of eight or nine when we moved to a larger flat – this was Berlin in the 1920s – in which I was allowed to have the maid's room behind the kitchen as my bedroom (it measured 2 x 3 metres). For playing and homework I was supposed to use the large boys' room, occupied by my brother who was three years older than me – not a very happy solution, as you can imagine. I arranged everything all the more prettily in my room, which now embraced everything that personally belonged to me.

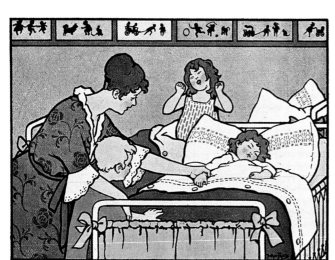

10
Illustration of a children's bedroom from a school primer of the 1920s.

The roles of the sexes, learned and impressed upon one from childhood days, had still changed little; and the leitmotif of patriarchy and paternal authority, emanating from parents who lacked imagination, repeated itself down the generations. Nazism sought to take this situation a step further, by restricting women completely to their purely biological role as child-bearers. Despite all the proclamations that the family was the "nucleus of the State", the leaders of the State mistrusted the family as a site for the socialisation of children – realising, correctly, its bourgeois character. It was considered desirable to remove children as soon as possible from the influence of their upbringing, and give them over to the political, pre-military institutions of the Hitler Youth. In such a society, a children's room could mean only a hygienic bedroom and a place for small infants, the responsibility of the mother in the child's first years. The war, however, changed things; requiring women to work in great numbers at a whole range of jobs, it put to the test women's and children's abilities in tasks that were totally unaccustomed and unexpected. Thus the authoritarian Nazi model of the family was destroyed even before it could be carried through in any detail.

The events of the war and its consequences after 1945 brought a return to the primary form of the family, for which there was an emotional need; for many, it was the only social unit that had remained intact. However, the old system of

patriarchy was salvaged as a quality traditionally considered to belong it. Advertising gladly used this cliché, and believed that it reached the majority of the population in this way. Again it was the father who took the lead, and the mother who took care of making the home, using her skill with the washing machine and her talents in the kitchen.

The concept of the small post-war house corresponded, to a certain extent, with this family model. It was a great step forward that terraced houses were always planned with a children's room in mind, even if it was often the furthest removed from the centre of the house – for example, as a fully fitted out loft. Small children in particular are frightened in rooms like this; despite child-friendly furnishings, they feel excluded. Does appropriate furniture make a child's dream of self-determination within its own four walls, its own world, a reality? Clearly there is a conflict of interests between a child's need for personal space, and familial warmth and integration. The child wants to be able to be alone, but does not want to feel excluded. It is not a case of either one thing or the other.

Yet circumstances are in constant flux from year to year. The choice offered by architects and furniture designers becomes ever greater and more carefully thought out. The history of the children's room and of its absence runs parallel to the social history of the family in society. In general, a re-evaluation, a change in traditional norms, has not yet taken place. We can see from social history that the old-style middle class family gradually began to question itself. The beginnings of this process lay in the isolation of the child, the way in which the father's professional activity, money and sexuality were all rendered taboo subjects; thus a generation gap came into being, which gradually became more and more unbridgeable. Authority, fear, respect and reverence for the untouchable models provided by adults often replaced a friendship of equals between parent and child. But even the friendly side of the old-style parent–child relationship – the care for the child and the child's world, the loving protection and prolonging of childhood – could not only nurture a friendship of equals, it could also hinder it. A new generation of parents is beginning to free itself of these constraints, parents who allow their children to call them by their first names and ensure that they participate at mealtimes. Above all, this is an attempt to introduce democratic concepts into the family. Now, in line with new movements in contemporary society, a model of partnership is growing up in contrast to the hierarchical power schemes that were current for centuries.

11
Modern children's playroom made out of cherry wood, 1919.

No Nursery

The nursery displayed its wealth of facilities – all its potential for physical, emotional and intellectual development – from the Biedermeier period onwards, but we need to pose a question about its social extent. There is no doubt that the

nineteenth-century nursery was a middle-class, even upper middle-class, institution, at least in the larger towns and cities. Its great significance for the socialisation of children is obvious. But what about the many children who did not, and do not, have one? What did, or do, they actually miss? This is a class-specific problem, related to the social–historical development of the century that produced the nursery.

The social class from which the middle classes felt such an urgent need to distance themselves in behaviour and in domestic upbringing was that of the urban labouring class, the blue-collar workers. This new group had had to set themselves up without any external help and without any cultural model; their possibilities for structuring family life in a way that would benefit their children were minimal. Families were dependent on wages from all members, even children from the age of ten; they worked excessively long hours and had little free time; their living conditions were poor and their nutrition inadequate, and parents could offer children few opportunities for the future. The separation of home and workplace turned out to be a negative move for this particular group. Whereas in the middle-class family a social transformation had produced new space for the wife and mother who had benefited by turning her attention to household and children, the same process of change had quite the opposite consequences for the workers. Their homes became nothing more than places to sleep, and increasingly lost any qualities of security and intimacy they may have had. How was a woman to find time and energy for domesticity when she was working ten to twelve hours a day in a factory, not to mention her lack of material means? Plagued by numerous pregnancies, she did not usually find children a blessing, and was unable to offer them the protection of a stable family life.

However, despite cramped living conditions, the mother of Erich Kästner (1899–1974) obviously did succeed in creating a feeling of security:

"I lay in the cradle and grew. I sat in my pram and grew. I learned to walk and grew. My father was still working at Lippold's munitions factory. And my mother still sewed linen strips.

"I watched her from my cot, which was fitted with a wooden grille as a precaution.
"She sewed deep into the night.

"And naturally I was woken up by the singing sound the sewing machine made. Actually, I quite liked it, but my mother wasn't at all pleased. She put the shiny cover over the Singer sewing machine and decided on the spot to let out a room."[17]

In other words, his mother wanted to end a state of affairs connected with her working at home, and contribute instead to the family budget in a different way. But the child liked the sound of the sewing machine and his mother's closeness, and he probably felt happier than he would have done alone in a nursery (not that there was in any case room for a nursery in the small flat). And, as his mother correctly recognised, satisfying his sociability was not the most important thing – for the worker's wife, as for the mother working at home, it was a question of how best to utilise the family's restricted living space.

17 Kästner 1975, p. 64.

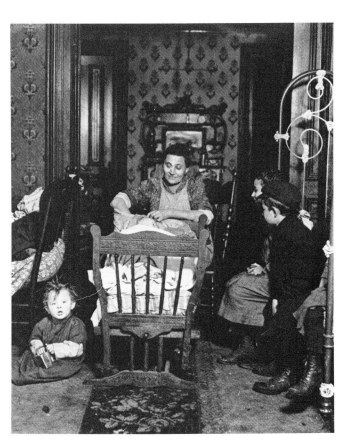

12
Living-cum-bedroom of a
working-class family.

The most important problem for working-class families was where the children could sleep. And it was here that the greatest contrast to the well cared-for children of the middle classes became apparent. Simone de Beauvoir (1908–86) describes this contrast in her memoirs from the early 1920s:

"Only once did I get some inkling of the meaning of misery. Louise lived with her husband, the roofer, in a room under the roof in the Rue Madame; she had a baby, and I visited her with Mama. I had never before set foot on a sixth floor. The gloomy corridor, on to which a dozen absolutely identical doors opened, had a depressing effect on me. Louise's tiny room contained an iron bedstead, a cradle and a table, on which a spirit stove stood. She slept, cooked, ate and lived together with her husband within these four walls; all along the corridor, people lived in the same suffocating nearness in just the same sort of holes. The close quarters of our family at home and the monotony of the days of middle- class existence already seemed oppressive to me. Here I sensed a world in which the air that one breathed smelled of soot and was covered by a layer of dirt through which no ray of light could penetrate; existence here seemed to me to be a slow agony. A short time afterwards Louise lost her child.

"I sobbed for hours; it was the first time that I had seen misfortune so close at hand. I imagined Louise in her cheerless room, bereft of her baby, without anything; such misery should have shaken the earth to its foundations. It is unfair! I said to myself, and was thinking not just of the dead child but also of that corridor on the sixth floor. Finally, however, I dried my tears, without seriously having questioned society."[18]

Now here is an eight-year-old Viennese child from around 1930: "I hurt all over all the time, because we have a lodger now, so I have to sleep with my mother and Gretl and little Hansi in one bed. You keep getting kicked and you can't stretch out."[19] Just as inconceivable for a middle-class child of the same period are the childhood memories of Adelheid Popp (1869–1939) from Vienna:

"Luckily my mother was suspicious, and we rented a small room just for us alone. My younger brother moved back in with us, too, and brought a workmate, with whom he shared a bed. Thus we were four people in a small room that didn't even have a window but received its only light through the windowpanes in the door. Once, when a maidservant we knew well was out of work, she came and joined us. She shared a bed with my mother, and I had to lie at their feet and rest my own feet on a chair that had been pushed up."[20]

The pictures of Heinrich Zille (1858–1929) speak volumes about the living conditions of working-class children in Berlin. A worker's son relates an episode from his childhood in the 1920s: "It wasn't easy for a family of six to find places

18 De Beauvoir 1958.
19 Hetzer 1937, p. 94.
20 Popp 1977, p. 36.

to sleep in a one-and-a-half-room flat. I was allowed to sleep in the armchair in our large kitchen-cum-living room, which had two windows. Although most of our domestic life took place in this room, I had to go to bed at 7 o'clock in the summer, and as soon as it got dark in winter."[21] For working-class children, there was a total absence of all those facilities that the nursery provided for middle-class children. The hygiene conditions of the former both at home and in the workplace were characterised by inadequate sanitation. Water often had to be brought from some distance away, and was too precious to use for washing. After a very long working day, the children were often too tired to wash anyway.

Nor could working-class children's needs be met with regard to food. From as young an age as possible, a child had to keep up with its elders, or eat its soup in a corner of the kitchen and its piece of bread in the street: "The following spring my father, who was a foreman in a paper factory, was often on night shift, and I was allowed to take him his evening meal. Proudly and carefully I carried the big lidded basket, which contained potato salad and a hot sausage, into the factory. How longingly I watched each bite disappear into my father's mouth, since potato salad and hot sausage seemed to me the highest of all pleasures. My

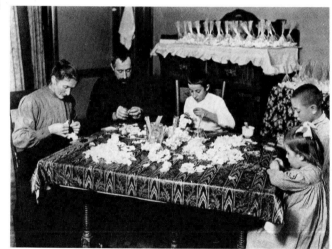

13
Home worker's family making artificial flowers, 1912.

father obviously saw my greedy looks but acted as if he didn't notice anything; it was his view that children's desires should be suppressed, so that having to go without things later on in life would not hit them so hard. He packed the remains of his supper – he never ate it all – back into the basket and enjoined me to go straight home. However, my good father had not reckoned with the strength of a child's cravings: the merest glance at the lid of the basket was enough to make my mouth water. Hardly was I outside the factory than I set the basket down in a corner of the covered bridge and devoured the sausage end and the scant leftovers of potato salad with rapture. Longingly I asked myself: 'Will I ever in my whole life get enough sausage and potato salad – really enough, four, even five, sausages and a big bowl of salad to go with them?' But that had to remain wishful thinking for a long time, seeing that my father at that time earned around twenty francs a week as a foreman. Even if living was cheap and we lived extremely frugally, the pay was hardly enough for a family of six. Mother helped out by working at home."[22] This moving story by Verena Conzett (1861–1947) tells us a lot about hunger, while her mother having to take in work at home to improve the budget was true of many families during that time of misery for the working class, and considerably reduced the children's potential for play.

Unlike the children who played in nurseries, these children were trained to work regularly from the age of four in those families who undertook outwork – this was particularly true amongst the dollmakers of Thuringia and the toymakers of the Erzgebirge. Such obligatory work for many hours a day contrasted with middle-class children merrily painting and making things for their own pleasure. The

21 Brust 1989, p. 7.
22 Conzett 1929, pp. 21ff.

occasionally expressed notion that working together around the family table would create a certain warmth within the family – even perhaps give a new reality to the old spirit of joint management of the household's resources – can arise only out of ignorance and misinterpretation of the true circumstances. Home workers did not own their means of production, but had to sell their and their children's labour at the lowest level, at prices determined solely by those distributing the work. A certain family solidarity may well, of necessity, have been engendered in the face of such techniques of existence, but the development of the social form of the family could not happen in such an environment, and development of children according to their own individual capabilities could not flourish. Their opportunities in life were restricted in the extreme. The macabre fact that, in the dollmaking industry, children often worked effectively for children and that this continued well into the twentieth century should give us cause to think very carefully about the mentality of the class society of those times.

What about children living in the countryside? Children of day labourers and farmworkers, as a result of cramped living conditions and the early age at which work started, suffered from the same limitations as working-class children in the cities. However, things were different for the children of farmers. Agrarian society still did not acknowledge any childhood status as such; it was the children's task to grow up, so that little by little they would be able to carry out the same duties as adults, and to gain experience. They wore miniature versions of adult clothing, used shortened tools, and carried out the chores (gradually becoming more complex) that they were allocated in house and farmyard, garden and field. They did not have a nursery. At first they usually slept in their grandmother's bed, later with the maid or farmhand. Their few toys were related to farm work or were intended to foster competitiveness and skill. Nobody bothered very much with school work; schools had little standing in villages in any case. Reading was considered to be a superfluous pleasure that one could indulge only in secret.[23] In short, the farmer's child went without a nursery, not because the house was short of space, but because a nursery would not have fitted into the intellectual and social network of village life. The number of children without a nursery must have been considerably greater than those who did, at least up to the 1950s. The testimony of those other, luckier children reveals how much having their own room contributed to enriching their lives, adding a wealth of possibilities to the process of socialisation. Children who used their nursery facilities well had an advantage over the others from the outset. A nursery can help children to discover their own individuality and identity, and thus give them a more favourable starting point for their journey through life. Lack of one, whether through necessity or lack of understanding, entails a decisive loss of opportunity.

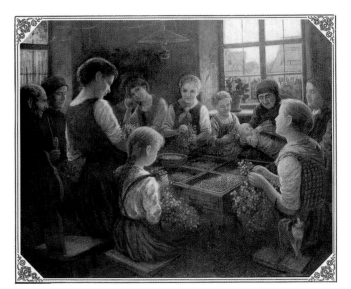

14
Leonhard Raum (1859–1944), village team picking over hops, 1925.

23 Weber-Kellermann 1988, pp. 243ff.

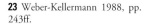

Noreen Marshall

The Big Sleep

1
Rocking Ceremony, parish church at Blidworth, Nottinghamshire. A wooden plaque in the church is inscribed with the names of all the "cradle-rocked" babies.

The cradle (or cot, or crib), an infant's first bed, is among the most potent symbols of infancy in the popular imagination. They were sometimes carried in wedding processions to wish fertility to bridal couples, and miniature pottery cradles were given as wedding or Christening presents (although it has always been unlucky to rock the cradle before the birth, or to have it too obviously present in the house beforehand). If you stepped into the church of the Purification of the Virgin Mary, at Blidworth in the English Midlands, on the Sunday nearest to 2 February, you would find an old wooden cradle standing by the altar as a symbol of Christ's infancy. On this day the service of "Rocking the Cradle" commemorates Christ's Presentation in the Temple. The baby boy born nearest to the previous Christmas Day in the parish is presented at the altar by the vicar, who rocks him in the flower-decorated cradle, saying the Rocking Prayer.[1]

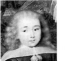

The presence of the baby in the cradle would often have been accompanied by anxiety: in addition to the physical dangers of illness, an infant was considered especially prone to attack by supernatural forces. The cradle might be protected by tokens, including lighted candles, pieces of iron, rowan branches, parental garments, and red cloths or ribbon, as well as religious symbols. Perhaps the greatest fear, which persisted almost to within living memory, was of the changeling – a fairy substitution for the human baby, usually made as it lay in its cradle. According to tradition, a changeling never walked, talked, or grew up. The two most widely advocated remedies were to surprise it into revealing itself, or to mistreat it until its true parent came to claim it back. One explanation was that fairies were originally a defeated human tribe, which exchanged their sickly children for the healthy ones of their conquerors. These legends were probably a way of accounting for the birth, for example, of children with disabilities such as Down's syndrome.[2]

Cradles have been made with both economy and extravagance. Among the first were hollowed-out logs and rush baskets; and boxes and drawers have been adapted for babies to sleep in. One far-fetched piece of economy was suggested in an article on the sleeping arrangements of the poor in 1910: "An empty banana crate makes an admirable substitute [for a cradle], purchasable for 1d or 2d . . . sheets, pillowcase and mattress-covers can be made cheaply from flour-bags . . ."[3]

1 Few cradles and children's beds survive from before the seventeenth century. Some of the best preserved of those that do were made for religious ceremonials such as this; an example is the cradle for the Christ Child in Cologne Cathedral.
2 Mary K. Harris 1980. The idea of a Down's Syndrome child being taken for a changeling is explored in Kathleen Hersom's story The Half Child, 1990.
3 Babyland magazine, 15 April 1910, Selwyn & Co., London.

2

Walnut cradle from
Pennsylvania or New Jersey,
1740–1800, Henry Francis
Dupont Winterthur Museum,
Delaware, N.J.

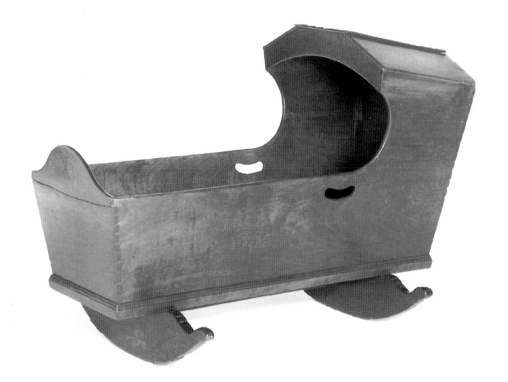

42

In the absence of a separate bed, babies slept with siblings or adults, despite concerns about incest and smothering. The Italian arcutio, a frame that enclosed and protected the baby within the bed, seems never to have been in widespread use. Child-sized beds have always been relatively few in number, even with the mass-production methods that first appeared in the nineteenth century. Once the cradle was outgrown (or another baby arrived to occupy it), children tended to share full-sized beds, or use the truckle beds that were stored beneath them.

Among the few cradles surviving from poorer families is one of simple and cheap construction dating from between 1770 and 1820 (Bethnal Green Museum of Childhood, London). It required a minimum of labour, technology and wood: three poles, four curved slats and several offcuts have been assembled with peg joints and basic finishing. Traditional techniques and the use of available materials are consistent with a cottage origin, as are the cradle's easiness to store and its adaptability. Because of its rack-like construction, it could hang from the wall when not in use; inverted, it could make an improvised seat. Another relatively cheap option was the wicker cradle and its variant, the Moses basket. These were also in use in wealthy families: the children of George III had cradles of split wicker,[4] but these are likely to have been on wooden rockers and of more elaborate workmanship than those of the cottagers. Wicker cradles were lightweight, easy to repair, and could be destroyed without great loss in the event of an infectious epidemic.

At the other end of the scale is the formal luxury of the cradle provided for the infant King of Rome, born in 1811, and an even more spectacular example associated with Henri-Dieudonné, Duc de Bordeaux, grandson of Charles X – born in 1820, seven months after his father's assassination, he was known as the

4 Supplied by Catherine Naish at a cost of £13 2s. Quoted in Lawrence Wright 1962.

"miracle baby". The Duc's cradle was lavishly decorated with carved wood and gilded bronze, velvet and silver braid, and hung with massive silk curtains. Dominating the piece are the strong lines and powerful presence of the winged guardian spirit, carved at its foot. Instead of hovering over the infant, as in the King of Rome's cradle, this figure precedes the child, triumphantly bearing a massive cornucopia of exquisitely carved flowers, fruits and vegetables. Such cradles are the princely baby's equivalent of the lit de parade, or state bed, and are at least as much about status and familial hopes as anything else.

Cradles and beds are more than sleeping spaces, however, and lend themselves to other uses. A mid-nineteenth century Punch cartoon, for example, shows a piece of domestic drama: as his wife's labour begins, the father-to-be is shown putting the cradle over his head and shoulders to protect him from attack by criminals as he runs through the streets for a doctor at two o'clock in the morning.

Beds have also played a part in the discipline and punishment of children. The inculcation of hardiness was considered good training for the young of better-off families. Along with cold baths and plain food, many children's sleeping arrangements were like those recalled from the 1830s by Mary Haldane: "Our cribs were of pinewood without springs, and had cross-bars on which we rested on mattresses of straw . . ."[5] The tradition continued longest in boarding schools: "Each cubicle had a narrow 'hospital' bed, with a thin, hard mattress, said to be very healthy for the young . . . On the bed was a thin under blanket, a sheet, one thin pillow, a top sheet and two thin blankets . . ."[6]

A happier role for the boarding school bed came with the holding of midnight feasts: it might conceal the refreshments, act as chair and table for the feast, and refuge for the culprits if they were discovered. Louisa M. Alcott describes one such feast, discovered by the headmistress, in her book An Old Fashioned Girl: "Out went the candle, and each one rushed away with as much of the feast as she could seize . . . With sudden energy the old lady plucked off the cover, and there lay Sally . . . among papers of candy, bits of pie and cake, oranges and apples, and a candle upside down burning a hole in the sheet . . ."[7]

Sending a child to bed during the day for bad behaviour provided an alternative to physical punishment, although possibly it lost some of its point as children's bedrooms became places of comfort and recreation. One writer not only advised against it, but worried about the consequences: "Unless he sleeps he will probably be bored, and boredom may suggest the beginning of unpleasant habits which are very difficult to cure . . ."[8]

Privacy for a child, even in bed, is a comparatively modern notion. In the closely regulated world of nineteenth-century childhood, such a thing was rare indeed. As children, the Brontës created fantastic kingdoms of their own, which were carefully documented and hidden from adults. Less well known (and not written down at all) were the "bed plays" originated by Charlotte and Emily, who shared a bed at night. Charlotte wrote: "Emily's and my bed plays were es-

5 Pollock 1987.
6 Giggling in the Shrubbery 1985.
7 Alcott 1870.
8 Frankenberg 1947.

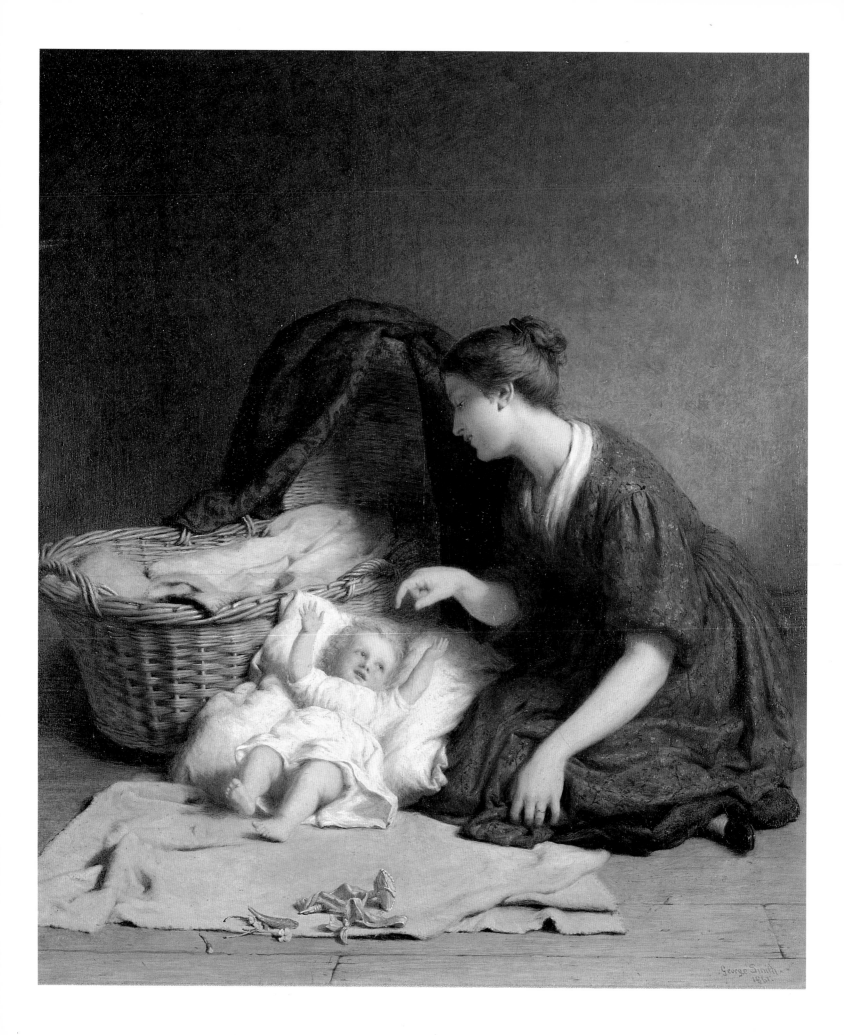

3
George Smith, Fondly
Gazing, nineteenth century,
oil on canvas. Private
collection.

4
The arcutio wooden cage,
Italian, seventeenth century.
Used to protect an infant
sharing a bed with an adult,
it was equipped with a gap
to allow for breast-feeding.

9 Juvenilia of Jane Austen and Charlotte Bronte 1986.
10 Luke 8: 52–54 (Authorised Version).
11 For example, Ariès 1960, Stone 1977.
12 Pollock 1987.
13 Pevsner Nikolaus, The Buildings of England: Vol. I, London. Rev. edn, Penguin, Harmondsworth 1962.
14 Manchester City Art Gallery.
15 Lieberman Ilene D., Sir Francis Chantrey's Early Monuments to Children, and Neoclassical Sensibilities. In: Journal of the Church Monuments Society. Vol. v, 1990.

tablished December 1, 1827; the others March 1828. Bed plays mean secret plays; they are very nice ones. All our plays are very strange ones. Their nature I need not write on paper, for I think I shall always remember them . . ."[9] It was the one time when no one else was present – and the sisters, aged eleven and nine, spent hours creating their private world, where life could be as different from the bleak reality as they chose to make it.

Sleep occurs as a poignant metaphor for death; "not dead, but sleeping" is a phrase used to console the bereaved over the years, with its implications of resurrection. It originates in the story of Jesus restoring Jairus's daughter to life: "And all wept, and bewailed her: but he said, Weep not; she is not dead but sleepeth. And they laughed him to scorn, knowing that she was dead. And he put them all out, and took her by the hand, and called, saying, Maid, arise. And her spirit came again, and she rose straightway . . ."[10]

Contrary to what has long been thought, bereaved parents in previous centuries were not necessarily indifferent to the deaths of their offspring.[11] Linda Pollock's researches into family papers include "bitter loss", "disconsolable" and "cannot express the grief" among the phrases used.[12]

Some parents found a measure of consolation in arranging for memorials for their children. James VI and I's daughter Sophia died at a few days old in 1606: her tomb effigy by Maximilian Colt in Westminster Abbey shows her as a baby asleep in an elaborate and richly draped cradle. Although the depiction is at first sight an unusually intimate one, it is nevertheless a formalised concept of considerable grandeur, affirming her royal status. Pevsner calls the use of the cradle "a questionable conceit"[13] but the device recurred during the seventeenth century in England. Two brasses in St George's Chapel, Windsor, and another at Little Ilford show dead infants in their cradles: one of them, to Dorothe King and dated 1630, carries the motif through in an accompanying verse which refers to her as "bedded in dust". In the Aston family portrait of 1635 by John Souch,[14] central among the symbols for Thomas Aston's grief at the loss of wife and child in childbirth is a wicker cradle draped in black. Topped with a skull, it carries the motto "Qui spem carne seminat metet ossa [he who sows hope in flesh may reap bones]."

In the case of the tomb sculpture of 1817 by Sir Francis Chantrey, known as "The Sleeping Children", the allusion to sleep is additionally a deliberate recollection of life. The piece represents the two daughters of the Revd William Robinson, and the composition was inspired by a conversation Chantrey had with their widowed mother, who commissioned the monument.[15] Mrs Robinson spoke of her memories of seeing them "locked in each other's arms asleep" as she had looked in on them each night. Ellen Jane and Marianne are represented dressed in their night shifts, relaxed in sleep on a mattress and pillow, with their arms about each other: it is hard not to read into this an element of protectiveness on the part of the elder girl, while the younger one shows a confiding quality.

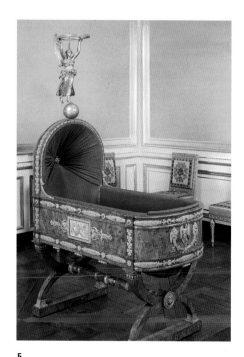

5

The King of Rome's cradle, French Empire, 1811, after Prud'hon and Thomier, ormolu mounts by Thomire. Musée du Louvre, Paris.

6

Maximilian Colt, memorial tomb of Princess Sophia, daughter of James I, who died in 1606 aged three days. Westminster Abbey, London.

A quite different symbolism is to be found in children's literature, notably in fantasy. Occupying a kind of no-man's-land between waking and sleeping, and associated with dreams in which anything may happen, the bed becomes a place of transition where supernatural events take place more readily, and are more credible. Peter Pan, for instance, operates entirely in this territory. It is when the children are in bed at night that Peter first meets Wendy, teaches the children to fly, and entices them away to the Neverland of their dreams; while the children are missing from home, their empty beds in the nursery remind the grieving parents of their loss.[16]

In fairy tales, the ambiguity of this transitional quality of the bed may be heightened, making it a place of transformation and deceit. Transformations usually involve the giving of ill wishes to an infant: E. Nesbit's Princess Melisande goes bald, and George MacDonald's Princess Daylight is condemned to sleep all day, waxing and waning with the moon.[17] The shock to on-lookers is the greater for the momentary concealment of the process within the cradle: Princess Pirlipat, in Hoffman's Nutcracker and Mouse-King, is horrifically changed by Lady Mouseykins: "How great was their dismay, however, when they looked at Pirlipatkin, and saw what had come to the sweet tender child . . . a thick, distorted head stood on a small, shrunken, crooked body; the sky-blue eyes had changed into green goggling balls staring straight before them; and the pretty little mouth gaped from ear to ear . . ."[18] The cradle motif emphasises both the defencelessness of infants, and the fact that the effects of these spells will last for some years, since they are not usually resolved until adolescence.

In the traditional story Twelve Dancing Princesses, the girls deceive their watchers by means of sleeping draughts, and leave their beds to dance with dream partners in a fantasy landscape, a normal enough piece of adolescent behaviour. Their literary descendants are the school story characters who slip out of their dormitories to visit parties or cinemas. Laurence Housman's The Traveller's Shoes, however, has a more vampire-like theme: the eldest of twelve princesses magically takes to herself her sisters' beauty as they sleep, leaving them hideously bald and withered – only to have the same fate turned back upon her tenfold when her greed is discovered.[19] The climax of the theme comes in a group of tales which includes Mally Whuppie and Hop o' my Thumb. A group of siblings share sleeping accommodation with the children of a giant who wishes to kill them during the night. The most resourceful of the human children exchanges the identifying markers which they all wear, causing the giant to butcher his own offspring by mistake: "In the middle of the night, up rose the giant, armed with a great club . . . It was dark. He took his own lassies out of the bed on to the floor, and battered them until they were dead, and then lay down again, thinking he had managed finely . . ."[20]

Although the positive characters in such stories may give a child role models for coping with terror, it is but a short step from these tales to the fears associated

7
Bartholomeus van der Helst,
L'Enfant Mort, oil on canvas,
1645. Goudstikker,
Rotterdam.

8
John Souch of Chester,
Sir Thomas Aston at the
Deathbed of his Wife, oil on
canvas, 1635, Manchester
City Art Gallery.

16 Barrie 1904.
17 Nesbit 1901.
18 Hoffman 1892.
19 Housman 1978.
20 Jacobs 1890. The oldest version of this story – Greek, dating from the second century AD – tells of Themisto's plan to destroy the children of her rival Ino, foiled when Ino exchanges the different-coloured nightdresses which the children wear; see Opie 1974.

9
Sir Francis Chantrey, The
Sleeping Children, memorial
tomb of the Robinson
children, 1817. Lichfield
Cathedral, Lichfield.

10
Gustave Doré, illustration to
"Hop o' my Thumb", from
Les Contes de Perrault,
Firmin Didot, Paris 1862;
reproduced in Peter and
Iona Opie, The Classic Fairy
Tales, Oxford 1974. The ogre
is unwittingly about to cut
the throats of his seven
daughters.

11
John Hassall, illustration to Peter Pan, c. 1906. In the Darling family nursery, Peter enters in search of his shadow and Wendy awakes. City of Bristol Museum and Art Gallery.

with bedtime, especially when they are told as a prelude to sleep. Not only are there nightmares to contend with, but a child may believe that wild animals, criminals or monsters hide about the bed, that the room is haunted, or that everyone else in the house has gone away. Children have insufficient experience to know what will cause fear until it happens, and adults can neither predict what will scare a child, nor prevent the fright from occurring. The most that can be done is to provide reassurance, whether in concrete form (religious symbols, lights or a favourite possession) or of a less tangible nature (affection, reasoning or prayers). Lella Gandini, writing about bedtime, sums up the dilemma: "In order to give themselves up to sleep, children have to be reassured that their parents will continue to be present and to love them even when they close their eyes and lose control of the situation."[21]

The bed may be somewhere for a child to be protected, rested, displayed, amused, nursed, punished, fondly remembered or menaced. It is a place of quiet, fun, imagination, nightmare and terror – in short, a place of contradictions.

21 Gandini Lella, Sleep and Dreams. In: Ottagono, September–October 1994.

Sally Kevill-Davies

The Wide World

"The Four Ages of Man", from Le Livre de la Propriétés des Choses by Bartholomeus Anglicus, French, 15th century. Bibliothèque Nationale, Paris.

Left: detail of pl. : (see page 57).

"What wast thou being an infant but a brute, having the shape of a man? What is youth but an untamed beast?" These stark words from a seventeenth-century Puritan manual concisely expressed the belief in original sin, rife among childcare experts, theologians and educationalists until the end of the eighteenth century. Children were perceived as base creatures, imperfect adults – little better than domestic animals until they had been trained and moulded by Draconian discipline and a Christian education. Any visible behaviour patterns that reinforced this view of the child's imperfect state were therefore ripe for correction. A naturally childish action such as crawling, for example, was condemned as "animal-like", so that infants were forced upright on to their feet at a much earlier age than would be the case today. François Mauriceau, for example, a writer of popular manuals in the late seventeenth century, instructed about the infant: "He must be swaddled to give his little body a straight figure, which is most decent and convenient for a man, and to accustom him to keep upon his feet, for else he would go upon all fours as most other animals do."[1]

Simple wooden walking-frames with wheels for infants learning to walk have been recorded since medieval times. A late fourteenth-century embroidered opus Anglicanum orphrey panel, The First Steps of the Virgin (Burrell Collection, Glasgow), shows the infant Mary clinging unsteadily to the crossbar of a three-wheeled wooden support frame, with two wheels at the back and one at the front. This ultra-simple design of basically triangular shape appears in many early images, including Christ Child with a Whirligig by Hieronymous Bosch (c. 1450–1516; Kunsthistorisches Museum, Vienna) and a woodcut from the 1550 edition of Bartholomaeus Metlinger's childcare manual, Ein Regiment der gesuntheit fur die jungen Kinder.

This same design was easily adapted to four wheels on a rectangular base, with a wooden handle at waist height on which the child could lean. This in turn was elaborated during the eighteenth and nineteenth centuries, when ideas about the importance of learning through play were evolving, to support a cylindrical-bodied wooden horse with a string or horsehair mane and tail. In our own century, stuffed dogs with glass eyes, mohair bodies and red leatherette tongues offered a more realistic appearance for the sophisticated modern child.

1 Mauriceau 1673.

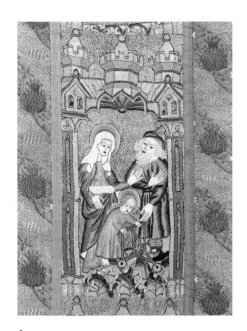

2
Detail from embroidered
orphrey panel on Italian
dalmatic depicting the first
steps of the Virgin, English,
late 14th century. Burrell
Collection, Glasgow
Museums.

2 Letter of Lord George Hay to
the Earl of Mar, 25 November
1707, Scottish Record Office,
Mar and Kellie Papers,
GD/124/15/519/6.

The handles could be made of tubular metal, and shallow boxes of bricks could be included to develop coordination and numeracy. Contemporary push-along toys in brightly coloured moulded plastics still follow the same basic shape as those early supporting structures.

With the child's upright stance and independent mobility came the attendant danger of falling. Grave risks came from unguarded fires, steep dark staircases, and hard cold floors – often, in rooms shared with domestic animals, harbouring excrement, verminous straw and tempting scraps of half-eaten food. It was therefore necessary to enclose inquisitive and active toddlers within protective mobile frameworks. Among the earliest of these was a square, four-wheeled frame with four splayed wooden supports, into which the child was lifted. The frames reached to the armpits, thereby maintaining the child in a standing position. The Holy Family at Work, a drawing by Giulio Romano (c. 1499–1546; Duke of Devonshire's Collection, Chatsworth), shows the carpenter Joseph offering just such a wheeled frame to the infant Jesus.

By the beginning of the seventeenth century, the baby-walker had evolved into a device which, but for its materials, would instantly be recognised by a modern parent. Known by a variety of names – go-cart, go-gin, baby-walker or baby-runner – seventeenth-century examples comprised a circular wooden waist-ring, attached by four or six splayed supports to a square or later circular or hexagonal base frame, on four or six large flat castors of brass or wood. The supports were often decoratively turned with a succession of knobs, which terminated in a large ball with a turned finial. According to the status of the small occupant, the waist-ring could be upholstered in padded leather or velvet, and was hinged and fitted with an iron hook and eye for easy opening and snug fitting. Such baby-walkers appear to have been particularly popular in England, Germany and Holland. Indeed, Jan Luiken (1712), with a typically Dutch leap of metaphysical symbolism, uses the child in the baby-walker as a metaphor for man's dependence on God: "Verelst de zwakheid leunen/God geest zyn ondersteunen [Where frailty needs to lean/there God gives his support]."

During the eighteenth century, walnut, beech, ash, yew and mahogany were used, in addition to the original weighty oak. From around the same time, the ungainly bulbous castors were replaced by small neat ones in brass, with the thick supports becoming more slender and unfussy, in keeping with neo-classical elegance. Cheap, lightweight examples were made in wickerwork. In 1707, Lord George Hay described how his nephew Thomas "runs up and down the room in a machine made of willows, but my lady the Countess takes care that he does not stress himself with walking too much."[2] Wickerwork was cheap and portable, and could be quickly burnt at an outbreak of infectious disease.

Among the aristocracy, baby-walkers were made by carpenters employed on their estates – the Howard Household Books record a payment for two days' work to a servant for making a "going-cart" in 1620. They were also cobbled

3
Giulio Pippi (Giulio Romano), The Holy Family and St Anne with the Christ Child about to be taught to walk, c. 1517–18, pen and brush with brown ink, plus black chalk on white paper. Devonshire Collection, Chatsworth.

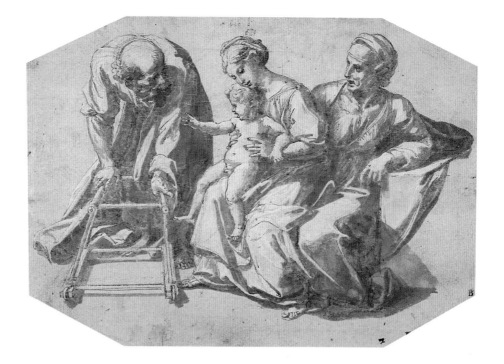

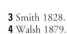

53

together in the hovels of the poor; crude, unornamented examples can be seen in many engravings of the period. In the early nineteenth century, John Thomas Smith recounted that "the go-cart was common in every toy-shop in London."[3] Short "going-frocks" were worn – as opposed to the long "carry-ing-frocks" worn by babes-in-arms – so that infants did not become entangled in their long skirts; "short-coating" was a major milestone in a child's fragile life. Small heads were encased in padded "pudding" hats to protect them from knocks and falls – these are shown in the paintings of Boucher, Chardin, Rembrandt and Rubens, although they are rarely portrayed in English art.

Child-care experts were divided in their enthusiasm for the baby-walker. Some felt that early walking would strengthen and straighten an infant's growing limbs; others, misled by the prevalence of childhood rickets, feared that early walking would cause immature legs to buckle under the strain. Jean-Jacques Rousseau in his seminal novel, Emile (1762), advocated that all artifical aids be abandoned, but it was not until the late nineteenth century that J. H. Walsh reported that "the old-fashioned go-cart is quite out-of-date, but why I know not."[4]

In fact, baby-walkers were superseded during the 1840s by a newfangled contraption from America. Known as the "Baby Jumper", it consisted of a canvas-and-leather harness in which the child sat, his nether regions concealed by an attached "modesty apron" or a gathered skirt (later, the all-in-one jumper suit was designed to cope with onlookers' sensitivities). The harness was suspended from a strong elastic spring attached to the ceiling or a door frame, so that the child, by vigorously bouncing up and down, could just reach the floor. From the childminder's point of view, the great joy of this "Patent Infant Gymnasium", as it was advertised, was that the child could tire himself out with healthy,

3 Smith 1828.
4 Walsh 1879.

4
Boy with Coral, 17th-century
English School, oil on
canvas. Norwich Castle
Museum.

leg-strengthening exercise without ever moving from the spot to which he was attached. By the end of the nineteenth century, S. Fawkener Nicholls's "Baby Care Taker and Exerciser", extolled as "thoroughly substantial" and "very handsome", was considered suitable "For use in any room – the lawn – the sands &c." It was the prototype of the modern baby bouncer, suspended from a freestanding, tubular metal frame.

Views about the benefits of exercise had always been divided; sometimes, passive exercise was considered safest. Swaddling sought to restrain babies from moving their arms and legs lest they fracture, yet swaddled babies were "tossed" by nursemaids or violently rocked in cradles to give then "exercise". One device designed to give the young child controlled exercise consisted of a pivoting pole, fixed upright between floor and ceiling, from which an adjustable arm projected at right angles. At the end was an iron waist-ring, which held the toddler while he trudged round and round the pole like a dog in a turnspit. Possibly more attractive was a type of wooden baby-cage, dating from the seventeenth century and still in use in parts of rural France at the beginning of the twentieth century. This consisted of a square piece of wood with a central waist-ring. This ran along grooves in the long rectangular frame, which was supported on four splayed legs. At either end a small tray contained food or small toys to encourage the child to practise staggering from one end to the other.

The Dutch, ever pragmatic and relaxed in their dealings with the young, developed a close-boarded chair, known as a "going-chair", in which the child could be wheeled from room to room according to the time of day and the activities of the household. Known in Holland as a speelstoel or "play-chair", it was designed with a play-board in front, on which the child could keep a few small toys and, perhaps, a pretzel or sugar-plum. In a cupboard underneath the seat a hot brick or brazier could be inserted to keep the chill at bay and, if the seat was pierced with one large aperture, a chamberpot could also be introduced. It was a perfect example of a nursery on wheels, an ideal means of integrating the young child with his adult peers. It was also made in wickerwork; an example from an Arts and Crafts nursery was reproduced as the frontispiece of Walter Crane's The Baby's Bouquet, published in 1877.

While a going-chair could be trundled between rooms with the child installed as a participating spectator, many less satisfactory pieces of furniture were used to confine children in less enlightened households. In an age when play was considered unimportant, the raw rumbustious energy of a young child was often threatening to the adults in society, who came up with some confining structures verging on cruelty. One was simply the hollowed-out section of a tree-trunk, forming a cylinder rather like an umbrella-stand, in which the hapless child could neither bend nor stoop. Indeed, the English word "play-pen" articulates something of this need to control an untamed creature. The first edition of Metlinger's Regiment in 1473 contained advice to parents to con-

5
Late eighteenth-century baby-walker, Cambridge and County Folk Museum. Such wooden frames on legs, with a sliding waist ring to hold the infant, were used until the last century in France.

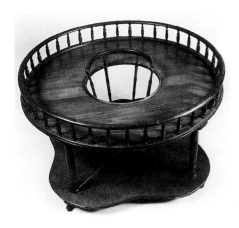

6
Baby cage with large circular table for playing with toys, on ceramic castors, English, mid nineteenth century. Bowes Museum, Barnard Castle.

5 Holt 1894.
6 From the diary of the Revd Benjamin John Armstrong, Vicar of East Dereham, Norfolk, 26 July 1855; quoted in Hampshire 1980.
7 Chavasse 1839.

struct a "little pen of leather". Over four hundred years later, the American Luther Emmett Holt recommended that "a nursery fence two feet high, made to surround a mattress, makes an excellent box stall for the young animal."[5] The euphemistically named "Baby's Playground", advertised in 1902 by Abell & Co. of Derby, was to all intents and purposes a cage; it was perhaps justified to parents by the makers' optimistic notion that it could be "capital as a Fire Guard" and would convert "at will into a Tennis, Croquet, Hat Stand or Easel".

One of the most far-reaching factors in the chequered history of childcare was the realisation that fresh air could actually benefit a child's health. Certainly Rousseau's Emile had advocated the healthful effects of children playing and exercising in the open air, and from quite early in the eighteenth century baby-carriages were made by the coachbuilders on great estates for use exclusively by children. The most simple baby-carriage consisted of a wooden platform mounted on wheels, on which a seat was provided for the child to sit up in. It was pulled along by means of a towing bar in the front, by a servant, a small pony or a dog. The earliest English baby-carriage on record is a splendid affair, designed by William Kent for the children of the 3rd Duke of Devonshire in 1730. The body was formed in the shape of a shell, inside which the child, the "pearl", sat. It had a leather hood, upholstered interior, and brass carriage lamps on either side. The children of the agrarian poor, on the other hand, were piled into bumpy stick-wagons of the type used by agricultural workers. Middle-class children were taught a good riding seat by the use of a nursery rocking-horse.

The first English pram factory opened in 1840, making three-wheeled conveyances based on the design of contemporary invalid chairs. Instead of being towed from the front, they were pushed from behind, by the "perambulator" – literally, the person doing the pushing; the great advantage was that the baby could be seen at all times. These prams, as they came to be known, had two wheels at the back and one at the front, since it was illegal to push a four-wheeled vehicle along the footpath. When the young Queen Victoria ordered three for her growing brood, they quickly became de rigueur in fashionable households. In 1855 a country vicar visiting London remarked that "the streats are full of Perambulators . . . whereby children are propelled by the nurse pushing instead of pulling the carriage."[6] Not all commentators were so impressed. Henry Pye Chavasse expostulated: "these wretched perambulators are dangerous in crowded thoroughfares. They are a public nuisance, in as much as they are wheeled against and between people's legs, and are a frightful source of the breaking of shins, of the spraining of ankles, or crushing of corns, of the ruffling of all foot passengers who unfortunately come within their reach, while in all probability gaping nurses are staring the other way, and every way indeed but the right."[7]

Chavasse had identified a real problem in the rapid proliferation of prams.

7
Gesina Terborch, A Dutch
Bedchamber, 1669,
watercolour, fol. 74 from
Familieboek. Rijksmuseum,
Amsterdam.

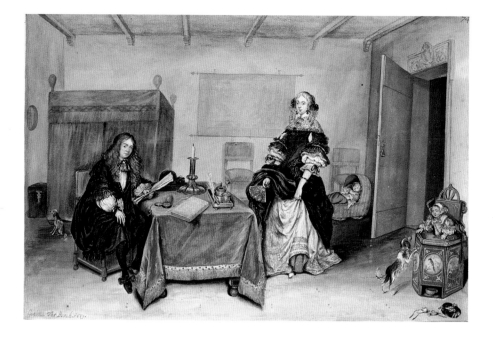

The concentration of wealth in towns, coupled with the rise of an affluent middle class as a result of the Industrial Revolution, meant that many more households could afford to employ a servant or two. The advent of the pram, coinciding with this new wealth, meant that babies, once cradled in a pair of plump and friendly arms in the nursery, were now wheeled in a pram to a gusty park where they were literally kept at arm's length from the nearest adult. Eliza Lynn Linton noted caustically that "the shabbiest wife with her two financial ends gaping, must have her still shabbier little drudge to wheel her perambulator."[8] Mothers were urged to visit the park unannounced, to check that their infants were not being neglected while the nannies gossiped or flirted. Marion Harland urged her mothers to take their babies out themselves: "To wheel a perambulator is a crucial test of your moral courage and innate ladyhood."[9]

Early perambulators were wholly unsuitable for young babies who could not sit, as Chavasse observed: "It is painful to notice a babe of a few months in one of these new-fangled carriages. His little head is bobbing about . . . he looks, and no doubt feels, wretched and uncomfortable."[10] The answer came from the Continent in the form of a bassinet, a light and flimsy basketwork bed lined with American cloth, supported on a high four-wheeled chassis, sometimes with a collapsible hood to protect the baby from the weather. Although it had four wheels, the law sensibly seems to have turned a blind eye to its use on the footpath; in Germany, however, it was allowed only by licence. Children still had few rights, and society could be a frosty alma mater.

From the 1870s until the outbreak of the First World War a two-wheeled vehicle, with two stabilisers at the back and two bentwood handles at the front, was the rage for up-to-date children. Based on tradesmen's delivery carts, it remained within the law, although with the introduction of kerbstones the small stabilisers were replaced by larger wheels. It was originally intended for older

8 Linton 1883.
9 Harland 1886.
10 Chavasse 1839.

56

8
Arthur Devis, Sir Thomas
Cave, Bt., and his family in
the grounds of Stanford
Hall, Leicestershire, 1749,
oil on canvas. Private
collection.

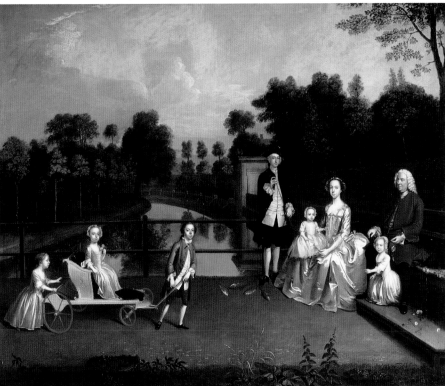

9
 Walter Crane, frontispiece,
The Baby's Bouquet, 1880.
Private collection.

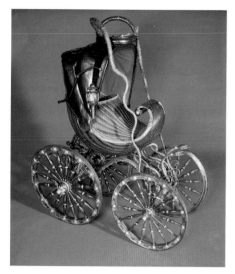

10
Baby carriage designed by
the architect William Kent
for the children of the Duke
of Devonshire, c. 1730.
Devonshire Collection,
Chatsworth.

58

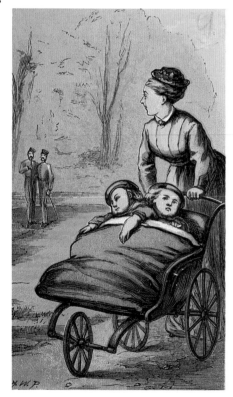

11
H. W. Petherwick, illustration
from Aunt Louisa's
Welcome Gift , c. 1870s,
London.

11 Ballin 1902.
12 Barrie 1904.
13 King 1913.

children, but later models were converted to a shape in which an infant could lie, albeit rather unsuccessfully. Ada Ballin grumbled: "it is a pitiful sight to see . . . infants sitting all in a heap, with their spines and legs bent, their chests contracted and the strap pressing against their stomachs."[11] The decorative reeds that ornamented the bodies of these "mailcarts" were sent across the Atlantic from the USA already "worked up", made into mailcarts in the UK, then re-exported to America.

However, it was the coachbuilt prams developed from the bassinet that proved the enduring models. Made by companies such as Hitchings, Dunkleys, Pedigree, Westline and Wilson, they were built of metal and wood, with metal wheels replacing the costly wooden wheels of earlier perambulators. These carriage prams were hung from leather straps on two C-springs to ensure a smooth, swaying ride. Developed by William Wilson, a prolific inventor who held around thirty patents relating to prams, the hammock-swung pram revolutionised the baby's comfort, while its smart leather upholstery and solid coachbuilt body pleased the point-scoring nannies in the park. Wilson's Silver Cross pram became a transport of delight for nursemaids and nannies. The most luxurious accessories could be added by affluent parents, including brass carriage lamps for London smogs, wolfskin rugs and silver-plated fittings. Interiors upholstered in white leather found favour with mothers, but nannies preferred the more traditional dark colours, which encouraged the babies to go to sleep.

The shallow-bodied Edwardian prams scored full marks for elegance, but were found to be unsafe. The Lost Boys in J. M. Barrie's *Peter Pan* were identified by Peter as "the children who fall out of their perambulators when the nurse is looking the other way".[12] Appearance frequently triumphed over safety. Fitted brakes were not standard equipment until the 1920s, when pram bodies became much deeper as a safety measure. However, in the early part of the century the deep-bellied pram was considered unhygienic and airless. Dr Truby King, the childcare guru of the time, railed against "the spectacle of an unfortunate infant sweltering and sweating under an American leather pram hood."[13]

After the Second World War, the folding stroller found favour with servantless mothers. Early examples based on American models had wooden slatted backs and carpet seats. They were popular with parents who left the smoky cities for day trips at the seaside, where they could be hired for a shilling from the railway stations. This was the prototype of the folding metal pushchair, which rose in popularity as society became, in every sense, more mobile. The breaking down of class barriers and the increased availability of the cheaper motor car sounded the death knell for the coachbuilt pram. The folding carrycot, which could be lifted on to a collapsible metal chassis at the end of a car ride, and the folding metal-and-canvas pushchair were what parents wanted. To combat these innovations, pram makers resorted to headline-catching

12
The Grosvenor Mail Cart, 1895, made by Star Manufacturing, London, in painted wood, lined in tan and cream. Jack Hampshire's Pram Museum, Kent.

13
The Silver Cross "hammock" sprung perambulator first made by William Wilson at his factory The Silver Cross Works, Leeds, in 1898. It continues in production today. Jack Hampshire's Pram Museum, Kent.

14
A folding pushchair with slatted wooden back, carpet fabric seat and leather armrests, c. 1915. Jack Hampshire's Pram Museum, Kent.

gimmicks, including Dunkley's Pramotor, which worked rather like a motorised invalid chair, with the child in a kind of sidecar while nanny rode behind.

The rise of the light and practical baby buggy and the recent popularity of the baby sling, together with smaller flats and houses without the space to keep an old-fashioned perambulator, have made it almost a thing of the past. Mothers are, literally, more in touch with their children, and baby conveyances are virtually extensions of their own bodies. It may be fashionable now to laugh at the old ways, but they were not always bad. Osbert Sitwell, born in 1908, clearly had the adults in his life just where he wanted them, and spoke fondly of his pram: "The motion is agreeable, the range of vision extensive, and one has always before one's eyes the rewarding spectacle of a grown-up maintaining prolonged physical exertion."[14]

14 Sitwell 1945.

Mike Scaife

Creativity in Childhood

1
"I'm the nurse and you're
the patient!": understanding
of social roles develops
through pretend play.

Is the process which led Mozart to produce an opera at the age of fourteen the same as that which led Charles Darwin to produce the theory of evolution? Is there something different about these achievements from the drawings made by kindergarten children or from the improvisations of a fashion designer? In other words, are they all being creative in the same way?

If we ask the question "What is creativity?" we quickly discover that there is no simple answer. Most attempts to define it have said something like this: creativity is the ability to see new relationships or to produce unusual ideas, especially when they obviously deviate from established patterns of thinking. In fact, creativity is not likely to be something we can understand as a single trait that varies with individuals as, say, height does. Rather it refers to a number of different, although interrelated concerns. Psychology, the discipline typically concerned with investigating this problem, works with a number of questions. What is the process of creating something? Is there such a thing as a creative personality? Can we encourage creativity?

Capturing the essence of a creative act is not easy. One approach has been to see it as a form of "divergent" thinking, where a novel solution to a problem is required, rather than an accepted (or "convergent") one. An example would be the difference between asking the questions, "How many uses can you think of for a brick?" and "What are bricks usually used for?" However, these kinds of approaches typically treat creativity as being about how individuals, working alone, solve problems; it is not clear that this captures enough of what we usually mean by creative activity. A better way is to consider its history during human development, and to recognise that creativity is defined in relation to existing social practices and also arises from them.

Bruner has argued that what is unique about humans is that cognitive and social growth depends upon the history of the species, rather than on genetics. His point is that "The growth of mind [will] depend on how a culture assists the individual to use such intellectual potential as s/he may possess".[1] How does culture do this? One way is through the existence of "amplification systems" which act to enhance the power of individual skills. We are all familiar with amplifiers of physical actions, such as wheels and levers, and of the senses, such as microscopes and heat detectors. But there are also amplifiers of thought

2

Infants discover the
properties of objects by
experimenting with them.

processes, which cover symbol systems such as mathematics, writing and logic. All of these systems can act to enhance creativity, but they are not "given" to the individual – we have to learn to use them appropriately, and this is the task of educational practice. Bruner points to three routes into mastery. These are: play practice of component skills; teaching in context, and the formal teaching typical of the modern western school. All of these are relevant to our issue, since the one thing that everyone agrees on is that mastery of a domain is essential before truly creative work can be done.

Play in the young is, as far as we can tell, ubiquitous within our species and in all mammals. In animals its main function seems to be the practice of skills, such as feeding and social behaviours. In humans, play has a far more extensive role in promoting cognitive and social development. Its importance is such that Erikson has claimed that a child who cannot play will become an adult who cannot work.[2] What, then, is the nature of play?

First, we see that play tends to go through a number of forms as a child gets older. The infant experiments with the world of objects, both physical and human, learning the properties of each. The two-year-old begins to engage in "pretend" play such as feeding dolls, and engage in constructive games, such as building blocks and activities that resemble drawing. By three and four years of age, activities such as hide-and-seek are possible – games with rules. At the same time, fantasy and pretend play become increasingly elaborate enterprises, usually involving others and often characterised by the child taking on a series of roles. This will involve extensive use of props and seems to peak by the age of six.

The ubiquity of play underlines its importance. We know, for example, that young children who engage in less play seem to be more aggressive and disruptive as adolescents. In addition, pre-schoolers who do the most fantasy play seem best able to work out the plots of stories read out to them. While we must be careful with attributing cause and effect, this is consistent with widely held views on the value of play for development of social and cognitive skills. Effec-

2 Erikson 1963.

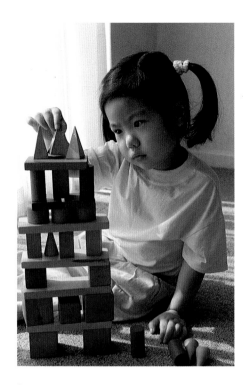

3
Building with bricks helps
the child to understand
properties of size and shape.

tive play, particularly with others of the same age, relies on the group cooperating on a common goal. As such, it encourages communication, and teaches children to establish social relationships and solve social problems. Play also supports emotional needs, as in the option of re-enacting and changing the outcome of something unpleasant. Above all, play shrinks the world to a size that children can manage and control.

In the changing forms of play as the child gets older, we can see a steady development of the link between cognitive and social achievements. There is, for example, an increasing sophistication in the child's ability to use play to integrate with the social group. Younger children, three years of age and less, typically do not join in with an existing play session, but will observe or play with the toys in parallel. By five, however, they will join in, discuss the activity, borrow toys and assign roles according to the scenario. Part of these developments can be seen in terms of the child's increasing need for group approval and social acceptance. Wallon pointed out that imitation of others, as when the child plays in parallel using objects in the same way, is a method that three- and four-year-olds have for getting access to existing activities. By acting as another does, the child gains insight into the other's viewpoint, thereby helping him to develop the crucial self/other distinction.[3]

The benefits of play can also be seen in more purely cognitive terms. Piaget firmly believed in the cognitive stimulation to be achieved through exploratory play. The infant makes discoveries about the essential perceptual properties of all objects – such as size, shape, texture and their ability to appear and disappear. The older child, playing with bricks, clay or water, learns the more abstract properties of mass and volume by engaging in activities such as building or matching shapes. The Montessori method of pre-school education, originally devised for giving an educational push to deprived children, has a similar assumption. It emphasises the use of physical materials that illustrate particular spatial/mathematical relations, such as shapes that fit holes of specific sizes, and has been effective in aiding cognitive development. One implication of these claims is that we should provide every child with a wide range of material props for playful activity, and research has shown that increasing the space and props for play increases its occurrence. These do not need to be expensive toys, particularly with the presence of other children to stimulate, ask questions and provide the right environment for pretend play to occur.

So material objects – whether as props for pretend play or as things to act on – are essential to the process of development. However, we need to ask what role these objects play and how they relate to cultural learning. This requires theories which have a wider scope than individual development. Valuable here are the writings of Vygotsky and Leontiev, Russian psychologists who sought to combine work in anthropology, semiotics and psychology to formulate a Marxist perspective on human development. Unlike Piaget, for whom development was targeted on the child's understanding of the physical world, Leontiev saw

3 See Wallon 1949.

4
Games with rules teach the
basics of social
collaboration.

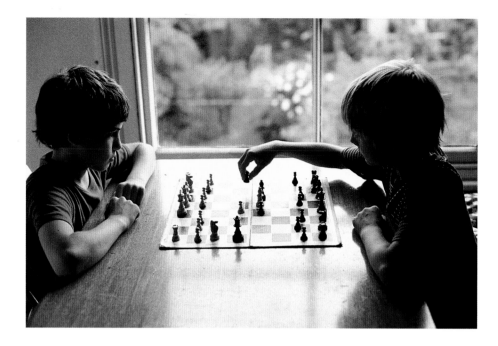

the goal as explaining how we become social beings. By this he meant that in-
dividual development was about the ability to know and engage in the practices
and activities that constitute a culture. In this process artefactual objects play an
essential part because, for the child, they have a dual nature. They are things
with material properties such as size (as Piaget emphasises), but they also em-
body human social practices because they have arisen from them. Any artefact
has to be understood by the child in both these ways. Consider an infant learn-
ing to feed with a spoon. Leontiev observed that, at first, the infant carries it to
its mouth as though it were handling any other object, not considering the need
to hold it horizontal. Over time, with adult guidance, "the movements of the ba-
by's hand with the spoon are radically reorganised and are subordinated to the
objective logic of using a spoon." In other words, the spoon is shaped in the way
it is because of the social practice of feeding (the objective logic) and, in turn,
the infant's task is learn that relationship – to discover what practice(s) the ob-
ject embodies. By contrast, a spoon dropped into the cage of a mouse, say, will
only ever have the status of just another physical object, no different from that
of a stone.

However, there are indications that at least one other species can use imple-
ments: chimpanzees have been observed using sticks to reach distant objects.
This raises the question of how human development goes beyond that of ani-
mals. Vygotsky answered this by stressing the role of cultural transmission via
learning. Initially the child, in the period before it acquires language, is like the
chimp with a knowledge of cause and effect and the physical properties of ob-
jects. However, constant interaction with cultural practices and their mediation
through artefacts exposes the child to a world where symbolic forms are dom-
inant. The child begins to respond to the world, not directly as animals do, but
indirectly on the basis of mental representations. The key acquisition for the
child is that of symbol systems such as language, numbers, music, art. In this,

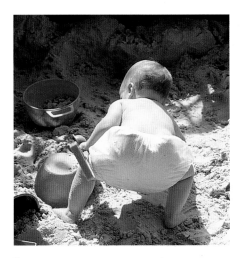

5
Playing with materials like sand leads to an understanding of abstract concepts such as quantity.

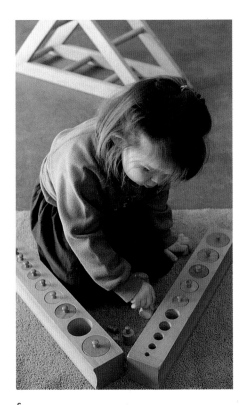

6
Montessori schools use shape-matching to encourage cognitive growth.

4 Lave 1977.
5 Gardner 1982.

play with objects has a vital part, for it allows the child to come to understand the arbitrary nature of symbols. An example would be when, in pretend play, he separates the literal understanding of an object such as a horse, from an object such as a stick that becomes "a horse".

A similar emphasis on culture in development is found in the perspective of situated learning, a view heavily informed by anthropology. The argument here is that learning something should be done in contexts that reflect the way that knowledge will be most useful in real life. For example, teaching mathematical skills should be considered in terms of their relevance to different contexts such as accounting or shopping or geometry proofs. These arguments have led to the promotion of a different model of school practice – that of apprenticeship, with its emphasis on learning by doing and learning in context. One example is a study made of tailors in 1977.[4] Young apprentices, taken on for a five-year period, have a complex and orderly sequence of tasks that they are allowed to perform as they progress from novice to master tailor status. First, they are allowed to work on underclothes for children, inexpensive items that are not visible. They then move on to external formal garments, ending their apprenticeship with the top-of-the-range suit. In terms of their specific tailoring skills, there is another progression: they are allowed to do only pressing and sewing at first, with cutting-out kept for later. This system has its advantages: it protects the novice from serious, financially costly mistakes early on and – in emphasising style and cut – it also teaches him (they are always male) much about the social significance of garments in his culture.

These kinds of ideas may be useful in encouraging creativity. Research into the career development of creative people has indicated that such talents are usually fostered better by interaction with a knowledgeable person – analogous to the apprentice model – than by studying books or exhibits in a self-contained way. The benefits lie in the access to direct modelling of skill, as well as inner processes of thought which are not revealed by books. However, access to expertise is apparently only one ingredient in the development of creative individuals. A final concern has to do with individual differences. We tend to consider creativity from the benchmark of the exceptional individual – the Bach or Einstein of our culture. But are we all potential geniuses? One view is that all children are inherently creative, but that somehow this capacity is disabled by subsequent experiences. Gardner's observations from the Harvard Project Zero investigation into creativity tell an interesting story about this possibility.[5] He emphasises the young child's freedom to combine and innovate in his creations. Representations in drawing, for example, are not simply limited by technical skills. The child may explain that a part of the picture patch is a scar on the sky, showing his readiness to use metaphor in his representations. Yet as the child gets older, from seven years of age or so, there is a prolonged period when experimentation and novelty are greatly diminished. Gardner attributes this, at least in part, to social pressure to conform – a literal stage, where the continu-

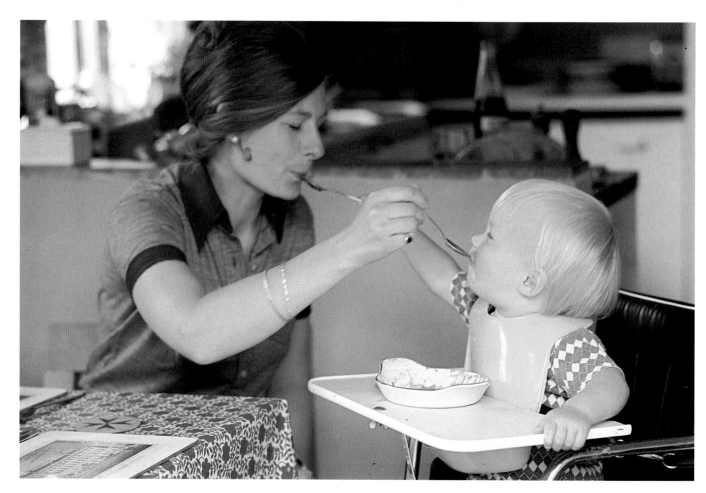

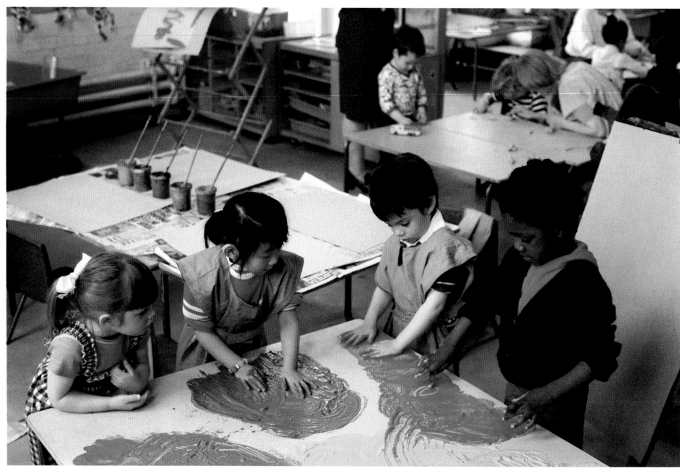

7
Participating in social interactions teaches the child about its culture.

8
Young children will be creative without regard to existing conventions of composition.

9
Behaving like an adult helps the child to see the world in different ways.

10
Is this a horse or an object? Learning that it is both at once is a vital step to the understanding of symbols.

ing mastery of symbols is aimed at copying or reproducing established genres. It is only around the start of adolescence that creativity surfaces again, defined in terms of deliberately breaking away from convention and playing with new forms.

One immediate question is whether the creative process seen after the literal period is the same in some fundamental way as that which went before. In one sense this is unlikely to be the case. The freedom to invent seen in young children is not technically innovation at all, since they have no representation of what stylistic and compositional rules exist in the first place. By contrast, a creative adolescent typically will work from a good grasp of such conventions and, by the same token, can use them as a basis for trying variations. Such knowledge, together with the conditions of natural aptitude and a stimulating environment, seems to be necessary. However, beyond making these general statements, we still seem to know very little about creativity. Paradoxically, perhaps, this may be because it is not a special process at all but, rather, a defining quality of everyday human life. In one sense, almost everything we do should be regarded as creative and we should adjust our ideas in this direction, rather than trying to value some activities and products more than others.

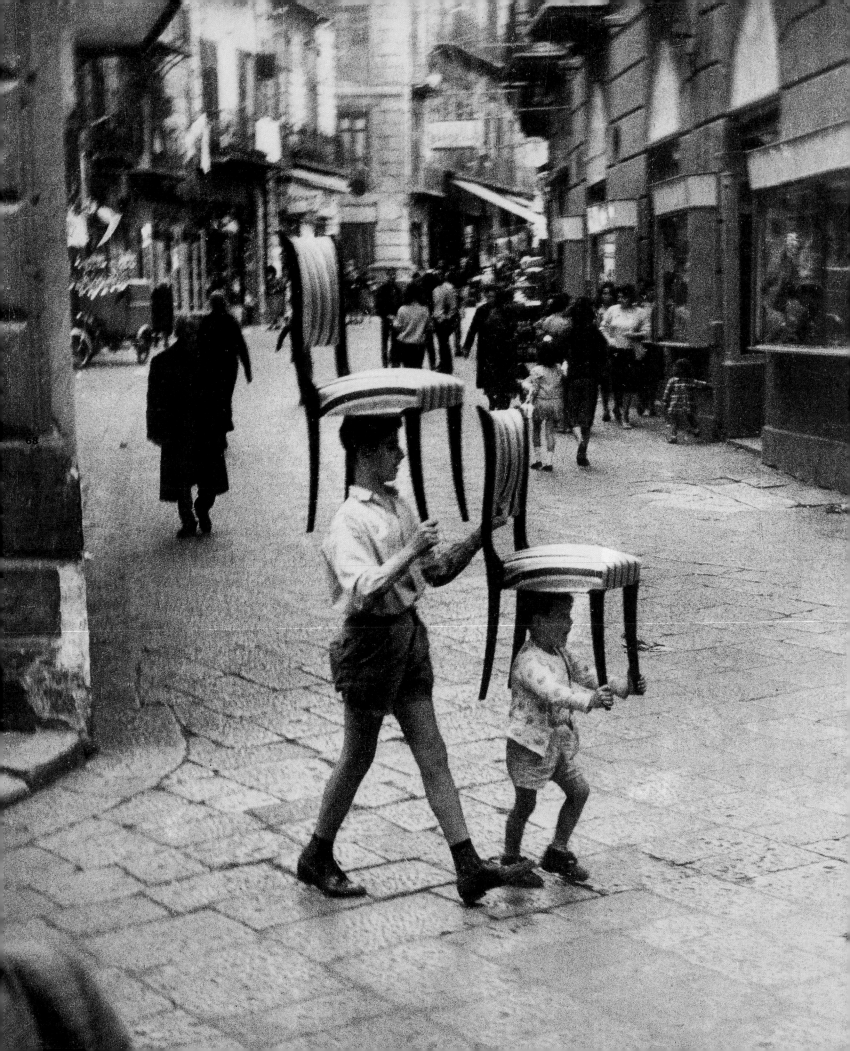

Franco La Cecla

The Remains of the Toy

Every childhood accomplishes something great, something irreplaceable for mankind. Every childhood, in its interest in technical phenomena, its curiosity about every sort of invention and machine, binds the conquests of technology to ancient symbolic universes.[1]

Epoch by epoch, games and toys tell us what kind of relationship exists between adults and children. More precisely, they tell us what image grown-ups have of children, and what adults conceive to be children's "job" in society. Of course, children also play by themselves, inventing their own ways of playing with the world; but adults "take advantage" of the seriousness of childhood play, in order to channel it into the paths they expect children to follow. In this sense, games are the materials of a relationship between two categories of human beings who, for all their "familiarity" with each other, ultimately remain strangers and divided.

"Play" is the name adults give to an activity which is really the permanent activity of childhood, in the hope of pinning it down and cutting it down to size. Childhood takes itself and the world seriously, establishing experimental relationships with its own physical and interior existence, and with the world out there as embodied in objects and persons. To grown-up eyes, this ongoing activity of experimentum mundi looks like a sort of "time off" which the child enjoys while awaiting the obligations of adult life. In enabling themselves to grow up, grown-ups have so distanced themselves from childhood that they forget that, back then, there were as yet no clear-cut demarcations of times and functions, and the experience was everything. Joy and pain, darkness and light, tenderness and harshness formed a single, primordial continuum, suspended in time.

While true of middle-class children – plump "Benetton kids" – this also holds good for the offspring of the less well-off, and even for high-risk children and street children. So far from being a luxury that only the lucky ones can afford, play is the fundamental condition of childhood, its primordial, first-time-ever experience of the world. Looked at in this way, less fortunate children frequently have access to aspects of the world and experience denied to the Benetton kids. Street play, a life lived out of doors and among adults, while certainly more dangerous than life sheltered in the nursery or kindergarten, is also far richer and more complex.

Risk has always been a part of experiencing the world and growing up in it. Growth means experiencing the world without falling victim to it, and this requires an ability to recognise danger. This, too, is part of play – as children, who love dangerous games, are well aware.

1
Carrying chairs, Palermo, 1960.

1 Benjamin 1982, p. 576.

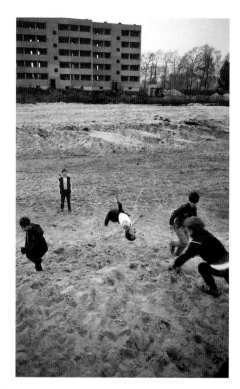

2
Children playing in the
suburbs of the city, Warsaw,
1991.

Playing with toys is but a small part of all this experience, and one which, in the case of fortunate children, is ninety-per-cent controlled by adults. As has already been suggested, play is seen as corresponding to an office or factory worker's time off, and is made to obey the same logic: it is leisure, a holiday, time that is not quite serious. Children are "permitted" to play, and there are special institutions and instructors whose task it is to teach them how to do so. Nowadays, children are required to "learn" how to play – as if this were not their speciality, the field where they are the teachers! From this standpoint, toy stores can tell us more about the image today's adults have of children than could any sociological study. As Roland Barthes wrote in 1952:

"Of the French adult's vision of the child as but another version of himself, there could be no better demonstration than the French toy. The most frequently encountered toys are essentially an adult microcosm: they are all small-scale reproductions of human objects, as though, in the eyes of the public, the child were basically just a smaller man, a homunculus who must be supplied with objects appropriate to his size."[2]

What Barthes says can easily be applied to other children as well, be they English or American, Italian or German, Japanese or Australian, just so long as they have been reached by the internationalisation of the homunculus. Toys have gone worldwide. They are linked to television programmes and animated cartoons, and the companies making them often have close connections with the media world. Children are the target of an onslaught by child-oriented multinationals which, needing to consolidate demand, push them towards the consumption of miniature media figures. There is something odd about this whole operation. Why is it that, back in the days of the fables of the brothers Grimm or of Andersen, no one was manufacturing miniatures of Little Red Riding Hood or Tom Thumb or the Seven Dwarves, the way they do nowadays? In those days there were illustrations, children's books with drawn characters of extraordinary visual impact; but those characters were not transformed into homunculi. Why are today's children asked to play – and why, indeed, do they play so much – with three-dimensional, small-scaled repetitions of something they have seen on a screen? Children have become homunculi who play with miniatures of homunculi.

This downscaling of childhood expresses adults' ideas of children: they are meant to be miniature grown-ups, so it is only logical that they should play with miniatures of reality. Children are "minors", which is to say that they are not yet mature; they have a handicap, which is that they are not grown-ups. The image of childhood transmitted by much advertising, and by much of the media in general, is that of a world inhabited by cute little dolls. Children have themselves become dolls and toy soldiers, in a strange play of mirrors. Toys, real toys, have become the images children are asked to accept as models for their own identity. The packaging of the giant-sized Barbie doll says it all: "Now that Barbie is like you, you can swap clothes with her!" The dolls our grandmothers

2 Barthes 1952, pp. 51–53.

Eveny child playing with
bread puppets which he has
made in the form of reindeer
antlers, Sakkyryr, Siberia,
1996.

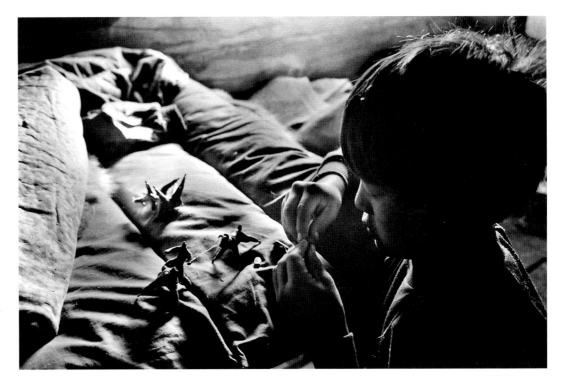

and our mothers used to play with did not come with a pre-established name:
it was the little girls who gave them one. Then Barbie came along, and Sailor-
moon and, along with them, a host of other characters whose stories and per-
sonalities had already been defined in advance.

This process involves something sensed by Walter Benjamin first, and by
Barthes after him: the imposition upon childhood of preconstituted meanings.
Children play with characters, stories, and settings predetermined in every par-
ticular. Everything has already been assigned a name. Benjamin reminds us that
all this conflicts with the child's gift for remaking the world:

"It is stupid to wrack one's brains in order to create products – visual materials,
toys or books – meant especially for children. Ever since the Enlightenment,
doing so has been among the stalest obsessions of pedagogues. Their infatua-
tion with pyschology keeps them from noticing that the world is full of in-
comparable, absolutely perfect objects for childish attention and effort, and
that children are notably attracted to any place where visible work gets done on
things. Children are irresistibly drawn to leftover workshop materials, to the
by-products of housework or gardening, tailoring or carpentry. In these left-
overs of productive work, they recognise the face that the world of things shows
to them, and to them alone. They use these things, not so much to reproduce
the works of adults, as to put the most disparate materials in new and discon-
tinuous relationships, by turning them into something through play. In this
manner, children build for themselves, all on their own, the world of objects, a
small world within the big one."[3]

The world of toy manufacturing is headed in the opposite direction. Children
know how to play with the remains of the world, putting it back together in
their own new ways, and how to transform bits and pieces into characters by

3 Benjamin 1972, p. 13.

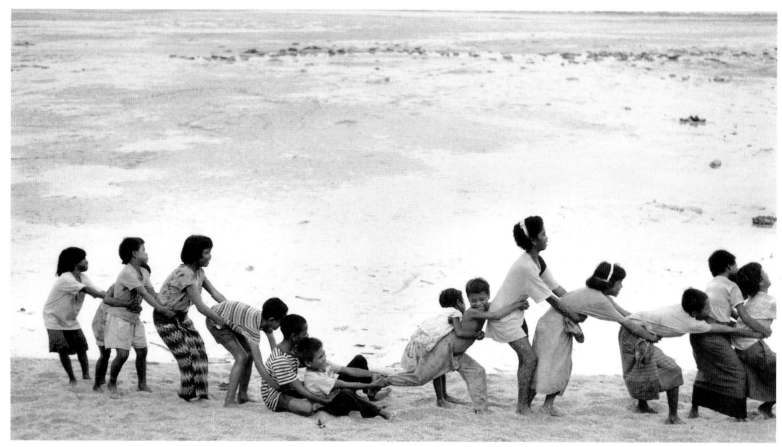

4
Moken children on the
beach, Thailand, 1994.

giving them names. They know how to baptise bottle caps, marbles, and puppets made from old rags, and how to draw speech from shoes, drinking glasses and light bulbs; but the world of toys offers them more and more ready-mades. There is less and less room to exercise the ability to take apart and put back together. These days, even such traditionally "abstract" games as Lego and Meccano are presented as pieces of a scene that must be re-assembled, as though it were a puzzle: a petrol pump, a castle, a railway station.

"But, faced with this world of faithful and complicated objects, the child can only take upon himself the role of owner and user, never of creator; he does not invent the world, he uses it; unadventurous actions have been prepared for him, lacking both surprise and joy. He is turned into a habit-bound little proprietor, who need not even invent for himself the mainsprings of adult causality; these are supplied to him ready for use, and all he has to do is use them, without ever having to travel down some pathway by himself."

And Barthes goes on, à propos of construction games: "Even the smallest construction game, just so long as it is not too recherché, implies quite a different way of being apprenticed to the world: the child does not create objects that mean anything, and he does not care whether they have a grown-up name; he is not a user, but a demi-urge, creating forms that walk, that turn; he is creating life, not property; the objects move all by themselves, and are no longer matter lying inert and complicated in the palm of the hand."[4]

4 Barthes 1952, pp. 51–53.

5
Bedouin child with his
father's boots on, Jordania,
1994.

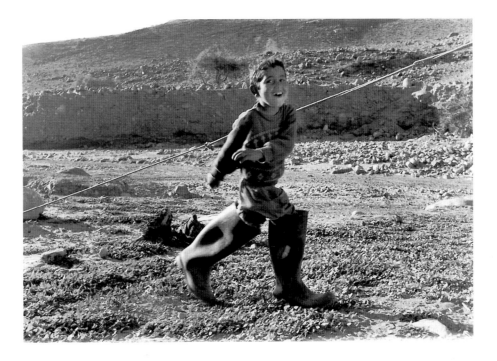

The tendency nowadays is to eliminate just that aspect of construction games that once brought them closest to childhood's ability to invent the world without needing to accept it as already signified. What lurks behind this adult fear of the void, this horror vacui, which demands that no room be left, even in play, for the non-assembled, for the fragment, for the leftover, for the indefinite?

Once again, the answer comes from childhood, with its direct relationship with things and objects. Childhood's capacity to play with the remains of the world, so brilliantly described by Benjamin, is also the reason children break toys, especially those that are too well defined. The little boy who disassembles his "electronic" toy, and the little girl who takes her doll apart, tossing a leg here and an arm there, are just resuming their task of reducing the grown-ups' world to material that lends itself to the patient labour of reinterpretation. Children take the adult world apart into bits and pieces – and so that is what they do with the toys they are given. The stance underlying this behaviour shows a familiar relationship with the world of things which we adults have often forgotten. The child is caught up in a world where objects are animated presences, companions who speak to him. Faced with this world, he manifests a disorderliness typical, at one and the same time, of both the collector and the hunter.

To break, to parse, to disassemble is to get back to the raw materials, to prepare a list of ingredients. That is what the child is doing, when he seizes upon the objects he finds or is given: "To him, every stone he finds, every flower plucked or butterfly captured, is the start of a collection; and anyway, everything he owns is, in his eyes, just that: one big collection. In [the child], this passion shows its true face, that severe Indian gaze of which – in antiquarians, researchers or bibliophiles – there remains only a clouded and maniacal glimmer.

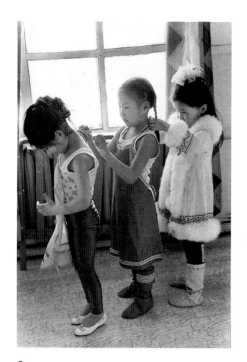

6
Eveny girls preparing for a school party, Sakkyryr, Siberia, 1996.

74

7
Vezo children learning how to sail their *pirogue* boats, Madagascar, 1993.

5 Benjamin 1972, pp. 35–36.

His stance towards life is already that of the hunter. He hunts spirits, whose traces he senses in things; he spends whole years amongst spirits and things, years during which his field of vision remains free of human presences. His experience is dream-like; he knows nothing lasting; he thinks things just happen to him, just present themselves to him. His years of nomadic life are hours spent in the Wood of Dreams. From there, he brings his booty home to where he can cleanse it, consolidate it, free it from magic spells. His chest of drawers must be transformed into an arsenal, a harem, a museum of crime, a crypt. To "tidy up" would be to destroy a building full of prickly chestnuts which are iron-toothed maces, bits of tin foil which are a silver treasure, building blocks which are coffins, plants which are totems, and copper coins which are warriors' shields. For some time now, the child has already taken to helping organise his mother's linen closet and his father's bookshelf; but on his own Indian reservation, he is still a nomadic and warlike guest."[5]

The child is a Surrealist being. Without needing to be taught it, he has the capacity to assemble the most disparate elements, to carry around with him the phantasmagoria of objects, placing them in relationships of which he alone is master. This is where his originality and his savage state reside.

This Indian wildness is what adults fear most and understand least. At bottom, all the grown-ups in the world – even the adult natives of an African or Amazonian village – know that children are in touch with worlds from which they themselves are shut out. The children of the Gourmantché of Gobinangou in Burkina Faso are still able to converse with spirits – at least until they are old enough to stand up. Their parents know it; and so, every so often, they have to "bring them back" by means of a gentle little blow on the head, to stop them from chatting with the pola, the spirits of the forest and of the indefinite. Childhood has privileges that the adult world finds troubling. The most troubling is the capacity for taking the material world so seriously as not to take it for granted or get used to it. Play is the opposite of habit. As Freud intuited, this is why play is so often repetitive: because, as with all experimentation involving repeated trials, it does not take for granted that "things are a certain way, and that's that." It may turn out that experiments with fire, with light, with falling objects, with the way a vase shatters, do not always yield the same results. "Compulsive repetition" is the opposite of nonchalance, of the seeming naturalness with which we adults open a door, walk, pick up a pen or a vase. For adults, discovery is a rare and surprising episode; it is children's daily bread. Part of discovery is finding out that one is a thing among things. Children feel their own presence, in the midst of the presence of things, as though it were caught up in the same power. They are part of a living complex:

"The child behind the curtains himself becomes something white and fluttering, a ghost. The dining-room table beneath which he crouches turns him into a wooden idol in a temple whose four columns are the table's wooden legs. When he's behind a door, he, too, is a door: covered by this massive mask, he

8
Children at play reconstruct
a firing squad, Palermo,
1960.

9 (following spread)
Children playing Cowboys
and Indians capture a car,
Palermo, 1959.

is a sorcerer ready to cast a spell on any unsuspecting being who crosses the threshold. At all costs, he must avoid detection. When he makes faces, he is told that, should the clock chance to chime, he'll be stuck that way forever. In his hiding place, he can test the truth of this. Whoever discovers him can make him stay a wooden idol beneath the table, weave him forever, ghostlike, into the fabric of the curtains, imprison him for life in the solid wooden door. This is why, when he is caught by those who have been searching for him, he drives out the demon who has transformed him so he wouldn't be found: in fact, he doesn't even wait for the moment of discovery, but instead beats his discoverer to the punch with a shriek of self-liberation. This is why he never grows weary of struggling with the demon."[6]

The house and its objects are very important. The houses a little boy builds of cushions and chairs, the Indian stockade made from the packaging of a television set, or the country estate where little girls receive amidst kitchen doormats, call into question the function that such objects – cushions, chairs, rags – have been given once and for all. Children are almost amazed when they see grown-ups use these things in such inappropriate and short-sighted ways. This is the reason they prefer toys of metamorphosis, the kind which at least leave other possibilities open – such as monsters that become cars – and this is why they love monsters, which are disguise carried to excess.

In this ongoing work which is play, children follow the fundamental law of mimesis. Their animism is a way of absorbing the fact that, in order to learn

6 Ibid., p. 36.

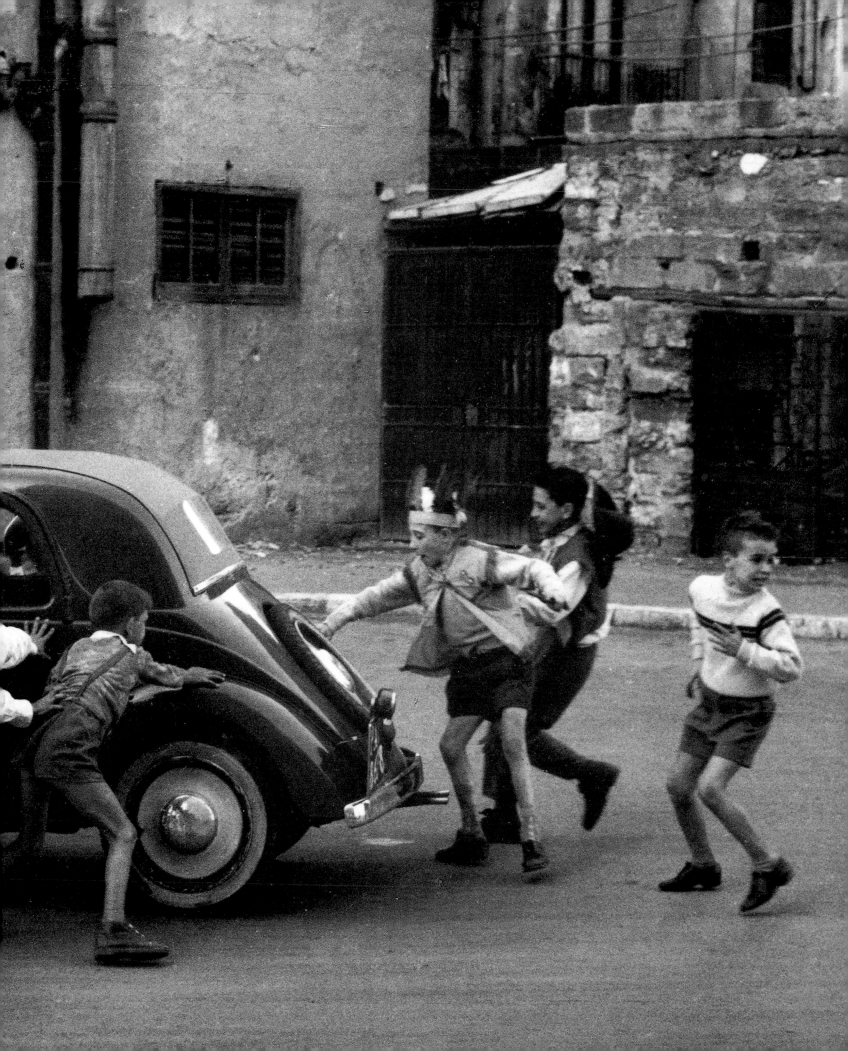

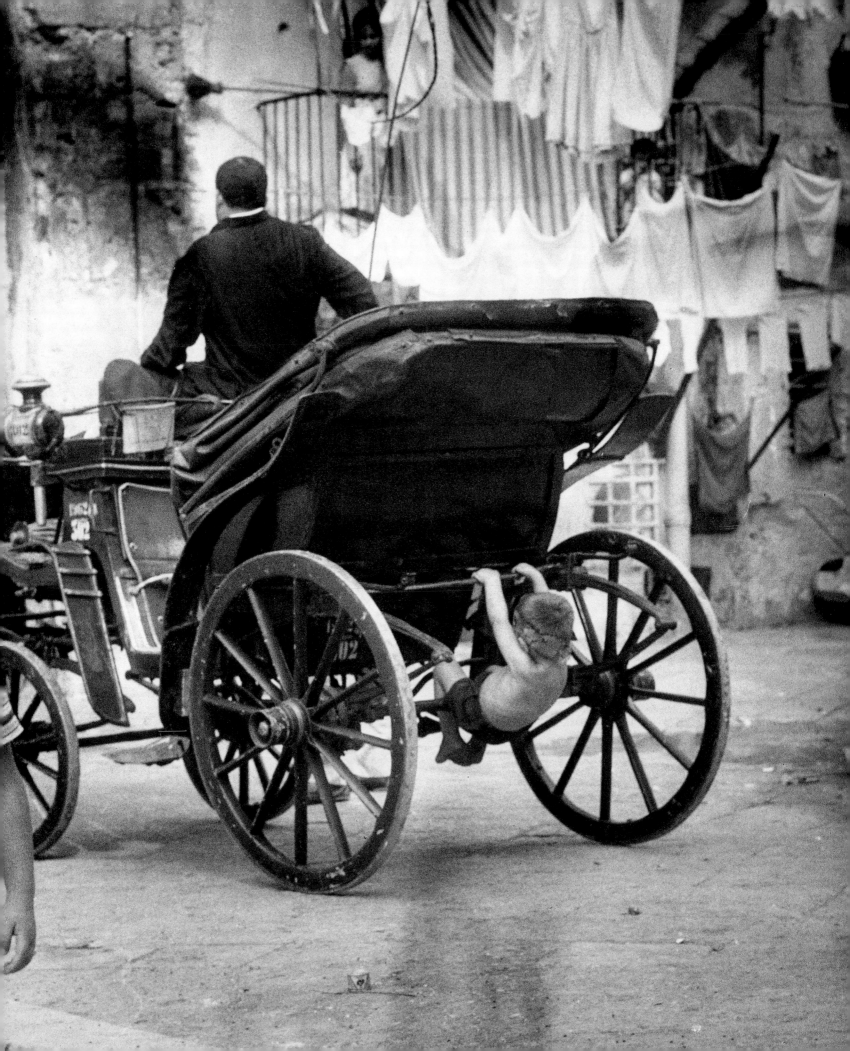

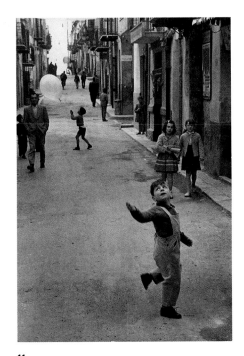

11
Boys and balloons on the
streets of Montelepre, Sicily,
1958.

10
Boy riding on the back of a
horse-drawn carriage,
Palermo, 1959.

about the external world, they must become it. Mimicry and imitation are the means by which observing the cat means becoming the cat, hearing the mother's voice means becoming that voice and learning to speak as she does. Benjamin says that imitation is the origin of language, in the sense that language is an attempt to reproduce the world. The infant shows us this effort in its purest form: he reproduces the world by means of a sound, a manner, a composition never previously heard.

What happens to these children when we sit them down in front of a television, video or computer game in order to make them behave? What happens is that, even there, they still exercise their desire to experiment, but it is a bit of a trap, because the narrative contained within those boxes is not infinite, but directed. However mobile and fascinating the imagery may be, the plot is ultimately a dead-end. Things end up in a certain manner; there is one way of winning and one way of losing. To be sure, this might seem to resemble the narrative of fables, but fables have a strangeness that no moral can take away from them. Fables are a discourse on the world built up over centuries of amazement, not a game with clear rules for winning. Something makes us believe that children are eternal competitors; and that "something" is the horrendous legacy of organisations such as the Scouts and Guides, blended with the military spirit of our Western religious cults. The competitiveness of the child is the mimetic spirit, which is more imitative than competitive. It is we adults who misunderstand it. We think that the child's world is the desire to participate in contests, to win and lose. In reality, it is we who are reassuring ourselves in this fashion, by making children take part in contests in which we ourselves are the guaranteed winners. We do not accept that, in the game of mimesis, we are instead the losers, who have forgotten that every imitation demands a strong faith in the risk of becoming the Other, whether that Other be a table, a doll, the moon, a horse or its rider. In the animistic experience of the world, an experience children continue to cultivate, there is redemption from the over-narrow bonds of individualism; there is the feeling that the world is an enormous aquarium, where the borders between things and people are not so clear-cut after all.

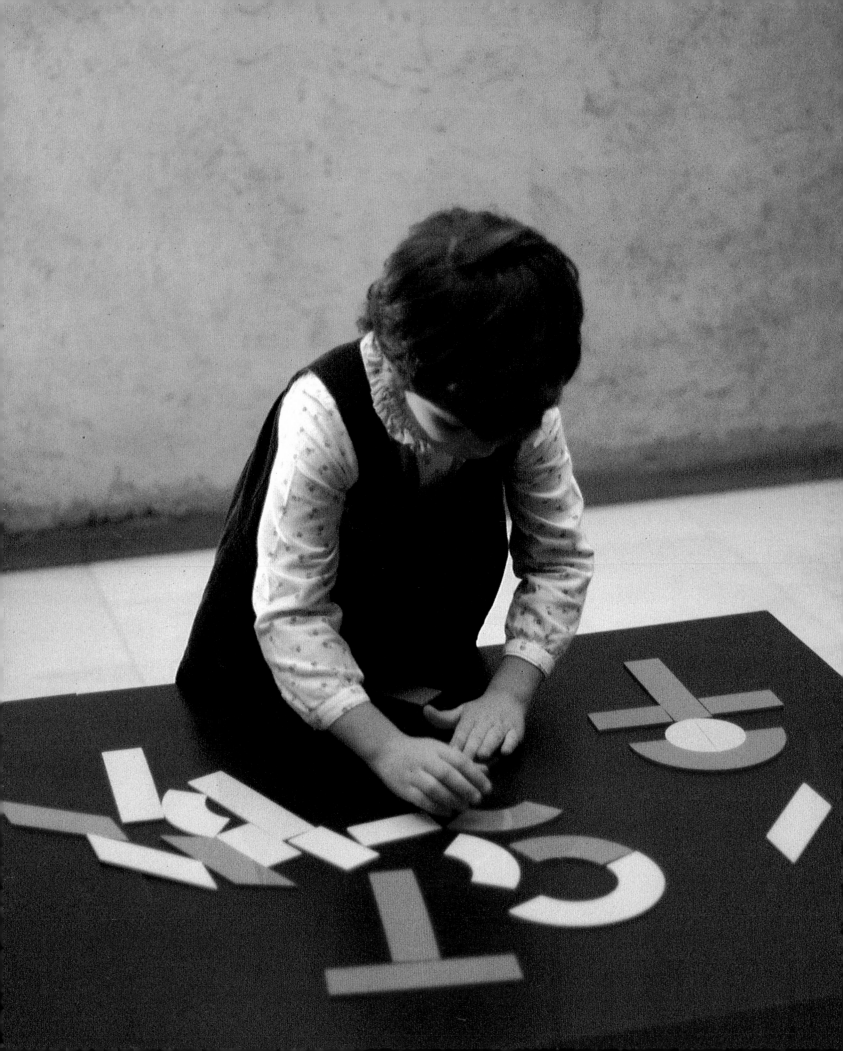

Renato Pedio

Playing by the Rules

ABC con Fantasia (ABC with Imagination), designed by Bruno Munari for Danese in 1960, uses coloured, non-toxic plastic shapes to compose capital letters, but also other imaginative forms.

Thrown into the world, the child immediately sets to work to master it – and his work is what we often call play. Now, "play" is one of the most ambiguous terms in all language. Despite warnings from students of pedagogy, there remains, in adults' use of the word, an implicit sense of escapism and wasted time, of unreality and uselessness, of unproductivity, of something which serves only itself. Adults, in fact, often seem to be "playing" (or, even more frequently, watching others play) in order to fill time while waiting to die.

"Play" also signifies a series of opposites: "tolerance" (in the mechanical sense, as in the play of a hinge) and "rigorous planning" (as when a foreign power sets play in motion); a show, part of a training process, an athletic competition; escapism ("just playing") or commitment ("the forces at play") and so forth. To me, it seems possible that the term's true value lies precisely in this ambiguity. Play is uncertainty; it is, so to speak, ambiguity in a pure state; it is a denial of immediate, direct utilitarianism, and is thus the exact opposite of the "serious" logic of power.

For children, play is work of a very productive sort, and furthermore is linked (in common usage) to a connotation of joy. The English language, as is well known, makes a distinction between childish "play" and what we might call the mature variety, which it terms a "game"; the implication appears to be that the former is an individual, arbitrary affair (and thus ambiguous), while the latter is based upon a series of conventions shared with other people. In antiquity, there was something of a similar difference of inflexion between the Greek paidià and the Latin ludus. And since the Greek term means, literally, "a childish thing", it seems to suggest that the child is engaged in a play process involving only itself, exercising the senses and the mind in preparation for playing with the world; as it grows, it will learn the rules of the game as shared by everyone. In the beginning, "play" is thus understood as synonymous with childhood; later, in adulthood, it is taken to stand for that part of childhood that always remains.

None the less, there is another, truer contradiction between "play" and "game". Even when playing "by itself", the child still uses the world's signs; the world sends it infinite and incomprehensible messages, whose meaning it learns to construct. In this construction process, it assigns temporary, ambiguous, capri-

2
Pieter Bruegel, Children's
Games, 1560, oil on wood,
Kunsthistorisches Museum,
Vienna.

cious and shifting "meaning" to what it does not yet understand. Having no immediate utilitarian purpose, this incoherent and extremely concrete play must be identified, according to a certain type of mythography, with childhood "creativity". It is play still characterised by ambiguity, availability to multiple meanings, a sort of fantastical gift for metaphor; one is continually encountering instances is which the child, out of ignorance (which, if not docta, learned, is none the less mirabilis, wondrous), makes arcane connections between things with results that are genuinely poetic – or at least, that look that way to us – but which are so only because of the uncertainty, or rather the multiform richness, of meaning. But the child has still got to learn those various languages, mastering their semantic areas with ever greater precision, and restricting the latter to the meanings and values accepted by the outside world; it is a matter of survival.

In short, the child learns "the rules of the game" – no longer inventing them, but discovering them. Its capacity to communicate thus grows, while its capacity for arbitrary invention diminishes. Play gets scaled down, and is increasingly assigned an escapist role. This can be a painful process. There is a marvellous anecdote related by Piaget of a child who ordered the clouds to make the wind carry them in the opposite direction. They paid no heed, so he himself turned around 180 degrees – and, in that way, obtained their obedience. The child was lying. With this stratagem he was able to put off, at least for a litle while, the trauma of the passage from his isolated, sovereign play to the great game of the world. His was a brilliant act of cowardice, inspired, perhaps, by the fear that accepting one of the rules of the game (i.e. that clouds go wherever they want) would mean losing the arbitrary creativity and illusory omnipotence he so desperately wished to preserve – qualities that were, in a sense, his very self.

But there is a classic confusion in this irreducible opposition between convention and free play: the confusion of a language with the way it is used. This is anything but a minor oversight. It gets asserted at very serious levels, in such weird locutions as "creative language", a term frequently encountered in art criticism. Even the youngest child must deal with the signs of the world (e.g. the table's hard edge, which hurts); it is just that it uses them in ambiguous, unpredictable ways. None the less, while the child goes on with the process of learning the rules (rules it has not made up, but which it must come to understand and accept), including the rules of its own perception, it goes on playing; and the adversary, the interlocutor, the partner who is playing along is, in the end, the child's entire known cosmos. It will go on this way, if it can, for its entire life. This process is called research, genius, or various other, occasionally inhuman names (such as the "titanic" poet), when it is in fact nothing other than the most flexible, articulated, universal, indispensable and misused of human functions.

The point is not to distinguish between, and to oppose, "play" and "game" (although it is quite a useful distinction); it is rather to find out why, as the indi-

vidual matures, play becomes extremely rare, while games become compulsory. For play is not just a different kind of game, but rather the authentic way of playing. It is broader and higher than the game, just as the latter is more demanding and larger-scaled than play. The structure of society, of course, reinforces the very contraposition whose validity we are here refusing to accept: society stresses the rules of the game (including the kind we call sports) at the expense of play, which is denatured and left to those who have no rights. The truth is that it is never possible to speak of education or of possibly didactic games without getting involved in politics, as institutions and churches are well aware. The usual anomaly is set up: by almost imperceptible degrees, the child becomes the object, rather than the subject, of educational action; it is indeed taught the rules of the game to be played with others and the world, but from a seriously distorted perspective. Were things otherwise, the door would be opened to creative exploration, which is simply the game played in a vital fashion; and childhood would once again be the process of learning such a game. What happens instead is that the child's partner, and then the adult's, is no longer his entire known and unknown cosmos, but becomes power, which identifies itself with all of reality and impresses this vision of things on people. The child learns twisted rules and how to lie – inescapably miserable meanings, which literally misrepresent the rules of the game to him. I hope readers will forgive my sloganeering when I say that games should be taught honestly, and play should not be forgotten.

This is what is so interesting about the games manufactured by the Italian firm of Danese, set up in Milan in 1957 by Jacqueline Vodoz and Bruno Danese, which devotes a third of its activities to children's products. These are not limited to amusing ways of learning and exercising the perceptual, compositional, logical-mathematical and linguistic "game" – not even considering that they do all this honestly, without the distorting elements of violence and deception. Right from the outset, they take into account the need to preserve, even when

3, 4

I Prelibri (The Prebooks), designed by Bruno Munari for Danese in 1979, consist of 12 books made of paper card, cardboard, wood, cloth, wettex, frisellina and transparent plastic, each with a different binding.

objective rules are indispensable, that sovereign play which, just by accepting such rules, makes them part of a new and higher type of play. It seems to me that the ones really being tested – the true subjects of the experiment – are, if anyone, the grown-ups. Wittgenstein warned us against linguistic generalizations (which are, so often, instruments of power), precisely in reference to games: "Don't say, 'There must be some shared element, or else we wouldn't call them games,' but look and verify whether there is any shared element . . . Don't think, look!" This warning is valid, first of all, for me in discussing games: there are so many of them. Pieter Bruegel's Children's Games of 1559 shows 78 of them – many still current, just like war. But I think that the warning also holds good for educators, and for parents in particular.

I'm not talking about those who intend to park their child, and buy one of Danese's games to set their cultural conscience at rest; I am referring to those who are seriously seeking games at once educational and creative, and who are willing to take part in them, to enter into the child's play with their own time, their own emotional involvement and their own mind, all without deceiving the mind of the child. "Don't think, look!" means (let's hope that Wittgenstein's shade won't be embarrassed) "Come into these games, and see what there really is inside them." They vary, and what they contain is not, in my opinion, "some shared element, which is why we call them games"; rather, they all bear the mark, or at least some trace, of an authentic quality of formal creativeness – from the first, Enzo Mari's 16 Animali of 1957, down to Bruno Munari's Prelibri of 1979 (the latest at the time of writing). One of Danese's secrets is that, as the backbone of the project to create these tools, he has chosen artists of genuine substance, who are at once true "children" and self-aware "planners". It is they who have given this work its practically unfailing visual quality and operational freedom. Of these two important aspects, the former is perhaps the more crucial, given that the use of toys leaves memories, which are pathways (i.e. "education") for the latter – memories of the freedom with which the components may be assembled, a feature on which designers and pedagogues have obviously been in agreement for decades. And yet – this is the point – these are never "merely" aesthetic images for adult contemplation; use matters. It is distinct from form, yet merges fruitfully with it, out of an identical interest in play. Artists, at least for now, are the only adults in whom, despite plays of power, childhood has endured, nourished by passionate skill and awareness. Danese is right to get the experts to draw upon artists' work, and to get children to try out the results. This is, literally, a game well worth pursuing.

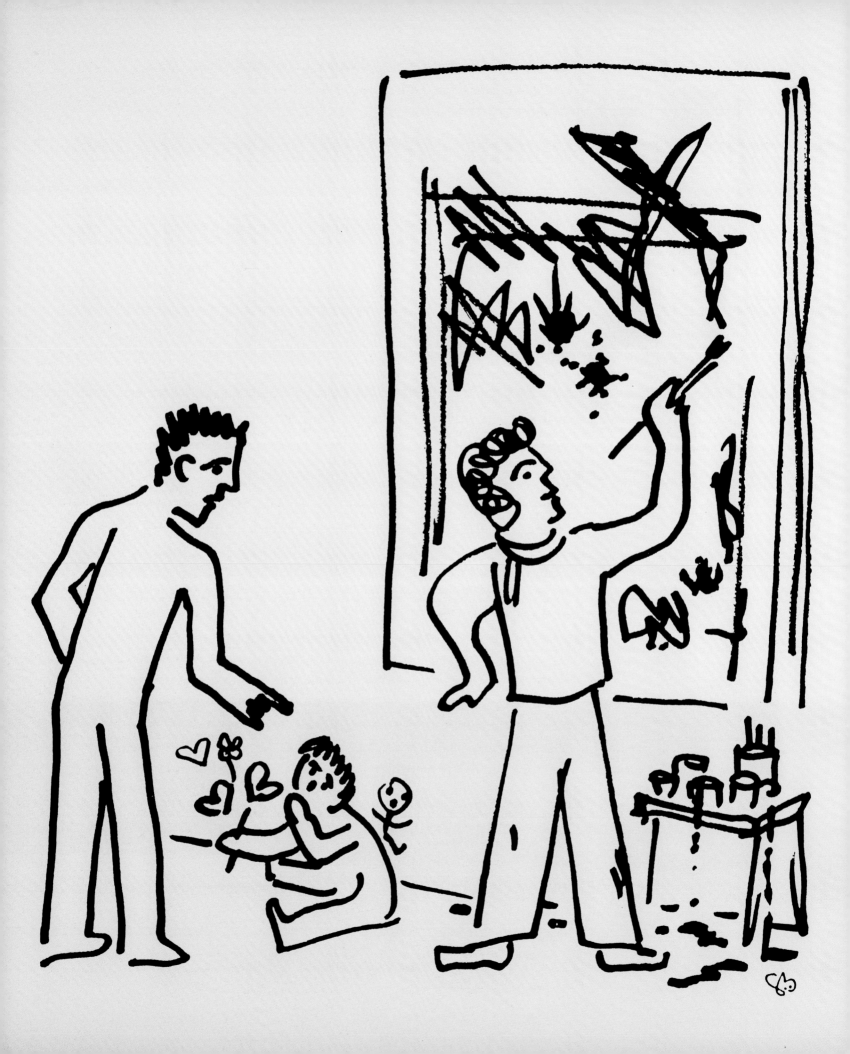

Günter Beltzig

Child-like, Childish, Child-friendly: is there such a thing as children's aesthetics?

This text is not a philosophical or scientific discourse, but an account of my own experience and knowledge which help me to recognise, in my daily work with children, the contradiction between their feelings and adult thinking.

Do aesthetics form a set of natural rules which are universally valid and have an absolute value? Or can they be perceived in a variety of ways, and are they changeable? Theory for theory's sake is not my mission; I am pragmatically inclined, and attempt to apply knowledge in real life. There is no arguing about taste, they say. But since parents and educational theorists now need only take evening classes in painting to consider themselves competent, and Josef Beuys' smudged bath tubs are sold as works of art, taste and the definition of aesthetics have become the subject of debate, even in the nursery. Graffiti or smudging, beautification or destruction, artistic brilliance or vandalism, aestheticism or kitsch – where do we draw the line?

Even though we may not always be sure about aesthetics ourselves, we claim that children do not know what is beautiful, and that we as adults must instil a sense of aesthetics in them. But how do we define aesthetics? We interpret it as beauty, but the word, which originates from the Greek, means "perception". Children, of course, have a natural sense of perception: they do not need to learn how to perceive. Simplified, perception works as follows: everything we see, hear or feel is transferred to our brain by our senses; an impression is registered by the brain, where it is compared and interpreted. We find it difficult to recognise things that do not fit into our experience pattern; in such cases we try to con-

struct a link to other, non-related experiences, which can lead to misperception. It is also possible that certain things fit into several experience patterns at once, which can all be recognised and interpreted in a variety of ways. The well-known alternative images of the vase and the face are a good example. When, however, we see something that we cannot interpret on the basis of our experience (a face with four eyes, for example), our system of perception becomes disturbed.

Of course, a newborn baby does not have a body of experience at its disposal. But its brain is structured in such a way that it accumulates the new experiences that it hears, feels or sees every day; the more frequent and varied these experiences and impressions are, the better and faster the infant will develop its structure of understanding. This continual integration of perception into the process of understanding is called learning. The child does not need a teacher, nor does it need to be prompted to learn – it learns automatically.

The natural, child-like form of learning is play, where the child accumulates impressions and modifies them. As with many things human, learning is governed

by motivation: acquiring new skills is fun. To perceive and experience new impressions makes the child happy. Therefore it will learn eagerly and on its own initiative, provided it is not put under pressure by adults, which can turn motivation into a burden.

Children choose, reject or are indifferent to many things long before a sense of aesthetics is instilled in them. Why is this so? Is there such a thing as an instinctive feeling for aesthetics? Let us look at the things children reject. A baby is not prejudiced: it will grab anything within reach and put it into its mouth to increase its sensitivity to its environment. If adults are inattentive a baby may be burnt or poisoned, or may choke on something, but it is the baby, none the less, who perceives what is good and what is bad. These recorded impressions help the infant to recognise and categorise things. Based on its own experience and understanding, it believes rejected objects to have bad qualities. When it rejects something unknown, it has either confused it with something else or constructed a link to something with which it has had a bad experience.

Another question is raised by why children appear to be indifferent to certain things. Why do they often not notice what adults consider to be important, remarkable, astonishing or beautiful?

We have to realise that our senses are exposed to a flood of impressions – we are able to absorb only a minute fraction of them, and we more or less automatically filter out everything that is for the moment uninteresting or irrelevant. Since a child does not have a fine-tuned structure of perception, it is not able to recognise and interpret things as quickly as an adult. Everything that lies outside its world of experience is, to the child, a miracle – but when the entire world is full of miracles, they become ordinary. Is Superman a miracle when there are thousands of planes in the air? When you can receive images in your living room from television, and you have the power to make them appear and disappear, why should it be a miracle for a ghost to appear, or for Scottie to beam the crew anywhere from the starship Enterprise?

Hereditary structures in the brain influence certain behavioural patterns independent of experiences, yet these patterns can be shaped, structured, neglected or suppressed by experiences. One of these basic structures is the need for tenderness – cuddling, snuggling up to someone, warmth, softness and bodily contact – which leads a child to like cuddly things such as teddy bears, soft toys and security blankets. The adolescent makes experiences that re-route this craving into different channels, and it is eventually eclipsed by different needs.

A second basic structure is the need to protect the young and helpless. This is shaped in adolescence, and emerges in adulthood as care for the weak and the responsibility that parents feel for their offspring. This tendency already resides within the child – it is why it likes things and creatures smaller, weaker and more in need of protection than itself. It is the difference in bodily proportions that helps us determine what constitutes a creature in need of protection. The overall size is not as important in perception as the proportion of individual body

parts to the whole, and how these differ from those of an adult: large eyes, small nose, small mouth, short arms and legs – in short, the proportions of a baby.

A third basic structure that influences children's needs is gender-specific identification. Children behave in "typically male" or "typically female" ways from a very early age. The search for their own sexual identity leads children to play with gender-specific dolls that symbolise the desired identity: girls play with Barbie dolls with firm breasts, long hair and slim legs, while boys play with manly, muscular action dolls whose tools, weapons and accessories are the attributes of a macho world.

A fourth basic structure one that adults often fail to comprehend – is the need for children to toughen themselves up against fear by confronting the sinister. Adults are disconcerted by children's intense fascinatation with gruesome, repellent and

eerie things. The appeal of the unusual, the new and the uncertain surely plays a part in this tendency, which so often makes adults shudder. Monster-dolls and frightening comics, films and books are not typical only of our times; the most gruesome fairy tales have always been the most popular. The attraction of many games lies in the spooky and the uncertain, which have a titillating appeal – this is why adults reject such games as unfit for children, and try to prevent them.

There are further influences. The need to belong to a peer group, to be part of a family, is another basic structure. Children are indiscriminate in their imitation of their environment and the behavioural patterns found within it, whether good or bad. Things that are frowned upon or forbidden, but are nevertheless apparent, are copied just as much as things that are permitted and accepted.

When the child grows up and gains access to other groups through kindergarten, school and friends, it wants to identify with new group behavioural patterns. The child adopts the symbols and behavioural rules of different groups, and is shaped most strongly by the group it considers the most important at any given time. In order to attain a strong and recognised position within this group, the group member (i.e. the child) will attempt to acquire possessions and behavioural patterns that are considered prestigious within the group. Items of clothing, dyed hair, earrings and tattoos – as well as behaviour and expressions – are group characteristics, and they are considered inappropriate and annoying once the member finds itself outside the group. Thus is the group member bound even more strongly to the group, because the symbols and behaviour are recognised only by that group. Group identity behaviour is very much ruled by fashion, and the symbols will change accordingly. Adults do not necessarily need to know what these symbols are, but they should know and accept that they exist and they should tolerate them (graffiti is one example).

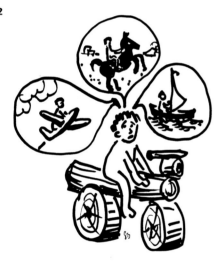

A basic structure that often leads to misunderstanding between adults and children is the highly developed fantasy world of the latter. They are able to "transport" themselves into other worlds; they can change their environment. In their imagination, a tree trunk turns into a motorbike, a rusty drainpipe into a horse, a dinosaur, a space ship, a boat or even a witch. These imaginative games – children's interpretation of objects – have led to adults devising games and similar things for children based on preconceived ideas. A small house may thus be built in the shape of a mushroom, a tree trunk may be transformed into a tractor or a dragon, a seat into a car. By using these figurative preconceptions, however, adults fall victim to a misunderstanding. First, they rob the child of the freedom to interpret its environment on its own terms, especially since the child will use its imagination according to its mood, and the kind of game it is playing. Furthermore, the preconceived tree trunk is rarely shaped like a nice, detailed tractor or dragon, but rather indicates only a symbolic copy. We thus demand too much of the child, who finds it hard to recognise abstract forms: imagining that a block of wood is a motorbike complete in every detail is easy; it is more difficult for the child to recognise as a motorbike an abstract wooden object with two wheels. When a child has the choice between a cheap plastic motor bike with clearly defined detailing and an expensive and slightly abstract motorbike that has been beautifully crafted from precious wood, it will almost always choose the cheap plastic bike. The child is interested in detail, not in abstraction. After playing with the plastic bike for a while and becoming bored with it, the child will then, however, imagine that it is a rocket, a plane, a boat, a horse . . . Adults think that they can inspire the child's imagination through abstraction, but instead they manipulate it by forcing it to follow their own preconceived ideas. A child does not need aids to imagination.

Another adult misconception is the creation of things large and out of proportion for our children. They live in our world, a world shaped by adults for adults. In this world of giants, children are the gnomes, the Small Ones who are simply tolerated. Things are generally too large for children; they would prefer a miniature world. When we think back to our childhood, we realise that everything was rather big: the living room, the door, the garden, the bench, and the teddy bear which was almost as tall as us. When looking for a present for a child and feeling sentimental, we will buy a huge teddy bear because we remember that we also had one of those large, furry animals. But the child is frightened of this huge, soft creature: it is difficult to handle and rather too heavy to play with. If we come across our very own teddy bear that we used to play with, we realise it is just as small as most other teddy bears – we only thought it was huge because we were still small ourselves. Children prefer proportions that correspond to their own; they like a miniature environment which they can easily oversee and manage.

Children and adults often experience colour differently. The perception and experience of colour is undoubtedly a very subjective matter which is governed by fashion and periodical influences, by daylight, artificial light and personal moods. When we imagine the vast amount of outside impressions flooding the child's perception, we will understand why children become insensitive to these impressions, despite their curiosity. Only things unusual, bright, curious and loud will get the child's attention. Strong colours, contrasts in colour, and colours that interact with each other prompt children into action. Whether these colours are beneficial for children, whether children feel at ease in a constantly stimulating environment, cannot however be gauged by their spontaneous reaction. Often, the subtle and unspectacular, the things they only notice the second or third time round, are more beneficial for them.

Another crucial influencing factor, which is experienced differently by children and adults, is time. For a five-year-old, one year amounts to one-fifth of its life, and its past reaches back to the beginning of its world: we understand that chil-

dren interpret terms such as "in those days" differently from adults. Children have no notion of time: they want everything now, instantly and immediately. Expressions like "But just half an hour ago you . . .", "Wait until the evening . . ." and "We only have two miles to go . . ." represent an eternity – for children they are unfathomable values. And when they cannot see the whole distance or schedule they start whining. Attending adequately to children's needs means recognising and respecting the distances and time schedules that correspond to their desires and abilities.

The idea that old people live in the past and adults in the future, while children live in the present, casts some light on why we often misunderstand children where time is concerned. Six months ago, a child was smaller and unable to do certain things; six months from now, it will be taller and able to do these things, and many more. Being a child means undergoing constant change. The immediate built environment becomes smaller as the child grows, but its ability to see and think further with increasing age means that its overall surroundings expand. Knowing more today than it knew yesterday also leads the child to become more daring. While it ventures out to discover the world it is held back time and again by barriers, learning along the way that today it is able to overcome the barriers of yesterday. Children are "barrier-busters". Because many barriers are symbolised by bans, such as "You're not allowed to do that yet . . ." or "When you are older you may . . .", the child has to ignore these bans. Being disobedient is part of being a child. Being a child is a floating process.

Adults shape the world for their children according to different criteria from those they use to shape their own world. When we create something for children, we have the feeling that we can finally express ourselves creatively, that we can let go of the demands of adult aesthetics. When creating for children, we fall back on an aesthetics that we consider to be funny, imaginative, unusual and also educational, that reminds us of our own childhood. We hardly take into consideration whether our children actually like what we give them, and whether it meets their requirements and needs. The shaping of the children's environment – the nurseries, children's furniture and toys – is symbolic for the way in which

we deal with children. They are not allowed to create the objects they need for their own purposes; they are hardly allowed even to select them. In the end, it is always the adult who decides.

Children's environments, furniture and toys are always a reflection of the way a culture reaches out to its young, and of how far it meets their needs, and whether it supports, suppresses or ignores them. A rich and plentiful world is not necessarily a good environment for children; on the contrary, it shows rather how much adults strive to be the centre of attention. A child-oriented environment allows children the freedom and space to create, shape and form things – it allows change and decorations that we might consider destructive, ugly or kitsch. A child-oriented world has its own aesthetics.

The children of today will be different tomorrow, and they will change more quickly than we might want them to. If they want to be independent, they will have to liberate themselves from our constant attempts to make up their minds for them. They will provoke and shock us, they will deliberately do things differently from us. They will create their own world, their own aesthetics. This is, essentially, what being a child is all about.

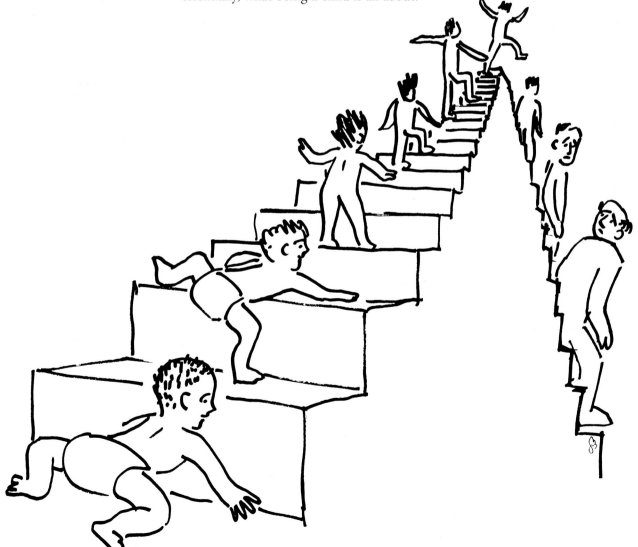

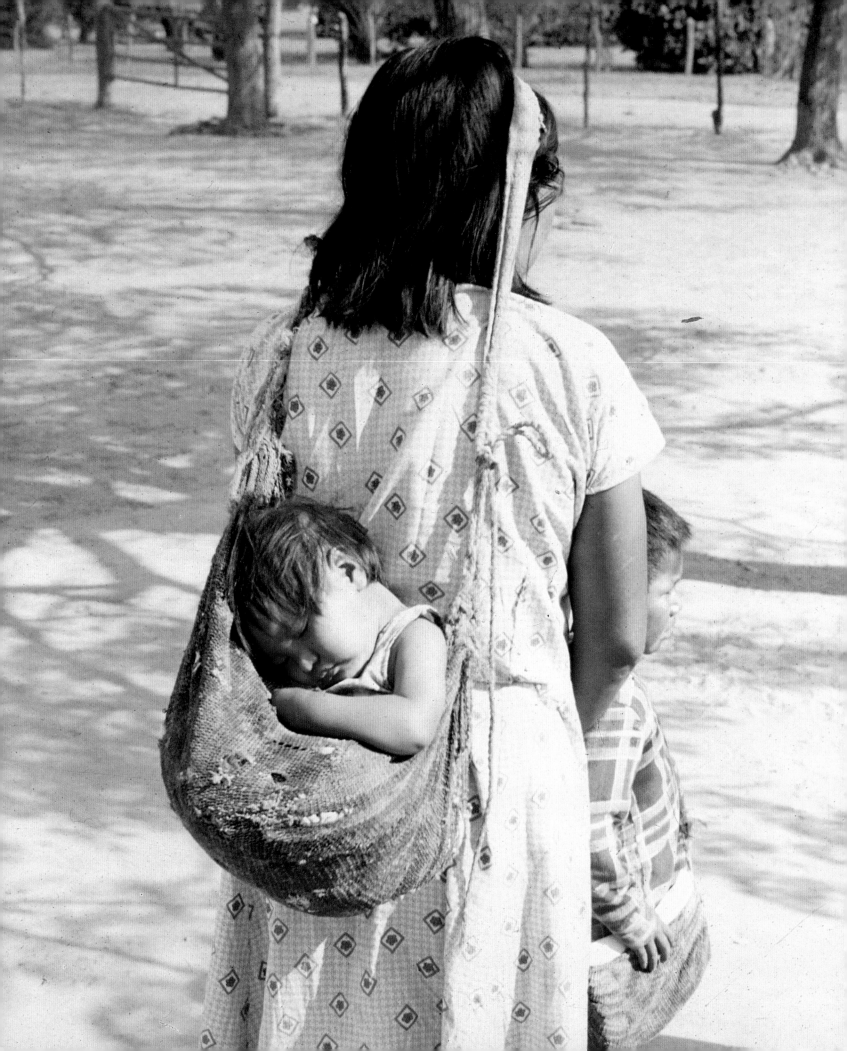

Annemarie Seiler-Baldinger

An American Indian Concept of Mobility: tied up and tied in

2
Maya, a woman from Panajachel, Guatemala.

1
A Nivaclé women from the Gran Chaco in Paraguay with a toddler in a common type of sling, featuring a strap over the head.

Native American Indian children are mobile; they accompany adults wherever they go, whether they are planting crops, fishing, on a hunting expedition, visiting or on a business trip. The "trappings" of childhood – despite the suggestions of the word – are for the most part movable and designed to be so. Children, and above all infants, are literally bound up with cloths and bands – but, in the more extended sense, they are integrated into their society as equal members.

Even before Columbus "discovered" the New World, its native inhabitants were using the same items as they use for children today. Evidence for this exists both in pre-Columbian ceramic grave goods and in the early reports of the European conquerors. Columbus himself was the first to mention the *hamaca*, the hammock, as the native Indian bed; however, as might be expected, he paid practically no attention to matters relating to children, since women and children took flight at the sight of white men.

97

The Aztecs

It is in connection with the subjugation of Mexico and Peru that we first hear about the way in which children were brought up and something of their world. We are particularly well informed about the conditions among the Aztecs and Incas, because the achievements of these "high cultures" were a source of wonder and great interest to Europeans.

What is striking in both cultures is the degree to which the upbringing of children was structured and regimented. This is especially true for the Aztecs, where we have numerous early colonial sources at our disposal.[1] The Codex Mendoza, an Aztec manuscript,[2] strikingly depicts in illustrations and text the cycle from birth to entry into adulthood. After birth, infants were bound into little beds that were equipped with four carrying handles so that they could be moved around. The following description of ancient Mexican customs comes from the chronicler López de Gomorá: "The cradles are made of cane or light sticks, so as not to make the burden too heavy. Then the mothers and women throw a cloth round their shoulders, the ends of which they tie over their breast, and in this way they carry the children with them and suckle them. After a child's first bath they give a boy an arrow in his right hand, and a girl a spindle and a weaver's shuttle.

1 Sahagún 1990; Testimonio 1990.
2 Codex Mendoza 1978.

3
A cradle with an infant.

4
A nine-year-old girl is
punished by her mother
with agave thorns.

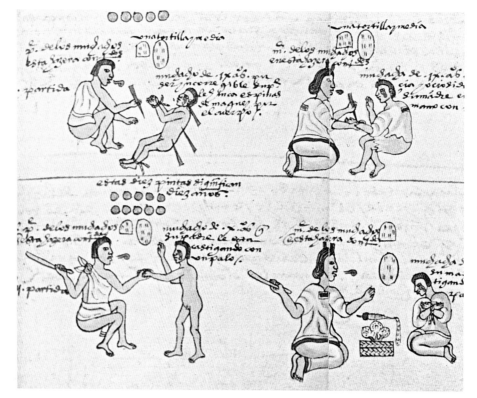

Among other peoples . . . they used to give the boy a shield in his left hand and
an arrow in his right, and the girl a broom."[3]

Even in the first days of a child's life, an indication is given of the future roles
of the sexes. For boys it was the insignia of reputable professions (goldsmith,
feather worker, woodworker, scribe or warrior) and for girls the emblems of
womanhood (the broom, spindle and work basket). Upbringing proper started
at about the age of three, initially through the example set by parents, accom-
panied by verbal, stereotyped admonishments. Upper-class children were
brought up by wet-nurses and servants. Children were given simple tasks to
perform. Boys' tasks included, for example, collecting twigs for the girls'
brooms or collecting maize, beans and other foodstuffs from the market. Girls
were taught by their mothers how to spin. Later, boys helped their fathers with
the hand-net during fishing trips, while girls perfected the art of spinning un-

3 López de Gomorá 1966, p. 398.

der their mothers' watchful eyes. For all these activities, children sat on the bare ground; boys on their haunches and girls on their heels, kneeling down, as is still very common among native Americans today. Sitting mats were exclusively reserved for men, as they were a sign of dignity and authority. However, everyone, including children, slept on woven mats.

At about the age of seven or eight, children apparently reached their naughty phase, for it is at this age that records of punishments begin. These consisted, for example, of tying naked children up by their hands and ankles and pricking them with agave thorns if they had lied. It was also common to beat children with sticks or hold them in the acrid smoke of burning chilli peppers. The punishments became more serious with age. Thirteen-year old girls were dragged from their beds and made to sweep the house clean, and boys had to lie naked and bound for a whole day on damp ground. Sahagún comments: "A father and mother take a great deal of trouble that their child should not turn into a scoundrel: they hit it, lash it with switches, pinch it, cut its ears, and beat it and beat things into it by means of various punishments, to encourage good behaviour in language and respect towards other people."[4]

Among the tasks of seven- to ten-year old boys was fishing from a canoe; girls learned weaving and how to make tortillas, the maize-flour pancakes that were the Aztecs' staple diet.

At the early age of seven, lower-class boys were given up by their parents to a *telpuchalli*, a home for boys, where they had to undertake lowly tasks. These included sweeping and cleaning the floor, and fetching firewood for the fire. All boys had to sleep there, "and anyone who was missing, anyone who did not sleep in the boys' home, was punished. The boys also ate at the home." In the next age group (about ten years of age) they had to fetch green twigs and straw for sitting on. Later they "all went out together, wherever there was work to be done: shaping clay bricks, erecting walls, planting maize, building irrigation canals, cutting firewood or weaving mats."[5] Later, some of the boys attended a *cuicacalli*, a military school, from which the warrior class came. Others became apprenticed to famous craftsmen where they helped out to start with, for example by making birdlime for the feather workers.

Boys from the upper class, with the exception of those of particularly virtuous parents, attended the *calmeac*, the "house of tears and sadness", an extremely strict school run by priests. The tasks were very similar to those in the boys' home, and consisted of keeping the priests' house clean, chopping firewood, cutting agave thorns for the priests' blood-letting rituals, and producing dye for ceremonial body painting. Later they learned how to play conch shells and sacred trumpets. The only difference from the boys' home lay in the fact that these boys slept alone. The two educational establishments were in strong competition, and their members fought ritual battles with each other.[6]

Daughters of the upper class also had the advantage of a special education. They were able to enter into the temple service, where they were taught to weave and

4 Sahagún 1990, p. 317.
5 Ibid., pp. 239, 248.
6 Ibid., pp. 208, 243ff, 246, 169.

293 DEȝIMA CALLE QVIRAVPICAC·VAVA

5

The infant in the little portable bed is one month old.

100

how to prepare cocoa for ritual sacrifices.[7] Daughters from the reputable class of feather workers learned how to dye rabbit hair and feathers.

We are less well informed about the poor. Children from the lower class were often chosen for human sacrifice. The priests bought the infants from their mothers, and sacrificed them on sacred mountains and by sacred lagoons: "the more [the children] cried, the more you could expect rain".[8] Generally, children were obliged by their parents to lead hardworking lives, and they helped out in the fields, on fishing trips or with the housework. It was inculcated in girls at home that when they went out, they should always allow others to go before them "and if you are living in another house, take care to light the hearth fire there, put the house in order, sweep the floor, reach hastily for the spindle and the loom, fetch water, the grinding stone, and the work-basket".[9]

The common people's furniture was relatively meagre. Children slept together with their parents on straw or mats, and dressed in cloaks where they could afford to do so. The head rested on a piece of wood, a stone or, in the best cases, a palm-leaf pillow, which was also used as a cushion.[10] Their diet depended on their age. After weaning at three or four, children usually received half a maize-flour pancake a day, two at most, until puberty.[11]

The Mayans

Conditions similar to those found among the Aztecs prevailed among the Mayans. Five days after birth, a child "was laid face down on a bed base of cane, its head between two wooden boards . . . firmly bound, and it suffered like that for several days, until its head . . . was finally flat."[12]

Children slept naked until the age of five, and then they were given a blanket, which also served as clothing. A child was carried on its mother's hips which, in Landa's opinion, led to bow legs. Mayan children were brought up as strictly as Aztec children. In a situation analogous to that of the Aztecs, there was a boys' home for sons of the upper class, where the boys slept and practised the ritual ball game.[13]

The Incas

We find a similar situation among the Incas of ancient Peru. A newly born child was wrapped in cloths and bound firmly to a bed frame on the fourth day. This quirau could always be positioned within the mother's reach, or carried on her back in a shoulder sling. Infants stayed on this portable bed until they were weaned, and they were called *quirao picac*, "those in the cradle" or "those who have not progressed from the cradle".[14]

After weaning, until the age of five, children were known as *lluclla cunai*, "those who are beginning to walk". From the age of five to nine, they were known as *puclla cunai*, "children who play", and were required by their parents to help in the home and in the fields. Girls helped by fetching wood and water. From the age of nine, tasks were assigned according to gender. Boys learned how to catch birds; girls, known as *pan-aupallac* or *pavay pallac*, had to search for the dyers' weeds

7 Ibid., pp. 210, 505.
8 Ibid., pp. 66, 97ff.
9 Testimonio 1990, pp. 71, 83.
10 Sahagún 1990, p. 406.
11 Codex Mendoza 1978.
12 Landa 1978, p. 55.
13 Ibid., pp. 53ff, 33, 52.
14 Murua 1987, p. 339ff.

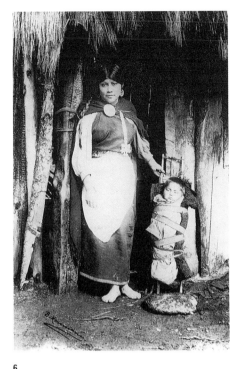

6
A young Mapuche woman
with a sling.

that were employed to dye the wool used for making the *cumbi*, "clothes of the sun".[15] One task for 12- to 18-year-olds was tending cattle; girls did the housework and boys worked in feathers.

All inhabitants of the Inca empire were registered, whereby the ruler's officials saw to it that children were assigned to a different age group every five years. The most suitable children from these groups were recruited into the service of the upper class. There were several schools for the upper class in Cuzco. At the head of the school were old men and women of high rank, who were in charge of several teachers of both genders. In the first class children learned "the language of the Incas, which was rather different from *quichua* and *aymara*".[16] At the next level, children learned about religion and sacred places. In the next tranche, boys learned about *quipus*, by means of which the vast empire was administered, as well as about the administration of justice. In the fourth year, again with the help of *quipus* and the *amautas* (teacher), they had to learn the history of the Incas by heart. At the end of these four years of education, boys entered the Inca page-boy service.[17]

There were also schools for girls of noble birth. In the first year they were taught spinning and weaving, in the second how to make typical Inca clothing, and prepare the food the Incas ate. The third year was intended to train them as cooks, and the fourth was given over to learning dance, herding llamas or tending gardens. The culmination of girls' schools was service in the temple of the Sun. The "sun maidens" were chosen from all corners of the land and "span *cumpi* cloths of the finest kind in the temple for the idols".[18]

Unfortunately, very little can be derived from the conquerors' reports on the furnishings in schools and children's furniture. Portable children's beds and ways of carrying children are all that is mentioned, again and again: "When the mothers have to go somewhere, they carry their children not in their arms, but on their shoulders, wrapped up in one of those bags like a small poultry sack, with their arms and legs sticking out."[19]

Unbroken Traditions in the Andes

We find cases of unbroken tradition even today among the Arhuaco of north Columbia and the Nivacle of the Gran Chaco in Paraguay. Pre-Columbian traditions are also still alive in Peru. Infants in the Andes are "put in a rush basket known as a *tira* or *tirau* These cradles are very robust and can be used for several children one after the other, lent between families, or rented out for a small fee or in exchange for produce or a day's work. Children stay in the tira all day long. They are taken out at night and sleep with their mother."[20]

Thus the *quirao* of the Inca period has come down to us unchanged, as a frame with four legs, a rectangular baseboard and an arch as a continuation of the bed legs at the head end. One of these beds takes an hour to build. The frame is bound with cowhide thongs; the ends are of plaited woollen threads. Blankets or a small fleece are used as bedding underneath the child. The mother wraps the infant in old pieces of cloth, which are tied in place with *chumpis*.[21] These are

15 Ibid., pp. 399–400.
16 Ibid., p. 377. Because the children were drawn from different subjugated minorities, learning the language of the Incas was a means of integrating them.
17 Ibid., pp. 377–78.
18 Ibid., pp. 391ff.
19 Ocaña 1987, p. 67.
20 Burgos Lingan 1966, p. 148.
21 Chumpis during the Inca period denoted precious materials and bands, to which special powers were attributed (Murua 1987). There are several ways of spelling the word: cumpi, cumbi, chumpi.

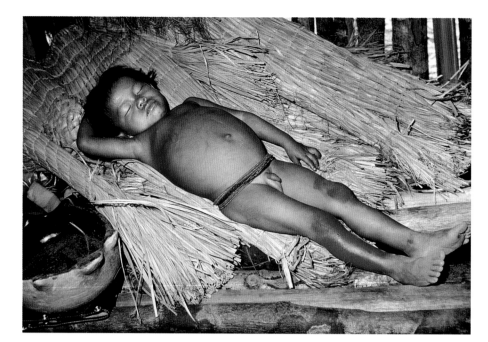

102

meant to give the child strength until it begins to crawl. Over the child are laid first a white blanket and then a black one: the colours have a symbolic role. Many ritual actions are carried out to protect the child – for example, fastening a red thread around the wrist to ward off the evil eye. Mothers carry the frame either on their backs in a cloth thrown over the shoulder, or on a strap. The deformation of the head described above is still common in remote places. After six months, the babies are taken out of their beds because they are too heavy, and from then on are carried in a cloth thrown over the shoulder and knotted at the front. Mothers bathe their children in bathtubs or earthenware vessels. There are still customs today handed down from pre-Columbian times connected with placing the child's bed on the ground for the first time at the time of the potato harvest. Both actions symbolise belonging to society, in the same way that the chumpis emphasise being tied in to the social group.[22]

Cradles with board, rod or slat bases are common in the Andes almost as far south as Tierra del Fuego. They are found among the Ona, Tehuelche, Araucanian and Mapuche Indians, where infants spend the first few months of their lives tied to a fleece beneath them. When it is time for sleep, the Araucanians hang these cradles up by the four corners, or put them on the ground. "If the mother is busy, she sets the cradle up on its end near her – she even carries the child with its board on her back while riding."[23]

Araucanian children are taught very early to use their own potty, and their waste is used later for soap, medicine or in the dyeing process. When children begin to crawl, they use bamboo trellises of a suitable height, fixed parallel to each other, as walking aids. At the age of ten girls are given their own loom, and boys lassos, bolas and hunting slings.[24]

On the Andean ridges that spread out to the east and merge into the tropical rainforests, slat-based cradles are rare, although the Mashco constitute an exception. The father cuts a base out of light balsa wood, and there is a basket cover to pro-

22 Potatoes, being a domesticated plant, symbolise culture – as opposed to nature, symbolised by plants growing in the wild (Burgos Lingan 1996, pp. 150, 154).
23 Schindler 1990, p. 150.
24 Titiev 1951, pp. 87ff, 92.

8
A toddler in a head press,
Ucayali, eastern Peru.

25 Califano 1975, pp. 271ff.
26 Tessmann 1930, p. 194.
27 Tessmann 1930, pp. 51ff., pl.
67; Tessmann 1928.
28 Jones and Whitemore-Ostlund
1980, pp. 36–41; Lith 1994.
29 Lafitau 1983, pp. 170ff.

tect the child's head from the sun. The infant is wrapped in banana leaves and spends the whole day tied to the board with lianas. This lasts about a year, until the child learns how to walk. The Mashco claim that this "cradle" helps the child to grow up straight.[25] Later, children sleep with their parents on platform beds, as these are the norm in the mountain region. With the Mashco we are certainly dealing with one of the groups inhabiting the eastern Andean ridges, as most of the inhabitants of the eastern flanks of the Andes use platform beds with or without mats, and small children usually sleep by their mothers, occasionally also in hanging baskets or hammocks. More rarely, children have their own sleeping quarters, as among the Koto,[26] while young boys in the lowlands of South America mainly sleep in the men's house or men's quarters.

A further characteristic of Andean peoples is the practising of head deformation on infants, as was previously the case among the Omagua of the upper Amazon, and as occasionally still happens among the Shipibo or in North America.[27]

Board-Based and Slat-Based Cradles in North America

Board-based and slat-based cradles are the most widespread and diverse forms of cradle among the natives of North America. They are known from the south-west among the Pueblo Indians, from California, from the Grand Canyon, and from the north-west coast to sub-arctic Canada. The materials in which they are made and the techniques by which they are constructed – usually with feet as supports and a covering for the head – are as varied as the ways in which they are decked out inside and decorated. Decoration may be painted, or consist of precious embroidery made from pearls and porcupine bristles. The crafting and decoration of north American slat-based cradles is invariably carried out with care; the motifs, which depend on the gender of the infants, are meant to strengthen and protect the child. In stratified societies, like those of the north-west coast, for example, the motifs also indicate the child's status.

Children were firmly bound into these slat-based or basket beds until, at the latest, the age of two. Girls were then given exact replicas of their cradles with dolls, as a present. Cradles are not sold, but are handed down from generation to generation; still used today, they are often the subject of native American painting. Portable cradles have a long ancestry, and have been associated with immigration from Siberia.[28] A detailed description of this widespread item of children's furniture may be found in the writings of the Jesuit Lafitau, whose concluding remark is that children were "extremely warm and comfortable in their cradles". At the same time, he mentions that children were able to play with rattles and other trinkets attached to the edge of the cradle, and that they were put in nappies.[29]

Cartier was in a position to make similar reports about the Huroni. He noted that when children were wrapped up, an opening was left at the front; he states more specifically, with regard to girls: "Into this opening they place a rolled up corn cob sheath, which helps carry the water away, without the child becoming dirty by wetting itself." At night children slept at their parents' side. In some cultures they

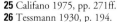

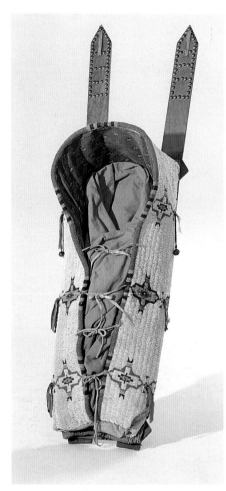

9
A child sling and a leather bag embroidered with pearls and lined with cotton, Cheyenne, USA.

30 Cartier, J., de Champlain, S., Sagard, G.: Trois voyages au Canada. Ed. by B. Guégan, pp. 142ff.
31 Lafitau 1983, p. 172.
32 Knotted hammocks are found in south and central America, but are never used without a cushioning lining, because the knots are not very comfortable. On the use and history of hammocks, see Seiler-Baldinger 1994.
33 Hissink and Hahn 1989, p. 92.
34 Léry 1967, pp. 301ff.

were wrapped up and laid in a fleece blanket which was hung from the roof beams and occasionally rocked by the parents.[30]

In some groups in Louisiana the infant's head was put through a hole at the head end of the cradle, and then the mother tied a clay mass firmly to its forehead to obtain the desired elongated form of skull. This procedure, carried out at night for several months, was described by Lafitau: "The children suffer terribly during the first attempts at this violent procedure, which makes them go black and exude a whitish, viscous liquid through their noses, eyes and ears."[31]

Just as girls were given dolls in cradles, boys practised with small bows and arrows. Later on, older children slept with their parents on mats or fleeces, and were given the warmest place next to the hearth.

Portable Pouches

The possessions of the inhabitants of the tropical forests of central and southern America look somewhat different. Although cradles that can be hung up are common in the north and in the Andes, and are the norm for toddlers, this custom was not carried over into adulthood. Swaying above the earth was probably "discovered" by the inhabitants of the Amazon–Orinoco basin. The hammock – which Columbus came across on 12 October 1492 in the Antilles, and for which he used the Aruca word hamaca – has always been the favourite all-purpose furnishing of the lowland Indians. Without exception, small children sleep in their mothers' hammocks. They are given their own only when they have reached at least two years old; this is then considered to be their own property, and is hung up very close to the mother.

Some of the inhabitants of the savannah of the Mato Grosso of the Gran Chaco in Paraguay hang up woven mats, normally used for sitting on, by four cords, or (as with the Cayapa Indians in Ecuador or the Huichol Indians in Mexico) they lay the children in knotted hammocks that have been lined with a woven mat.[32] We also find as a variation strips of bark fibre that have been hung up. Among the Chimane Indians of Bolivia, these are painted and decorated in part with toys (perhaps a small canoe for a boy) or with amulets such as the umbilical cord, anthropomorphic figures made of bark fibre, colourful parrot feathers or bird skins.[33]

Elsewhere in subtropical parts of America, people sleep on woven mats or fleeces on the ground or on platform beds. Infants are carried around all day in child slings by their mothers or their older brothers and sisters. As early as 1556, Jean de Léry, a Calvinist from Burgundy who had spent a year imprisoned by the Tupinamba Indians of east Brazil, made the following report: "After the birth, [the father] places the baby in a cotton bed that is hung up like a hammock, without putting it in nappies." The boy would then receive a club, and a bow and arrow. Léry adds: "The mother carries the child around in a sling hung round her neck. The sling is made of cotton and is made specifically for this purpose. The mother then goes like this into the garden or goes about other business."[34]

10
A Hoti woman with her
infant in a hammock,
Amazonia, Venezuela.

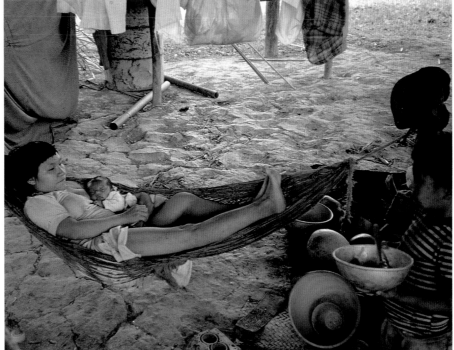

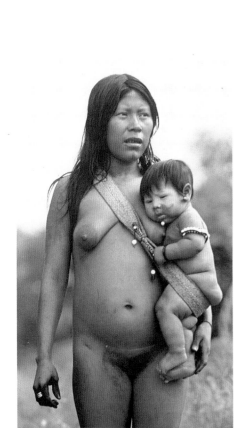

11
A Mekranoti mother carrying
her youngest in a braided
sling, central Brazil.

A German contemporary, Hans Staden, who likewise spent a long time imprisoned by the Tupi Indians, commented briefly:

> "They carry their children on their backs
>
> in hoods of cotton yarn
>
> they do their work with them
>
> the children sleep and are very content
>
> however much the adults bend over or move around."

He illustrates this several times in his Wahrhaftige Historia, and so we see pictures of women with infants planting, brewing manioc beer or dancing.[35]

For the rest, Léry compares the customs of the Tupinamba Indians with those of the Europeans, and comes down in favour of the Indians, who manage without putting their children in nappies or wrapping them up, and closes his chapter with the following words: "In my opinion it is very damaging for the poor dear creatures, if you wrap them up so warmly in such heat, that they must feel half cooked in their nappies and other clothes, as if in hell."[36] This evidence is reported by other Europeans, too, who were obviously struck by the fact that children were not wrapped up as in Europe, and for whom continuous body contact between mother and infant must have seemed unusual.

Symbolic Child Slings

These child slings are made from the most diverse materials, such as bark or palm fibre or cotton. Either the band is laid over the forehead with the child sitting on the back, or the woman carrying the child puts the band straight across her shoulders, with the child sitting on her hips. The principal kinds of sling are woven, half-woven or plaited; sometimes extra decorative strands are introduced into the weft.

35 Staden 1982.
36 Léry 1967, p. 303.

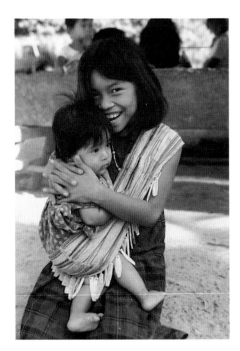

12
A young woman carrying
her child in a cotton shawl
decorated with bone discs,
eastern Andes, Peru.

13
Two girls on a swing,
Veracruz, Remojada culture,
Mexico, AD 500–600
(collection Stavenhagen,
Mexico).

37 The jaguar has played a key role
in the mythology of South Ameri-
can Indians since pre-Columbian
times, and is closely connected
with shamanism.
38 This information is taken from
Casevitz 1980–81.
39 Kepler 1993 attempts a reading
of the signs.
40 Ibid., p. 9.
41 unesco 1977, pl. 17.
42 Torre 1989.

Children's slings in south America bear surprisingly little decoration, if we make an exception for the Urubu Indians (the Tupi in north-east Brazil), where colourful bird feathers are twisted into the vertical edges. However, we should draw attention to the unusual child slings of the Matsigenka and Campa-Ashaninka of the eastern flanks of the Andes in Peru. These woven cotton slings are in fact decorated on the front with little bone tiles, which are sewn on and bear incised designs. They are not merely intended for the child to play with, but are imbued with a profound symbolism. On the one hand they unite the male and female principles: it is the mothers who weave the bands and the fathers who work the bone tiles. Likewise, the horizontal female stripes of the fabric are complemented by the vertical male element of the tiles. Incidentally, the horizontal woven stripes are described as ancestors, and are equated with the rainbow.

The tiles are made mainly from the bones of peccaries, tapirs and agoutis, all of which are hunting prey for men. Their form and raw material emphasise their sacred and protective nature. The rhomboid form definitely belongs in the male sphere, and is associated with the jaguar, the son of Thunder.[37] After taking a mind-altering substance (*ayahuasca*), the carver sees in his visions the patterns he has to scratch; the succession of patterns tell a story which only the carver can "read" correctly. The scratched patterns are coloured with Orleans red, a colour that symbolises blood (i.e. life) throughout South America, while the beige-white of the bone denotes immortality.[38] The patterns are a kind of graphic expression of the father's voice; the soft, continuous clinking of the tiles is supposed to calm the child, and at the same time acquaint it with the history of its ancestors.[39] Among the Ashaninka, these meaningful carrying bands are part of a woman's formal attire.[40] These slings are among the most unusual in South America, although the carrying pouches of the Quechua and the Aymara in the Andes, which also have many other uses, are decorated with symbolic patterns that go back to pre-Hispanic times – for example, the *kenu-mayu* (zigzag river) or the *chasca* star motif.

It seems that originally native American children used hardly any furniture, but usually sat on bare ground or on their parents' woven mat. Mats made especially for children, as are found among the Piaroa of Venezuela, are rare. Where we do find stools or benches, these are meant for use by adult men. Occasionally they are used by boys, but never by girls. Overturned canoes or beer troughs and tree trunks, as well as tortoise shells, are used for sitting on. As is to be expected, little chairs are produced for children today, in imitation of the ways of the mixed race population; in school, of course, children sit on such chairs.

Mention should also be made of a very particular sort of seat – the swing. This can be shown to be pre-Columbian; for example, there are two models from the Remojadas culture of girls sitting on swings (Veracruz, Mexico, 500–750 AD).[41] We find further representations of children on swings by the Swiss painter Hegi from Mexico.[42] In the South American lowlands, children improvise swings out of lianas, or even use their hammocks. Rather rarer are the "true" swings made

14
A Kobéua child in a hanging chair, Rio Cuduiary, Brazil.

15
A market trader in Bogotà has temporarily put her child in an improvised cot.

out of cayman skin, found among the Chimane Indians,[43] or made out of a palm leaf sheath that has been hung up, as among the Chama.[44]

Walking Aids and Toys

Normally it is parents, older brothers and sisters or other relatives who teach children how to walk. Among the Jivaro Indians of Ecuador, the father builds a "pen" around the three open sides of the bed platform. Playpens are also known among the Chama and Koto, where in addition a walking stick is pressed into the toddler's hand.[45] Considerably rarer are hanging chairs such as Koch-Grünberg saw among the Kobeua and Siusi Indians of north-west Brazil, which he describes in detail: "If a child becomes a nuisance to its mother during her housework, she puts it in the little hanging chair. These hanging chairs are extremely functional, and are constructions of flexible sticks and strips of bark fibre, in which the child sits up straight or can even stand up. This helps both parties. Indeed, if the chair is hanging so low that the child can touch the ground with its feet, the child can learn to walk while sitting in the chair."[46]

A similar device exists among the Okaina. Tessmann's vague description runs as follows: "Children have a sort of swing, perhaps a ring, which is hung up by three fibre bands."[47]

The objects which native American children have at their disposal are their own. Among these are toys, of course, such as rattles for babies and, later, dolls carved from wood, or made from wax, clay, fabric or even bread dough. Sometimes these are made by the parents, sometimes by the children themselves. Among the Karaja Indians, girls from a very early age make small clay dolls which represent scenes from daily life. These Karaja figurines, known as *litjoko*, have become much sought-after souvenirs.[48] In addition, Yagua girls from north-west Peru produce

43 Hissink Hahn 1989, p. 113.
44 Tessmann 1930, p. 84.
45 Harner 1973, p. 87; Signorini 1968, p. 64; Tessmann 1930, pp. 914, 212; Tessmann 1928, p. 208, pl. 55, fig. 4.
46 Koch-Grünberg 1910, p. 148, pl. 87.
47 Tessmann 1930, p. 549.
48 Fenelon Costa 1978.

Waura children using a
basket as a car, Xingu,
Brazil.

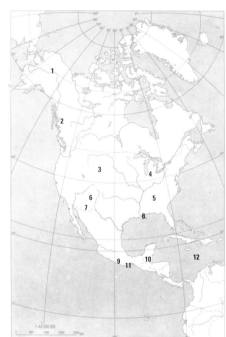

17
1 Inuit (Eskimo)
2 North-west coast
3 Prairie
4 Huronian
5 East Forest
6 Navajo
7 Pueblo
8 Louisiana
9 Aztec
10 Maya
11 Veracruz
12 Antilles

49 Tessmann 1930, p. 206, fig.
41.
50 Nordenskiöld 1912, pp. 64ff.

very fine, small bags for their fathers and brothers, which they can also trade. Interestingly, they trade only with other girls of their own age; I have never been able to obtain one for myself, whereas my 12-year-old daughter managed to acquire them in swaps without any problems. Other toys are feather balls and rubber balls (as long as latex is available as a raw material in the area), buzzing sticks, tops, catapults and stilts. Boys are given small canoes and paddles from their male relatives, as well as small blow-pipes, bows and arrows, little flutes and drums. As well as dolls, girls are given manioc presses and graters and, according to their age, small baskets and carrying nets to follow in their mothers' footsteps.

Children's possessions also include combs, necklaces (often amuletic in character), feathered reed canes, feathered caps, and items of dress (for example, calf bands, armlets and belts, which vary according to age group). Children's crockery is rather rare, although "children's drinking vessels" among the Pioche of east Peru were mentioned and illustrated by Tessmann.[49] In the Gran Chaco in Paraguay, girls use their own jugs for fetching water and, as with the baskets mentioned above, the size of the jugs depends on the girls' age.[50] Children's possessions can even include small calabashes, used as drinking vessels or to store little bits and pieces. An adult would never dispose of a child's property. When parents die, the children normally inherit the dead's most important possessions, if they are not too young.

Conclusion

In conclusion we may say that children in hierarchically divided societies (for example, the Aztecs and Mayas in Mesoamerica, the Incas in the Andes, the Mapuche in Chile and the North American Indians) grow up somewhat differently from those in societies organised along more egalitarian lines (the na-

18

13 Piaroa
14 Omagua
15 Yagua
16 Tupinambe
17 Urubu-Kaapor
18 Shipibo
19 Campa-Ashanika
20 Piro
21 Inka
22 Quechua
23 Aymara
24 Karaja
25 Mapuche
26 Shuar-Jívaro
27 Chimane
28 Matsigenka
29 Cayapa
30 Okaina
31 Amahuaca
32 Mato Grosso
33 Koto
34 Siusi
35 Chama
36 Gran Chaco

51 The relationship between sitting and a settled mode of existence has been very neatly outlined by Eickhoff 1993.

tive Indians of the lowlands of south America). This can be deduced from children's furniture as well as from their upbringing. In stratified societies, parents tend to bind babies with bands on to frames that serve both as beds and carrying cots. These items are particularly varied among the North American Indians, and are very attractively kitted out, with gender-specific decorations with symbolic meaning. The bands with which children are bound in the Andes also have symbolic value, with their main function to protect the infant from any kind of danger.

On the other hand, among the lowland Indians of South America, infants sleep with their mothers until they are weaned, either in hammocks, on mats and fleeces on the ground, or on platform beds. Where they sleep when older depends on their gender. Special conditions obtain for girls at the first onset of menstruation: they are segregated from society in a "menstruation hut" or a closed-off part of a house for several families. Boys, after initiation has taken place, move into a men's house if one exists.

Surprisingly, living conditions and climate have very little effect on children's furniture, particularly in the way in which small children are carried. The function of the carrying cloths, pouches and slings of Central and South America is replaced in the far north of North America by the anorak hood, for example among the Inuit. Furniture meant expressly for children, apart from those items to do with their sleeping arrangements or their transport, is somewhat rare among the native Indians. Occasionally, we find walking aids and swings. Generally, older children use the same furniture as adults, although this is dependent on gender. Thus stools are considered mainly to come within the male sphere, and mats for sitting on within the female. A trend for making smaller, child-size versions of adult furniture, as part of the assimilation to western models, can be detected only in recent times. Children enjoy a relatively large amount of freedom in day-to-day life in egalitarian societies, but also take on responsibility at a very early age (for example, for their younger brothers and sisters).

The education of members of the upper class is differently structured. It corresponds – even in its furniture – to our schools. Since missionary work began (the monopoly of missionary schools in remote places is unchallenged, even today), native furniture and the way in which children are brought up have changed drastically. Children are removed from their parents and are, so to speak, forced into a settled mode of existence on school benches and chairs while alien knowledge is imparted to them.[51] Native children still growing up in the traditional manner enjoy bodily contact with their parents and relatives – who carry them, in all senses of the word – that lasts longer and is more intimate. So items used for carrying children take the most important place among movable furnishings, followed by the paraphernalia associated with sleep and death.

However, the increasing flow of the indigenous population away from the land towards the cities has a long-term levelling effect on the parent–child relationship – and, as a result, on the material expression of this connection.

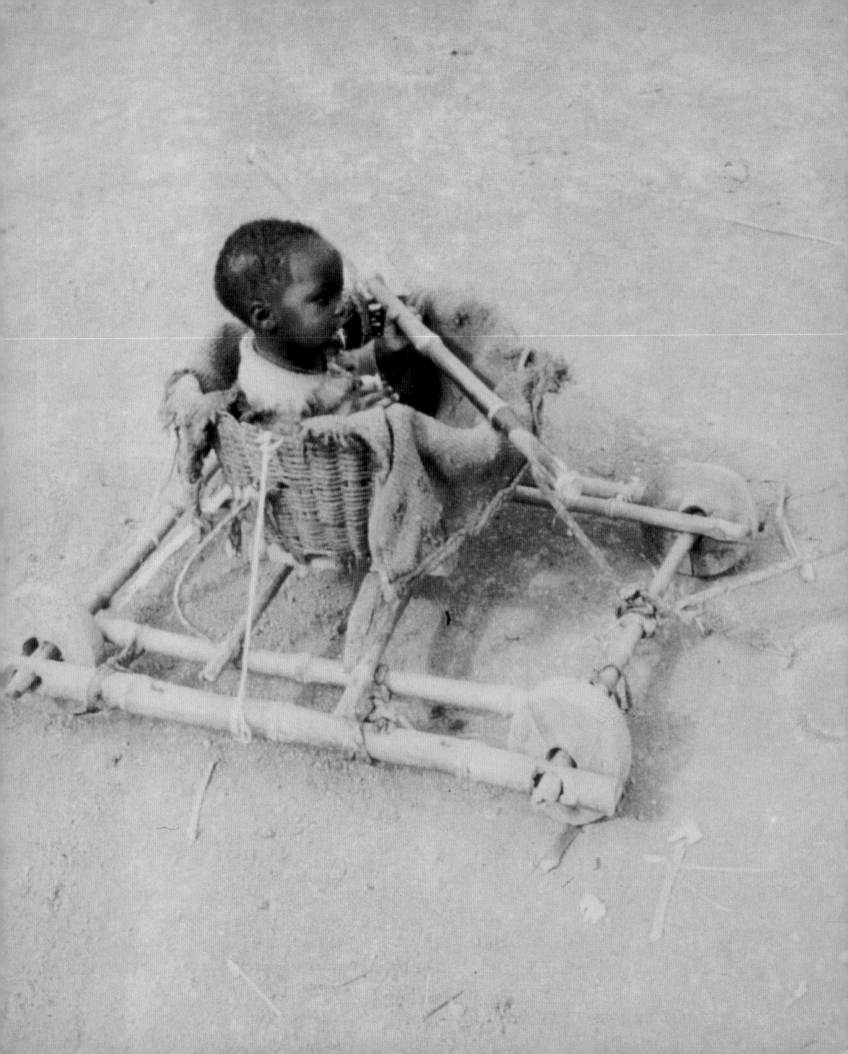

Gerhard Kubik

Children, Child Education and "Children's Furniture" in the Cultures of sub-Saharan Africa

1
This pram is made of four wooden wheels and a basket in the middle which is apparently placed on shock absorbers made of elastic timber slats; the child sits on an old maize bag. Lupanga, Njombe district, south-western plateau of Tanzania, 1960.

The following notes on African cultures are restricted to sub-Saharan Africa, since conditions in the northern Arab areas are very different from those in the south. But even in sub-Saharan Africa, it is not possible to generalise on the role and position of children within society. The trenchant initiation rites which must be undergone by adolescents in some societies do not exist at all in others. These can include segregation according to age within a village, as well as formal education in special initiation schools. Some societies perform physical initiations such as genital mutilation which other societies forbear. Furthermore, there is a problem of definition: what exactly is a child, and from what age is a human being considered to be an adult? One needs to know only one African language to discover that descriptions that appear to correspond to the words "child, enfant, Kind" have a variety of meanings. Scientific research therefore attempts first to examine the extent to which certain words or expressions in a language and its corresponding moral values allow a linear translation into a European language. For example, the term kanike (plural vanike) in the languages of the east Angolan Ngangela group can be used as a specific, but also as a more general, definition. Sometimes it refers to the age group before inititation – ten- to twelve-year-olds – but it may at other times mean adolescents in their late teens, an age group which in Europe would prefer not to be labelled as children at all. Furthermore, this language shows remarkable gender-neutrality: there are no directly translatable terms for "boy" or "girl". Descriptions such as kanike wayala (roughly, a young male being) or kanike wampwevo (a young female being) must be used. The word kanike can also be used in relative terms – for example, to distinguish a man of 25 from the "wise old men" who have gathered in the ndzango, the open pavilion.

I have pointed out[1] that, when examining this region as well as any other in the world, it is best to imagine the processes of enculturation (growing "into" a culture) and socialisation (adapting to its societal regulations and values) on two parallel levels: on the cognitive level, one learns to categorise, to create symbols, etc. Certain forms of orally transmitted knowledge – in the form of riddles, for example – are crucial to this learning process, as are the daily interactions between "adults" and "children"[2] on the socialising level,

111

1 Kubik 1982.
2 Kubik 1992.

ideology is mediated and values are internalised. This is done in the form of direct instruction, but also through role play and oral literature such as fairy tales.[3]

Learning processes that unfold on these levels can be infromal as well as formal. Children in African cultures learn in three ways:

• through *imitation* and *absorption*. Here, the behavioural patterns of other children and adults and, recently, those observed in ever more popular videos (for example, Schwarzenegger and Kung Fu) are copied and enacted in role play in order to be experimented with, rejected or finally accepted.

• through *informal tuition*. This describes any learning relationship between teaching and learning individuals, regardless of age, who come together occasionally to impart knowledge or skills to one another, be it craft skills, dances, games or songs, etc.

• through *formal tuition*. This was previously thought not to exist in Africa, and the term "formal education" was understood to refer only to tuition on the European model. The fact that all initiation schools in Africa are institutions of education and formal tuition was ignored. The professional teaching of crafts (such as blacksmithing), music (such as royal music) and other disciplines were also of a formal character.

I consider formal tuition to include any imparting of knowledge that takes place at regular meetings between teaching staff and a group of students. Initiation schools such as the mukanda in Angola are typical examples.

The diversity of Africa is accessible only to those who are prepared to abandon stereotyped expectations and sociological models. Attempting, for example, to discover a parallel in the "user values" of children's furniture will undoubtedly lead to erroneous conclusions. European children's furniture cannot be compared in any way to objects produced in Africa. It would also be wrong to conclude that the object an African uses to sleep on corresponds to an Amazonian hammock or a European cot or cradle. The term "children's furniture", useful in the context of Europe, is deceptive when used in cultural comparisons. In sub-Saharan Africa, this term would have to be so extended in its application that it would lose its original meaning. As a general rule – based on my own field work since 1959 in eighteen African countries – it can merely be ascertained that the interiors of private dwellings very rarely comprise specifically manufactured children's furniture. If there is such a thing as interior furnishing at all, it is principally subject to the authority of adults.

In Africa, children usually have no voice within the adult environment. Nurseries or children's rooms, in the European sense, which they can decorate themselves exist only in families that have absorbed the relevant influences

3 Kubik 1988.

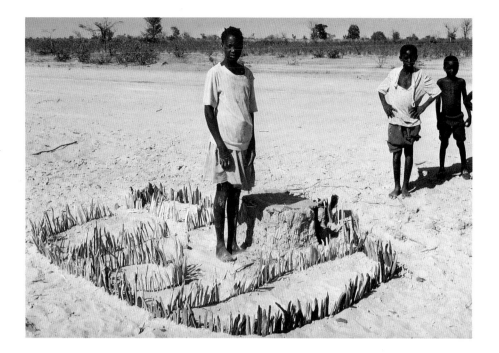

2
This Ovambo farm model shows the central clay hut and complicated palisades which, in the case of larger farms, are often arranged in a labyrinthine fashion. Ovamboland, north-western Namibia, 1993.

from the outside world. This does not mean, however, that African children are subordinates without a will of their own. They have their own creative world, to which adults often have no access at all.

In many African cultures, eight- to twelve-year-old children imitate the life of adults, absorb it through precise observation and then creatively re-enact it on a reduced scale. In southern central Africa, it is customary for children to gather at a playground in order to reconstruct an entire village, along with the living and eating habits of its adult population: the children have their own village within an adult village, as it were. They perform role-plays, imitate social structures and form families. The girls cook with any food that is available to them, in old metal cans or discarded saucepans. This game is not played every day; but once the children have agreed to play, they do so with remarkable intensity and concentration. When playing, they are virtually autonomous; adults do not interfere. Apart from these "make believe" games, children in other parts of Africa build entire farm models, as we documented in 1993, for example, with Ovambo children in Namibia.

In central Africa, children often form small secret societies, imitating adult institutions. These societies usually last only for a limited period of time; they are founded by an active group, and their members appear in public as a group performing music, theatre and dance. They disappear after a few years, when the children have grown older. A good example is the akulavye society, founded in 1966 by girls of the Mpyemo-speaking village Begine in the south-west of the Central African Republic.[4] The group manufacture everything they require: the little raffia chairs on which the girls sit at public dance performances, the colours for body painting, decorative objects such as fur pieces and pearls, as well as musical instruments. Members must abide by rig-

4 Kubik 1993, pp. 42–50.

3
Akulavye, the dance of a Mpyemo girls' secret society. The equipment for a public performance consists of small chairs and two musical instruments (a slotted drum and a fur drum). The dance is performed sitting down, in a circle, with rigorous movement of the shoulders and legs. Leg-rattles and body paint give the girls a new and original appearance which distinguishes them from the adult village population. Bigene, Nola district, Central African Republic, 1966.

orous rules, and the girls sleep together in their own "society house". Older boys often indulge in mask-making, forming their own Secret Mask Societies. I have documented particularly impressive displays of mask-making in southern Malawi and in Zambia, where a boy copied a larger-than-life hyaena (see pl. 4).

These examples show that children manufacture their own objects – "furniture" and toys – outside the adult household, albeit in proximity to adults. It would never enter their minds to store these objects in their parental homes: what you make yourself you want to manage and control yourself. Sub-Saharan African societies evidence the same phenomenon that Florence Weiss encountered in Papua New Guinea, which she called "autonomous children's groups".[5] The children are autonomous in their own play-world; adults interfere only when conflicts arise that appear to be irreconcilable. Occasionally, children astound adults with their inventive and imaginative activity. Some of the "furniture" they produce is very useful, such as the pram made by a Tanzanian boy which turned out to be a welcome help for his mother. Since it is not possible to make pieces of "furniture" in the adults' houses, all objects required for play are made in the open air. They symbolise what children in the respective societies identify with. Particularly in Africa, these identification processes are gender-specific. In the autonomous children's groups, role-play is also always gender-specific.

Since the car and later the aeroplane first appeared in Africa, making vehicles

5 Weiss 1993, and see pp. 129–39 in this volume.

4
A special mask depicting a hyaena. The boy who made this mask, who has been initiated into the secret of masks, is only allowed to approach the village, not to enter it. Inside the village, another boy dances from time to time with swaying, sideways movements. Sangombe, Kabompo district, north-western province, Zambia, 1987.

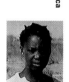

has become a prime interest of most ten- to fifteen-year-old boys. All sorts of vehicles are made, according to the available raw materials. In one area, for example, with a high concentration of raffia palm trees, the stem of the leaf, with its soft marrow and hard epidermis, is used almost exclusively for the making of pretend vehicles. Of course, boys copy the car models they have spotted, but the other imaginative shapes created in the process have attracted collectors from European museums. The raffia zone extends mainly over the countries of the west-central African tropical rainforest: southern Cameroon, Gabon, eastern Nigeria, the south-western Central African Republic and northern Congo. In most areas of southern Africa – the republic of South Africa in particular – children build so-called "wire cars" which have chassis made of inter-woven wire. In contrast to the cars made by Portuguese children, the African models are always pushed, never pulled. In order to push the car, a long stick, often equipped with a steering wheel at the top end, is fastened to the little vehicle. Turning the wheel moves the axle laterally and thus allows the car to be steered.

Over time, many different styles and inventions have evolved which can be traced to specific eras and geographic areas. Quite often, vehicles are constructed in full-scale size; the technology has become ever more refined and complicated. At the beginning of the 1980s, mobile puppets began to appear all over southern Africa, some of which are musical. The puppets are fastened to the chassis of the wire cars; with the aid of a simple transmission device,

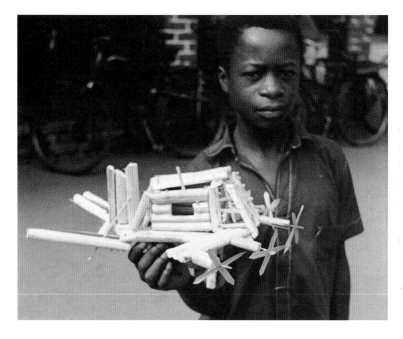

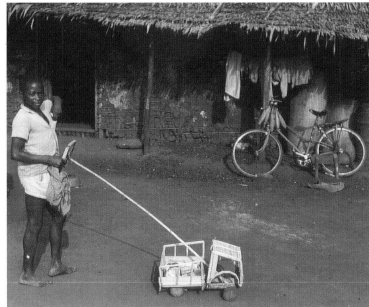

5
A raffia model of a military transport plane, made by a boy of about ten. Makanjila, Mangochi district, Malawi, 1967.

6
A "lorry" made of raffia leaf stem pith; raffia needles keep the structure together. Gbamina, Nola district, Central African Republic, 1966.

they move when the car is pushed. In southern Malawi, for example, an important theme for these musical puppets is sholisho, the drummer or banjo-player.[6]

Those who do not endorse genetically inclined hypotheses about the principal mental differences between men and women will expect that children of both sexes initially have similar interests.

As my work with young children has shown time and again, this is indeed the case. However, intense social pressure is exerted on children in Africa – much more so than in Europe – to prepare them for the gender-specific roles they will later have to fulfil. Paradoxically, these expectations of socialisation are based on societal structures that have in fact become obsolete: children are prepared, under considerable pressure from adults, for a social environment that no longer exists. The role-specific expectations of the adults are internalised by the children from an early age. Here, boys appear to be at a huge advantage, as they are granted a wide scope of creative activity. Girls, less fortunate, are indoctrinated into what they are supposed not to be interested in. This leads to girls not making cars and not experimenting with mechanics at all; they are also kept from learning mathematics, which later leads to the false conclusion that they are less talented in the subject than boys. But girls are encouraged to learn craft skills, particularly in areas where, for example, the manufacture of pots lies firmly in the women's domain. These skills are acquired early on, at play, when girls make clay dolls and similar objects. In Malawi, for example, at the beginning of the rainy season, the children will hurry to those places where suitable clay can be found, to make little clay figures. The boys are not excluded from this enterprise, but the girls appear to be better skilled. People, animals, all sorts of furniture such as tables and chairs, but also things like cameras are modelled in clay. The girls' flair for decoration and colour composition, which they are expected to possess, is al-

6 Malamusi 1987, title page.

7
Sholisho. The vehicle features the chassis which is typical for these "wire cars", made of industrial waste. A puppet, whose right hand and legs actually move, is mounted on to the car. As soon as the boy pushes the car with a long wire, shaped into a steering wheel at the top, the vehicle starts moving forward, the puppet comes alive, and a drumming noise is heard. Singano village, Blantyre district, Malawi, 1983.

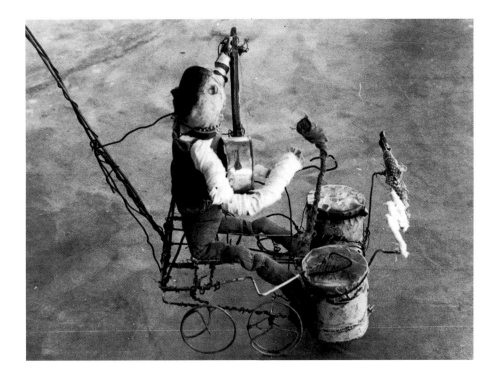

so expressed in other areas such as mural painting, or in the preparation and execution of make-believe children's weddings, complete with dress, veil and all the pomp.

The culture of sub-Saharan Africa emphasises the children's huge creative potential, despite the ephemeral nature of most of the objects: things are made, but just as quickly discarded. In many areas, the children's creativity is allowed to be expressed autonomously and without limitations, because adults are usually not interested and intervene only when they feel disturbed or threatened. For the time being at least, Africa has been spared any form of educational theory on play and any "cutefying" of children, which would lead adults to try to provide a colourful, so-called "child-oriented" environment.

8
Clay sculptures, some of them painted, made by boys and girls of the village in their play areas during the rainy season. Singano village near Chileka, Malawi.

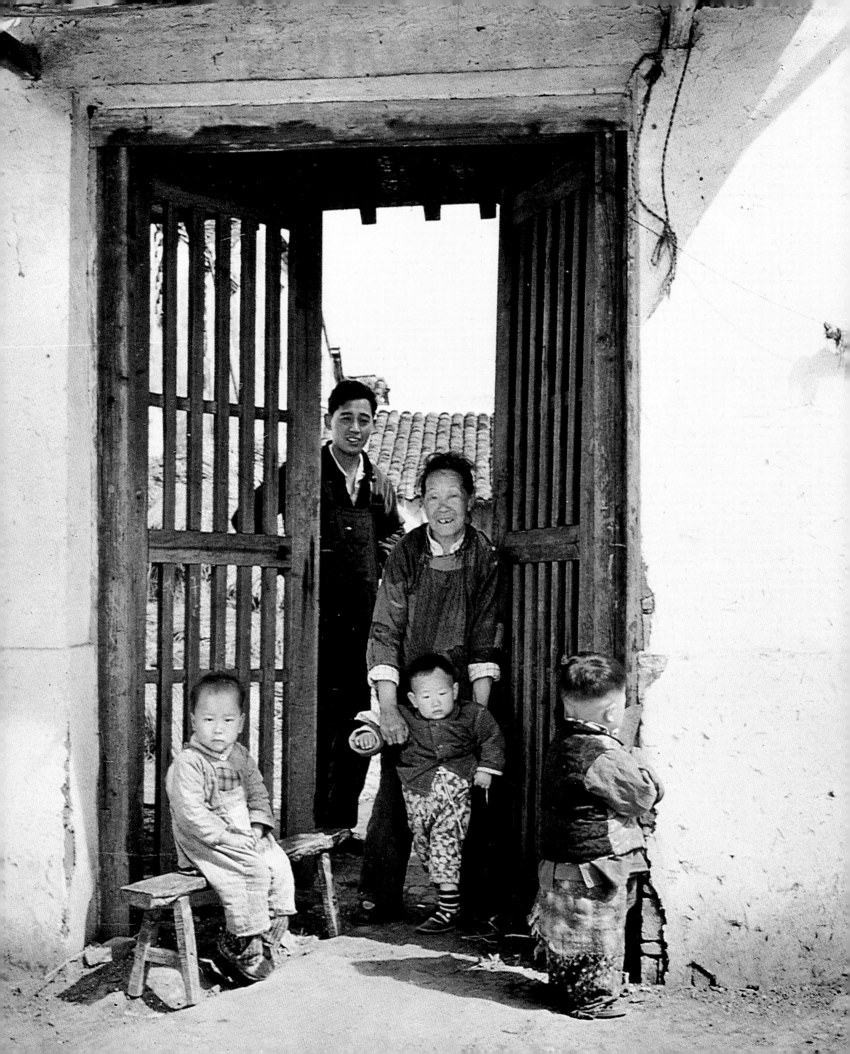

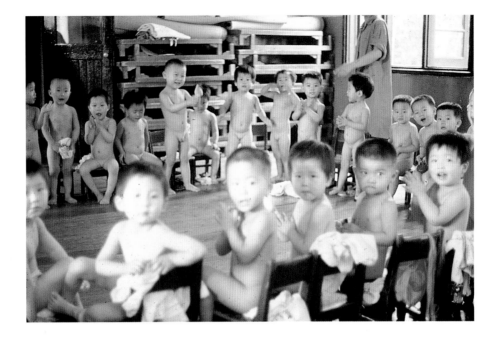

8
Health and hygiene
education play an important
part in collective children's
education.

125

bringing sets no store on independent achievement or the blossoming of an individual, but on the child's integration into society. In this way it lives up to the cultural expectations placed on children in China.

Corrective Upbringing

Since the introduction of the one-child policy in 1979, kindergartens are increasingly seen as places where child-raising errors on the part of the parents can be corrected – only children, it is felt, are likely to become spoilt because of the concentration of their parents' love, and may develop undesirable behaviour. Independence of spirit and selfishness – the two character traits most frequently mentioned in this respect – are to be avoided at all costs, because they endanger the concept of collectiveness.[11] Most parents therefore gladly accept collective upbringing as a corrective measure to what goes on in the family. In return, the state feels obliged to ensure that these precious only children grow up as healthy as possible; health checks are carried out every Monday morning in state kindergartens as a matter of routine.

Collective upbringing does occasionally entail a deep intrusion into the parents' raising of a child, as well as criticism of the parents' role, but this does not appear to bother parents unduly. Unlike Western parents, the Chinese do not, as a rule, expect that the goals of public institutions in raising children will coincide with their own. It seems unavoidable that an only child will turn out spoilt, and so a complementary role is expected of collective organisations. It relieves parents of the sole responsibility for turning their only children – "little emperors!", as they are known colloquially – into good, patriotic members of society, who will become responsible citizens in the party's sense of the words.[12]

11 Böcker and Simson 1989.
12 Tobin, Wu and Davidson 1989.

9
A bicycle with a sidecar for
carrying children.

10
A crossroads in Mangshi, a
small town in the extreme
west of Yunnan province.

11
More than one child can fit
into the typical Chinese
pram.

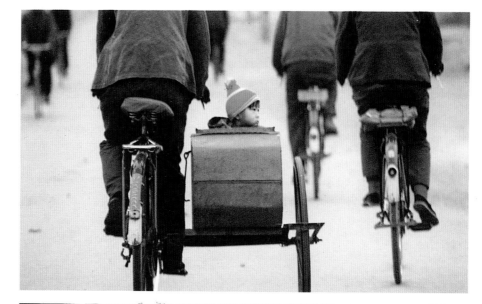

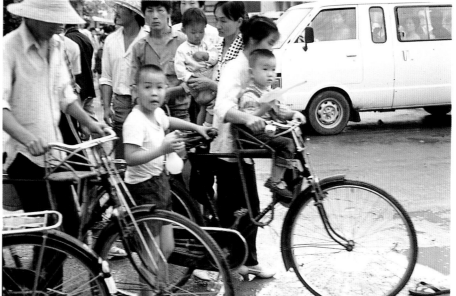

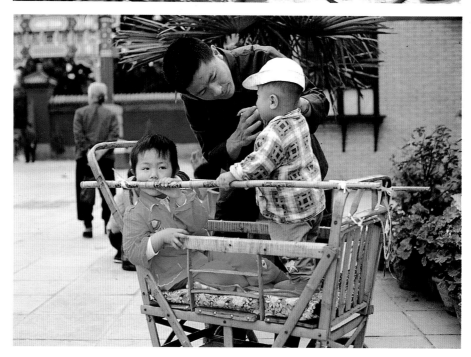

12
This woman of Dai nationality has wrapped her child in a cotton shawl which she has strapped around her shoulders; Mangshi, Yunnan province.

13
In today's China, children spend most of their time in educational and learning groups rather than at home with the family.

13 Chin 1989 gives a figure of 90 per cent of women in the People's Republic of China working away from home. This estimate seems too high, since in 1988 only 37 per cent of white- and blue-collar workers were women (Yearbook 1989). The growing scarcity of work is increasingly forcing women, even in communist China, out of the work market and back to the kitchen.
14 The People's Republic of China regards itself as a multinational state, containing a total of 55 recognised ethnic minorities besides the Han majority.

Prams and Children's Bicycle Seats

In addition to furniture designed for children – almost exclusively found in collective establishments – there is a whole range of ways of transporting children. In modern Chinese society women are expected to work away from home, so ways to transport children are absolutely essential.[13] In particular, bicycle seats of various materials are very common, although it is now forbidden in Beijing to carry children on motorcycles, for safety reasons. Prams are a hallmark of urban living, and now even different Western models are available. A characteristic Chinese version, which allows several children to be carried at once, is seen less and less frequently: made of bamboo, it looks like a playpen on wheels in which children are pushed through the streets, either standing or sitting on stools.

Cloth Slings

One characteristic carrying device of many ethnic minorities in China is the cloth sling on the adult's back. In the southwest province of Yunnan, where about a third of the population belongs to a minority, this way of carrying children is normal even among the Han majority.[14] In the country, where nursery places for infants are often not available, small children spend most of the day on the backs of their mothers or of other adults entrusted with their care, during all activities – cooking, washing, working in the fields, even using the public toilet. Even five- and six-year olds are sometimes carried on the back, if they are tired or if the adults are travelling on foot and are in a hurry.

Conclusion

The absence of furniture specially for children can be understood in the context of the importance of collective upbringing. Children spend most of their time, not at home, but in crèches or kindergartens where parents believe that they will receive exactly what they require for their development. Suitable furniture has to be seen in this context, along with the regimentation of the course of the day, strict discipline and moral instruction. Instead of spending their money on children's furniture, parents can spend it on consumer goods – colour televisions, refrigerators, washing machines and fans – from which the entire family benefits and which are in any case more prestigious items. In addition to such pragmatic considerations, the rarity of children's objects in everyday Chinese life also has cultural foundations. Furniture for children simply does not belong in a culture whose aim is that everyone, child and adult, should fit into set structures, and therefore also into existing households. It is generally feared that children might become spoilt and turn into unconventional and egotistical personalities, and in a country like China this counts as something to be strictly avoided. What was true in Confucian times – that the wellbeing of society always precedes that of the individual – is still valid today in the People's Republic.

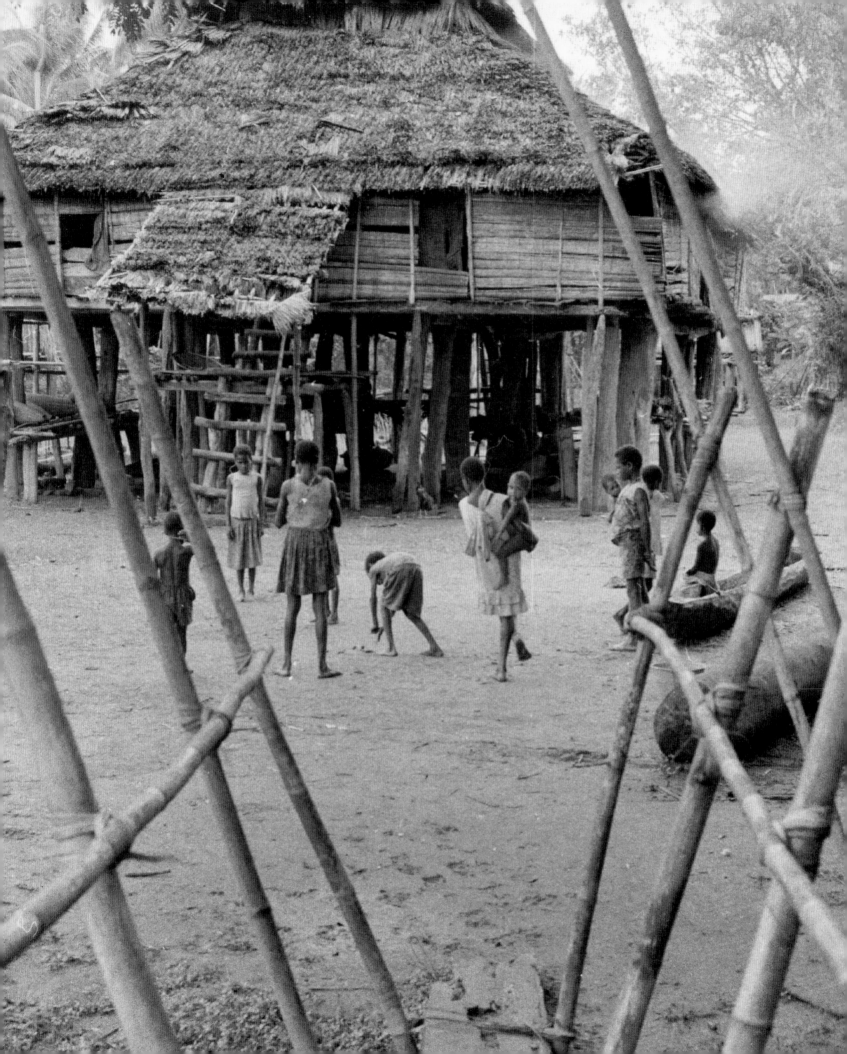

Florence Weiss

People, Not Furniture:
The Iatmul in Papua New Guinea

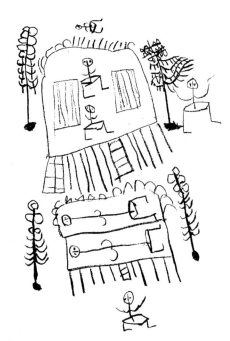

2
Ceremonial village square
with the two "men's
houses". Drawing by
Kasoagwi.

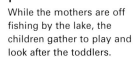

1
While the mothers are off
fishing by the lake, the
children gather to play and
look after the toddlers.

Children and Adults in One Environment

When a child is born, it comes into a world with an already established set-up
– the group of people it encounters already have their cultural objects and their
rules of communal living. The way in which this world is set up varies accord-
ing to time and place. In Europe in the late twentieth century, it is a world de-
fined by technology; in the cities, nature has been reduced to front gardens and
public parks. There are few people to relate to on a personal level, and a vast
number of all kinds of objects. This environment has a profound influence on
the child's life, even though it may initially not conceive of this world as an en-
tity. The lives of adults and children are inextricably linked.

The Iatmul

The Iatmul people of Papua New Guinea live in lake dwellings on the banks of
the river Sepik. Two imposing ceremonial houses stand on a large stretch of
grass in the village centre – grass grows everywhere in the village. Palm trees and
a variety of other plants grow between the houses. There are forests and grassy
swamps, as well as small rivers and lakes nearby. When the water level rises
above the banks during the rainy season, the canoe is the only means of trans-
port. The Iatmul find everything they need in the environment they inhabit –
fish and other aquatic animals for daily food, timber from the trees, and other
plants for the construction of houses and canoes. When the water level recedes,
they cultivate the soil. When they need materials they cannot find in the vicin-
ity, they barter goods with the people of neighbouring villages: stones to make
tools, mollusc shells for ornaments, and the pith of the sago palm tree to make
their flat bread.

This way of life has been broken up by the colonialism of the 1920s and 1930s.
Until then, the Iatmul spent their entire lives in and around the village where
they were born. But for many decades now, a great number of them have mi-
grated to the cities, and industrial products have found a way into their every-
day life.

The Living Environment

Iatmul houses are large and rectangular; they are built on piles, with the floor

3
Interior, with mosquito net
in place.

4
A boy prepares a snack of
sweet potatoes from his
garden. The little food
baskets, one for each
member of the family, can
be seen in the foreground.

level two to three metres above ground. The walls are made of rows of palm leaf ribs, and the span roof is covered with leaf tiles. Wide steps on the short side of the house lead down to the ground. Daylight falls only through the door and a few window openings, so that even during the day the large and high room is partially dark.

The family members cook, eat, engage in craft work, sleep and play in the house. Although the room does not have partition walls, it is divided into sections. Adults and older children each have their own work and sleeping areas. During the day, the children occupy the centre of the room. At night, mosquito nets are put up: the father and older children each have their own net; the mother sleeps with any infant, and the smaller children share nets. When the woman has done the cooking, she places the food in grass-woven baskets which are hung on carved hooks in the centre of the house. Many families use a drum to communicate, and everyone has their own personal drum signal for sending and receiving messages.

Because of the pile construction of the houses, a further room – open on all sides – is created underneath the house. During the dry season this room is used in a variety of ways: there is a wide bench on which one can work or rest, and which is used to store baskets, firewood and tools. In a fireplace on the ground, the children cook their morning snacks. The hooks, the fireplace, small stools and the small drum are the only furniture in a Iatmul house.

Children's Items

The specific features of the Iatmul culture are reflected in the objects they use and live with. Given below are the typical furnishings and utensils used every day by children.

Kasoagwi, a girl aged 10, uses the following objects:
For sleeping: sleeping mat, cushion (formerly a neck support), cotton mosquito net (formerly made of braided mats).
In the kitchen: fire bowl, sago storage jar, hook.
For eating: food basket, enamelled plate (formerly made of coconut shell), metal spoon and knife (formerly made of coconut and mussel shells).
For transport and fishing: net bags and baskets, canoe and paddle, spear, basket, net.
Clothing: blouses, skirts, t-shirts (formerly fibre skirt), fibre skirt (today worn only for special occasions), a hat or a piece of fabric for sun protection (rarely today a braided hood).

Kumbal, a boy the same age, uses the same utensils for sleeping, eating and moving about as Kasoagwi. There is, however, a gender-specific division of work in the Iatmul culture: women and girls fish and cook, men and boys do all the craft work, such as building houses, and making canoes and carvings.

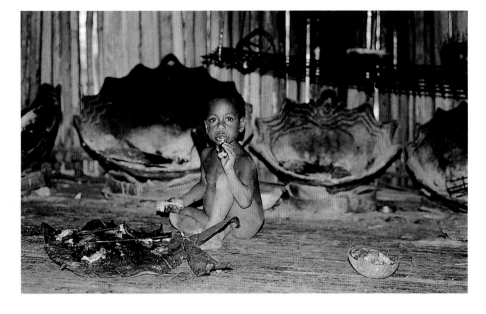

5
There are no communal
mealtimes; everyone eats
when they are hungry. The
cooking bowls can be seen
in the background.

Kumbal therefore uses a variety of tools: a hatchet, hammer and chisel for timber, hunting utensils such as a sling and clay pellets for catching birds, and a spear. One piece of furniture particularly manifests this gender difference: on a normal day, his mother and sisters sit on the floor of the house, but Kumbal and his father sit on small, carved stools.[1]

Compared to the array of objects used by children in the Western world, it is remarkable how many – such as tables, chairs and cupboards, central to our culture – are missing in the Iatmul house. The number of objects appears to be very limited.[2]

Kasoagwi's mother uses the same kind of utensils as her 10-year-old daughter. She requires two or three canoes and paddles, however, as well as several fire bowls and sago storage jars.[3] The same applies, in principle, to Kumbal's father. As the organisation of rituals forms part of a man's duty, he has another category of objects at his disposal: musical instruments, masks and ritual objects. Kumbal will be allowed to use these only after he has been initiated into the community of adult men.

It is not the case everywhere that the material world of adults corresponds so well to that of children as with the Iatmul. But it seems logical that in a society where adults cannot exist without canoes, the children have their own small canoes, too. When, in our culture, rooms occupied by adults are filled with all sorts of objects, we naturally find this wealth of goods in our children's rooms as well. When most offices are equipped with computers, they will soon find their way into our nurseries.

The Dependency of the Child

A child's situation is unique: it is not independent. Emotionally, physically and economically it relies on adults, and requires their loving and protective attention. Children of all societies need to be fed and carried. It takes time for them to learn to speak, to eat without help, to walk and to keep clean. The depen-

1 In mythical symbolism, the stool represents the original female creature; the man can draw strength from it only when it is well disposed towards him. A stool is personal property which is never lent to anyone, like a pipe in our culture. Every object of the Iatmul culture has a symbolic mythological association. For further information see Stanek 1982 and 1983.

2 Stanek divides the entire material culture of the Iatmul into 272 object categories, more than half of which (156) are ritual objects. See Stanek 1984.

3 At 12 years of age, a girl is already capable of performing all the work normally carried out by grown women. Interestingly, boys can perform all "male" work only when they are 18. This difference is due to the great levels of power and strength that are required to perform the men's craft work: for building houses and canoes, large trees have to be felled and transported to the village. See Weiss 1981, pp. 320–38.

Kasoagwi paddles across the lake in her boat to check whether she has a catch with the fishing hooks she put out earlier.

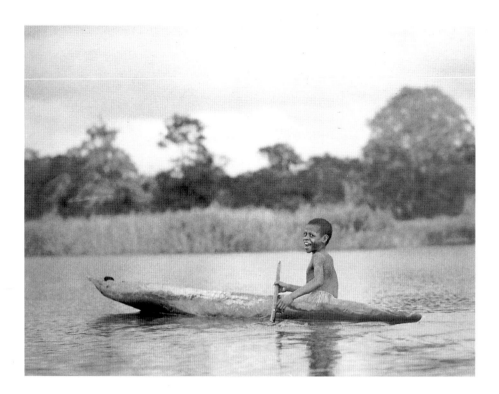

dency of the child, particularly during its early years, gives adults a position of power and responsibility.

Euro–American culture features a variety of objects and furniture specifically for children. Infants are placed in cradles or cots for safety. In time long gone, they used to be immobilised by being wrapped up, tied up or given alcohol to drink. Walking frames, prams and carrying devices are used; on one hand, they serve as safety devices to prevent injury to children but, on the other hand, they prevent them from getting at the interior furnishings of the home. These objects also define the way in which childhood is regarded: children must be under constant observation and must be taught by adults how to do things properly. Without these interventions and controls, the child's development cannot be guaranteed.[4]

People, not Furniture

The desire of the Iatmul children to move about freely and to discover their environment is not inhibited in any way. The newborn infant lies on a cushion and at night sleeps with its mother on a thin mat, protected by the mosquito net. Once it begins to crawl, it can move around freely within the house and outside it. The child in a Iatmul village is never confined or, as in our culture, tended while in a cot; however, the environment in which it lives is rather dangerous. The Iatmul respond to the dependency and need of the child by being always in its presence and intervening when necessary – if it gets too close to the fire, the house steps or the river, for example, or puts something dangerous in its mouth. The children – able to move around to their heart's content – develop a sound understanding of their own bodies and eventually turn into very agile adults.

[4] See Rutschky 1977.

7
A newborn baby with an older brother.

8
A small boy tries out the drums, inspired by the men's drumming during a celebration.

The Influence of the Working Environment

The Iatmul do not favour unnecessary intervention or control. The fact that several adults often attend to an infant simultaneously reflects their structure of work. All the members of the community, including the children, have access to the most important means of production – the rivers, lakes and soil, all of which exist in abundance. With enough for everyone to live on, each person decides how much and what kind of work to do. Long working hours and the recruitment of all available workers are simply not necessary. Women and men work towards their own family's requirements; a Iatmul adult spends an average of six hours a day to complete all the work required, including household duties and necessary journeys. Children work considerably less than adults.

Our working world is geared towards efficiency, and children have no place in it. Caring for children while one is at work is, under the strict laws of performance, considered to be a nuisance. This performance-related rationalisation also affects the home: the wife and mother has to fit meals around her husband's work schedule and her children's school timetable. She has to chauffeur the children to school or to the doctor. We consider it a luxury when the ratio of carer to child is one to one. Every woman staying at home has several duties to fulfil, and caring for children is only one of them.

The socio-economic structure of the Iatmul society allows every mother to interrupt her work schedule at any time in order to tend to a child. If the preparation of food is delayed, everyone will accordingly adjust their routine. Looking at Iatmul society emphasises an aspect of childhood life in the developed world which is rarely analysed: different kinds of children's furniture, utensils and furnishings, as well as the "invention" of the nursery, are there to confine and restrict the child, to get it out of the way and to encourage it to spend time alone. These are culturally accepted means whereby women are enabled to complete their domestic tasks.[5]

Iatmul mothers are also, of course, confronted with the conflicting requirements of childcare and work. Every morning, the mothers fish in the lake. The Iatmul do not like them to take the toddlers with them, fearing that they will not be able to look after them adequately; the older children care for the younger ones instead.[6] Thanks to their work structure, the women are thus able to combine maternal duties with half a day's work outside the house, without their youngest children having to suffer, and without having to worry about them. Furthermore, the women have the chance to enjoy each other's company away from the children.

Equality of Adults and Children

Iatmul ideology considers adults and children, on principle, to be equal. Children are not regarded as more active, more naive, less knowledgeable or happier than adults, to name just a few of the characterisics assumed in our own so-

134

7 Nor have any substantial differences been detected in Iatmul culture between men and women; see Weiss 1995.
8 See the story of the melon thrown out of a window in Weiss 1981, p. 340.

ciety.[7] The difference between adults and children lies in their physical and psychological development and in their experience. As in our society, these differences are recognised, and adults take on the role of mediators and educators, but the idea that children can only turn into adults if they are exposed to an intensive education programme is an alien concept to the Iatmul. Even today, they remain convinced that, within the context of village life, children learn everything they need to know from the community, on their own initiative.

Children participate very early in the work of adults and of older children, initially in a playful manner. They begin with the simplest of tasks until they are able to do the work by themselves. Over a relatively long period, their repertoire of work is gradually expanded, but they are not expected to master a specific task by a given time. The kind of work they do always comprises the same things that the adults do. There are perhaps just two tasks which are typical "jobs" for children: passing things around, and running messages, which are the most important forms of work for the smaller children.

This fundamental equality between children and adults is manifested in various ways. Children, for example, have the right of property: two-year-olds already have their very own spoon and plate for their exclusive personal use. The same applies to the food pouches: no one is allowed to take food from someone else's pouch without permission. Five-year-olds have their own gardens, and it is entirely up to them what they do with the products they have grown. All the everyday objects that Kasoagwi and Kumbal use belong to them. A child's personal property can also include palm trees and fruit trees, as well as the series of names of their clan. Parents expect their children to share things with others, but it is up to them; simply taking something away from them is not permitted.[8] In this way, children learn to defend their rights and to share

10
Girls participate in an adult
celebration in the
ceremonial village square.

their property on their own initiative from an early age. Bringing up children to be independent by emphasising autonomy is characteristic of fishing societies like this one. The Iatmul can allow their children to organise themselves independently only because of their conviction that the children are fundamentally equal.

A Children's Culture, as opposed to a Culture for Children

The existence of autonomous groups among the children is conspicuous within all age groups; even three-to-five-year-olds form a separate unit. These groups are mixed until the children are 14, after which they split into boys' and girls' groups. The children have a variety of activities: they meet in front of a house in the village to play, they organise celebrations and picnics, or they work together. They can be away from home for hours without any adult meddling in their affairs. When the older children are caring for an infant, they take it along to the group. Newborn infants and fractious toddlers are carried on the hips; otherwise, toddlers crawl about on the ground. Infants thus have contact with other children for some hours every day. Forming groups outside the family continues in adulthood: women have women's groups, and men have men's groups.

A sort of autonomous children's culture develops in these groups. The economic premise for this is twofold: the spare time that allows children to gather and pursue their own activities, and their unlimited access to all the means of production. The attitude of the adult Iatmul towards the children's groups is just as important: they are convinced that the children can learn from one another, and by keeping each other busy, they give the adults some relief from their care.[9] An accepted and independent culture emerges – a children's culture, rather than a culture for children which is characteristic of our society.[10]

9 This is particularly important during adolescence, when the relationships between children and adults are full of conflict. The adolescents retreat into their own groups. Information about the everyday routine of such adolescent groups, and the difficulties outsiders encounter in trying to become integrated in them, can be found in Morgenthaler, Weiss and Morgenthaler 1984, pp. 233–44; regarding women, see p. 288.

10 It is not possible to convey here how the Iatmul children actually perceive and experience the conditions of their society. Self-portraits of the children can be found in Weiss 1981 and 1993. Two ethnopsychoanalytical books give an insight into the adults' perception: see Morgenthaler, Weiss and Morgenthaler 1984 and Weiss 1996.

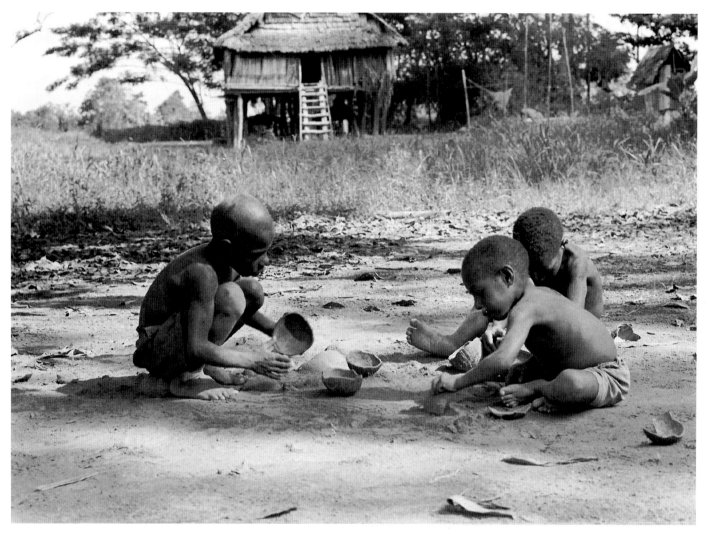

11
Four- to five-year-olds play
in the sand with coconut
shells.

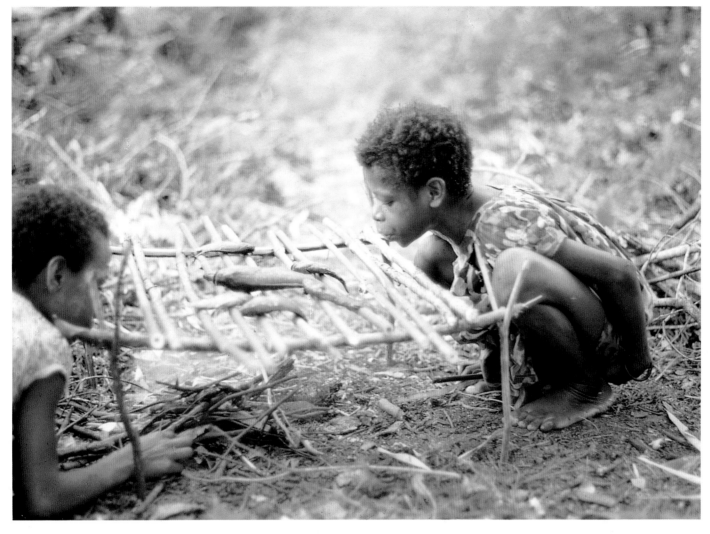

12
Fish is grilled at a picnic in
the forest.

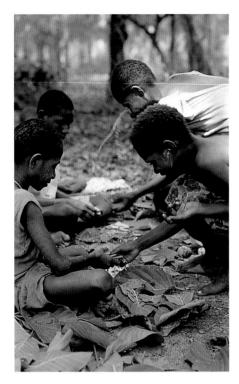

13
The market is entirely in the
hands of women. Girls
imitate their mothers,
bartering fish for the pith of
the sago palm.

Return to Objects

The crucial elements of a Western childhood are toys and utensils, provided for our children in nurseries, kindergartens, schools, parks and school playgrounds. Not a single toy can be found among the objects used by Kasoagwi and Kumbal. Iatmul children, however, do not play less than children of our culture – quite the contrary. But the objects they use at play are made specifically for the occasion. When the girls pretend-play at their mother's trading, different kinds of leaves represent the fish that are traded for sago. When they organise a picnic with fish which they have caught themselves, they make small grills to cook them. And when they organise a fete, the girls make skirts from grass and the boys make masks from twigs and leaves. When the festivities are over, they leave the skirts and masks behind them in the forest.

Conclusion

The example of the Iatmul of Papua New Guinea shows that an analysis of the children's environment concerning space and objects allows a precise insight into the relationship of a society with its children. This relationship is defined by specific solutions that are strongly related to the general conditions of a society. The example of the Iatmul is of particular value to us because they are so different from us: this focuses the way in which we can view the situation of children in our own society.

Today, a development is beginning to take shape in Papua New Guinea similar to one that happened in our society during the eighteenth and nineteenth centuries. Because of changes in socio-economic conditions, education and training are increasingly being taken over by specialist institutions. Many Iatmul parents now wish to send their children to school – a reason often given for migration into the cities, since to keep the children at school regularly would be almost impossible in village conditions. Iatmul children in the cities do indeed have a comparable situation to that of our children. They are increasingly subject to interference, from their parents as well as other adults. As in our culture, they are turned into the objects of educational measures and intervention.

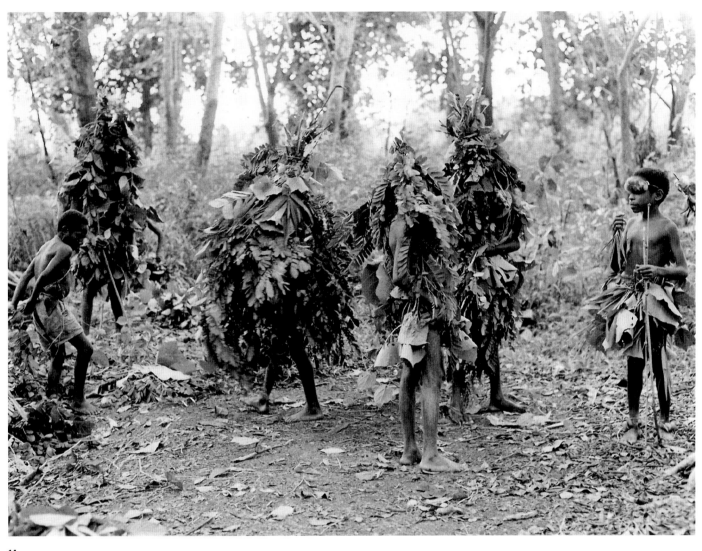

14
Children enact a game with
masks in the forest.

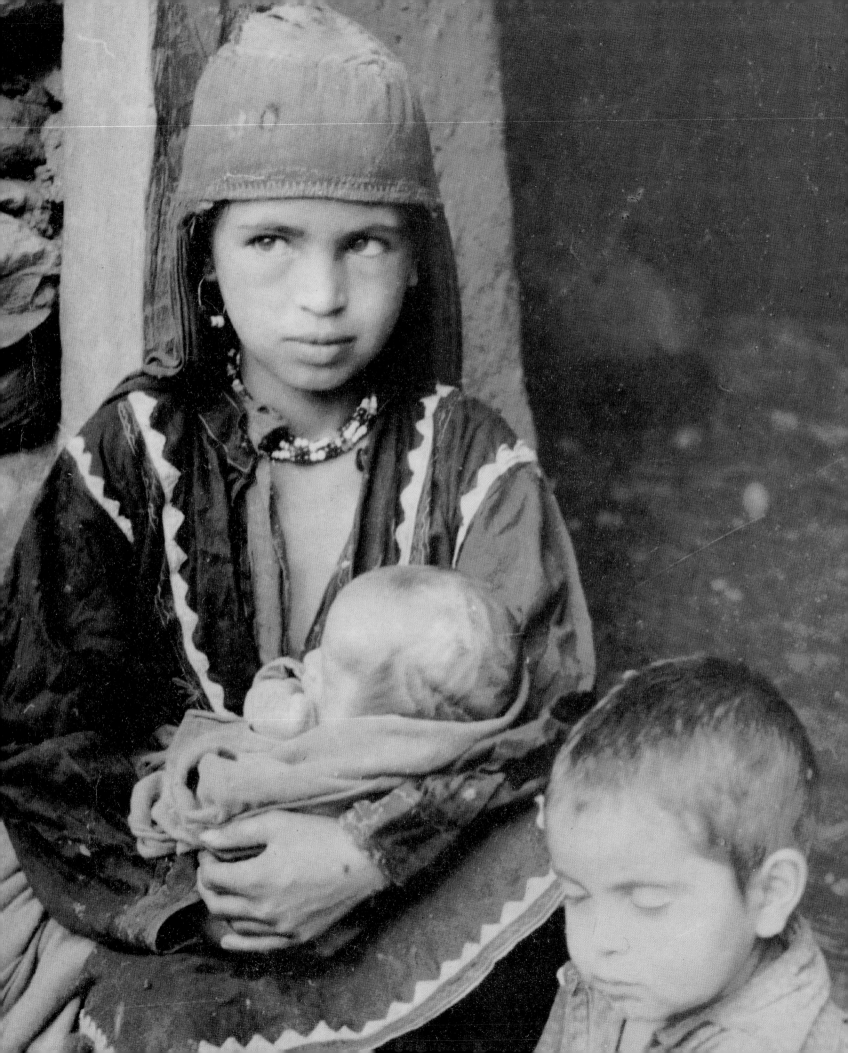

J. S. Bhandari

The Peasant Family System in India

India has always been predominantly an agricultural country, which has greatly influenced its social structure. The rural economy and the agrarian social system have been the chief features of Indian society since time immemorial, and are manifested in the ubiquitous society of the village and the caste system. To a great extent, the continuity of Indian civilisation has been maintained by these institutions, and further characterised by the predominance of the joint family system which constitutes the basic social unit of Indian society.

2
Siliserh village square,
Alwar.

The Joint Family System

Typical of Indian society, this usually connotes a household of two or more married couples, who are related to one another by filial ties – either father and son, or two or more brothers. Ideally, it consists of a man, his wife, his married sons and their wives, his unmarried sons and unmarried daughters, and the sons and daughters of his sons (married daughters do not remain as they leave to join that of their husbands). A joint family is thus usually a three-generational unit. The family is patrilineal in descent pattern, and patrilocal in residence pattern. These patterns are not merely a cultural ideal but, to a great extent, the empirical reality. The joint family structure, shaped by the agrarian economy and the laws of inheritance, is reinforced by ethical, moral and ritual beliefs and practices. Land is the most important asset, and is held for the whole family by the father. His sons have equal rights in the family land, but cannot seek their share during their father's lifetime; daughters have no rights. Even after the death of the father, the sons seldom seek to break up the joint family into individual households, but usually continue to live together for several years. In these cases, the family can be composed of many brothers, their wives, their married sons and daughters-in-law, and their grandchildren, along with unmarried sisters and daughters. Irrespective of its demographic size, the family always remains one single commensal unit – everyone eats together from the same food store. A joint family is thus a residential unit, a commensal unit and a property-owning unit, structured around the core of the agnatically related male kin and their spouses.

Though the ideal and, to a great extent, the actual structure of the family in India is the joint family, this does not mean that the nuclear (or elementary) family – consisting of husband, wife and their unmarried children – is nonexistent, but it is not a regular feature in the life of most individuals. Such households

1
The older sister takes care
of her siblings

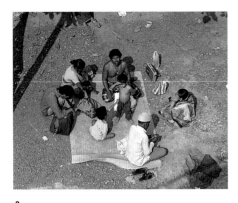

3
Family scene in Calcutta.

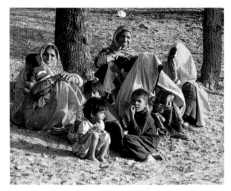

4
Women and children in the community, Rajasthan.

come about when a large joint family breaks up after the death of the father, and his sons decide to divide the land and property and establish their own independent households. But these households themselves then grow into joint families over a period of time, once the sons are married and have children of their own. People are therefore members of joint family households for most of their lives. The composition of the joint family entails a number of diadic relations between its several members on the basis of lineal and collateral kinship. These relatives are in one's own generation (siblings, cousins); in the first ascending generation (parents); in the first descending generation (children); in the second ascending generation (father's parents), and the second descending generation (sons' children). Besides these agnatic kin, a person also interacts with many women affines (wife, son's wife, etc.). The large number of diadic relations that characterise these structures are defined by kinship norms. For the continuity of a large joint family over three generations, much depends on the institutionalised roles that define the reciprocal relationships. Basic values and norms of behaviour are shared by all members – norms which have moral, ethical and ritual value as well as coercive power, and which govern day-to-day interaction.

The social relationships within the family may be identified as hierarchical, based on the criteria of generation, age and gender. People belonging to an older generation are superior, more venerable and powerful than those younger. Within each generation, those older have preference over those younger. Finally, the men are superior to the women: more powerful, and with more access to resources. This hierarchical model is well defined, and is socially reinforced in each new generation.

The relationship between husband and wife is for life, immutable and indissoluble. Mutual fidelity is the highest form of dharma for both man and woman. As husband and wife, they are complementary – the belief of the sages is that only when he marries and begets children does a man become complete; until then, he is merely human.

The Functioning of the Family

The family in the agrarian system is almost a self-sufficient unit; in production and consumption terms, it fulfils most of its members needs, with specialised services provided by service and artisan castes. Its functioning as an effective unit requires harmonious and efficient coordination between the members. This is reflected in the division of labour, based on generation, age and sex. Household domestic chores, including the processing of grain into cereal and cooking, are exclusively the domain of the married women; unmarried daughters help in kitchen work. Non-domestic work is the province of the men, who look after ploughing and preparing the fields, sowing and harvesting. Women also have their share in agricultural chores – such as weeding, harvesting and threshing. These are largely the responsibility of the younger family members, with the elders having a smaller burden.

6
Women at work in the
kitchen.

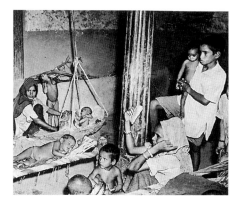

5
Communal sleeping room of
the family.

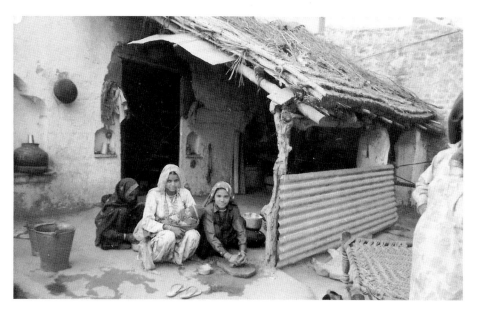

Parents and Children

The relationship between parents and their offspring is that of protector and
protected, with the father the symbol of goodness and kindness. Patrilineal
Hindu society makes the position of the father very powerful, and his words
are honoured more than those of the mother. Scriptures are full of narratives
in which the son is enjoined to respect his father and obey him without ques-
tion, and fathers are held in great awe. The relationship between a man and
the children of his brother is modelled on the same lines. Under the injunc-
tions of the Dharma-Shastras, the mother is equally venerable, although she is
not as powerful.

Siblings and Cousins

Second only in importance to the father–son relationship is that between
brothers. After the death of the father, the eldest son inherits all the father's re-
sponsibility towards his younger siblings. Brother–sister relationships are qual-
itatively different, because a sister is considered only as a part-member of the
family, destined to sever permanently her relationship with her natal family on

7
A child sleeps with its
mother until it is
approximately three years
old.

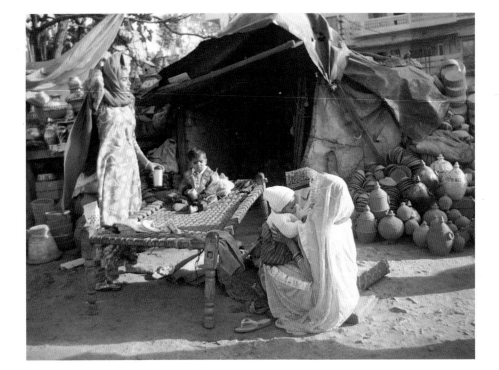

8
Caring for children at the market.

144

9
A wooden cradle (*panala*) for one or two children, decorated with mirror fragments; the older children enjoy using it as a swing.

marriage. Thus the feelings between men and their female kin tend to be based more on affection and sentiment than on long-term responsibilities.

The Child in the Family

The birth of a child is a joyous occasion, especially if it is the first, or a boy. The birth of a son is most desirable, and male children are given clear preference. It is the son who performs funeral and post-funeral rites for the father, which are absolutely essential for the peace of his soul. Besides, a son is a permanent member of the household and will ensure the continuity of the family name as well as look after his parents in old age. This gender distinction is reflected in discrimination against women in all spheres of social life – domestic and non-domestic.

The Child and Domestic Space

The concept of independent space earmarked for a child is totally absent in the Indian home. The child goes through a series of changes in terms of its interaction with other members of the family, but it is not perceived to be an independent personality with a distinct identity until such time as it is able to articulate a perception of its environment. Moreover, social personality is conferred on the child only through appropriate rituals.

All babies sleep with their mothers until they are two or three years old, and have no separate cots. In this way, the mother feels fully protective of the baby and can feed it easily and conveniently. The same bed may be shared by the mother's husband – thus a family consisting of a married couple and their infant child or children occupy not only the same room but also the same bed. When not sleeping, an infant is looked after by its mother, grandmother or older sibling.

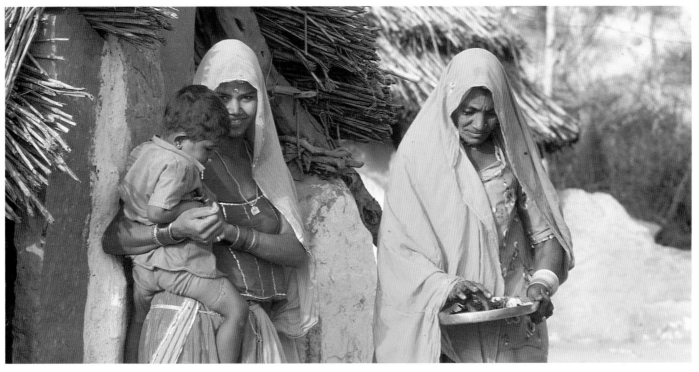

10
Children are mostly carried
on the hips without a shawl.

During the daytime, a baby may be put in a hammock or palana. A hammock
is simply a long piece of cloth, tied at both ends and hung from the ceiling,
with the infant laid within its folds; the feeling is believed to give the baby a
sense of security. A *palana* – a small swing, with a rim on all sides to prevent
the baby from falling out – is less common. When not sleeping, an infant is
carried by its mother or some other woman on her hips; it is customary in some
communities to tie the infant to the mother's hips or back by a sling. The dai-
ly routine includes a bath, usually in a small metal tub. Nappies are made of
used cloth, or may be bought from the market; toilet training is initiated quite
early, with children using the family lavatory from the age of two. Toddlers may
have a walking support, a simple device consisting of a three-wheeled frame
that can be leant on and pushed along.

In this type of traditional large household, a child is never totally alone: there
is always someone very close, many kinsfolk to interact with, and many other
infants and children for company. The child is not, however, treated as a sepa-
rate individual, and its place in the family is not identified with any specific
space or objects. The constant companionship of the mother or other relatives
makes toys – which are essentially substitute objects – unnecessary. Furniture is
not generally used, so children have none either. But all this is changing. New
structures in households, their smaller size, and different roles for housewives
have greatly affected the interactional pattern of the child in the family, and are
bringing about a new lifestyle in which the child is making its presence felt as
an individual with its own identity.

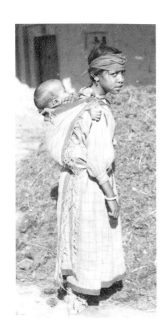

11
A young girl carries her little
sibling in a shawl.

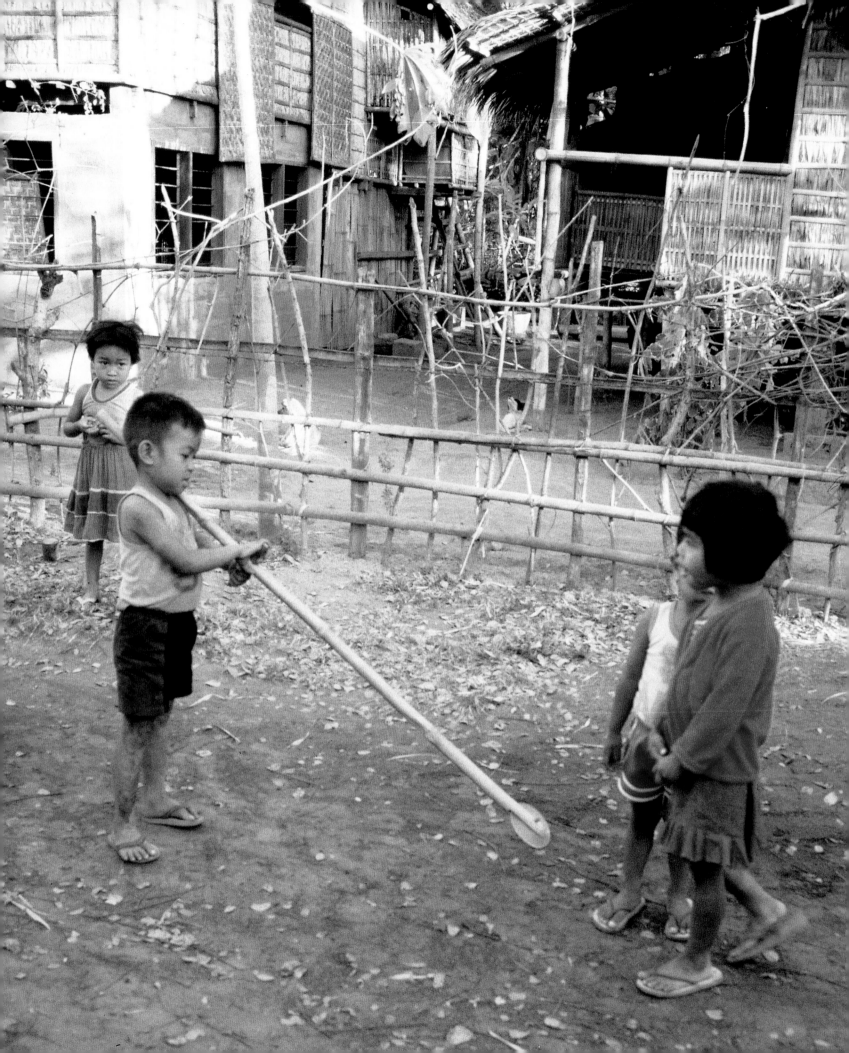

Barbara Fehlbaum

Children in a Filipino Barangay

Western products for children, such as furniture and toys, are quite common in Filipino cities today. In remote areas, however, there are many villages (called barangays) where a supply of consumer goods along western lines has not yet been established; it is the socio-cultural environment of children in these villages that is outlined here.

Ecological Context

The village of Asin is located on the island of Luzon, in a remote region of Pangasinan.[1] The name, meaning salt, refers to a specific problem facing the village: the springs in the vicinity increasingly produce salt water, so that only one source of drinking water now remains for the sixty houses of the village.[2] The Asin people predominantly cultivate peanuts and wet rice for sustenance, setting aside a small amount of the harvest for trade. Trading goods is the principal economic activity.

The architecture of the village buildings is simple and fairly uniform. The houses, mostly made of bamboo and nipa palm, are raised one to two metres off the ground on bamboo posts, giving them a very fragile appearance. They are divided into two or three rooms. A large room serves as the communal sleeping quarters for the entire family.[3] There is no furniture in this room except for sleeping mats, which are rolled up during the day and placed in a corner. The living room (sala), often built as a long bay, has walls made of braided bamboo with large openings, so that the occupants can see what is going on outside. The room is furnished with long bamboo benches.

The third part of the house is the kitchen, equipped with a clay pot for the fireplace, a clay vase for water and a few cooking utensils stored in bamboo cupboards. The adults in Asin usually possess only a sleeping mat and cooking utensils.

The children's equipment is equally spartan. For toddlers, the Asin make cradles from braided bamboo. Bamboo constructions acting as barriers are placed in front of any potentially dangerous steps. There are no objects used exclusively by children, and no children's furniture as such. The children do not possess a personal sleeping mat; they share a large, adult sleeping mat with their siblings.

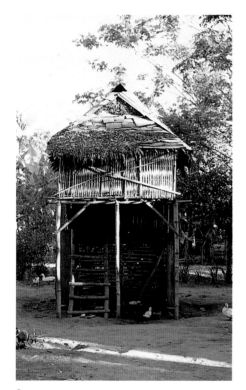

2
A raised house made of bamboo and nippa palm.

1
Girls and boys play a game of skill.

1 Certes 1974.
2 Fehlbaum 1982.
3 For girls who have started to menstruate and for newly-weds, a small part of the room is partitioned off with fabric or bamboo walls.

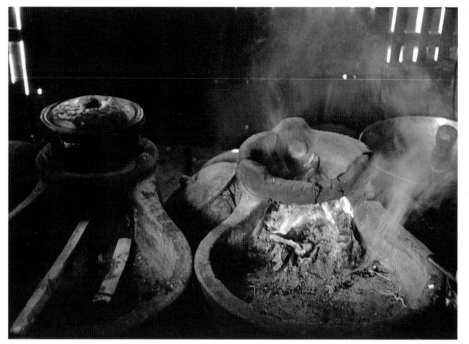

3

An open fireplace in the kitchen.

4

A kitchen with a clay water container.

4 Despite the Asin's official Catholicism, many villagers believe strongly in ghosts, demons and gnomes, and their belief is deeply rooted. See Bucher 1985 for a description of the conflict that this creates.
5 Jahoda 1975.
6 Berry 1992.
7 Fehlbaum 1987.
8 Veerland 1976, p. 107. The extended family comprises the nuclear family as well as all grandparents, great-grandparents, several aunts and uncles and their families. A fourth cousin or a great-great-grandfather can also still be described as a close relative.
9 According to the principle of seniority, the older generation has certain powers over the younger generation, for example in the choice of spouse or profession.
10 An older brother will be addressed with Goja plus his first name, an older sister with Ate plus her first name. See Himes 1974.
11 Owen 1971.

Social Context

On one hand, family structures in Asin have been shaped by 300 years of Spanish rule, by Catholic missionaries and by subsequent American rule.[4] On the other hand, many cultural and ritual practices (for example, the banning of evil spirits,[5] or medical care provided by healers[6]) remain very much alive, indicating that the internal contexts of the primary society have been partially preserved.[7]

Filipinos live in extended families: "The paramount importance of the nuclear and the bilaterally extended family as the principal focus of social, economic, religious and, to a large extent, political activity, makes kinship relations the most significant and influential set of relations in the life of a Filipino".[8] The family is described as a place of tranquillity or refuge. The young have enormous respect for the older generation, indicating a vertical social integration pattern. Observations in Asin show that the principle of seniority[9] is expressed only in language forms.[10] The current parental generation claims unanimously not to be exerting any pressure on their offspring.

A preferred form of family extension is the cumpadre system, in which a godmother and godfather are selected for each child, preferably from a wealthy family residing outside Asin.[11] This godparenthood lasts a lifetime, and the godchild is not the only beneficiary: the entire family benefits from the prestige associated with the wealthy family, as well as from their support during times of need. Adults asked to be godparents cannot refuse; it may not appear particularly desirable in the beginning, but later on it can prove advantageous. If godparents face difficulties, they can naturally count on their godchildren's help without being in any way indebted. The system also guarantees that no one in the village need ever live alone. Children may, for example, live with an elder-

5
A cradle made of braided
bamboo, suspended above
the mother's sleeping mat
by four straps.

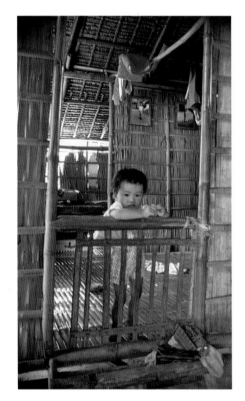

6
A protective barrier made of
bamboo is placed in front of
steep steps.

12 An Asin family has, on aver-
age, six children.
13 Whiting 1961.
14 Minturn and Lambert 1964.

ly, single relative for several years, helping with daily chores and making sure he
or she is not lonely.

A household usually comprises a family of grandparents, parents, children and
two or three relatives.[12] The patrilineal system is particularly manifest in the fact
that a woman always moves in with her husband's family, but she does return
to her parents for one or two months when a baby is due. During this time, her
husband's relatives take care of her other small children. A mother's life always
revolves around her youngest child; she takes it everywhere, usually on her hips.
This close, mobile contact makes the child feel safe and cared for, as well as pro-
tecting it from insects and dangers that it could encounter at ground level. If a
mother needs both hands to work, she gives the infant to an older child, who
will continue to rock it gently on his or her hips.

Babies are breast-fed at any time, day or night, and at the slightest sign of dis-
comfort. Crying babies are attended to immediately: they are breast-fed, rocked
gently, massaged, or diverted in some way. If these measures prove ineffective,
it is immediately assumed that the child is ill. One hardly ever hears a child cry-
ing or screaming, such is the intensity of the care and attention given to the
children. A toddler sleeps in a cradle suspended above his mother's sleeping
mat, or with its mother on her mat. Babies do not wear nappies; any soiled
clothes, mother's or child's, are simply changed straightaway without a fuss.
The last child usually remains very close to its mother for several years. It is
breast-fed for longer than the others, and even when older prefers to stay near
its mother rather than play with other children.

Children growing up in extended families enjoy particularly close attention be-
cause more people are available to provide care than in a nuclear family; the ex-
tent of care each child receives is proportional to the number of adults.[13] Al-
though observations show that mothers spend less time with their children if
other women and children are on hand to care for them,[14] the degree of care
the child effectively receives none the less remains very high, particularly for
children older than two.

Once a mother becomes pregnant again, she immediately stops breast-feeding
the youngest child. He or she is then no longer the centre of attention, and

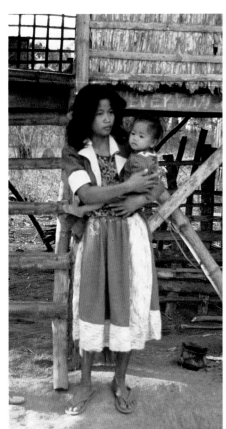

7
Toddlers are carried
sideways on their mothers'
hips wherever they go.

must find a new caring environment in one of the relatively autonomous children's groups. Group members are aged from two to twelve, and come predominantly from families in the vicinity. Being a member of such a group in fact constitutes the enculturation process: a new member is introduced to Asin customs and behaviour by the other children in its group.[15] Children spend most of the day in their groups, where they play and help each other out at work in the house and the fields; parents do not interfere. The children are acquainted in a playful manner with the sort of behaviour that enables life to proceed without significant tensions. Should problems arise within a children's group, a youth capitano, who is directly in charge of six group members (the brigade),[16] is responsible for mediation and problem-solving. This youth brigade corresponds to the adult system of councilmen.[17]

The more or less peaceful cooperation of children within their groups makes a strong contrast with the behaviour of adolescents and adults, who argue frequently and fiercely, often about trivial things. One reason for this may be tensions that result from a non-linear process of socialisation. The vertical structure of socialisation during infancy[18] changes abruptly into a horizontal structure during early childhood, only to revert again to a vertical structure at the onset of puberty.[19] Up until then, no gender-specific socialisation patterns are discernible: girls and boys play and work together equally. Once they reach puberty, they are separated. Girls get their own, separate sleeping quarters and may no longer play with boys; they are kept increasingly busy with domestic duties, and they may not go for walks unaccompanied. Boys are given free rein and form societies of their own. But once a couple is married, gender-specific separation ends again: men are just as involved in household duties as women are in field work.

A Day in the Life of an Asin Child

Asin children usually set their own daily agenda. Once they are big and strong enough, however, they will be integrated into the work of the village for several hours a day. Work normally begins in the early morning (between 4 and 5 a.m.), when the caribou are led to the fields to graze. A caribou is an Asin family's most important possession; it will be guarded by children at all times, except when it remains in the stable. Once their herding duties are over, the children return to the village to help feed the domestic animals, do garden work, clean and tidy up. The time-consuming chore of getting water from the water source is mostly done by children, who use the time spent waiting by the source to play boisterous games.

As soon as it begins to get hot, at around 9 a.m., demanding or hard work is suspended until the evening. The children use this time to play games or to roam the area around the village. During a quiet moment, fathers will often make objects for the children, particularly miniature versions of things in the adult world, such as little chairs, bamboo benches, miniature fireplaces and

15 Poortinga 1992.
16 Orendain 1978.
17 The system of councilmen shapes the political structure of the barangay.
18 Vertical structures are those that are hierarchical (for example, parent–child) as opposed to horizontal (for example, child–child).
19 Sinha 1996 points out that such phenomena can only be explained with a psychology that is inherent to a culture.

A nine-year-old boy brings
in the harvest, riding on a
caribou (water buffalo).

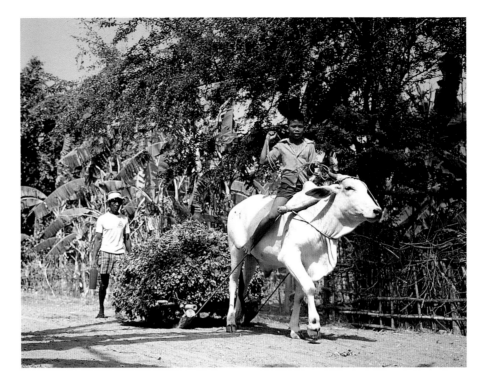

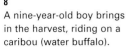

caribou sledges.[20] The children may play with these objects from time to time, but since they are expected to perform responsible work within the village's daily routine from an early age, the desire to re-enact the adult world in their play is not strong. Games of skill, hopscotch and tag, together with making short-lived objects from palm tree leaves and carving, are very popular with Asin children. They often spend hours in the shade beneath the houses making things, chatting and teasing each other. Towards evening, less physically demanding work is completed around the house or in the field. After an early communal evening meal, the children gather once more to play until dusk, when the village finally falls quiet.[21]

Formal Education

There are no schools in the smaller villages, but children can attend primary school in the nearest larger village. Most children do not complete the obligatory six years of school. Often they are kept from attending because they are needed in the field, or because the family's finances cannot cover the cost of required school material; if they simply do not wish to go, they are not forced against their will.

The choice of subjects at school is geared towards the rural population. Simple and practical classrooms are furnished with benches and tables. The school garden is considered very important.[22] Most parents will invest all available funds in the education of just one child, often asking relatives or godparents for support. There is therefore immense pressure on the "chosen" child to perform well: he or she will be expected to maintain the entire family after finishing at school, and will be the focus for all hopes of a future life free from care.

20 The harvest is brought in on large, heavy sledges; wheels are too expensive and would get stuck in the muddy soil during the rainy season.
21 Oil and kerosene for lamps are relatively expensive and are therefore used sparingly.
22 In these gardens, the children are introduced to cultivation and vegetable growing.

Conclusion

The environment of the Asin village offers a plethora of stimuli and natural re-
sources, and the Asins' craft skills are quite sufficient for them to be able to
manufacture a multitude of adult and children's furniture. Despite these con-
ditions, however, children's furniture as such plays no part in village life. Since
they are always fully part of village life – the smaller ones being carried every-
where, the older ones gathering in groups outside the house – children have no
need for furniture of their own.

The family and nursery are not only segmented divisions of culture, but they
are the social environment where all basic experiences which will shape that
culture in the future are made. The culture of this remote village will soon be
undergoing rapid change. When the area is connected to the national power
grid, the water supply and the road network, its traditional social structures will
be replaced by the western-style consumerism which has already found its way
into all the larger Philippine villages and towns.

Eileen Adams

School Grounds

1
Outdoor acoustic
laboratory, Knightdale
Elementary school, North
Carolina, USA

"The vision of the new school landscape is a challenging one. It rejects our pre-conceptions of what the school environment is for and what it should look like. It requires us to project into the future and to consider the nature of schooling in the next century and consider what functions the school environment might serve. It requires parents to imagine the kind of place they would want their children to spend at least eleven years of their lives, teachers to value experiential and investigatory learning and to consider how the grounds might constitute a resource for learning and designers to understand more about the processes of learning and teaching."[1]

 155

Compared with other environments, outdoor school grounds have changed comparatively little in the last hundred years. There have been major changes in the nature of learning activities within schools, the way the classroom is organised and the design of school buildings. Yet the environment surrounding these has changed little. Teachers generally put a good deal of care and thought into how they set up their classrooms in a way that will stimulate and support learning. But this is not necessarily followed through in the outdoor learning environment of the school grounds. Through neglect, the area around school buildings is sometimes impoverished and degraded, offering little stimulus for learning. How might environmental quality be improved? How might learning opportunities be extended? The functions of schooling will probably change in the next century. With widespread use of computers creating greater access to information and expertise, we need to question the use and design of the outdoor school environment and consider how it might adapt to the demands of a new age. What kinds of experiences should be provided in the "outdoor classroom"? What experiences and activities are appropriate to help children develop as effective learners? What are the design implications? How might young people participate in the process of design and development?

In the UK, school grounds have been characterised by open expanses of playing fields or featureless tarmac which have provided space for team games; their use, however, has been limited to physical education. The school playground has provided space for play, but has also functioned as a drill yard, where children were expected to learn the control necessary for a disciplined workforce through lining up, marching and obeying orders. This kind of exercise was based on a military

1 Adams 1990.

Pupils at play during break,
Gillespie Primary School,
London

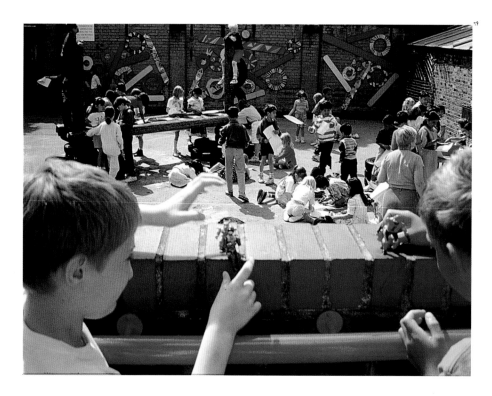

156

model and seen merely as a way of releasing physical tension built up after hours
sitting at a school desk.

Recent research in the UK has stimulated a different approach, where the out-
door school environment is seen as a valuable resource for learning across the cur-
riculum. The Learning through Landscapes project (1990) promoted develop-
ments in the UK and similar initiatives in other countries to acknowledge the im-
portance and exploit the possibilities of the physical outdoor environment as an
educational resource. Two key influences are evident: a growing concern for na-
ture conservation, and the rediscovery of the social and educational value of play.
The educational value of the school environment is dependent on the range of
stimulus it offers, and the capacity of its users to see its potential for learning. The
concern is for the child's physical, social and intellectual development. School
grounds present wonderful opportunities for experiential and investigative learn-
ing. This can be done by creating an atmosphere to support enquiry, and by mak-
ing provision for experiment and exploration. The outdoor classroom can be a
laboratory for studies of pond life and plant habitats, or for experiments in plant
growth. Or it can serve as a studio, workshop or gallery for art work, where pupils
can make large-scale, dirty or even dangerous work and display the results, per-
haps created from found objects or plant material. Or it can offer opportunities
for physical education through the use of a trim-trail, which emphasises exercise,
fitness and health. Or it can provide an outdoor theatre-in-the-round for dra-
matic performances. It can allow archaeological digs, quadrat surveys, geological
investigations and many more kinds of study which require exploration, obser-
vation and measurement.

The arguments for rich and extensive experience as a basis for learning are already
proven. The challenge for the teacher is how to extend children's experience and,

3
Pupils discussing plans for developing the school site, the Park Primary School, Bristol

4
Landscape designed and built by pupils, Blaydon Comprehensive school, Blaydon

through reflection, help them make sense of it. In infant schools, teddy bears have been put through adventures climbing trees or crossing streams with the aid of ropes and pulleys as a focus for science lessons. In primary schools, pupils have helped to design play structures to extend opportunities for play and social education. In secondary schools, pupils have created tree nurseries and experimented with crop growing, as an aspect of the science curriculum or as a means of developing economic awareness.

Colin Ward's The Child in the City and Robin Moore's Childhood's Domain describe eloquently how the environment acts as a setting and a source for informal learning experience. In an age dominated by the car, the television, the computer and adult fears that children may be harmed or abducted, children in western societies are being increasingly denied access to the outdoors. Tightly structured schedules leave many children with little time to themselves; breaks in school are becoming shorter as homework times lengthen. Children are missing social and environmental experiences that used to be taken for granted as a necessary part of childhood. School grounds offer a protected environment, and can provide endless opportunities for learning through an informal curriculum, where children themselves generate their own learning activities through play.

Children use the environment and each other as a focus for learning activities. Through play, children learn what it is to be a member of a group and to engage in social discourse. Through the development of social relations, they learn what it is to be part of a particular community and society. How far does the children's experience of the school environment contribute to this as a positive experience? Play covers a spectrum of activities, including physical play, social play (which can include role play and imaginative and dramatic play) and cognitive play.

Usually, only limited kinds of physical play are encouraged in school grounds.

158

There are age and gender differences in children's choice of play activities. In British schools, the tendency has been for boys to dominate the playground with football, confining girls to the margins where, given the opportunity, they generate a wide range of play activities. Because of the need for supervision, large spaces have not been divided to create a variety of settings for these different kinds of play activities. In schools which have introduced changes to improve play, improvements in behaviour have been noted, with children being able to take some responsibility for shaping and controlling their own environment. Improved play value does not necessarily depend on an increased amount of equipment: it depends on the range of stimulus available, and the children's ability to respond to it imaginatively.

Messages and meanings are embodied in the school environment – they could be called the hidden curriculum. What do children learn about what it is to be a child, to be part of a community, to be inducted into society? What do they learn about power and control, ownership and responsibility? School is most likely the first public building with which children are familiar, with which they identify and towards which they feel a sense of belonging. How does the school environment shape their attitudes and behaviours towards other people and places? How are children able to learn what are their rights and responsibilities as citizens? Children have valued places that have a particular ambience which signifies that they are valued, that the environment belongs to them.

The design of school grounds must take account of the experiences and activities that need to be accommodated in a learning environment. Each school is unique and every site presents different opportunities and constraints; however, certain elements should be addressed on each site. Hard landscape needs to address a range of spaces for a variety of educational uses, access and circulation; the choice

6
Design for playground
markings by pupils, Gillespie
Primary School, London

7
Outdoor classroom, St
Mary's school, Nairobi,
Kenya

of surfaces and site furniture should reflect this. The soft landscape design needs to take climate into account and, increasingly, ecological issues such as energy use and nature conservation. The trend in the UK is to create a more interesting relationship between built and natural forms. Planting is used more imaginatively, to protect sports pitches and buildings from wind and rain, or to create conservation areas as habitats for plants and animals as well as to provide a learning resource for children. Ponds have been introduced to create opportunities for scientific investigation and experiment. Every design decision will have implications for safety, management and the labour costs of maintenance. In the past, a preference for low maintenance has resulted in sterile environments of poor quality. Environments that appear well cared for and that show varied signs of habitation are less likely to be subjected to vandalism and damage.

School environments reflect cultural values; they provide an indication of how societies regard children. Many countries are changing school grounds to create better opportunities for learning. In the Netherlands, nature conservation is an important focus – schools are keen to create habitats for wildlife, organise composting and engage in food production. Similar initiatives have taken place in Sweden, where Skolans Uterum is a national project to develop school grounds. The introduction of children's gardens and the growing of food revitalises a tradition in Scandinavian countries that had disappeared from school grounds. The introduction of equipment for more adventurous play reworks lessons learned from the adventure playground developed in Denmark in the 1940s. The move to absorb after-school facilities, or fritiedshems, on school sites may be for economic reasons, but a spin-off can be the improvement of the school environment. In Japan, children traditionally make use of small plots at the edge of the playground to grow sunflowers. This is now being extended to accommodate a wider range of planting in a move to develop greater ecological awareness. In some schools in Australia, native planting is being reintroduced to create the diversity, subtlety and complexity of forms, textures, sounds and smells found in the natural bushland. In the USA, a meeting place, sometimes with a raised stage or performance space, reflects the importance placed on social interaction and communication.

The process of change and development offers an excellent focus for design education. If they themselves can participate in the design process, children can understand more fully what is involved in change and can develop positive, creative and responsible attitudes to dealing with it. They learn that shaping and controlling the environment is a result of negotiation and compromise, that it requires collaboration and involves the resolution of conflict. Through the experience of design, they can be involved in the process of conceptualising change and visualising the possible impact of their proposals. "Design is essentially speculative and propositional. It is about the future. All its methods and procedures are directed towards deciding how places, products and images might be. In this respect, it is highly unusual in a curriculum dealing primarily with the past and what we al-

8
Entrance to school grounds,
Bredbyskolan, Rinkeby,
Stockholm, Weden

9
Testing a self-built raft in the
school swimming pool for
Water Day, Yokohama,
Japan

10
Outdoor classroom at
Halloween, Knightdale
Elementary school, North
Carolina, USA

11
Meeting place, Georgia
O'Keefe High school, New
Mexico, USA

ready know. Design is not only knowing about the future, it is about imagining it, shaping it and bringing it about."[2]

In this way, pupils can be helped to develop skills of observation, analysis and criticism. They can develop design capability, where they are able to visualise possibilities for change, to conceptualise proposals for change, test these out and negotiate solutions to the problems they have set themselves. Sometimes, they can realise their ideas and monitor and evaluate the results of their efforts. The hope is that through such experience, they will be encouraged and enabled to take on active and positive roles as citizens in the wider community. The design process involves them in a sequence of studies:

• explorations to increase awareness and develop a sense of place;
• investigations to understand uses of space and perceptions of place;
• identification of the need or opportunity for change;
• generating ideas for change;
• consultation to test out ideas and seek the views of others;
• development and refinement of ideas;
• realisation;
• celebration;
• monitoring and evaluation.

Current developments in the design of school grounds highlight issues concerning the nature of schools and schooling, the importance of developing an understanding of ecology and an appreciation of the significance of social experience. The design of the outdoor school environment aims to create a range of learning opportunities, where children can be encouraged to become curious about the world around them as active learners, able to take responsibility for their own learning.

2 Baynes 1982.

Vedran Mimica und Kelly Shannon

Utopia as Tradition

1
Sunken sitting area in front
of the nursery classrooms in
the Willemspark School.

There exists an enormous challenge in designing the fantastic world of childhood: that of enriching the sense of wonder and imagination as the innocence of childhood evolves to understanding. The built environment poses a series of complex relations, scales and forms, many of which are daunting from the perspective of a child. None the less, the spatial encounters of early childhood frame visual, cultural and societal development. Therefore, the material world of childhood demands the utmost attention by architects and designers. The fundamental power of architecture in the creation of culture, through materialisation of universal values, should be manifested in the design of the built environment for children. Architecture of a children's world needs to ground a sense of identity.

A school signifies a place of formal mediation between the world of adults and the world of children. The school building as a "type" has been transformed by various cultures and individual architects throughout history. The meaning of a school – within society as an institution and within a city as an object – is expressed not only through the formal characteristics of the buildings but also through the social and pedagogical structures of education. Historically, schools have encoded the values of culture through design, construction and use. Two elementary schools will be discussed here, providing an awareness of different strategies that have been employed in achieving architectural value, symbolic meaning and environmental nurturing. A more direct relation to the design environment will also be addressed, since the furniture of these schools was also designed by their respective architects. The immediate sensorial and psychological encounters with the material world are embodied in the design of desks, chairs, tables and play apparatus.

Giuseppe Terragni's Asilo Sant'Elia nursery school in Como, Italy (1934–37) and Herman Hertzberger's Apollo Schools (the Montessori school and the Willemspark school) in Amsterdam, The Netherlands (1980–83) represent two canonical "material worlds" for children. These schools express paradigmatic breaks within the revolutionary changes of the twentieth century in the development of the "school type", and establish a clear relation between the inseparable notions of tradition and innovation.

Terragni, working within the tenets of Italian Rationalism, re-interpreted the

2
Terragni's final plan of the
Asilo Sant'Elia nursery
school, Como.

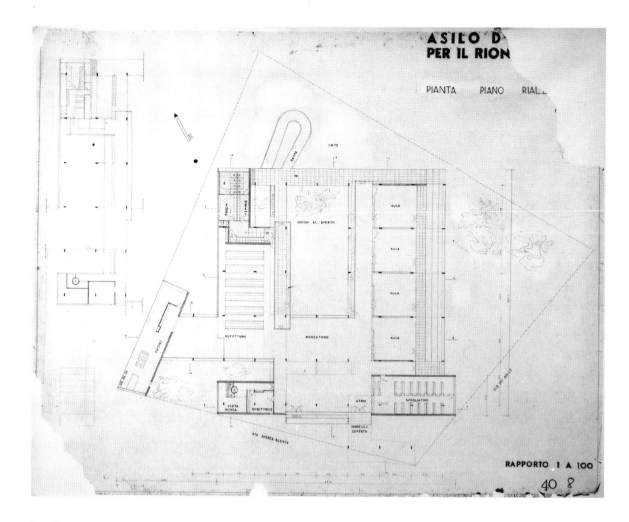

164

3
Front (Via Andrea Alciato)
and side (Via dei Mille)
elevations and east-west
section through the Asilo
Sant'Elia.

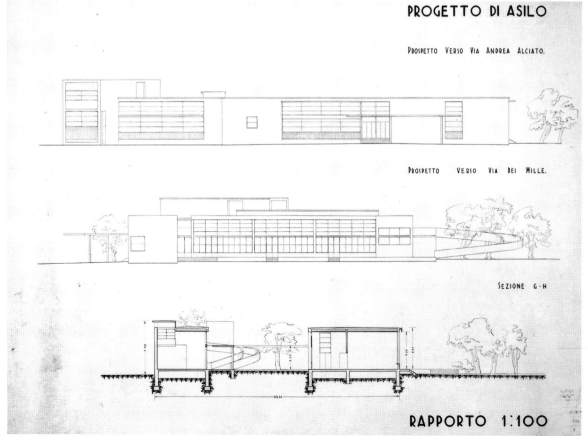

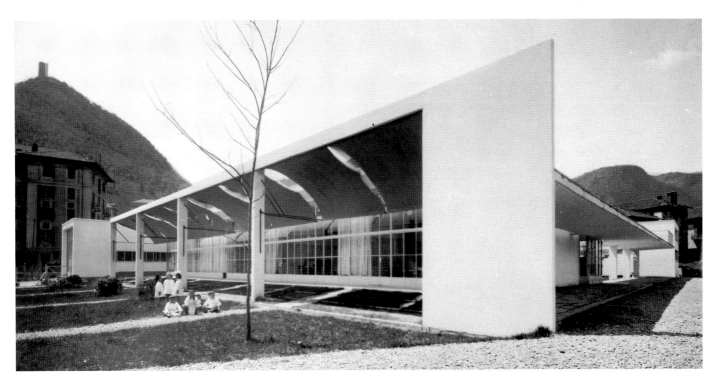

4
View from the east: children in front of exterior classrooms, marked by concrete frame protrusion with canvas awnings.

cortile (monastery cloister) as a "glass house for learning".[1] His Asilo Sant'Elia represents the continuum of Classical principles transformed within the syntax of the Modern. Half a century later, French linguistic Structuralism strongly influenced Hertzberger. His introspective, Apollo schools exploit the compactness of a historic type, the "urban villa" and infuse a spatial richness created by the "split level".

Asilo Sant'Elia School by Giuseppe Terragni

"Now Terragni reaches his poetic stage – the Sant'Elia School is his masterpiece. It erases all dogmatism, forgets the exhausted quarrel with the Regime and comes from a human understanding, full of well-educated and popular inventiveness. It is the kind of architecture which . . . [is] controlled by contents and functions, simple and bright, moulded by lived-in spaces more than volumes, holding a kind of dialogue between the inside and the outside because it has some panoramic connections. The school is not easy to analyse by European criteria; its inspiration comes from everyday experience."[2]

"The fifth and most humane of his significant buildings in Como, is an infant school, the Asilo Sant'Elia, the most fairy-godfatherly compliment ever paid to the young by a modern architect. Here, Terragni's passion for open frames and courtyard plans produces a delicate environment of airy, lightly-shaded spaces and framed views of greenery beyond, unaffected (though not without its formalism) and still, to my mind, the best school built in Italy in this century."[3]

Giuseppe Terragni (1904–43) was an enigma, an architect who realised only 26 works in his brief career spanning 15 years. His revolutionary designs, in nearly every category of building type, have only recently been revisited in respect of their importance in the history of twentieth-century modern architecture.

1 Schumacher 1991.
2 Zevi 1968.
3 Banham 1975.

East wing of classrooms, with divisions in bellow-stack, allowing for one continuous space. Children's furniture (GT1 and GT3) designed by Terragni.

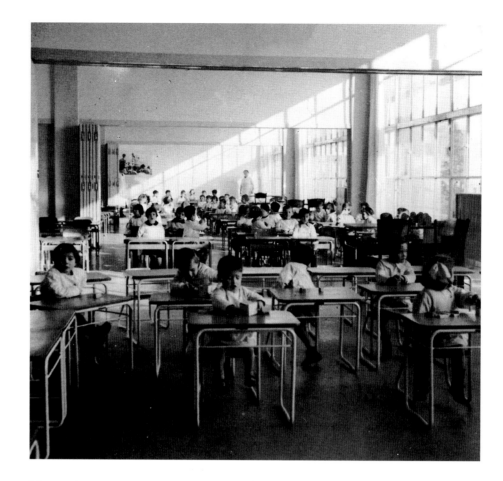

Terragni was a passionate, visionary architect who lived and died with a fervent belief in Italian Catholicism and in Fascism.

The Modern Movement was imported to Italy four years after Mussolini seized power; avant-garde architects, therefore, had to respond to a changing and progressively conservative social order which masqueraded as revolution. Before 1935, Mussolini was considered not only a saviour of Italy, but also an international statesman. Two competing architectural forces strove to win his favour – the nationalistic, Roman revival expressed through the work of Marcello Piacentini, and the abstract modern idiom of Italian Rationalism. Unlike Hitler and Stalin, Mussolini never formally endorsed any particular architectural vocabulary to represent the ideology of Fascism; he patronised both, as long as they expressed the grandeur of the régime.

The Italian Rationalists sought a rational synthesis between the nationalistic values of Italian Classicism and the structural logic of the machine age. Terragni was influenced by architectural and artistic movements from Russian Constructivism, the Bauhaus, de Stijl and Le Corbusier. In addition, his background as a painter, where he focused upon the dialogue between abstraction and figuration, was also highly instrumental in his development of architectural form. For Terragni, "architecture, a measure of civilisation, elementary, rising clear, perfect when it becomes the expression of a people who select, observe and appreciate the result, which, laboriously reworked, reveals the spiritual values of all."[4] The progressive and traditional aspects of Fascist

4 Zevi 1968, quoting from a manuscript by Terragni.

6
Children looking on to Via Andrea Alciato from front entrance balcony.

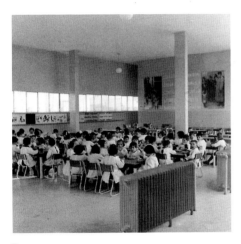

7
A view into the refectory with Terragni furniture and radiators relating to scale of children.

mythology emerged as a poetical expression of Rationalism as the new institution for Italian society of the 1930s. Italian architecture of the 1920s and 1930s was an architecture "of the state", and the work of Terragni was no exception.

The design of the Asilo Sant'Elia, actually done with the assistance of Terragni's brother Attilio, was meant to be a prototype for nursery/elementary schools of the Fascist régime. However, due to Terragni's departure for the Russian Front during the war his submission to government headquarters of wider-ranging plans was compromised, although this school certainly embraced the spirit of space as envisioned in Mussolini's new educational programme. Terragni's faith in this new society is embodied in a transformed "school type".

The school stands south of the city walls of Como, in the new Sant'Elia working-class quarter of the city, which had been developing since the early 1900s. The site is a corner lot, and the building is at a diagonal to the street plan with which the surrounding buildings conform. The ground plan consists of volumetric massing on three sides, opening towards a courtyard on the north-eastern side. The south-east wing houses four generous classrooms and a cloakroom. The north-west wing contains the refectory which connects to the section at an oblique angle on the north-west side to the kitchen.

The central zone for recreation (indoor and outdoor) separates the classroom wing from the dining and supportive facilities, materialising in a structure that is simultaneously intimate and monumental. The poetic functionalism of Terragni is expressed by asymmetrical distortions in a predominately rational ordering system. A dynamism to the entire complex is achieved through technologically sophisticated detailing, culminating in an elegance of expression. The manipulation of daylight and the series of layered spaces, of increasing openness, create a school environment rooted in mediation and dialogue with the elements of nature. Here, as in most of Terragni's buildings, exists the golden section of 8:13, carefully hidden in the plan.

In the Asilo, Terragni showed his understanding of the essence of the Open Air School in Amsterdam by Johannes Duiker (1929–30). Duiker's vertical organisation of semi-outdoor protective spaces for small children has been transformed horizontally. Each classroom has an outdoor terrace defined and shaded by canvas awnings (inflated by the wind), supported on a concrete frame. The entirety of the Asilo conquers outdoor space by dissolving boundaries into transparency, projecting volumes into the outside – refectory, corridor running along side classrooms, and balcony complex and canopy roof over the main entrance. The tight interplay between interior and exterior is revealed through the dynamic treatment of openings, including hopper upper lights that tip on a central horizontal axis, operated by rods, and the light rhythmic verticals of the entry porch.

Terragni designed all the furniture and fittings for the Asilo. In spite of a high ceiling, emphasised by the vertical glazing, the stairs, furniture, door handles,

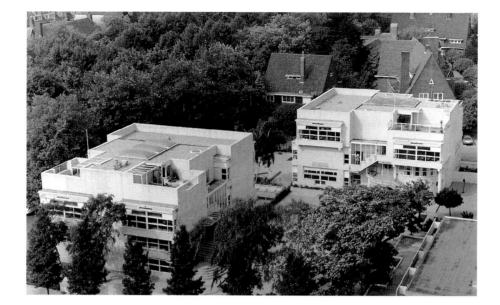

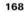

168

radiators, counters and bathrooms were all designed to accentuate the scale of a child. Innovative solutions in detailing transposed the classical Roman conception of stability towards the modern inclination to flexibility and dynamism. In the classrooms, teaching areas have a layered series of moving vertical surfaces; partitions between the classrooms consist of sliding wooden panels collected in a bellows stack, allowing them to be combined for assemblies.

There exists an obvious relation between the poetic functionalism of the furniture and Terragni's abstract conception of flexibility. Chairs and desks, made of tubular steel and plywood, were extremely light, and therefore easy to move. Their elementary nature worked from the precedents established in the Weimar Bauhaus. Marcel Breuer, Mart Stam and Mies van der Rohe had all been experimenting with contemporary machine methods and an array of new materials. "The tubular steel chair is as truly a part of the heroic period of the new architecture as are the transparent shells of glass that replace bearing walls," according to Siegfried Giedion.[5] Terragni re-interpreted their basic geometrical forms, built up from an analysis of details and function, to educational furniture, scaled to the child. Like the Bauhaus chairs, the weight-supporting framework was of tubular steel and the plywood non-structural parts, in more direct contact with the child, were less abstract and softer in character.

Apollo Schools by Herman Hertzberger

"To visit the Apollo Schools at the end of the school day, as classes slowly wind down and parents come to collect children, is a joy. Children, teachers, parents all use the building so fully and variously that there is a tangible atmosphere of enjoyment and belonging. Rarely does an architect's description of how a building should work seem to accord so well with practice as here."[6] Peter Buchanan "This is a school as a city-in-miniature, the school as a compensation, one might say, for the loss of a public forum in the community as a whole. It is difficult to imagine a more specifically political gesture than this and it would be

5 Page 1980.
6 Buchanan 1987.

9
Section of the Montessori
School: concrete structure;
the steps in the main hall
lead to the split level
construction.

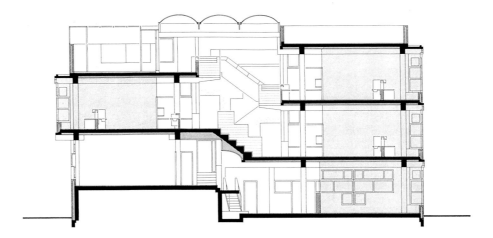

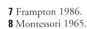

hard to find any school built during the last twenty years that is of comparable critical subtlety and depth."[7] Kenneth Frampton

Herman Hertzberger (born 1932), Dutch architect, critical intellectual and humanistic anarchist, firmly believes in propagating the cultural importance of architecture. To date, he continues his struggle against the positivism of contemporary culture through impassioned writing, practice and the education of a younger generation of architects. The school type holds a special fascination for Hertzberger, and through his numerous designs he has made a significant contribution to the architecture of the children's world. The timeless qualities of his schools have set new standards for the relationships of users and the built environment.

Holland, one of the most stalwart proponents of the welfare state, has a societal structure that reflects Dutch mercantile and land reclamation traditions. The national character is rational, pragmatic, culturally open, religiously tolerant and socially progressive. Moralistic soberness, economic shrewdness and political respect for democratic institutions create a homogenous, collective body that does not promote extreme ideologies. Hertzberger practises concurrently in accommodation of, and in opposition to, Dutch culture. However, through the prism of the Montessori subculture, he is selective towards the more liberal aspects of Dutch society.

The Montessori pedagogical methods were established as a vision for a way of life, as opposed to merely being an alternative educational system. The Italian educator Maria Montessori (1870–1952) stressed the importance of an architectural environment in the development of childhood. According to her, "children accept knowledge with all their physical abilities. Impressions do not only enter into their world, they also form it and become innate."[8] Education is not something the teacher does, but a natural process that develops spontaneously in human beings: it is not acquired through word, but by virtue of experiences in which the child acts on its environment. The "prepared" envi-

7 Frampton 1986.
8 Montessori 1965.

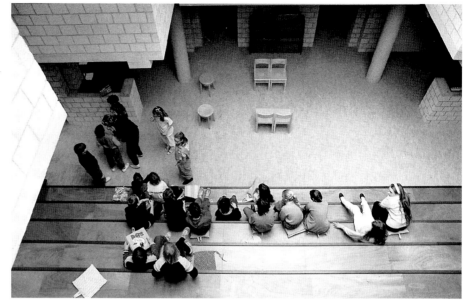

11
Central hall in the
Montessori School as a
large classroom.

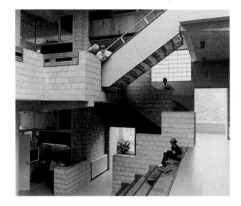

10
Central hall in the
Montessori School:
transition zone in front of
the classroom and north
170 staircase.

ronment is one that encourages the self-creating process of the child. In 1980, the authorities of Amsterdam South planned two primary schools with an identical programme, albeit with different pedagogical systems, on Apollolaan, a wide green boulevard which is a major axis of the urban extension of the city planned by H. P. Berlage in 1915 (South Plan). In conceiving the plan, Hertzberger questioned the rigidity of Structuralist design principles by a sensitive contextual approach towards the site. Responding to the requirements of division (the dissimilar educational methodologies) and unity (the massing of the site), Hertzberger developed two villa-like buildings. They continue the character of the urban residential fabric of Apollolaan, but architecturally they emphasise a striking transformation of the 1920s urban villa. The three-storey compact volume of each split-level "villa" contains eight classrooms, a small gym hall, central hall and teachers' support space.

The central ampitheatrical atrium, with two free standing staircases, creates the schools' dynamic performance setting. This place-form, void as space of public appearance, is the spatial focus of all programmed areas of the school. The complex overlapping of the public and private realms and the spiral circulation movement are congruent with the progressive pedagogical methods of the Montessori movement. Hertzberger himself describes importance of the void as "a movement (voyage) through space [which] is omni-present . . . Children identify themselves with certain spatial situations which offer them a sense of security. Children take care of the things around them and build their own space and surroundings. There is a continual movement through the space, which offers free, intellectual and creative learning . . . Spatial qualities of the central hall offer possibilities for individual work. The hall can therefore have a function of a large classroom. Steps can function as desks and each child can use these desks in his own way. The use is therefore not defined by the form."[9] While designing his first school (Montessori Primary in Delft, 1968), Hertzberger developed a unique theoretical concept concerning the relation of

9 Hertzberger 1985.

13
Transition zone of the
Montessori School, with
windowsills, shelves and
ledges for the display of
children's work.

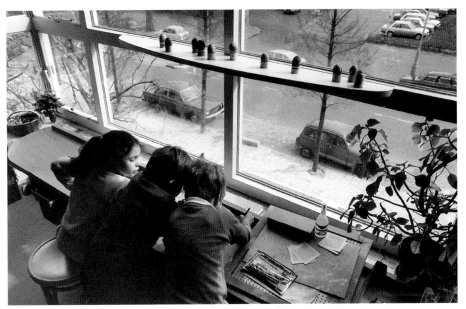

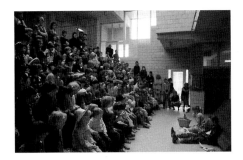

12
Central hall in the
Montessori School as a
public forum.

an object to an individual: "everything we make must be the catalyst to stimulate the individual to play the roles through which his identity will be enriched. A thing, exclusively made for one purpose, suppresses the individual because it tells him exactly how it is to be used. If the object provokes a person to determine in what way he wants to use it, it will strengthen his self-identity. Merely the act of discovery elicits greater self-awareness. Therefore, a form must be interpretable – in the sense that it must be conditioned to play a changing role. It must be made in such a way that the implications are posed beforehand as hidden possibilities, evocative but not openly stated."[10] This concept has been employed in the design of the interior elements of the "prepared" Montessori environment. Transitional zones and thresholds are enabling spaces for activities to happen.

Montessori pedagogy demands environments that offer possibilities for different and simultaneous activities. Strict Dutch building regulations concerning the allowed square meterage of classrooms led Hertzberger to place a freestanding kitchen element in the classroom, and then extend the classroom space towards the central atrium. In the transition zone between the classroom and the central hall are small, individual workplaces for students. Direct contact between the classroom and the central hall is achieved by a horizontally divided door of which either part can be open or closed. A shelf by the door is provided for individual classroom exhibitions. Tiles painted by children animate the classroom window ledges. Similarly, a projection of the children's work is presented to the outside world: window mullions are crafted to accommodate the creative efforts of the pupils. In the nurseries, Hertzberger innovatively re-interpreted the transitional floor surface as a gridded series of wooden box-chairs. The exact uses of these elements are left to the imagination of children and teachers.

Hertzberger's unique effort in the complete fusion of architecture and furniture defines a design strategy which proves successful in daily use. The colours

10 Hertzberger 1969.

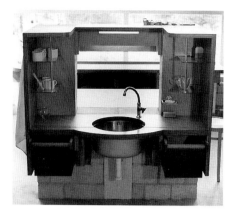

14, 15
Kitchen block with work table in the classroom of the Montessori School

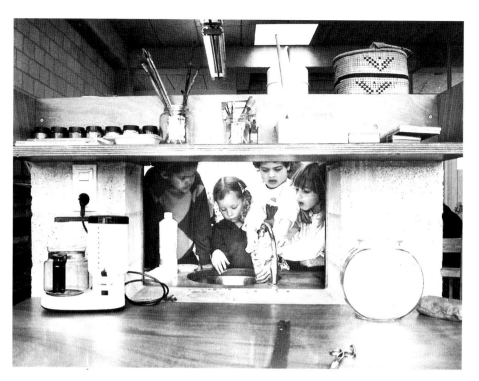

in the exterior and interior of the school are extremely neutral (white, light grey and light green), providing a frame for the colourful world of childhood to flourish.

Conclusion

Terragni and Hertzberger, drawing on their respective cultural heritages as well as contemporary European theories on teaching methods, successfully realised approaches to the world of children through design. Both architects creatively transformed references from the rich heritage of modern architecture in the detailing of their schools, adding to the multi-valent readings of spatial relationships.

Terragni's design demonstrates that it is possible to satisfy the needs of children and contribute to their education by starting directly from the environment – from volumes, from light and from air. The considerable size of the glazed areas and meeting zones (the play areas and refectory) enables the children to enter into a dialogue with the world.[11] Through the play of light, poetic detailing, furniture design and spatial concepts, Terragni expressed an optimism and enthusiasm for the belief in children's abstract thinking. The Asilo presents a new school type, a sharp contrast to the heavy, static and stable representation of the Roman era. The codes and messages embedded in Terragni's abstract functionalism frame an environment conducive to the imagination and wonder of a children's world.

The Montessori school of the Apollo Schools is the most intense and elaborate expression of Hertzberger's vision of the children's world. By following the basic principles of Montessori pedagogy, Hertzberger has created a space that is at the same time physically determined and programmatically undetermined – a

11 Marciani 1980.

16
Sunken sitting area in front
of the nursery classrooms in
the Willemspark School.

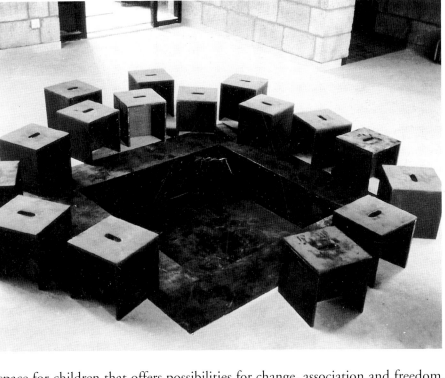

space for children that offers possibilities for change, association and freedom. His "inviting form" strategy and the richly detailed physical structures allow for individual reading and interpretation, with the use of metaphors.

The lessons to be learned from both architects stem from their drive for an ethical consistency and an absolute freedom of spatial experimentation. Ultimately, their visionary achievements reflect their utopian passion to confront the challenges in building the fantastic world of childhood.

Research for this article was made possible through the generous support of the Graham Foundation for the Arts. The piece is a part of a larger research project, to be published as a book, The Architecture of School Buildings.

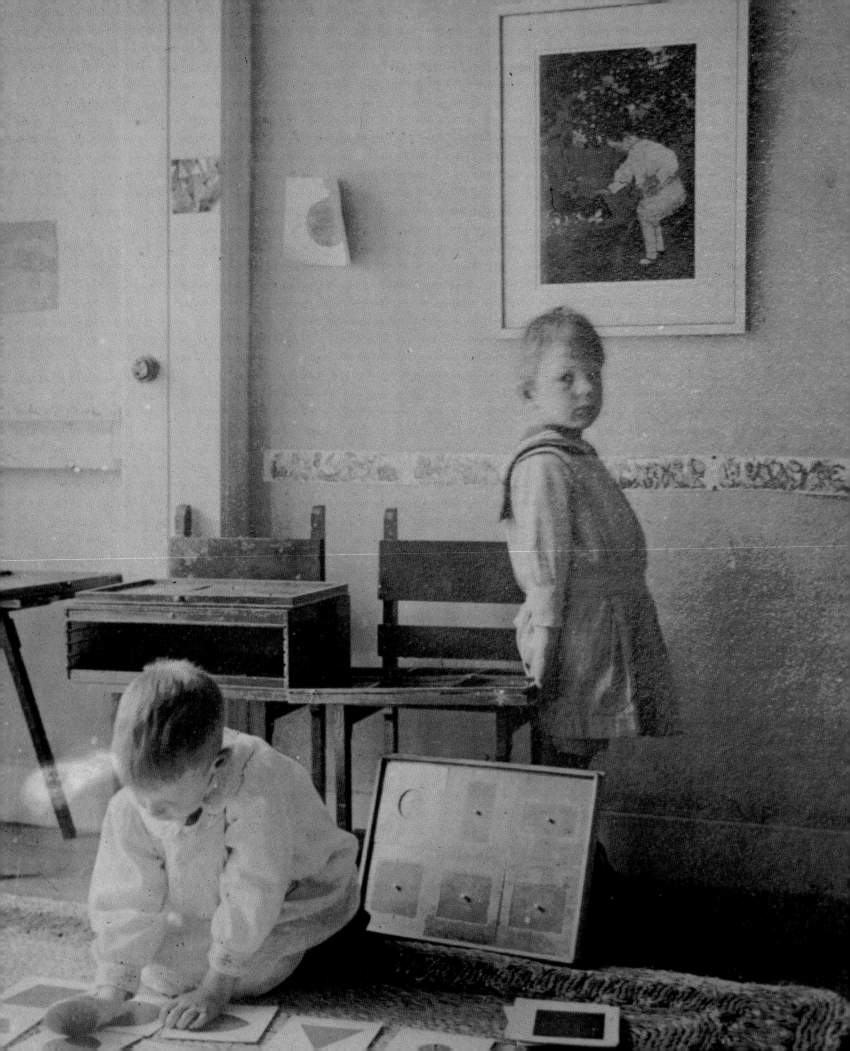

Jutta Oldiges

Maria Montessori's Concept of the Prepared Environment: "the interior as a living world of learning"

1
Several of the Montessori development materials require quite a lot of space, and they are therefore spread out on the carpet. A boy is concentrating on grouping different geometrical shapes.

At the turn of the century, the reforming educationalist Maria Montessori (1870–1953) developed a new type of educational concept that sent shock-waves around the globe, and gradually found many supporters among the progressive sections of society. Maria Montessori, the first female Italian doctor, turned to anthropology and educational theory after working with disabled children. She dedicated her remaining life to the needs of children, continually developing her own educational concept of "education for liberty".

Her educational approach remains valid to this day, and many aspects of it have been endorsed by standard educational theory. Her integrated approach is particularly convincing when applied in practice. The Montessori theory has recently attracted renewed interest;[1] parents and teachers alike look to it for solutions to an increasing number of problems relating to children, such as lack of concentration, hyperactivity and absence of motivation. The Montessori teacher Steenberg contemplates the increasing number of students who wanted to get an insight into a Montessori kindergarten ("children's house"): "People are so surprised by the calm and discipline, politeness and tidiness, the intellectual advancement, the natural co-existence of different cultures, of able-bodied and disabled, they usually suspect that children have either been carefully selected or that there is a wealthy financial backer. It strikes them as impossible. But it is possible."[2]

The essential principles of Montessori's model came from her observation that children are capable of pursuing an activity for a long period of time with the utmost dedication and concentration. They are in a contemplative state, "the child, the object and the environment merge into one unit".[3] She called this "polarisation of attention" (it is also now known as the Montessori phenomenon). She recognised this ability to concentrate as the foundation for the child's entire learning process, and for the development of its personality.[4] She once observed a little girl playing with a row of shapes: she inserted them into the corresponding openings on a wooden board 44 times without taking any notice of the other children in the room. "This phenomenon . . . could be determined as a continual reaction, which is triggered under certain outside conditions, which in turn are determinable. And

1 See Steenberg 1993, pp. 13–14; Esser 1996, pp. 7, 10, and Holtstiege 1994, pp. 6–8. There are approximately 700 Montessori establishments in German-speaking countries.
2 Steenberg 1993, p. 14.
3 Ibid., p. 29.
4 Provided that the child is free to choose to pursue its chosen activity.

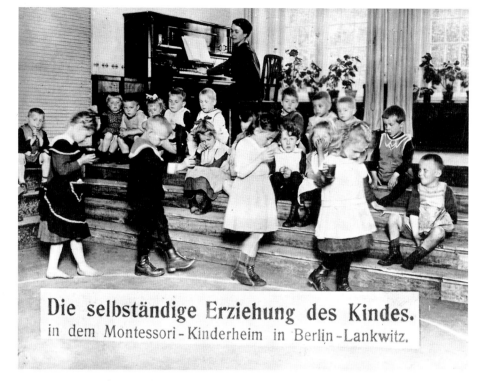

Die selbständige Erziehung des Kindes.
in dem Montessori-Kinderheim in Berlin-Lankwitz.

5 Montessori 1976, p. 70.
6 The value of using specific materials for, among other things, the improvement of the capacity for abstraction, is undisputed in developmental psychology. See Grunwald 1995, p. 16.
7 Holtstiege 1994, p. 95.
8 Ibid., p. 98.
9 There are also subject-specific didactic materials for school-children which are geared towards the different lessons of the curriculum.
10 Holtstiege 1994, p. 103.

every time such a polarisation of attention occurred, the child began to change completely. It was much more calm and almost became more intelligent and communicative. The child manifested extraordinary internal qualities, reminiscent of the highest consciousness phenomena, such as conversion."[5] Frequent repetition of an exercise is, undoubtedly, a child-like characteristic. In order to further this joy of repetition, Montessori developed didactic materials that she tested over long periods of time.[6]

Aided by development materials, her method has three different types of exercise: everyday exercises, movement exercises and sensual exercises. The everyday exercises, applied particularly to pre-school-age children of three to five, help develop sensitivity for "structured movement".[7] The child learns to take care of chores in its everyday environment (laying the table, washing up, cleaning, etc.) as well as tying its own shoelaces or buttoning up a shirt with the help of a tying aid.

Movement exercises refine the coordination of movement with the aim of "an improved organisation of the human personality into a functional unit".[8] They consist of everyday exercises as well as rhythm and gymnastic exercises, or balance and concentration exercises (e.g. walking on a straight line).

Sensual exercises aim to inform the sensory perception. Materials used here include bottles of smelling salts, sound boxes, boxes with colour images, shape-sorting boxes, weight cards, geometric objects, boxes of assorted letters and many more.[9] "The didactic intentions of the development materials are geared towards the development of intelligence, based on the refinement and training of the senses and of movement."[10]

It is the child, not the teacher, who decides which educational material to

Children's house interior,
Berlin, early 1920s; the
ambiance is homely. This is
probably the first German
children's house, opened in
1921 in Berlin–Lankwitz,
which was forced to close its
doors a year later due to
lack of funds.

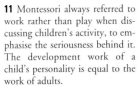

work with.[11] The teacher demonstrates the use of new material, then the child does the exercise on its own. The role of the teacher is limited to helping the child do things for itself. Once the child has mastered a specific material, the teacher will start to familiarise it with abstract terms such as big/small, light/heavy or light/dark, using the relevant material as a reference point. The teaching material is designed to enable the child to check on mistakes it may have made. The children's houses also have play areas with a choice of classic toys such as dolls' houses and cars, as well as reading areas with picture books.

Montessori observed certain "sensitive phases" within the development of every child. These may vary from child to child, but during a specific period of its life every child tends to be particularly receptive to certain learning processes, such as acquiring language skills. This sensitive phase must on all accounts be recognised and encouraged, because later it may be present only in a limited form or have vanished altogether.

The Prepared Environment

"The preparation of the environment and the preparation of the teacher constitute the practical foundation of our education. The teacher must at all times act from a position of love. The child comes first and the teacher follows and supports the child . . . He or she must remain passive for the child to be able to become active. The teacher has to grant the child the freedom to express itself, as there is no greater obstacle in the blossoming of a child's personality than an adult who opposes the child with all his superior power."[12]

The role of the teacher in children's houses and schools[13] is limited to that of

11 Montessori always referred to work rather than play when discussing children's activity, to emphasise the seriousness behind it. The development work of a child's personality is equal to the work of adults.
12 Montessori 1968, p. 21.
13 Montessori does not always differentiate between the children's house and school.

4
Nursery in Berlin, 1896. Apart from the group of children who have been allowed to get up to play a game, there is no sign of any freedom of movement.

observer and gentle supporter. The relationship between child and teacher is based on the teacher's respect for the child's expression of its will, its spontaneity, and an ability to empathise with its sensitive phase. "The child's very own activity enables it to understand; it adopts the culture from its environment, not from the teacher . . ."[14]

Apart from an atmosphere of trust which the teacher must create, and the availability of the development material, the Prepared Environment also includes the arrangement of the interior and its furnishings, which must respect the children's physical and mental independence. Other reformers before Montessori – among them Rousseau, Pestalozzi and Froebel – had advocated a more moral, child-oriented education. But Maria Montessori was the first to demand a fundamental reorganisation of the interior arrangements of nurseries and schools as a consequence of the child's autonomy. The very idea of collective tuition in Montessori schools runs counter to her rearrangement of the classroom and the children's house, which was revolutionary at the time. She banned traditional school desks, replacing them with individual pieces of furniture. For centuries, children had been kept prisoner within rows of desks and chairs. Didactic teaching was – and still is largely today – structurally authoritarian; instruction and obedience are prime concerns, individual responsibility and autonomy are not encouraged.[15]

If the child is to be independently active, the scale of its interior environment must correspond to its own scale. "The first step is to transform the classrooms into proper little children's houses and to equip them with objects which reflect the stature and strength of the actual occupants: small tables and chairs and washtables, small versions of bathroom equipment, small

14 Montessori 1966, p. 5.
15 Steenberg 1993, p. 15.

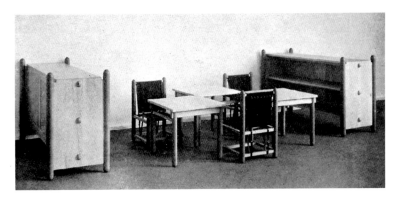

5
Children's house and school furniture, c. 1930, designed by Schwarz and Schwippert for an experimental school in Aachen, Germany. The furniture itself is supposed to become "material for the senses". The simple basic shape, the tactile quality of the wood, the user-friendly joints which allow the child to learn a variety of knots, as well as the removable covers, provide the children with an opportunity to experience materials. The lightweight furniture can easily be moved around within the room.

carpets, tablecloths and crockery."[16] All objects should be lightweight so that even the youngest child can carry them, in case it wants to work somewhere else in the room or even leave the room for the garden. On top of that, furniture should be clear and simple in design, pretty and harmonious in outline and colour, be painted in light colours, and be "beautiful and inspiring". "A children's house should be beautiful and pleasant down to the last detail, because beauty encourages activity and work."[17] Everything – the proportions of the rooms, as well as of the windows and doors – should be made with the height of the children in mind. Montessori in fact preferred curtains to doors, whose handles children are so rarely able to reach. Shelves should be placed at an appropriate height so that children can put things on them.

Finally, all the furnishings should be washable, not so much for reasons of hygiene but to give the child the opportunity "for a welcome chore". Montessori observed the great pleasure and skill with which quite young children can execute daily chores such as cleaning and tidying, as well as caring for plants and animals: "a child wants to know that there is an intelligent reason behind what it is doing, which is why children are not interested in mere gymnastics."[18]

Cost is also a consideration: her ideas for easy-care furnishings for classrooms are much cheaper than the traditional "imposing monuments of rows of desks and chairs, made of heavy wood and iron, the enormous cupboards and the oppressive teacher's desk and similar instruments that have been produced in such large numbers in order to quash the powers of our beautiful childhood."[19]

While children are often confronted at home by adult-imposed bans due to fear that they may cause havoc or break something ("Let me do that!" or "Be careful, you'll break it!"), in the children's house they are systematically introduced to everyday actions in order to train their motor activity. They repay this trust with an extraordinary sense of responsibility.[20] In the purposeful handling of objects, the child is able to train its motor coordination, learning quickly to get up from a chair without knocking it over backwards but quietly pushing it back instead. Such skills and attentiveness are learned only later in a traditional classroom, if at all. Montessori reported once from

16 Montessori 1968, pp. 39–40.
17 Montessori 1993, p. 82.
18 Grunwald 1995, p. 122.
19 Montessori 1968, p. 40.
20 They are allowed, for example, to have utensils of glass and pottery rather than metal or plastic.

6
Pupils cleaning their desks.
The pupils voluntarily treat
their environment with care.

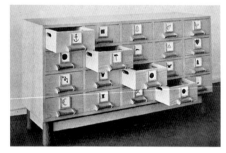

7
Chest, c. 1930, designed by
Schwarz and Schwippert.
Every child is assigned one
drawer to store toys or
handicrafts, recognisable to
the pre-school child by an
image stuck on the front.

21 Montessori 1993, p. 77.
22 Ibid., p. 83.
23 "The white uniformity and the
fact that every object can be easi-
ly cleaned is a sign of the triumph
of an era in which the battle
against microbes appears to be
the key in sustaining human life";
Montessori 1993, p. 84.
24 With the increasing popularity
and wider dissemination of her
ideas, companies started to man-
ufacture furniture and develop-
ment materials to her require-
ments.

a children's house in Milan where the children kept knocking over the iron figures used in their first drawing lessons, because the shelf they were on was not deep enough. But before the carpenter could fit a deeper shelf, the children had become so cautious that no more figures went crashing to the floor: "they developed and used their own skill to compensate for the fault in the shelf-design. The simplicity or bad design of outside objects thus contribute in developing the pupils' activity and skill."[21]

The children are always free to move about, but they are, however, asked to complete one activity before going on to the next. The environment has no rigid seating order, and encourages the children to become socially active, but it is up to them whether they want to remain by themselves or join a group. A few rules ensure that things do not get out of hand: the children are expected to be respectful and considerate towards the activities of others and to wait patiently for the desired material, which will only go round once. They are also expected to be attentive when the teacher greets them every morning. As Montessori schools usually cater for three class levels together, older children develop a special responsibility towards the younger ones, passing on the careful manner in which they themselves were instructed towards independent activity.

It is the adults' obligation to adapt the environment to the children's needs and to their relevant stage of development. It is essential for the children's capacity for perception that their lives evolve around an order that they have come to trust and that introduces them to certain structures. Established order is beneficial to the child's mental agility.

Regarding the atmosphere in the schools, Montessori was adamant that the child should live in total freedom: "The child's organism, from its physiological and vegetative side to its active mobility, must 'encounter the ideal conditions for development'."[22] Despite improvements to a number of traditional schools in the 1920s and 1930s (the size of classrooms increased, they became brighter and more airy, and stoves were installed), Montessori criticised the "white uniformity" and sterility of the rooms. She noted with surprise the rigid adherence to orthopaedic seating arrangements, regarding such seating, even when height-adjustable and swivelling, as misinterpreted "school hygiene".[23] Initially she had to produce all the furnishings for her schools and children's houses herself.[24]

Clara Grunwald (1877–1943), advocate of the Montessori educational theory before and after the first world war in Germany,[25] wrote in 1923 that, with the exception of chairs and tables in the correct proportions, the requirements of children are not met even in the children's room of a family home. A child must be able to reach everything it needs. It must be able to fill the washbowl with water from a little container, and to hang up its clothes in a low cupboard, or put away its underwear in a chest of drawers, all without assistance. How is it, asks Grunwald, "that furniture that corre-

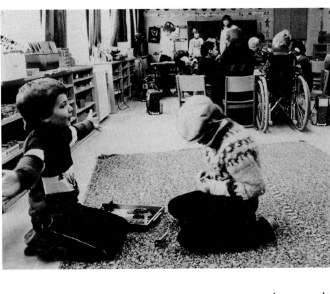

8
Sitting on the carpet is very popular. Both playing alone and with just one other child is possible.

9
Children engaged in a group conversation in a Montessori school in New York, early 1980s. The prepared environment of the classroom includes, among other things, a friendly and agreeable atmosphere, low shelves with teaching materials, a line for balancing exercises, a chalkboard, carpets and a tying frame.

sponds to a child's size is not available at all but has to be made to order, while objects, furniture and furnishings for dolls exist in all shapes and sizes?"[26]

The Prepared Environment, on the other hand, is geared towards children and their development. It is ideal for children to strengthen their motor activity and to blossom on a sensory, intellectual, emotional and social level. "Children make us experience a humanity that is better than ours, a humanity full of innocent vitality, strength and beauty."[27]

25 In Germany, the Montessori concept initially met with scepticism; it was far better received in Austria, Britain, America and, in particular, Holland.
26 Grunwald 1995, p. 131.
27 Montessori 1968, p. 38.

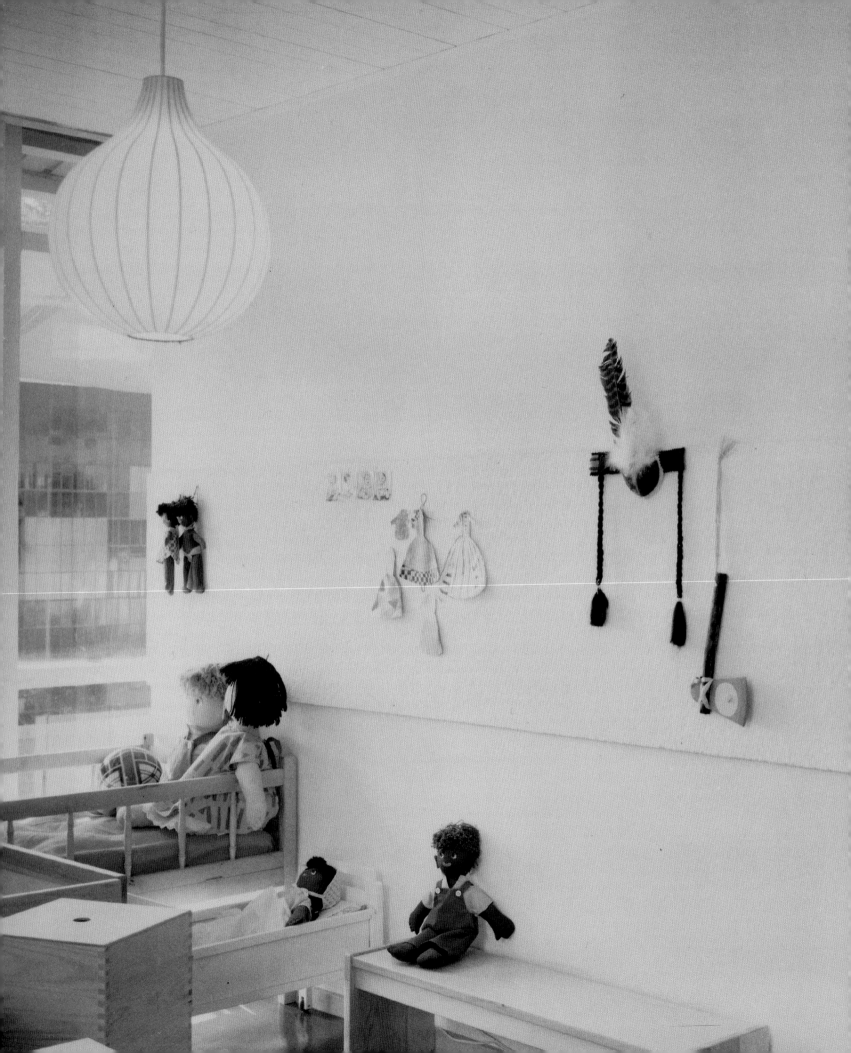

Denise Hagströmer

A "Child's Century" at Last?

1
All activities room at H55
Design Expo, Helsingborg,
designed by Lena Larsson,
1955. Illustration by Ulla
Molin, from the magazine
Hem i Sverige, 1955.

In 1901, the Swedish social reformer Ellen Key wrote The Century of the Child for "all those parents who hope in the new century to shape the new human beings".[1] In 1994, Swedish journalist Margareta Norlin's Whatever Happened to the Century of the Child? was an indictment of "the head-on attack against the world of children" that is taking place in the prevailing economic climate.[2]

183

Tracing this journey from turn-of-the-century optimism to turn-of-the-century pessimism by looking at how child-centred values are reflected in the child's design environment is an approach that has been given little consideration by historians. Here, published and unpublished sources will be used to examine how the particular needs of children, especially in Sweden, have or have not been acknowledged.

Ellen Key believed in the home as a mould for the child's future character, beauty and harmony being prerequisites for useful and productive future citizens. There is no doubt that her ideas on education and upbringing exerted a strong influence within the intellectual elite. Although The Century of the Child was translated into eleven languages, however, a more populist vehicle for her message was the paintings of Carl Larsson. These bright, cheerful, domestic interiors (often with children) were seen – not least by Ellen Key – as an ideal of bourgeois domestic bliss.

Despite Key's social concerns, children from the urban or rural working class did not seem to figure in her agenda. The childhood reality for most of the city of Stockholm in 1901 was all too far removed from her ideal: 17.5 per cent infant mortality before the first birthday, uncontrolled industrialisation, rampant urban migration and housing shortages ("bed bugs the only secure tenants").[3] The realities of rural life were just as far from Carl Larsson's idealisations. Stockholm's Skansen open-air museum and the Nordic Museum have examples of the "tools" used to encourage the child's physical development: the "stand-chair", the pot chair and the food chair ensured physical compliance for these activities, while the swing-chair kept the child safely away from the fire and the cold floor (another safety precaution was a wreath of plaited straw for the head). Play (out of the way, under the table, in winter) was allowed only until the child had developed sufficient manual skills to take part in household chores.[4]

1 As quoted by Pehrsson K. in
Åkerman 1983, p. 77.
2 Subtitle of Norlin 1994.
3 As note 1, p. 81.
4 Lönnqvist 1992, pp. 193–239.

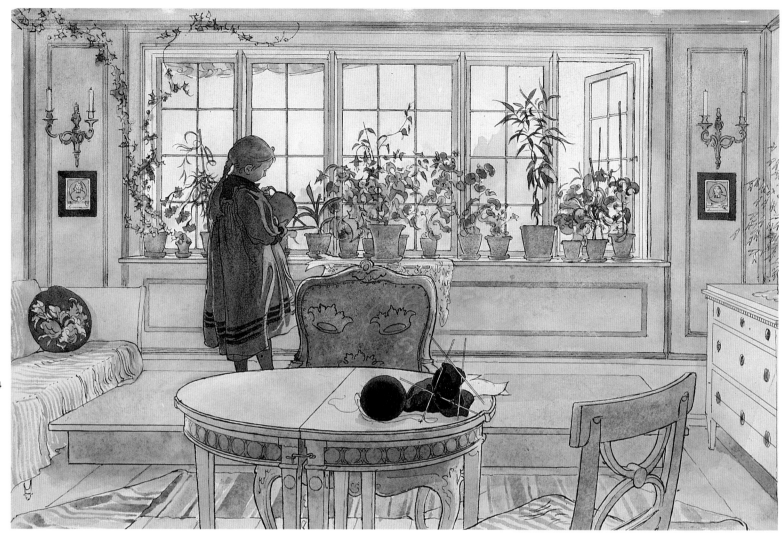

2
Carl Larsson,
Blomsterfönstret (The
Flower Window),
watercolour, from Ett Hem,
Stockholm 1899.

By the 1920s, children's status had risen. Educational and spiritual development (as advocated by Ellen Key and others) were seen as increasingly important. This is reflected by Asplund's inclusion of a children's section in his Stockholm City Library: in contrast to the rest of the building's severe neo-classicism, the style is vernacular, the appropriately scaled wooden furniture has a soft, "brushed", tactile finish, and a "Sandman" mural sets off the round story-telling room.

The 1930s saw Sweden in the process of dramatic change: a largely agrarian society converting to the modern industrialised model. Gunnar and Alva Myrdal's Crisis in the Population Question (1934) addressed the issue of couples having fewer and fewer children – according to the authors, a result of high unemployment and poor living conditions.[5] This book generated much political debate, and led to the introduction of a number of reforms by the recently elected Social Democratic Party, including municipal housing for large families.

The Myrdals also suggested that the costs of childrearing should be borne by the state. Nurseries should be made available for all children, providing a new cultural and social system to prepare children for citizenship, and to free

5 Myrdal A. and Myrdal G.
1934; Myrdal 1940 contains
similar ideas, and see also
Myrdal 1935 (2).

3
Interior of a children's story
room at Stockholm City
Library, designed by Gunnar
Asplund, 1928.

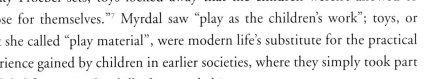

mothers to enter the labour market. The few existing nurseries were mostly for the children of single mothers, such as the Home for Single Mothers and Children of 1930–33 built by Ingeborg Waern Bugge, one of Sweden's first female architects. This included a nursery with scaled-down proportions and furniture.[6]

Another early iniative (from the late 1920s onwards) was the nurseries provided for members of the HSB Housing Co-operative. HSB was run by a radical architect, Alf Wallander, who also encouraged Alva Myrdal to establish what was to become a two-year course for pre-school teachers. She introduced new theories in psychology and education from Arnold Gesell, Jean Piaget and Charlotte Bühler ahead of their publication in Swedish, instituting a more individual, less authoritarian regime. An avid believer in the translation of theory into practice, she also introduced new nursery equipment: one of her students recalls "new toys and bigger and stronger play equipment, puzzles with big pieces, rocking boats, wall bars, slides, all replacing the finicky Froebel sets, toys locked away that the children weren't allowed to choose for themselves."[7] Myrdal saw "play as the children's work"; toys, or what she called "play material", were modern life's substitute for the practical experience gained by children in earlier societies, where they simply took part in adult life to gain the skills they needed.[8]

Ellen Key's vision of the child being part of the home as a work of art gave way to the rationalist view of the child being part of the home as a workplace. The flagship modernist project was the communal kollektivhus, or serviced house. The concept was suggested in the early 1930s by the Professional Women's Association, with Alva Myrdal again at the forefront. She involved progressive architect Sven Markelius, who designed the first kollektivhus of 1935. A profes-

6 See Janfalk 1995.
7 As note 1, p. 90.
8 See Myrdal 1935.

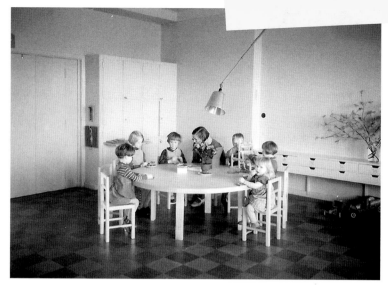

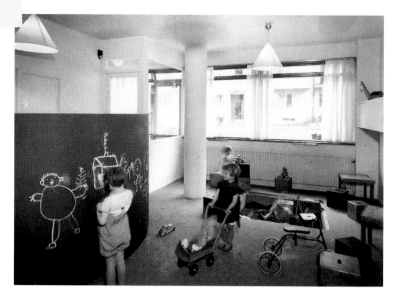

4
Interior of a nursery,
Polhemsgatan, Stockholm,
designed by Ingeborg
Waern Bugge, 1933.

5
Interior of nursery in
Kollektivhuset, John
Ericssonsgatan, Stockholm,
designed by Sven Markelius,
1935; furnishings by
Margareta Kohler.

sionally supervised nursery (staffed day and night) was at its ideological core. There was also a central kitchen and canteen, with dumb waiter service to the flats. All was serviced by professional staff, including the housekeeping.[9]

The nursery, on the ground floor, was connected by intercom to the flats. In it, the children experienced the four elements: in the playroom a paddling pool, a sandbox, an aquarium and an open fireplace; on the roof, fresh air and sun, another sandbox, paddling pool, and showers. There was one dormitory room for the younger children and one for the older, as well as a sick room. Markelius commissioned Margareta Köhler, one of the first Swedish female furniture designers. Her firm Futurum specialised in interiors and furniture for children, as did the shop, which also sold BRIO products). The kollektivhus furniture was, of course, adapted to the size and needs of its users. The chairs were in painted birch, with seats of saddle-girth braids in different colours, and all the furniture had characteristically rounded edges. The cots were on wheels, and the beds folded against the wall, as did the nappy changing tables. Like Myrdal, Köhler was a firm believer in the right of a child to a space of its own, and even suggested (a radical idea at the time) that in a two-room flat, one room should be given over to the children – the sunniest one, too.[10]

The 1940s saw a series of large-scale surveys comparing the functionalist ideas of the 1930s with domestic reality: what Myrdal called "child prisons", cramped and stuffy minimal flats (for those lucky enough to get them). The first such empirical study was Brita Åkerman's The Family that Outgrew its Home (1941). She describes children's strictly scheduled existence, ruled by pedantic mothers: "In this ordered, carefully enclosed and demarcated environment, the children are stifled. It is too cramped for them. They enter a world where oversized, overweight furniture stands inviolate, and remains on the same spot undisturbed as they grow up. Father and mother stand still as well, and surround themselves with habits and ideas similarly resistant to change. The child gets care and security from this home, but not stimulation

9 Nilsson 1994.
10 Eklund-Nystrom 1992, pp. 236–40, 292–96.

6
Tripp-Trapp-Trull bed by
Sigrun Bulow-Hube, 1944.

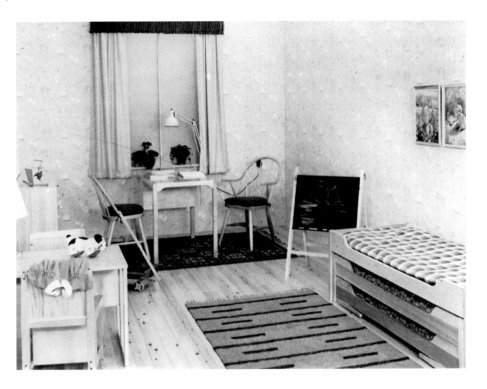

187

to encourage change and development."[11] More than half of the families studied lived in one room and the kitchen, reserving the "parlour" as a no-go area for the children, furnished with a monumental three-piece suite. The "material world of childhood" in these cases consisted, on average, of 17 to 18 cumbersome items of furniture! Thirteen per cent of children living in such flats shared their beds with siblings, with 23 per cent using a bed that stowed away during the day.[12]

The Swedish Society of Crafts and Design (Svensk Form) set out to promote furnishing for need rather than show, prioritising children's requirements for space of their own. By the mid 1940s manufacturers began to respond, one early example being the stacking play equipment and furniture designed by G. A. Berg and developed in collaboration with Märta de Laval of the House-Mothers' Association.[13]

From 1939 the Co-op was also instrumental in producing and retailing innovative furniture, such as Sigrun Bülow-Hübe's bed for "compact living" – two beds that slide away under a third for storage, inspired by the beds made for a rural children's sanatorium by a local carpenter. Their children's furniture was more than just "adult writ small", as shown by Erik Ahlsén's swivelling "build and play" furniture. Architect–designer Lena Larsson (trained at Köhler's studio) believed that children's furniture should be adapted to their need for play and space, and ideally should become a natural part of their play. The home, she said, belongs just as much to the children as the adults, spreading her message through a DIY manual The Children's Corner,[14] and radio programmes. Chandelier or Slide?, broadcast in 1946, pointed out that "it was children who suffered when we became city dwellers after centuries in the countryside."[15]

11 Åkerman 1941, p. 237.
12 Ibid., p. 39.
13 As note 1, p. 97.
14 Larsson 1956.
15 Larsson 1991, p. 75.

7
Robust highchair by Stefan Gip, 1962, manufactured by Skrivit, Sweden.

8
B A Series, nursery furniture designed by Stefan Gip, 1961, manufactured by Skrivit, Sweden.

16 Norlin 1994, p. 14.
17 Data from undated newspaper cutting in the private archive of Stephan Gip, architect, Stockholm.
18 Interview with Lena Larsson, Stockholm, February 1997. In 1995, she was given the Stichtung ikea Award "for her lifelong struggle for children's rights to a creative environment".

Lena Larsson's contribution to the international H55 Helsingborg Design Expo included the much-discussed "all activities room", an informal and child-friendly area where the whole family could relax. In the adjoining children's room the elements could be rearranged for the children to create their own environment – screens, giant cubes and a wall-long bed that converted to bench seating. The Finnish section included nursery furniture by Alvar Aalto, and Denmark's Kaj Bojesen designed an outdoor play area. Indeed, much of the Expo was aimed at the generation born in the 1940s.

Interest in child psychology grew in the economic and ideological hothouse of the 1960s and 1970s. This was, in part, perhaps a reaction to the cold and clinical rationalist approach of the previous decades. As the new disciplines of child psychology and pedagogik (education) held sway, the focus of interest shifted from the offspring of the poor to those of the middle classes, who were filling the nurseries and play schools in increasing numbers. The mid 1960s to the mid 1980s are singled out by Margareta Norlin as the "decades of the child" (a pragmatic retreat from the "century of the child").[16] Childhood was no longer regarded by anyone as a mere prefix to adult life.

After his 1961 degree project of a combined bunkbed and playcentre, Stephan Gip joined the Skrivit company, where he was to develop an impressive range of child furniture and related equipment. His Robust high chair of 1962 was, and still is, one of the best on the market. The fact that product development was conducted jointly with child psychologist Stina Sandels at Stockholm University attracted much media attention, The BA series, a seating and storage range in oiled beech with rounded edges, constructed without screws or nails, also enjoyed the input of some scientific enquiry. Testing by Svensk Form's new machines revealed that the chairs could stand 87,000 cycles of pitching back and forth carrying 70 kg.[17]

Young parents could shop at NK-Bo Nu and walk round examples of rooms furnished with goods on sale, a retailing initiative which provided the inspiration for others, including IKEA. Lena Larsson was one of the instigators, and hands-on experience for children was encouraged: "They could paint their own screens and cubes, jump in the piles of rugs . . . there were rocking horses, dolls . . ."[18] Being one of the most modern stores of its kind, including the children's department, it included Nana Ditzel's Trisserne [Bobbin] play series (back in production today), which could be rolled or carried from room to room, and which gained a new life as tables when the children grew older.

The Co-op also continued their policy of enlightened product development, a noteworthy example being Sune Fromell's multi-role furniture modules, designed to be recombined in different ways as the child grows. Borje Lindau and Bo Lindekrantz made furniture from brightly painted plywood board, held together with thick rubber bands. At the same time as the cradle came back into fashion, Pop design reached Sweden with Stephan Gip's 314-square-metre inflatable nursery of 1969. What all this – and work by others

9
Trisserne (Bobbin) series of
versatile play tables,
designed by Nanna Ditzel,
1962, manufactured by
Kolds Savvaerk, Kerteminde,
and later by Trip Trap,
Denmark.

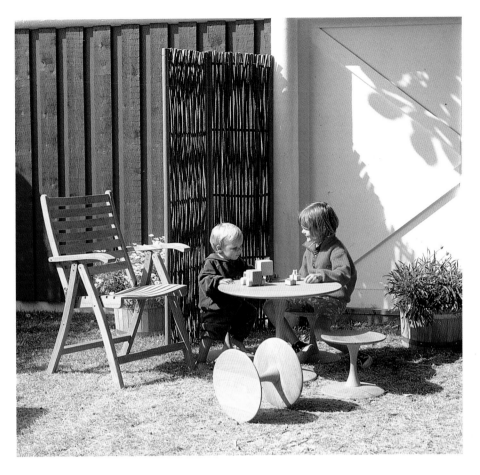

such as Elis Borgh, Brik Höglund and Kristian Vedel – had in common was
a wide-ranging potential of use, erasing the boundaries between practicality
and play (or furniture and toy).

After more than thirty years of debate, the Swedish government's 1968 child-
care report formulated a programme for children based largely on the ideas
of Jean Piaget. Standards were set for the design and planning of the rapidly
increasing number of nurseries.

The 1970s saw wide debate on childcare methodology and theory, meriting
closer study than is possible here. The decade started with a strong joint
Nordic showing at the Milan Triennale on the theme "Children's Environ-
ment". Particularly significant in the period was the extent of resources and
the amount of effort spent informing both nursery staff and parents about
how to create a stimulating environment for children. Touring exhibitions
visited cultural centres, publications appeared in volume and the latest re-
search was made available at drop-in centres.[19] The consensus (echoed in the
design press) was that the nursery should be a comfortable environment for
both children and adults. This encourages collaboration and dialogue, rather
than one-way supervision or instruction, nurturing children's independence
and initiative. With the Norwegian Peter Opsvik's Tripp Trapp chair of 1972,
children could sit at the same table as adults, making possible conversation
on an equal level and sparing the adults' backs. The height of this chair can
be adjusted as the child grows; two million have been sold to date.

19 Exhibitions between 1972
and 1979 include Minst behöver
mest [The youngest need the
most]; Som Syskon [Like broth-
ers and sisters], and Kom Loss!,
dealing with the interiors of af-
ter-school centres. Organised by
the Lekmiljörådet (Council for
Children's Play Environment),
the venues for the touring shows
included Kulturhuset in Stock-
holm, the Röhss Museum in
Göteborg and Form Design
Centre in Malmö.

10
Cover of the influential book
by Eva Norén-Bjorn Lek,
Lekplaster, Lekredskap (The
Impossible Playground),
Lekmiljörådet/Liber Forlag,
Stockholm 1977.

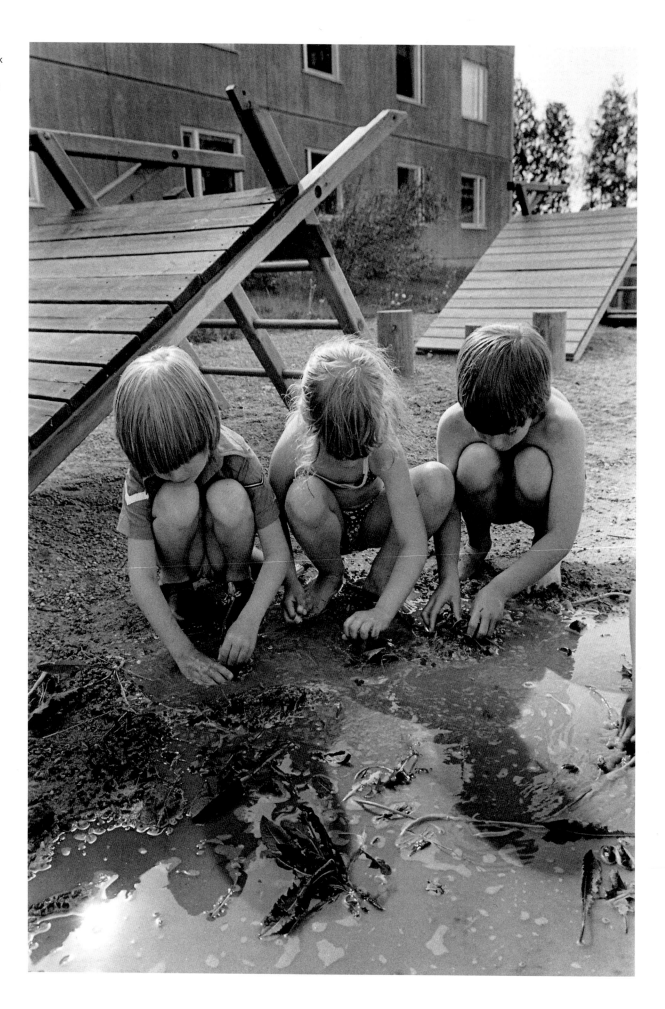

11
Plasthatten inflatable
nursery designed by Stefan
Gip, manufactured by
Skrivit, Sweden, 1961.

12
Mikkelborg wendy house
with swing designed by
Hans Sandgren Jakobsen,
1994.

20 Quotation from Som Syskon
exhibition booklet, p. 11, at
Lekmiljörådet archives, Social-
styrelsen (The Board of Social
Affairs), Stockholm (see note
19).
21 Form, no. 8–9, 1975, p. 322.
22 Quotation from ibid., p. 316;
see also Norén-Björn 1979.
23 See Wickman 1992 and
Åhlman 1989.
24 See Bergström 1992.
25 Snedkerlaugete Efterarsud-
stilling, the Cabinetmakers'
Guild Autumn Exhibition, is a
major annual design event in
Copenhagen.

In contrast to the "institutional" interiors and uniform furnishings of earlier nurseries, character and individuality began to appear, with colour, pattern, lighting and materials used to create a richer environment: "this hopefully creates a more natural environment for the child than one with just children's furniture, more like what they are used to at home."[20] Textile artist–designer Gunilla Lagerbielke (later to become rector of Konstfackskolan national college of art and design) was a vital force at the Council for Children's Play Environment (Lekmiljorodet). The nursery exhibitions she created used work by leading artists and designers, including fabrics from the Group of Ten. According to Form magazine, a good nursery should be able to change according to circumstances – dispersed lighting to alter mood, a mixture of old and new furniture, a "blue ceiling with clouds for children to lie and look at". Gunilla Lagerbielke questioned the value of "educational" toys, pointing out that a toy becomes educational only with interaction between adult and child: "Then, anything can be educational: a broom, pots and pans, a tape measure; more so, perhaps, than such toys, as it is the world around them that children are learning about."[21]

Swedish child policies moved into the international sphere in the 1970s, in particular with legislation of 1979 that prohibited corporal punishment, including that by parents. Swedish research was published in English, including psychologist Eva Norén-Björn's The Impossible Playground, which cited the problem of the continuing lack of creative playground apparatus: "A log can become a boat or train or sofa; a wooden horse cannot ever be more than a wooden horse."[22]

In 1990, the results of eighteen months of research into the child's design environment from the Capella Academy's pan-Nordic cross-discipline project were made public. According to Danish psychologist and ergonomicist Lis Ahlman, children are doing too much sitting, thereby damaging their backs. She is also critical of baby bouncers as "preparation for the TV lounger . . . the floor is the best furniture."[23] The Danish contribution included a high chair by Karen-Kamilla Kaer with an ergonomically spacious seat (in accordance with Ahlman's theories). A display supplied graphic illustration of the fact that child growth is, in effect, "downwards": head size changes least during life, while the legs proportionally grow the most. The Swedish group centred on the visually impaired, featuring a full-scale kitchen for the blind and partially sighted, and an "experience room" with "sound tent" for generating different sounds. Despite their popularity, television and computer games do nothing to encourage imaginative play or creativity. This is therefore an area where designers have an increasingly important role to play.[24]

At Copenhagen's 1994 SE exhibition,[25] Hans Sandgren Jacobsen showed a novel variation on the wendy house: a three-metre high wooden sculpture with "saddle" roof and integral swing, designed to fit in a limited space. Erik Krogh, head of Industrial Design at Danmarks Designskole, has been a dri-

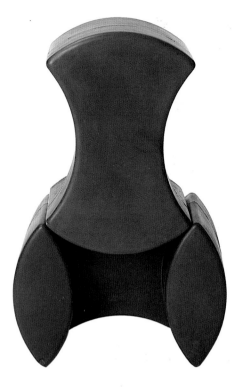

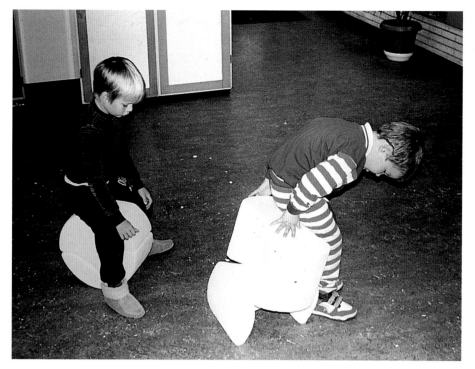

ving force in this field. "This is an incredibly difficult area. You have to jour-ney back into childhood, project your own childhood experience into the de-sign, and be a child in attitude."[26] He believes Kim Ellebo's stackable rubber "elements for sitting and lying" from his 1995 degree project show success in this exercise. Designed for the nursery, they offer infinite variations in sitting, and opportunities for play and mobility. Another DDS graduate, Steen Due-holm Sehestad, won an important Japanese design award for an origami-like stool, a translation of a torn and folded paper model into a stool of 2-mm sheet veneer. By contrast, Björn Dahlström, whose collection of colourful cartoon-inspired "animal furniture" also uses a minimum of wood, is one of the few young Swedes designing for children today.

Architecture critic Gunilla Lundahl has recently written a much-needed ac-count of how good architecture and design can be used as educational tools, providing spiritual and physical support for the child.[27] Having studied a range of nurseries and schools in Scandinavia and elsewhere, she discusses the significance of interior design, colour, light, furniture and the outdoors. Among her observations on Norwegian practice is the use of broad benches with crossbars as foot-rests, allowing different sitting positions and easy trans-formation of room space. Another feature is the *hemse*, a loft or two-level in-stallation with a staircase in between, allowing seating on different levels for storytelling. Swedish nurseries, by contrast, avoid stairs. Lundahl also singles out architect Erik Rasmussen's sculptural bedroom furniture, and the com-monly used fabric screens for creating space within space, from Waldorf phi-losophy. The increasing influence of Reggio Emilia philosophy is also reflect-ed in the more frequent use of easels although, in Lundahl's opinion, there is still a need for more tools for standing play.

26 Interview with Erik Krogh, Danmarks Designskole, Copen-hagen, February 1997.
27 See Lundahl 1995.

15
Stool in sheet veneer
designed by Steen Dueholm
Sehested, 1996.

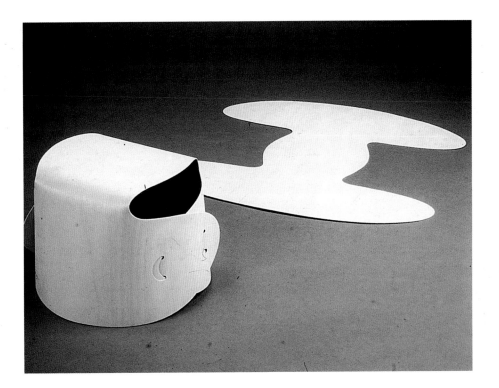

In the expanded children's department at IKEA opening in August 1997, children will slide through an "interactive wall", with creative play on tap with musical instruments, play houses and paints. IKEA's 28-page children's part of the 1998 catalogue is the result of three years' preparation, and features traditional and innovative furniture and fabrics, including a "play and learn" range, encouraging role-play, coordination and creativity, for nurseries and schools as well as the home. Numerous experts in child development were consulted, as well as families all over the world. Gösta Tyrefors of IKEA was introduced to Sweden's leading child specialists through the Child Ombudsman:[28] "We had to find out who exactly we were furnishing rooms for, and what sort of life was being lived in them."[29] One issue studied was how the physical environment of the home and nursery affects child behaviour.[30]

Although children in Sweden today have a much less cramped existence, the average child's room is still, at nine square metres, surprisingly small. The new low budget Trogen furniture range by Ann Svensson takes these constraints into account. Designed, like its 1950s predecessors, to grow with the child, the series starts with a nappy changing table that converts to a storage unit, and includes a bunk bed with adjustable desk and cupboard beneath. IKEA's "eco-range" features an egg-shaped crib by Robert Metell, a design student at Konstfackskolan, and represents a refreshingly new approach to an age-old subject.

Today children are seen as individuals with their own rights and identities, but the resources to support them are under extreme financial threat. So vulnerable is their position that, according to Norlin, "no other comparable group in Sweden has had to pay such a high price for budget restraints as children have."[31] However, both Laike and Lundahl have shown that creating

28 Founded in 1993, the Child Ombudsman promotes the rights of children and young people in society. They set up a cross-disciplinary network – Children, Young People and the Built Environment – that meets annually on International Women's Day, 8 March.
29 Interview with Gösta Tyrefors, IKEA of Sweden, February 1977.
30 See Laike 1995.
31 Norlin 1994, p. 18.

16
Animal furniture designed
by Bjorn Dahlstrom for
Pronova, Stockholm, 1995.

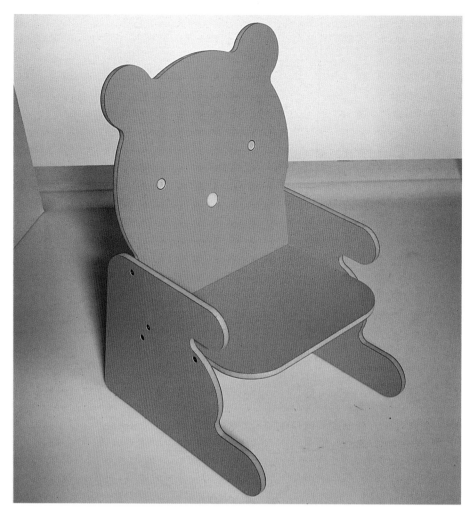

good child-centred environments need not be expensive; the importance of innovation and experiment cannot be overestimated. One example of successful innovation recently made the television news: a school in a deprived suburb of Malmö in southern Sweden gives children scheduled time in a "room of the senses", a white room with a water-bed and meditative light and sound.[32]

As for the home, a recent study reveals that children's rooms receive the least attention, and are not seen as being as significant as adults' rooms. According to Laike, "we must therefore increase understanding of the fact that children also need pleasant and comfortable surroundings."[33] A conclusion, sadly, not so very different from Ellen Key's in 1901.

32 The school is the Örtagårds-skolan in the Malmö suburb of Rosengård.
33 Laike 1995, p. 87.

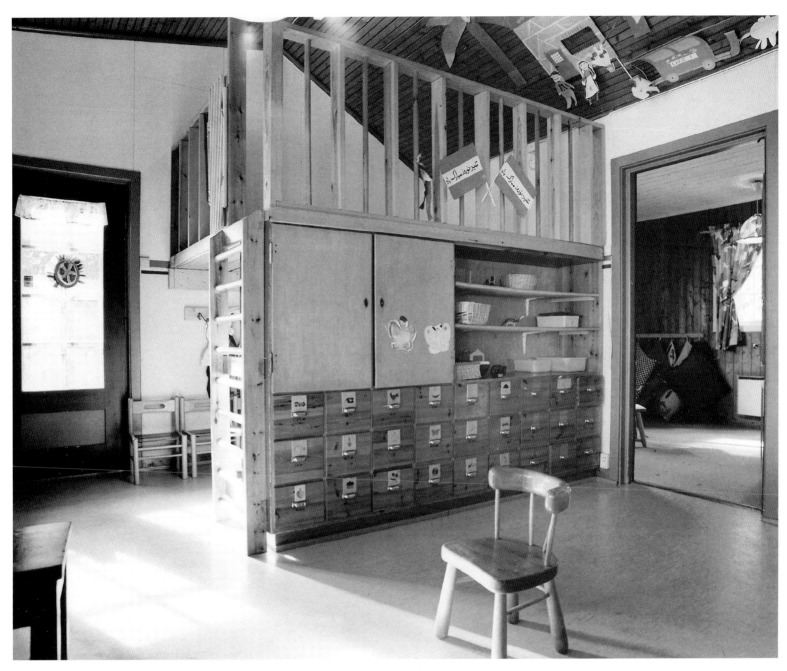

17
The hemse of a Norwegian
nursery, from Gunilla
Lundahl's book Hus och hem
for sma barn, 1995,
Byggforlaget, Stockholm.

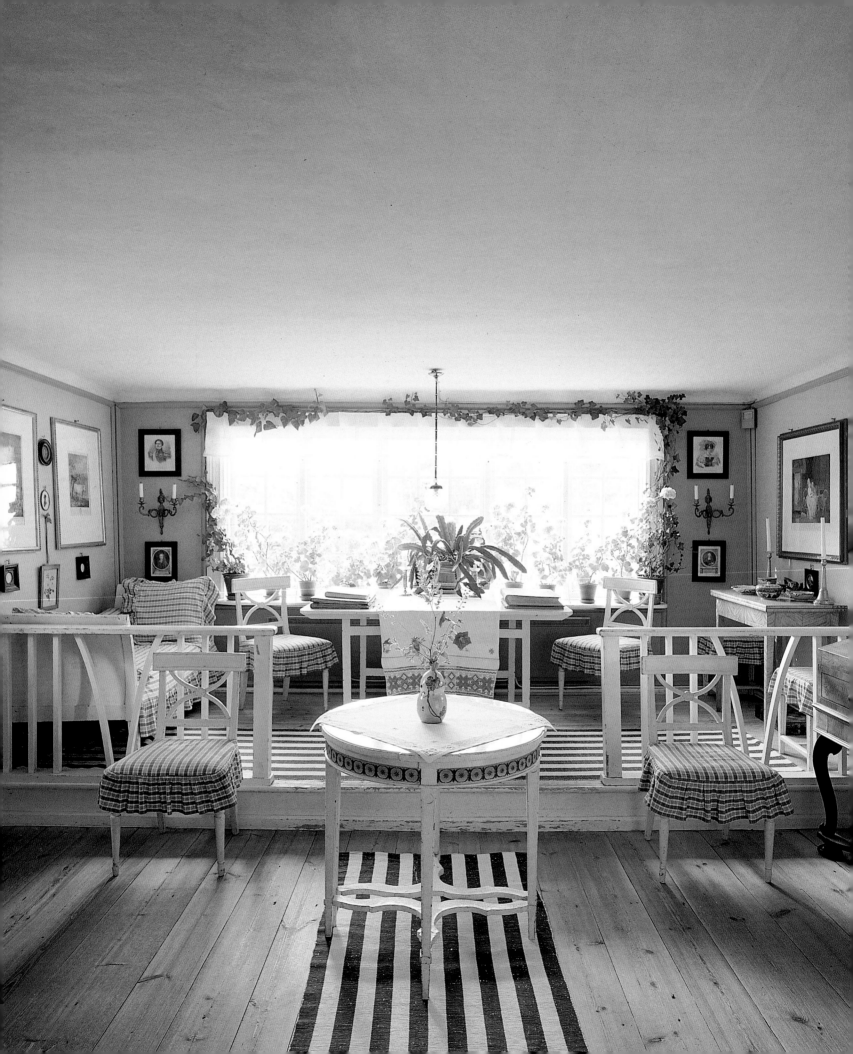

Stina Forsström

The Infancy of Fine Swedish Design

1
Living room of Carl Larsson's house in Sunborn, Sweden. The house was built at the beginning of the twentieth century in the style of the old houses of the Dalarna region. Several extensions were added as the family expanded.

The concept of offering products of good design and function at a price low enough for the majority of people to afford is hardly a new idea in Sweden: on the contrary, Swedish designers have been striving to achieve this aim (with varying degrees of success) throughout the whole of the twentieth century.

Around the middle of the nineteenth century, a number of Swedish individuals became enthusiastic advocates for more aesthetically based domestic life. Many were well-educated women from the upper echelons of society, who had both the time and money to create welcoming atmospheres in their own homes. Matilda Langlet, for example, had a clear vision of the kind of home environment in which children should grow up: "Children should be given the largest, sunniest room in the house, for children, just like flowers, need sunshine if they are to grow and blossom." Other important figures in this movement included Ellen Key, Carl and Karin Larsson and Svenska Slöjdföreningen, the Swedish Society for Industrial Design.

The Larssons, husband Carl and his wife Karin, were artists who lived in Dalarna, west central Sweden. The interiors of their home, Sundborn, have become famous throughout the world from Carl's charming watercolour paintings. It was Karin who was responsible for the decoration and furnishing of their home, clearly influenced by the British Arts and Crafts movement and, almost certainly, by what were still pioneering ideas in the journal The Studio. Their home became Carl's most frequent motif; he captured the light, bright, inimitably Scandinavian expression of Sundborn, with its great oases of open space where their children could play as they wished. The rooms were light and airy, with wooden furniture painted in bright colours and rag-rugs decorating the floors. The overall impression was of a home where children were made to feel welcome – a concept which, in those days, was far from the norm.

Swedish homes of the late 1800s were dark and murky, mirthless places cluttered up with heavily tasselled and ornamented furniture – hardly the kind of setting conducive to childish high spirits. However, voices were being raised from within the Swedish design collective, a counterpart to the British Arts and Crafts movement. There was talk of developing a more "honest" approach to the design of everyday objects. If artists were given the opportunity to work together with industry, they could help to ensure that products of good quality

2
Puzzle, chair, stool and table
in plastic, designed by Knut
Hagberg and Marianne
Hagberg, 1987.

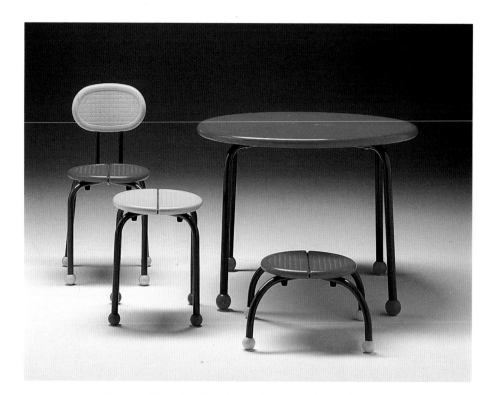

became accessible to all levels of society. The brainchild of the Deutscher Werkbund – a confederation of German architects, designers, theoreticians and entrepreneurs set up to bring a greater sense of propriety to the industrial design market – this idea fell on receptive ground in Sweden, where the highly active Svenska Slöjdföreningen was already involved in making Swedish art and craft more widely accessible, and encouraging the working classes to introduce more aesthetic elements into their daily lives. Another important milestone was the publication in 1899 of Ellen Key's pamphlet Beauty for Everyone, which was refreshingly frank in its criticism of everything uncomfortable, impractical or just downright ugly: "Not until there is nothing ugly left to buy, not until it is as cheap to buy what is beautiful as it is to buy what is ugly, not until then can beauty for everyone be a reality."

One aspect of the Svenska Slöjdföreningen's work was its efforts to develop better furniture for the working classes. Its Ideal Home Exhibition in 1917 showed proposals for how to furnish one- and two-room apartments for the urban proletariat; it was a huge public success, attracting over 40,000 people to the private Liljevalchs Gallery in Stockholm. However, its social aim – to communicate to the broad masses the value of simply designed, inexpensive furniture – was somewhat overshadowed by reality on three fronts. First, most of the visitors were middle-class, and had already accepted such ideas. Secondly, despite good intentions, the furniture shown was far too expensive for its intended target group. But the main reason why the working classes cold-shouldered the exhibition was probably even more down-to-earth: the 50 öre entrance fee represented more than one hour's wages for most workers, and was far beyond their means.

Fortunately, the next major manifestation of good design was more successful.

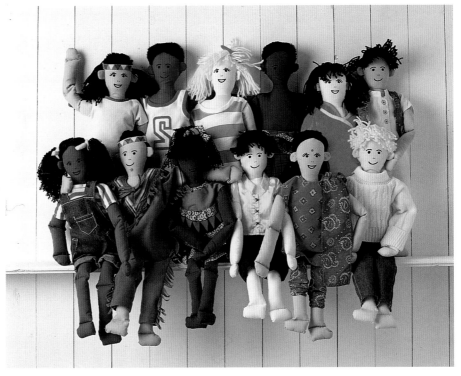

By the time of the Stockholm Exhibition of 1930, modernistic utilitarianism had taken root. Bolstered by the radical ideas of the Bauhaus and the influential Stuttgart exposition Die Wohnung of 1927, beauty had become synonymous with good form and function adapted to industrial production. From now on "the home" was not merely a question of layout and interior decoration; it became a social issue as well. Not even politics could escape this spirit of reform. Sweden's then prime minister, Per Albin Hansson, laid the foundation for what came to be known as "the Swedish people's home" when he decided that young families should be given generous loans from the state to buy and furnish their own homes. However, the 1930 Exhibition did, sadly, share one thing in common with the 1917 one – urban workers still could not afford the price of good, functional objects. By the same token, even fewer had the resources to think about furnishing bright, welcoming nurseries for their children.

Swedish interior design blossomed during the Second World War years, due in no small measure to research conducted into improving domestic environments, and to highly popular evening courses that gave home-owners an insight into interior design, furniture and materials. At the same time, people also started to take seriously the earlier entreaties of Carl and Karin Larsson to make their homes hospitable to children. At last, children's needs were being addressed by giving them room to play throughout the home. Pleasant, welcoming environments were being created for the benefit of both children and their parents.

The Infancy of Children's Design

The home furnishings company IKEA is undoubtedly one of the forces that have made such hospitable homes a reality since the war. Originally from the

4
Krokko, wood and fabric
crocodile, designed by IKEA
of Sweden, 1994.

5
Mammut chair, made of
hardboard and polystyrene,
designed by M. Kjelstrup
and A. Østgaard, 1992.

province of Småland – an area where poverty, frugality and perseverance have always been part of life – Ingvar Kamprad became a successful businessman who was driven by a vision to make a better everyday life available to the majority of people. Over the years, his small-scale business has grown to become a huge home furnishings company, unequivocally on the side of people with limited budgets. Perhaps those who have derived the most benefit from this are young families with children. Washable rugs and sofa covers are examples of products adapted to meet real needs and demands, so that the entire home is open to children rather than just one designated part of it.

In the early 1990s IKEA extended its scope by introducing a functional and appealing range of children's furniture and toys. For a company which had risen to prominence on the back of production-adapted manufacturing, where the key factor is always the economical use of materials and manufacturing resources, this represented something of a new departure. Low prices continue to remain an important goal, but this time the starting point is not spare production capacity, but something quite different – the needs of the parents and the children themselves.

To this end, some of Scandinavia's most prestigious child specialists were drafted in to assist with the project. All the employees working on the project were sent "back to school", to learn more about the importance of childhood. IKEA set up a unique School of Childhood, complete with classrooms, teachers and even a headteacher. Employees studied the psychology of child development, as well as being given practical tasks such as finding their favourite toys from when they were seven years old. IKEA is following up this formal course with regular in-service staff training in all its stores.

The range was split into sections to satisfy the needs of children during different stages of their development, and includes both practical items – such as a baby's changing table and a seven-year-old's homework corner – as well as objects for stimulation. What does a child need to develop in the most positive way? With toys, for example, the main thing is not just that they are fun to play with, but that they also stimulate the child's senses and encourage it to develop. Hence the evolution, from what was originally a single playmat, of an interlocking, jigsaw-type roadway play system. The separate pieces stimulate the child's imagination in different ways, enabling endless new road layouts to be built and dismantled in different shapes, even around corners and furniture legs.

A children's rug was developed with the distinctive pattern of hopscotch squares woven into the pile – a simple but effective way of encouraging even high-rise city children, for whom safe access to the outdoors can be limited, to hop, jump and develop their sense of balance and motor skills. With the squares clearly marked from one to ten, the rug also teaches children to recognize numbers and to learn to count while they are having fun.

Cooperation with child specialists was invaluable, but when it came to deter-

6
Kommun series, a toy town with combinable elements including fire stations, police stations, etc. Made of rubber, hardboard, steel and plastic, designed by Anna Efverlund, 1996.

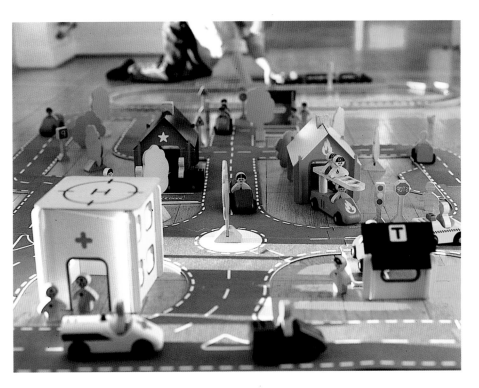

mining whether or not an item was to get the go-ahead, the children's reactions were always the deciding factor. To be sure of spontaneous and impartial answers, a number of crèches, kindergartens and nursery schools acted as test panels. The selection process was simplicity itself: if the children did not like a toy, out it went. The criteria that they applied – whether a toy was fun to play with, nice to look at, fun to chew – were accorded equal importance alongside the requirements laid down by the specialists eager to ensure that motor skills, creativity, sense of logic and artistic talent should be properly developed.

Only when these two diverse inputs had been analysed were the designers and design engineers invited to develop a production prototype. All the products are manufactured from non-hazardous, non-toxic materials, natural wherever possible. No toy has anything to do with war, violence or oppression. Safety tests involve the most stringent law in the most restrictive market.

The furniture for children's rooms will be in use over a long period of time, so it needs to be versatile, serving more than just one function. The baby's changing table can become a bookshelf, and the various components in a cradle can be reassembled to make a child's wooden sofa. Furniture for slightly older children is designed so that it is possible to extend and adapt it as needs change. IKEA's manifesto for the children's range is ambitious: "We believe in a childhood filled with positive memories, and this is why we are concentrating on products which encourage children and parents to do things together. Products which not only fulfil a need, but also create the right conditions for development and creativity in childhood." To take the emotional and physical needs of children seriously is an extremely important task: it is, after all, our children who are the future.

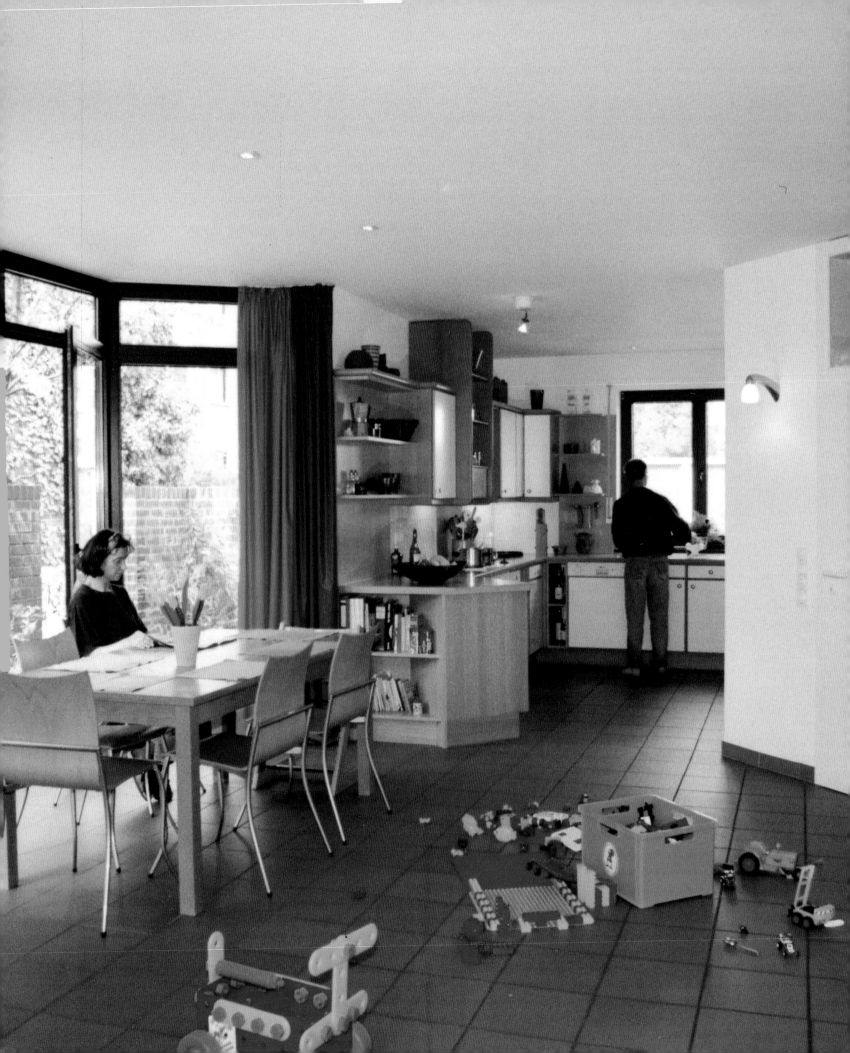

Elisabeth Dessai

Living with Children

2
Raising chickens near the house; children are integrated into economic life (Mahle estate, Stuttgart, 1936).

1
Open-plan kitchen in a modern terraced house, an integral solution, provided that the children are truly tolerated.

Before industrialisation the majority of the population lived in the country, as it still does today in parts of the so-called Third World. Children could always be involved with manual labour in the fields and in the stables, and could easily learn to understand it; many had to start sharing the workload from an early age. The transition from playful participation to responsible work was seamless. The adults' place of work was at the same time the children's place of learning. Peas did not come dried from a jar, they came in pods from the garden; and the children were present at sowing and harvesting. Meat did not come from invisible animals, but from pigs and cows which often had names; the children were present when they were born, raised and slaughtered. Heat for cooking did not come out of a socket, but from a home-made fire; the children learned from an early age, by observing the hungry flames, that fire needs feeding and that energy does not come free.

Even in towns, craftsmen and artisans lived next to or above their place of work; at the end of the nineteenth century, they still kept livestock for their own requirements. The manual labour of the artisan was comprehensible to children. Tools did not come from a factory but were made on site, where the children could see. Methods of work, technically comprehensible to observant and participating children, constituted their intellectual stimulation: at a spatial level, play and work were not separated.

Industrialisation brought with it the separation of the work space from the living space, and thus of working and playing. Family-run artisans' workshops ceased, to be replaced by machine production which had to take place in large plants. Exclusively residential areas evolved in cities, where there was no trade nor any keeping of livestock.

Where poultry are freely roaming around and adults are involved in manual work, the living environment is always eventful. Children like playing in the open air. Their space is not specifically a "playground", but a multifunctional space which includes playing in its purpose. Such informal places for playing are today found only in technically undeveloped areas.

The residential areas in the developed world are no longer places of production. Since the employee who works in an office or factory no longer requires a work space where he lives, all the free space can be treated like a garden. But

3
A purely residential area in Germany, with playgrounds installed for children.

when there are children, part of this green area must be sacrificed – to form a playground. Children, however, are bored by official playgrounds with sandpits and slides, while adults find them aesthetically unpleasing. Elderly residents, a growing number, may consider children playing in strictly residential areas as too noisy, leading to innumerable complaints.

Children's natural urge to be physically active, then, can no longer be satisfied outside the front door. Informal play in informal spaces disappears, a lack of freedom of movement which is compensated for by organised movement in sports clubs. Mothers become chauffeurs.

Within the home, formal rooms – where playing may be taboo – can limit the child's scope for expression, especially if they restrict the way in which adult family members can provide protective company for a child. All small children crave protection and human contact. Playing around the feet of adults makes casual conversations possible and thus benefits the child's in-

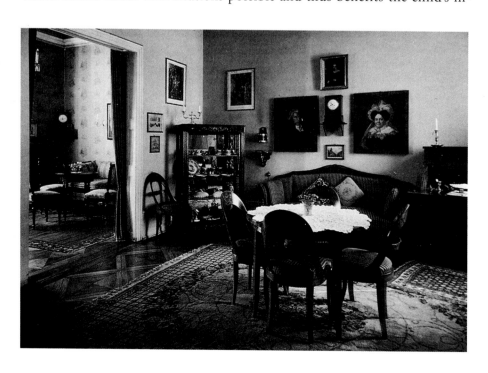

4
The salon in a nineteenth-century middle-class house, an elegant meeting place for adults. Children play in the kitchen area.

The kitchen in a middle-class house, c. 1850. This room, the active centre of the household, is a stimulating place of learning for children.

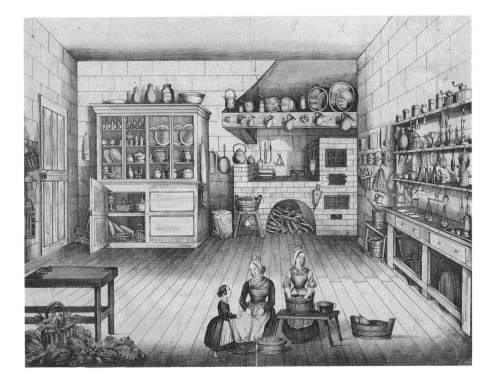

tellectual development. It should create no problems if there is a hard-wearing space within, say, the cooking area, which is also designated for playing.

Until the introduction, seventy years ago, of the minimal "galley" kitchen, all dwellings offered children possibilities for play within the area occupied by adults, whether they lived in a hut or a villa. This was because the living quarters comprised work spaces, or a mixture of work spaces and formal rooms, but never formal rooms alone.

Up to the eighteenth century, the kitchen in wealthy houses formed part of the hall; later, cooking was separated from the places where visitors and family were constantly coming and going. The rich, who could afford to heat several rooms, transferred eating to a separate dining room, and received guests in the parlour. These elegant and expensively furnished rooms were not suitable for creative children's play.

When bourgeois family members dined in a room removed from the vicinity of the kitchen, class differences between them and the servants were underlined. The kitchen eventually turned into an area for servants alone, where the mistress appeared only to give instructions. The desire to remove the process of cooking, including the people who did it, from the family living quarters resulted in the transfer of the kitchen to the basement area.[1] A dumb waiter then facilitated the delivery of food from the kitchen to the dining room above. The bell rope, used to summon the servants, became the symbol of this distance.

The fact that the elegant rooms were out of bounds for playing children did not necessarily limit their scope for self-expression. A middle-class villa does not consist entirely of formal rooms, but also of rooms where servants did the

1 Kastorff-Viehmann 1988.

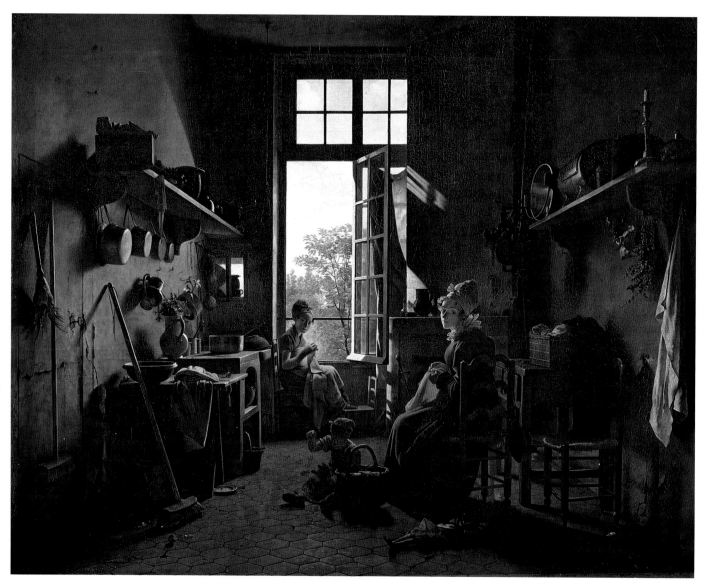

6
A middle-class kitchen, early
nineteenth century.

2 Dessai 1997.
3 Muthesius 1920.
4 Krausse 1992.
5 Günter 1995.
6 Dessai 1976.

housekeeping. These were designed for heavy use, so active play was not in the way; here, the children could be creative in the protective company of people who were familiar and trustworthy, but who were not members of their family.

The "best room" which, by the nineteenth century, wealthy farmers and artisans were adding to the kitchen and living room, was not equivalent to the parlour of the bourgeoisie. The latter, designed to emphasise the difference between master and servants, was in use on a daily basis by adults who never engaged in manual labour, contributing to their children being kept at a distance. The farmer's or artisan's best room, on the other hand, heated only on Sundays, had the function of differentiating rest days and holidays from ordinary working days, and was out of bounds to everyone during the week. Here, the working adults were not involved in sophisticated activities, but came home with dirty clothes and muddy boots.[2] So the banning of play in the best room was really no limitation on the children, whose centre of activity remained the large warm kitchen, where all housekeeping activities took place and where both young and old congregated. These children could

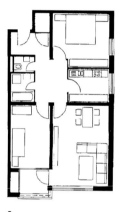

7
A kitchen-cum-living room in a rented flat in Düsseldorf, 1928. Children play in the adult work area.

8
A "galley" kitchen in a rented flat in Düsseldorf, 1976. Children are supposed to play in their own room.

9
A modern kitchen-cum-living room in a rented flat in Düsseldorf, 1994. Children are once more allowed to be creative within the adults' work area.

be creative in the company of both non-relatives and their own family members.

As a room designated for holidays only, the best room is rarely used, and socialist planners have always criticised this waste. Hermann Muthesius, however, co-founder of the Deutscher Werkbund, understood the desire for a room that was always attractive and tidy, which would not cause embarrassment at the arrival of an unexpected visitor: "One may hold whatever one wants against the 'best room', but it will not be easy to find a means to satisfy the occupant in a way that this room does."[3]

At the end of the 1920s the Viennese architect Grete Lihotzky designed a minimal functional kitchen for the quick execution of domestic chores; known as the Frankfurt Kitchen, it was based on the built-in kitchens of the German Mitropa train catering service. This "galley" kitchen, without a dining table, is widely used in modern housing developments. According to Joachim Krausse, its proponents regard the combined kitchen-cum-living room as a "lower form of living", and want to encourage people to dine outside the kitchen in a bourgeois fashion.[4] One effect of the desire to ban eating from the kitchen is the enlargement of the best room to compensate.[5]

The decreased size of the kitchen constitutes a major infringement on the child's freedom for creative play. Drawing and making a mess was always allowed at the table in the kitchen-cum-living room; the dining table in the best room, however, must be protected from such use. The living room is now the sole room in which children can play, and they invade it with all their toys. Since this causes a mess, a conflict emerges between adults and children regarding the use of this room.

Children's comprehension is fed by activity. They can make a mess in a room which adults also use for productive work without causing havoc, but in rooms designed for relaxation or for public display, such activities do, of course, cause disruption. Living rooms that serve the purpose of formally receiving guests do not tolerate creative children's play. Delicate furnishings cannot withstand dirty fingers. Since a room cannot be play room and parlour at the same time, battles for the "defence of furniture" are increasingly fought in formally furnished reception rooms.[6]

There are parents, of course, who make a point of not furnishing their home formally and who make no distinction between the best room and the living room. The furniture is hard-wearing and not expensive, and does not require extra care. In this kind of family, the living room is also the play room. Children are accepted as children, and adult guests are not received separately in the "parlour".

But in many homes the room which is called the living room is really a "sitting" room – one in which children may watch television, but are not allowed to be creatively active. The desire to protect expensive furniture from investigative children leads to the stress of increased scolding. Children who are

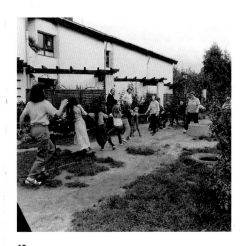

10
Living with children in
Moers, 1982. The private
gardens lead into a
communal garden.

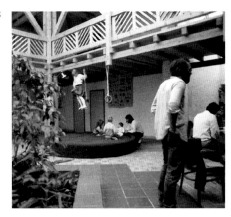

11
Modern communal living
with children in Les
Palétuviers, Linz-Leonding,
Austria, 1975. Access to the
flats is through a bright,
communal room.

7 Dessai 1985.

shooed away to play elsewhere may develop aggressive feelings towards their parents, who are perceived as not wanting them around. Such children soon learn that the formal living room belongs to the adults. But since the yearning for family protection and human contact is stronger than the fear of being told off, children will keep taking their toys back to the living room so that they can be with the adults they know and trust.

A decreasing birth rate, increasing life expectancy and more and more divorces result in a rising number of households without children. In Germany and many other countries, households with children are now in a minority. Buildings with several flats can be particularly attractive to residents and developers if there are no children about: the common parts remain swept and clean, and the entire garden can be an aesthetic delight for the adults. The desire to live in a child-free environment results in an increase in value and price in properties where there are no children.[7]

Planners for the future are concerned about increasing intolerance towards children's play, and are raising the issue of living arrangements that might be more child-friendly. In 1975, a community-based association was founded in Moers called Wohnen mit Kindern [Living with Children]; it works towards the inclusion of children's living needs at the planning stage of housing projects. House rules are developed which require residents to be tolerant towards children playing in the open air and to encourage it. All over Germany and Austria, parents are forming groups to live together as child-friendly communities, but most of them fail when it comes to finding suitable houses. In the projects initiated by Wohnen mit Kindern, active children's play is encouraged through space provided in car-free areas. The flats contain not only children's rooms, but areas within the domain of the adult family members which can withstand creative activity.

"Children need a hundred parents," said the Austrian architect Fritz Matzinger who, after visiting Africa in the 1970s, developed the idea of community-oriented "living villages". In those that were built in Linz and elsewhere, flats are grouped around a communal room with a glass roof to give light all year round, a layout that leads to many casual encounters with neighbours. Living with children is emphasised, and the adults feel responsible not only for their own, but also for their neighbours'. A new form of community-oriented living is also practised in several other Wohnen mit Kindern projects. In Dortmund, for example, terraced houses are grouped in a semi-circle around a communal house, which is intensively used by both adults and children.

The demand that children should be allowed to play in the kitchen area was largely unacceptable to planners in the 1970s. In the 1980s more and more people opted for the kitchen-cum-living room, a trend that is gathering pace today. The change in attitude has several causes. Where partners share the kitchen chores, a narrow galley for only one person is obviously unsuitable.

12
Living with children in
Dortmund, 1994. The
occupants of the estate
share a communal house.

New trends in eating habits suggest fast food for the weekdays, gourmet food for the weekends.[8] The preparation of elaborate food in the presence of guests is impossible in the minimal functional kitchen. In order to enjoy a sophisticated menu in the company of friends, hosts must have a dining table in view of the preparation areas and the cooker. And in a kitchen where adults make a mess when cooking, any mess a child makes on the table is not a problem.

8 Tränkle 1992.

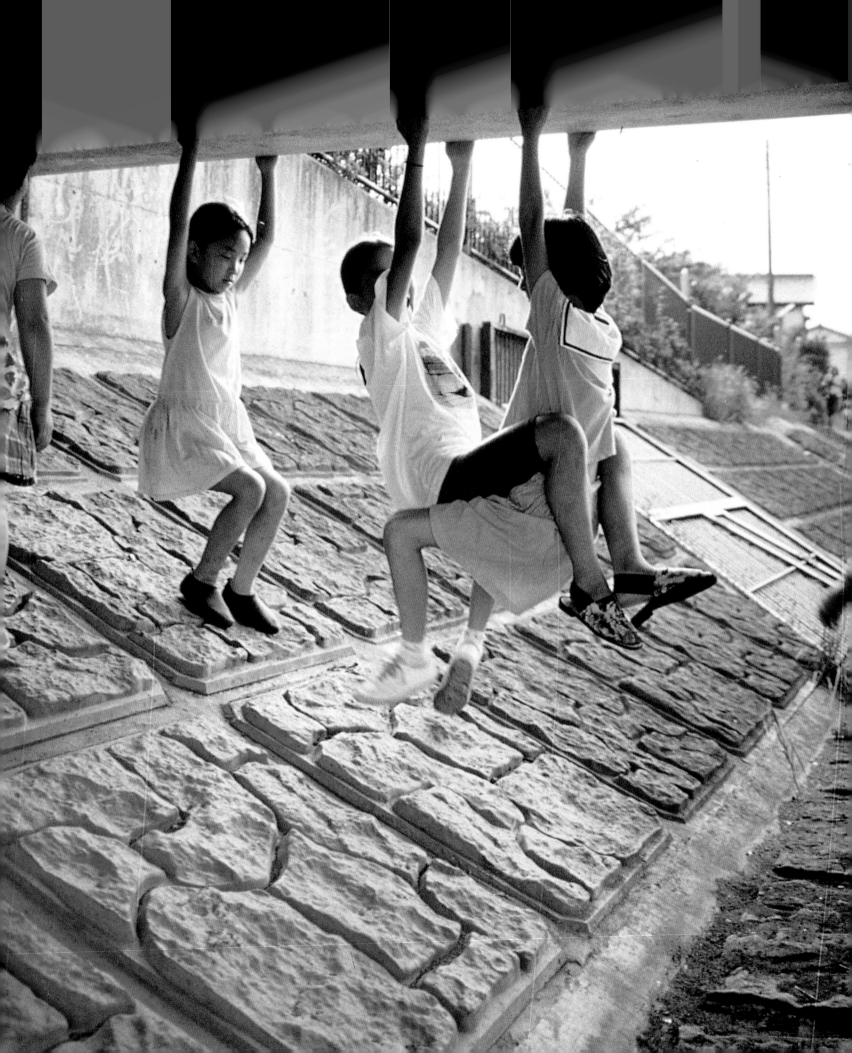

Massimo Alvito and Giulia Reali

Small Hands on Tokyo: urban icons in contemporary Japan

"There is a shift from simple 'projections of desire' to a more sophisticated 'acceptance of otherness." Xavier Bensky and Usman Haque, Neo-Tokyo

Glimpsing Children

Our shared idea of Japanese children is an unnecessary extension of the mental map of Western thought. In reality, the world of children in Japan is made up of much more than such simple truisms as: over-authoritarian education, a high rate of suicide and violence among the young, conflict between tradition and modernity. All too frequently, these stereotypes turn into one-way misunderstandings.

Let's try to catch a glimpse of Japanese children, bearing in mind the all-pervasive and shifting Japanese urban environment; let's try to get a bottom-to-top perspective on an extremely vertical society, without claiming to have illuminated and resolved, once and for all, the misunderstandings caused by our lack of familiarity with a culture we still perceive as exotic; let's try to grab hold of those "small hands" grasping at the amoeba city – Tokyo itself – twenty-four hours a day.

Then, perhaps, it will be possible to say something more about the children of Tokyo: the city which connotes the most significant aspects of a broadly urbanised society. It would be a more than satisfactory outcome, should our glimpse reveal even a small part of the lifestyle of Japanese children. For there exists evidence that the lifestyle of children is the most reliable index not just to the quality of life, but to a city's ultimate "meaning" as well.

Furthermore, on another level of analysis, children's reputation as possessors of a deeply rooted and highly intelligent mechanism of acceptance/refusal makes them the favourite target of both the planners of urban and social policy, and of whole industries wishing to penetrate the market for "not-just-for-kids" products. At once trustworthy and important testers, and influencers of grownup purchase decision-makers, children are put in the position of evaluating and confirming a product's success.

A look at contemporary Japanese children sheds a certain light on what it means to live in a society that, while denying that it is doing so, loves to overturn a generally accepted model, by giving enormous importance to what a child may like, want, see or think. What is more, this look will yield examples which, for all their undeniable interest when viewed from our remote, Western standpoint, can prove hard to interpret or even dangerous to follow, when

1
Checking out the amenities of Tokyo.

placed in the broader context of our growing overall knowledge of "other" children's worlds.

Here we have chosen to go East, in order to show that children's points of reference and outlook may pervade a whole society, perhaps making it more livable or enjoyable than it might otherwise be, and certainly keeping in check the adult world's ambition to normalise things. The question as to whether such a "kid-oriented" society is not made up exclusively of things meant for children is surely destined to provoke serious debate. And yet, from an East-Asian standpoint, such a holistic approach to "children's issues" may turn out to be the most orthodox.

We have thus adopted an epistemology based on the semantics of the Japanese word miegakure, meaning "to glimpse" (or, more literally, "to be seen while hiding"). Miegakure is less a form of the subjective act of seeing than an objective aspect of the act whereby one allows oneself to be perceived partially, to the extent that one wishes. It can also mean "to become invisible from time to time". By way of this cultural shortcut, we may enter into a closer relationship with aspects of the world of childhood in a society which, when viewed through Western logic, appears incomprehensible.

Touching the City

Children in Japan love the city and its streets. For them, to touch the city is to make an image of it. And it is precisely here that they allow themselves to be glimpsed, in the context of a particular image of the city, one which they themselves offer us. Traditionally, in Japan, the image of the city has been the outcome of the chaotic overlay of succcessive horizontally distributed strata. Hierarchies are "zoned" by basic functions. In modern times, and especially since

the 1960s, this type of order has become obsolete, unrecognizable, outmoded. With its capacity for shattering all existing order in order to propose new forms of order, and its ability to catch glimpses of alternative conceptions of the city, children's vision has helped the New Urban Thinkers who started turning up in the byways of the Japanese mainstream in the late 1970s with proposals for alternative planning procedures.

Tokyo wagered that it could rebuild the city most cohesively by shifting attention from the framework of space to that of time. In an urban context lacking tangible signs of the past, this idea provided the necessary impulse for that mental recovery of an ubiquitous Nature: an impulse which has made of Tokyo a most surprising adventure park for city-walkers and newly converted Nature-lovers alike. In the course of the Eighties, there arose a new way of "reading" the city, one which became fashionable during the ecology-conscious last years of the decade: city-watching. It was a full-time job for the hardened collector of unusual images, and a mandatory curriculum for the hundreds of children who went about armed with a basic kit of pencil, paper and daily train ticket. One can still run into them today, generally in groups of three, on foot, away from the most heavily trafficked streets, hunting for the source of some urban river which has vanished beneath layers of reinforced concrete.

The children of today's Tokyo like fast things, since they themselves move so fast. They want to be both here and there, especially at the pinnacles of skyscrapers – but also even higher up, in helicopters, like birds. When they draw their neighbourhoods, they manage to come up with high-resolution maps showing details that a professional planner or the "man in the street" doesn't see, even after having walked by it a thousand times or made a topographical relief. They draw rare bird's-eye views of that aspect of their lives they know

4
Tokyo metropolitan kid.

5
Tokyo metropolitan kids.

best: streets whose thousand hidden nooks and crannies are like secret drawers meant for hiding things from outsiders' indiscreet gaze; streets they are really in a position to use, in such a way as to determine the success or failure of its design, its amenities, the urban setting it provides. The children who move through Tokyo's streets know where to go and when to halt and, if it can be done, how to extract from a place its most unusual aspect, rather than just its best one. It is they who limn the true portraits of places people are no longer able to see.

Public debate on topics such as "the loss of spaces where children can live and play" in contemporary Japan has died down since the late 1980s, as a result of the comparative success of participatory planning actions involving children in a "professional" role. At the same time, the creativity of architects who started to "play" with the city, viewing in the ludic perspective of the Japanese form of Post-Modernism, has raised the problem of Toyko as a mechanism of space-time set in motion by new generations. Alongside this specifically urbanistic phenomenon, there are all the various representations of the Japanese city in general, and Tokyo in particular, as it appears in the comic books known as mangas and, thus, in the imagination of young urbanites as well.

A look at the figures is itself sufficient to show the extent to which Japanese society is urbanised: nearly half of the country's 123 million residents live in the three principal urban areas, with Tokyo in first place, its 32 million inhabitants constituting 23 per cent of the total. And when one compares the quality of life there with the world's other capital cities, it doesn't take more than a moment to imagine the extent to which Tokyo's million children may feel comfortable there.

Absurd? Incredible? It may look that way, and it may even be untrue by Euro-centric standards. But it's not a question of environment and education, open spaces and freedom of movement. After all, Tokyo's children have no access to such high-added-value things as large urban parks or coeducation. And it's not even true that Tokyo kids have no-wait access to every conceivable type of information. Strange as it may seem, in the High-Tech Empire there is, as yet, no information overload: at least, not in terms of all those zeros and ones issuing from the smart boxes called PCs. Although abroad, everyone thinks that every Japanese has one, by US or European standards, few families there do possess a computer. The issue is a different one: for a child in Tokyo, "being there" means being an explorer who, day after day, goes out to discover the city, and who shares his discoveries by means of mechanisms and languages going beyond the simplistic logic one might expect from the representatives of exotic childhood.

The Japanese city thus becomes a full-scale laboratory, a truly organic machine made up of places and objects, criss-crossed and brought to life by practices, cycles, and rhythms whose principal agents are those same commuter-children who take the suburban trains early each morning and late each evening. After this sec-

ond trip, off they go through the streets of the city's outskirts, on the way home after an eighteen-hour day of school, study and play – just like every other child whom we think we know! They move securely, thanks to a support system that means their mothers don't have to go pick them up. There's no time for that, nor is it necessary when there's someone else to worry about the kids' safety.

The city itself takes care of everything, providing whatever is needed to keep Tokyo youngsters in a place known as mai homu ("my home"), which they are free to use as needed. A city that does that is a well integrated, kid-oriented mechanism, whose urban places make ample allowance for the physical limitations of children, so as to "include" the latter in all their numerousness. An entire urban economy has grown up around Tokyo's children; at the same time, these children, by the simple power of their presence and involvement in so many phenomena, give rise to new meanings for such terms as "megacity", "consumer", "identity", and "Nature".

Urban Icons

The metatrends that inform Japanese urban society at the dawn of the 21st century constitute the matrix of all the phenomena acting at that society's deepest level, feeding currents of sensibility and strategies of behaviour in an historical and cultural perspective peculiar to this particular context. Thus it is, for example, that the cold rationalism and sterile herd behaviour that dominated the world's mass-media image of Japan during the Eighties have increasingly made way for a neo-individualism enriched by a typically "Nineties" multi-faceted sensibility.

Such metatrends correspond to precise narrative programmes, and show up as icons, first and foremost, in the material reality of the production of items

7
The human touch of
humanity.

meant for mass consumption, in accordance with rites and cycles characterised by a strong tendency to standardisation. This is how it happens that an historical-cultural path and consumers' actions converge and take on physical form in what we recognize as an "urban icon".

Urban icons are the visible representation of a shift in meaning necessary to the metatrends that drive Japanese society from below, nourishing its inborn need for novelty. The value of such icons depends upon their belonging to a setting – the urban one – and corresponds to a need to give shape to trends before they become tensions; to desires before they turn into compulsions; to the pleasure of knowing about something, before that knowledge turns into a need for possession.

In Japan at the turn of the millenium, some urban icons draw inspiration from the world of childhood, and are incarnate in the forms of a "kid-centred" world. A world, this, which, first and foremost, cuts across the world of grown-ups, giving it the biological rhythms it requires, enabling it to ensure itself a needed continuity, and leaving it free to meld its own being with a hidden sensibility: that of the non-childish child.

The various urban icons are thus keys unlocking the aperture through which we may catch our glimpse of the SHOTS, the Small Hands on Tokyo of our title. By seeking to penetrate the deeper significance of these various urban icons, we may grasp hold of some of the metatrends that permeate and explain today's Japan and, more specifically, the material world of Japanese children.

What are they, these Small Hands on Tokyo? Where are they coming from, and what are they telling us? Are these the perverse hands of a tiny but expert consumer, or the living, gesticulating hands of a little actor who brings life to the city, making it viable, not only for himself, but also for its millions of inhabitants? The better to understand and deal with this problem (without, of course, claiming to resolve it once for all, given the non-definitive, imperfect quality inherent in these shifting metatrends), let's see how the most extreme and advanced urban icon works: this is the Digital Playmate (DP).

The DP's emergence in Japan is distinct from the context of the debate surrounding the issues of new media, the digital era, and the role of cyber-culture in the world, because Japan is a digital nation of a special kind. There, there is no talk of children's cyber-rights or of freedom of digital speech. The cyber-kid doesn't exist there – at least, not in the form imagined by the pseudo-scientific fantasies of students of the new media. In Japan, the cyber-kid does, in fact, exist, only he's not a child who goes on-line at every opportunity. He is a virtual, purely electronic being, even if he can be loaded up with all the emotional, behavioural, physiognomical and personality traits one might expect in a digital individual. He is a product of the "edutainment industry", and he gives concrete form to the wish for cyber-kids in the imaginary world of the manga comics, conferring legitimacy upon the debate surrounding that world, by giving it a point.

8
Tocho (Tokyo Metropolitan
Government Office), drawn
by Small Hands.

The DP, a product conceived, designed, and produced for children, has become a phenomenon so widespread as to involve teenagers, businessmen and the whole population, with no limits of age, sex or social level.

From a decent level of sales to a large-scaled, feverish epidemic: that's the story of Tamagotchi, a Highly Interactive Digital Pet. It's an example of a phenomenon which, originally aimed at the world of children, has grown to the point where it has become a model for the society as a whole. It's a childish model that permeates the entire city. This "model-hood" makes it the current urban icon par excellence.

Tom-ah-got-chee

Tamagotchi (whose name, in Japanese, means "lovable egg") is the latest Japanese electronic gadget: a little egg-shaped gimmick with a minuscule liquid crystal screen, immediately below which are located three round push buttons. Small enough to fit in a child's hand, Tamagotchi requires that its master/player give it his unwavering attention; with sufficient affection and food, it can become an adorable virtual-reality pet, with a life-span of up to twenty-five days. There are various combinations of buttons for feeding it, playing with it, vaccinating it, punishing it, grooming it. As a digital pet, Tamagotchi is an extraordinary and unusual chick, capable of breaking through its virtual shell, but not of escaping from its cage (available in a range of six different colours). "It can grow with you as much as you can grow with it," proclaim the commercials.

We have identified the Tamagotchi as the ultimate urban icon, the one that best interprets and translates "trickle-up", a phenomenon we shall analyse further along. This virtual game differs from other virtual objects such as Date Kyoko, the Digital Kid designed to provide the exact opposite of gratification, as this term is normally understood, for the love and devotion lavished upon her by young Japanese can never be returned. DKs of this sort express a dependent relationship based on the principle of amae (love for a passive object).

But the Tamagotchi – a digital baby animal meant to be adopted, raised and perhaps even buried in an on-line cemetery at the end of its brief life, in accordance with either Buddhist or Christian ritual – is charged with an affectionateness of its own which it is capable of trasmitting or activating, thus involving its owner, who is, accordingly, induced to behave responsibly (first by adopting it through buying it, then by taking care of it, feeding it without overfeeding it, unless he wants to find a fat, spoilt chick shut up in its pixel-displaying cage).

Stereotypes such as "in Japan, there is a lack of space," or "the Japanese are very busy people," have brought it to pass that the Tamagotchi, launched as a plaything, has been transformed into something to be presented and justified as a real pet baby animal, one less demanding than a puppy in terms of space and time. These arguments in favour of the product are set forth as though it were aimed

at adults; and it is well known that Japanese adults are often credited with a need to take on board "therapeutic" instruments like the Tamagotchi-chick.

Such interpretations of the Tamagotchi as a "magical object" for adults present the electronic chick as belonging, in reality, to the category of "cult objects": items meant not to resolve serious and real existential problems but, instead, to produce pleasure by corresponding vaguely and ironically to the problems encountered in daily life, problems such as the need to express one's need for affection, or the desire for social contact.

Along with this vision of the Tamagotchi as a curative object, there exist further readings: for example, it can be seen as a device for training Japanese girls for motherhood. ("Make your digital pet grow up healthy, and cure it with medications as needed, should it fall ill.") In this case, the game's appeal would be based on the idea that humans have a maternal instinct. (A schoolgirl told a television interviewer that she felt the toy was teaching her traits that would be useful in later life: "It's great, because it teaches me how to be a parent.")

According to the same line, the Tamagotchi may help people to recognize the value of Otherness. ("Don't leave it alone; even if it's only a digital pet, it might fall ill and die.") This interpretation thus views the Tamagotchi as a learning device. (The environmental psychologist Takahashi Katsuhiko states: "Everyone has what is called an emotional demand; that is, the instinct to pour our emotion into someone, or to smother something with our affection. An urban amenity.")

Such are the prevailing interpretations of the Tamagotchi. They reduce the virtual gadget to the status of an object conceived, created and marketed to answer a need, by compensating for the absence of an adult target group, one less sensitive than children to the "purer", less functional aspects of play and pastimes. The only problem here is that all these after-the-fact readings fail to grasp the evolving process by which Tamagotchi has developed into an urban icon for the Japanese collective imagination.

10
Tamagotchi, the Lovable Egg.

11
The five elements of Tamagotchi's life.

These reductive readings capture only the current, superficia and most easily read stage in the process: the one showing us a pseudo-intelligent gadget. What is missing, in such analyses of the Tamagotchi phenomenon, is an understanding of its original meaning. The phenemon really signals the emergence of a "kid-oriented" society, in which a natural business event, such as involving a shift in the target group, can lead, by means of a process of "trickle-up", to the emergence of a full-blown urban icon: a representation reflecting the non-linear social significance of a cultural process never before seen in this digital age.

Unlike other accounts of the Tamagotchi given in Japan and the US, our interpretation shows it as a toy, a game, which nevertheless becomes an urban icon as the result of the trickle-up mechanism and of the inevitable explosion of a social and cultural phenomenon concentrated in the urban setting: the identity crisis and the need to find an outlet for altruism. Our level of analysis shows the Tamagotchi as a product initially meant for children and teens which has touched and invaded the minds and feelings of adults of all ages and both sexes as a result of its boom as a cult object.

This phenomenon exemplifies, in fact, the only direction that might be taken by a re-exploration of the original issue of the amae unrequited-love cult: precisely because the mechanism set in motion by Tamagotchi is based on a recognition of otherness, it allows for the full recognition of one's own individuality. The dependence inherent in the concept of amae, on the other hand, has always been understood as a statement of identity involving the elimination of the Self, which is abdicated in favour of the Other.

Tamagotchi suits contemporary Japanese society's tendency to produce new urban icons, serving to sustain the dialetical tensions between identity and otherness typical of the new generations. Behind the Tamagotchi lies the emergence of a new identity, along with the appeal of a new everyday spirituality: both these aspects fit in with that same latent mild animism, expressive of the Japanese inclination to attribute life to things in the form of animated figures, which also provides a strong impulse for the production of objects expressive of the identity of chilhood. Furthermore, the Tamagotchi accords well with the need for identification and dependency brought into play by certain other, less iconic social mechanisms, from the hierarchical and exclusive organisation of relationships, to the primacy of sensibility (kansei) over reason (risei).

Thus there finds expression a new identity, a new spirituality sustained by a substratum of animism, and, above all, an urge to scale the heights upon which Small Hands manipulate the need for a "perfect child", who finds incarnation, in the present case, not in the cyber-kid, but in the Tamagotchi itself.

Trickling It Up

The phenomena surrounding the Tamagotchi in Japan may be interpreted as a case of trickle-up. The very opposite of the trickle-down effect posited by Ve-

12
OLs (Office Ladies) are crazy
for Tamagotchi.

13
Adult Tamagotchi.

blen, trickle-up is the unnatural behaviour of cultural metatrends. In the case of Tamagotchi, the trickle-up consists in the unexpected success of an urban icon that has arrived from below. In other words: if a game designed for children works for grown-ups, the final effect is unexpectedly devastating, because it provokes an impressive chain reaction at the cultural, social and business level.

In the context of a unique social and urban microcosm such as Japan, all this lets loose a fast-moving flood of consumption that creates a prime role for instant consumers. This dynamic, which is connected with the typical Japanese-style bumu (boom), is typical of cultural processes, as opposed to the causative principles of natural phenomena. In this sense, Japan has gone beyond the idea and practice of mass consumption and given rise to a new isotope where expectations are not necessarily confirmed by beforehand strategies.

Bandai is the manufacturer of the first and second generations of the Tamagotchi, which costs 1,960 yen in Japan (although the boom has caused street prices to climb to as much as fifty times that). Nintendo, Bandai's main competitor, has been assigned to produce a Gameboy version of the Tamagotchi, meant to sell the gadget back to the market segment it was originally aimed at: children.

Having surpassed all marketing and sales projections, the Tamagotchi has become a "must" for adolescents and adults; but it has only reached children afterwards. Now, through the Nintendo version, it has once again become a toy for children. This version brings it back to the time-frame a child is used to from playing with videogames, and takes it back to its point of departure.

Bandai's strange, Nintendo-based strategy – meant to get the original toy back into the hands of the target group it started from – is the natural response to the trickle-up mechanism we've been investigating. There are good reasons for

Tamagotchi graveyard on the World Wide Web.

15
How Tamagotchi reacts to the wrong diet. (It doesn't like curried rice!)

adopting this strategy:

• The life-cycle of a Tamagotchi chick is ten to twenty days, while a videogame can last less than an hour.

• The goals posed by the Tamagotchi as a digital pet – i.e., to keep it alive as long as possible – are the exact opposite of the ones in a videogame – i.e., to achieve the highest possible score in the shortest possible time, by concentrating all the possible moves in a brief period.

Craze versus thoughtfulness.

Conclusions: the presence of the child

Children in Japan represent a far weightier presence than might be expected. They wield hidden authority. They are involuntary influencers, conditioners of the choices of social marketers. Their unwritten law can dictate the commitments of urban planning; they can set in motion the vitalist aesthetic of a post-consumer society like Japan's. In such a context values, language and behaviour seem attuned to every gesture of the fingertips of those Small Hands. Given these premises, what generally happens in a case like that of the Tamagotchi may be read as an imitative, top-to-bottom mechanism by which adults are brought to an awareness and understanding of a complex, "kid-oriented" urban universe. They learn to live, think and interact with a city made to measure for children's sensibility. This is the game, a game of viewpoints: from above, looking down; but also from below, looking upwards.

Those Small Hands that take over a big city turn out not to be so small after all. In such hands, Tokyo is a very small town.

Notes on captions
In the captions, information on the objects
appears in the following order: name of
object (if any); type of object; designer; date
of the design; origin (unless listed with
information about the manufacturer);
manufacturer; material; dimensions in cm
(height x width x depth); lender [in square
brackets], as well as information on functions,
shape, basic idea, user context, cultural
context, etc. If the object is still in production
and the manufacturer and the lender are
identical, the name will not be listed twice. If
information is not listed, it means that it was
unavailable. All texts are by the curators of
the Vitra Design Museum, with the exception
of those initialled L.B., which are by Lucy
Bullivant.

Catalogue

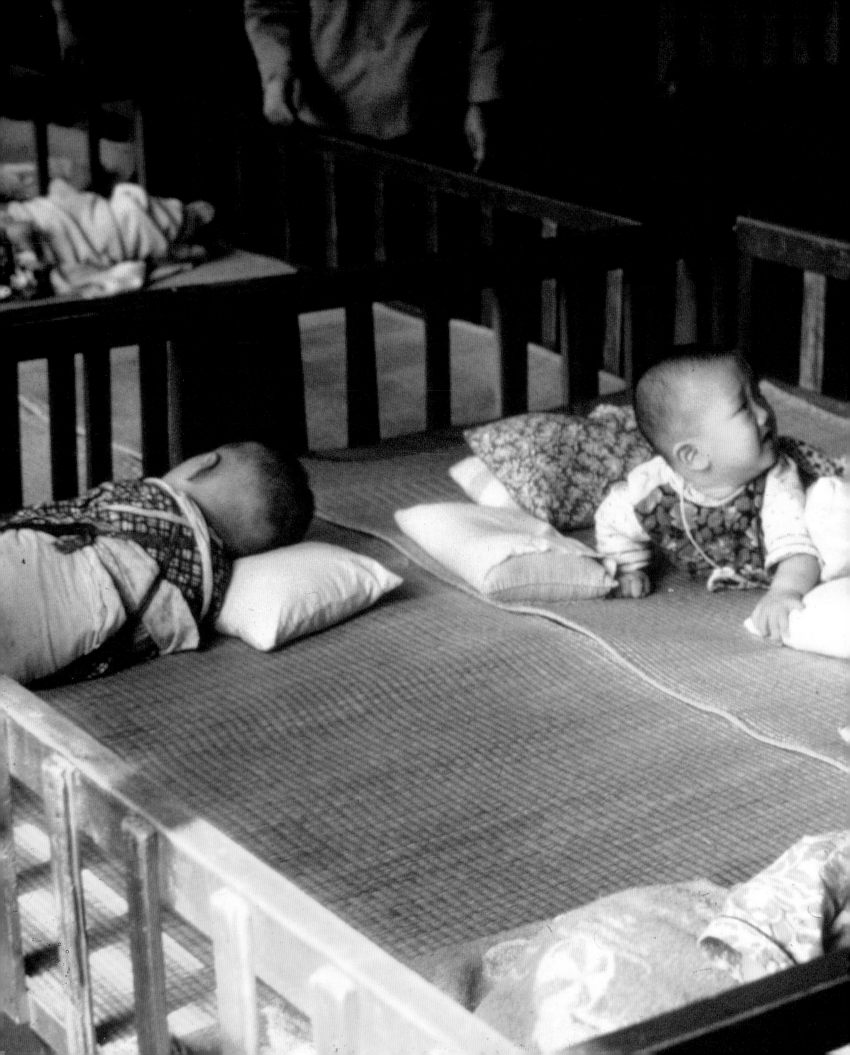

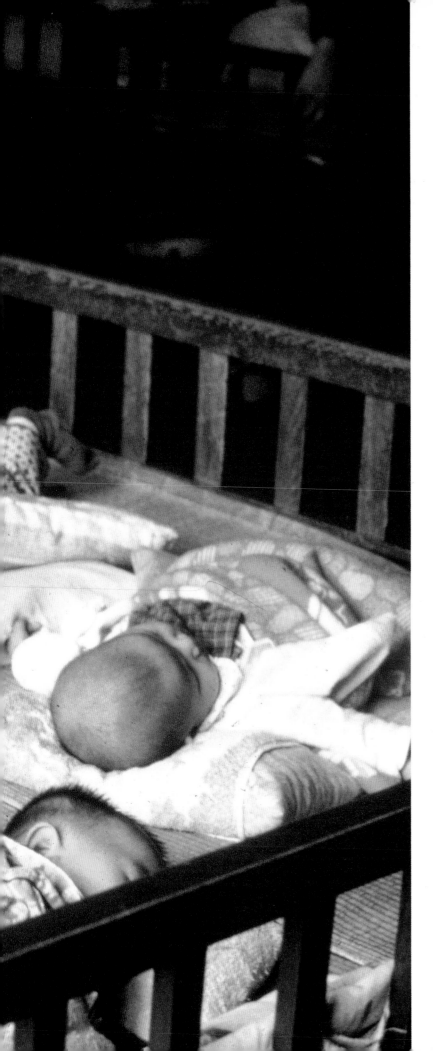

Patterns of sleeping

Contrasts in patterns of infant and child care mark out specific cultures, periods and stages in the child's development, and nothing is more central to perceiving this than the place of sleep. Whether elaborate or simple, fixed or mobile, through its design, materials, symbolism and methods of manufacture we can unravel adult attitudes towards the child's social context and family aspirations. Only in the Western world, for example, are children expected to sleep alone. Cots, cradles, hammocks, mats and cradleboards embody themes of intimacy and distance, security, mobility, adaptability and multi-purpose use as play objects. L.B.

1.1
Infant Jesus in a wicker
basket, manuscript
illumination, fifteenth
century.
Wrapping up babies very
firmly during the first
months was quite common
until well into the eighteenth
century, and was thought to
encourage straight growth
and to protect the infant
from injury.

1.2
Cradle, c. 1700, Basel,
pinewood, sliding adjustable
foot piece (25 x 77 x 45 cm)
[Historisches Museum,
Basel]
Bars and buttons were used
for fastening the blankets.

1.3
Biedermeier cradle, c. 1840,
Germany, pinewood,
(73 x 72 x 108 cm)
[Vitra Design Museum
collection]

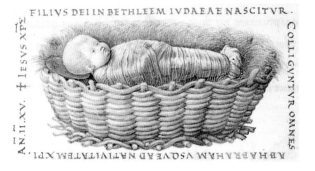

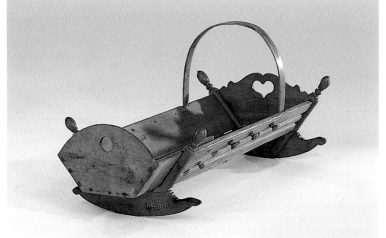

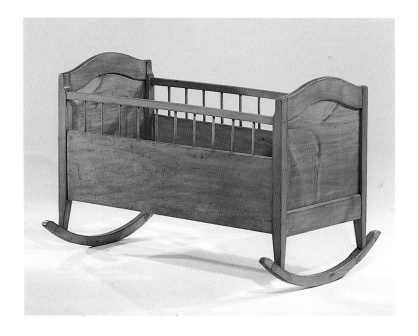

1.4

Wooden cradle, mid to late nineteenth century, Wales, painted blue interior (51 x 100 x 67 cm) [Museum of Welsh Life, Cardiff]

A traditional country cradle, locally made in the Cardiff area, and kept by generations of a Welsh family for a least a century. Its unusual feature is its vivid blue interior, probably added later, which gives it an individual identity. Babies, although oblivious to pastels, respond to bright colours; blue, the most universally preferred colour, is regarded as soothing and restful. L.B.

1.5

Wicker basket cot/bed, c. 1898 (75 x 45 x 96 cm) [Nordiska Museum, Stockholm]

Wicker cradles have been used for centuries, but most historic basketwork has perished. This example of a basket cot combines the simplicity of the genre with a degree of elaborate braiding and looping on the base of the body and legs. Two small handles allow the cot to be lifted off the leg base; medical opinion of the day was in favour of raising children's beds off the ground. This cot was owned and used by two generations of an entrepreneurial Stockholm family of elevator manufacturers. L.B.

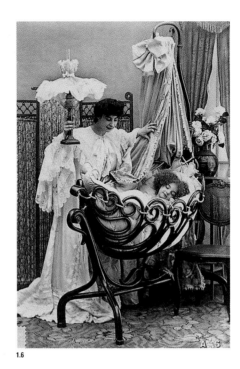

1.6 and 1.6.1

Cradle no. 2, 1883, manufactured by Gebrüder Thonet, Vienna, bent beechwood (216 x 136 x 61 cm) [Alexander von Vegesack collection]

Simple version of cradle no. 1. The bent vertical bar was used for fastening a canopy.

1.6

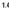

1.4

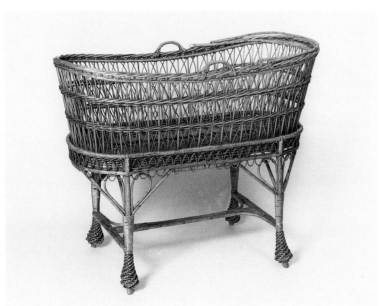

1.5

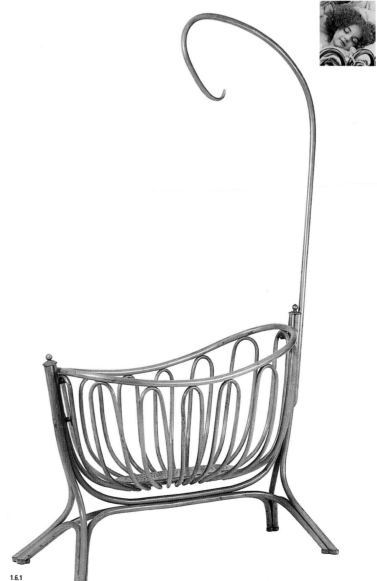

1.6.1

1.7
Cradle, 1901, designed by
Johan Thorn Prikker, carved
wood
[Haags Gemeentemuseum,
The Hague]
This cradle is an example of
Dutch Jugendstil, less
flamboyant than the French
or German Art Nouveau,
with typical ornamentation
relating to nature, and here
contained within an angular
form. Thorn Prikker's ideas
can be placed within the
Arts and Crafts tradition, and
are related to those of
Belgian designer Henry van
de Velde, whose children's
highchair, with its taut play
of lines, was well
coordinated with furniture
for his Bloemenwerf house
near Brussels. Like Voysey's
designs, the cradle
emphasises its structural
elements. L.B.

1.8
Cot, designed by Gerrit
Rietveld, 1931, high-sided,
five-plywood, metal and
canvas (76 x 103 x 53.5 cm)
[Stedelijk Museum,
Amsterdam]
Gerrit Rietveld, the Dutch
furniture maker and
architect, applied De Stijl
principles of straight lines
and surfaces to his designs
for children. Some of these
were adaptations of pieces
conceived with adults in
mind, and came about as
the result of individual
commissions. Rietveld was
a father of six children, and
continued his involvement
with children's furniture
over many years. This cot
was a later design, and
unusual in the context of his
earlier work, being less
formalist and chromatic.
Its high sides lend the
design the appearance of a
container, one geared to
maximum security and
reduced light exposure. L.B.

228

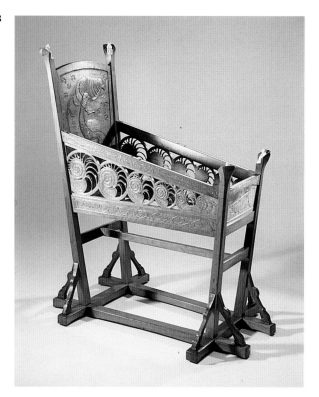

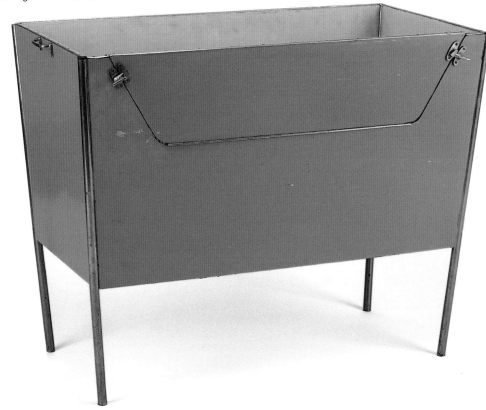

1.9
Cradle, designed by Peter
Keler, 1922, Bauhaus
Weimar, wood varnished in
different colours, woven
cane (90 x 98 x 91.7 cm)
Keler designed this cradle
for a furniture competition
for the showpiece "Haus am
Horn" in Weimar. It
embodies the application of
the principle idea of De Stijl
– reduction to basic
geometric shapes (in this
case circle and isosceles
triangle) and use of primary
colours (red, yellow, blue).
Keler had joined a group of
De Stijl artists around van
Doesburg and Kandinsky at
the Bauhaus Weimar.

1.10
Bed for children, designed
by Peter Keler, 1940,
Germany, wood varnished
in different colours,
wickerwork (55 x 42 x 91 cm)
[Tecta/Stuhlmuseum Burg
Beverungen, Lauenförde]
This simple home-made
bed, designed by Keler for
his own daughter, is far
more practical than the
famous Bauhaus cradle.
Whereas that is virtually
immobile due to a heavy
concrete core, this one can
be moved anywhere in the
home. Following the
Bauhaus theory of colour,
Keler applied to this
rectangular bed the colour
assigned to the square, red.

Not illustrated
Bed, 1936, varnished
plywood
(74.5 x 62.5 x 87/140 cm)
[Nordiska Museum,
Stockholm]
This austere Swedish bed
has an extra set of legs
attached to an extendable
structure to accommodate
the growing child. It was
bought by the Museum from
a stonecutter and his wife,
and had been in their family
for two generations. L.B.

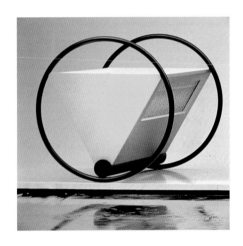

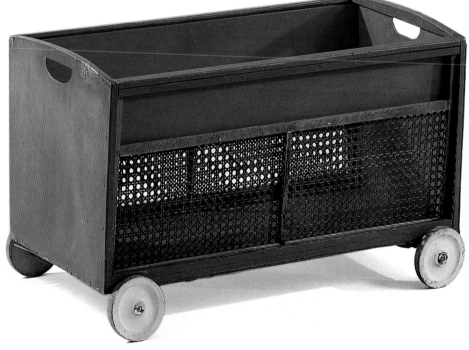

1.11 and 1.11.1
Bed for children, designed
by Emil Guhl, 1950–51,
manufactured by
Werkgenossenschaft
Wohnhilfe, Zürich,
beechwood
(85 x 80 x 185 cm)
[Emil Guhl, Stein am Rhein]
A space-saving, compact
bed able to "grow" with the
child, which retailed at a low
price. The basic unit is the
cot with bars and the chest
for changing nappies. The
bars could be removed and
used as a walking frame. The
bed could later be turned
into a bed for older children,
using the head and foot that
were pinned to the underside
of the cot, and promoting
the nappy-changing surface
to bedside table. The charity
Wohnhilfe donated some of
these beds to needy families
in Germany.

1.12
Rosemary's cradle, designed
by Elisabetta Gonzo and
Alessandro Vicari, 1993,
prototype made by Roberti
Rattan, Ferrante–Cassiani,
Italy, beechwood and woven
rattan (98 x 145 x 60 cm)
The special feature of this
design is that the mother
and child can rock together.

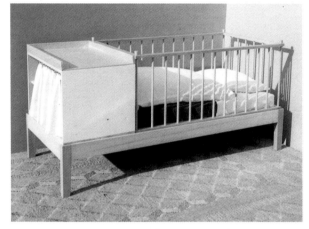

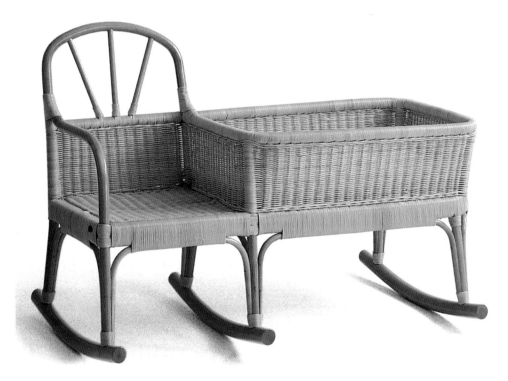

1.13

Touracot portable bed, c. 1940, chrome tubular steel, sailcloth.
Once collapsed, this foldaway and portable bed fits into a bag made of sailcloth which is included in the pack.

1.14

Cot, designed by Ole Gjerlov Knudsen, 1996, protoype made by AssiDomän, Dansk Kraftemballage, Kolding, Denmark, corrugated cardboard (60 x 85 x 48 cm) [Ole Gjerlov Knudsen, Gilleleje]
A foldaway cardboard bed, an intriguing alternative to the expensive and space-using traditional wooden cot.

1.15

Riposo cot, 1990, manufactured by Art & Form, Turin, wood, fabric (open 111 x 63 x 106 cm, closed 111 x 44 x 30 cm)
A foldable, highly portable cot on wheels, the modern successor of the *paidid* cot for two- to four-year-olds which was common in the second half of the nineteenth century. It featured side bars, an adjustable floor, and later wheels and a device for easy disassembling.

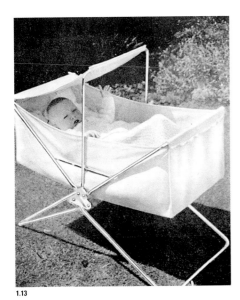

1.13

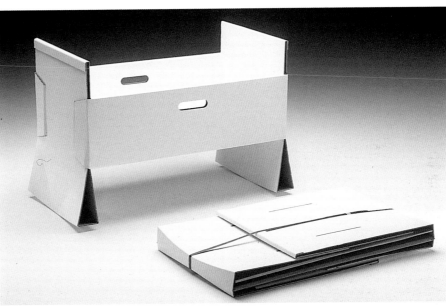

1.14

1.15

1.16 and 1.16.1
A'lua cot, designed by
Markus Harm, 1995,
manufactured by XS Möbel
für Kinder, Stetten i.R.,
distributed by Holzwerkstatt
Biiraboom, Kernen i.R.,
untreated beechwood and
laminated wood
(142 x 92 x 84 cm)
This cot, its height
adjustable to three
positions, can be
transformed into a children's
bed. The bars, once
removed, can be used as a
climbing and playing device,
and the solid rear part as a
chair.

1.17
Cradle, modern, Burkina
Faso, wickerwork, covered
in fabric (50 x 54 x 80 cm)
[Vitra Design Museum
collection]
The infant normally sleeps
beside its mother and later
shares a sleeping mat with
its siblings. This kind of
cradle with its own
mosquito net is still a
novelty, and is usually found
in cities.

1.18
Cradle, North America
(northwest coast), wood
(33 x 33 x 81 cm)
[Indianermuseum der Stadt
Zürich]
The two sides and the foot
are made from a single
piece of wood which has
been steambent into a right
angle. The underside and
the headboard, which
features the relief of a bird,
fit to the bent piece. The
cradle is decorated with
animal reliefs typical of the
northwest coast: on the
outside, from left to right,
a wolf, two birds, a human
face and a green frog; on
the opposite side, an otter,
a killer whale and a
thunderbird (a mythological
creature).

232

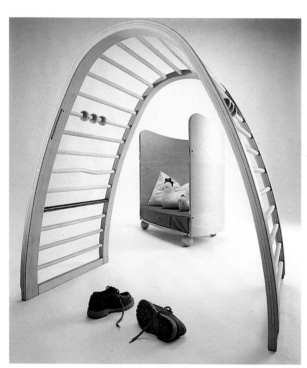

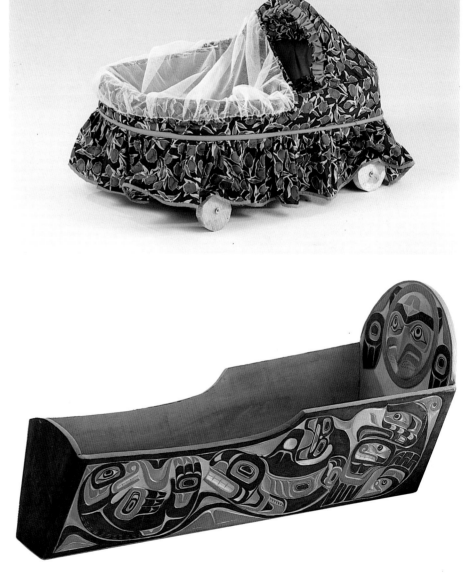

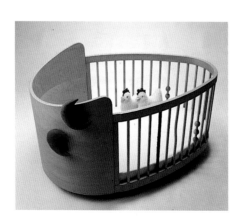

1.19
Cradle, Goa, India, wood
varnished in different
colours
[Vitra Design Museum
collection]
A modern version of a
traditional cradle, still made
to order by cradle-makers
today.

1.20
Headrest, river Sepik, Papua
New Guinea, wood, rotang
legs (12 x 43 x 9 cm)
[Museum der Kulturen,
Basel]

1.21
Sacrificial object (*palang
kiran*) for the God of infants,
Bali, wood (29 x 22 x 22 cm)
[Museum der Kulturen,
Basel]
A miniature chair with six
different parts: one basalt
part, a backrest, two
armrests and two figures,
one depicting a female
dancer and the other a
raksasa. The underside of
the basalt part and the
backrest feature carvings.
This sacrificial object is
suspended above the
infant's cradle after the
umbilical cord has
been severed.

1.22
Cradle, 1980, Asin village, Pangasinan, Philippines, woven bamboo
(20 x 116 x 85 cm)
[Barbara Fehlbaum, Basel]
The cradle, suspended with four cords above the mother's sleeping place, is very common in the northern part of the main island of Luzon.

1.23
Hammock for children aged 10–12, Xingú headwaters, Brazil, palm leaf fibre with cotton yarn (210 cm extended)
[Annemarie Seiler-Baldinger, Basel]
The patching is typical for discarded hammocks that have been passed on to the children; they are only given new ones when the old are no longer fit for use.

1.24
Cradle, Bali, Karangasem district, Tenganan, bamboo, including mat and hanging device (22 x 44 x 80 cm)
[Museum der Kulturen, Basel]
This type of cradle can still be found in some rural areas today.

234

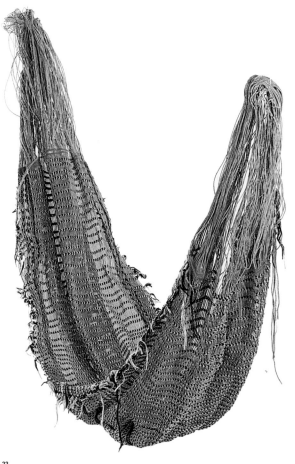
1.23

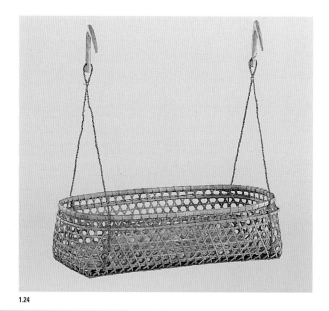
1.24

1.22

1.25
Mat, modern, Africa, artificial fibre (188 x 92 cm) [Vitra Design Museum collection]
These colourful sleeping and seating mats are extremely popular in Africa.

1.26
Mat, modern, Aibom, New Guinea, plant fibre (120 x 175 cm)
Sleeping mat, Timbuke, central Sepik, Papua New Guinea, bamboo fibre in diagonal and twill weaves (130 x 190 cm)
[Museum der Kulturen, Basel]

1.27
Sleeping mat for mother and child, Shimaku, Rio Chambira, eastern Peru, woven palm leaf fibre (219 x 50 cm)
[Annemarie Seiler-Baldinger, Basel]
Woven mats are relatively rare. The Shimaku use them predominantly as padding when sitting on the ground or on platform beds, and sometimes as blankets.

1.28
A mother has turned the undercarriage of her snack-cart into a sleeping place for her baby, Peru, 1964.

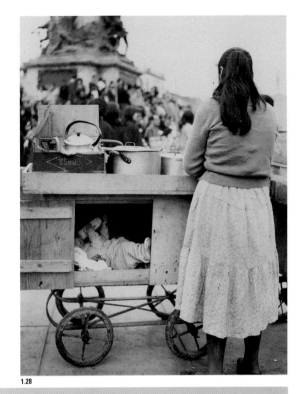

1.28

1.25

1.27

1.26

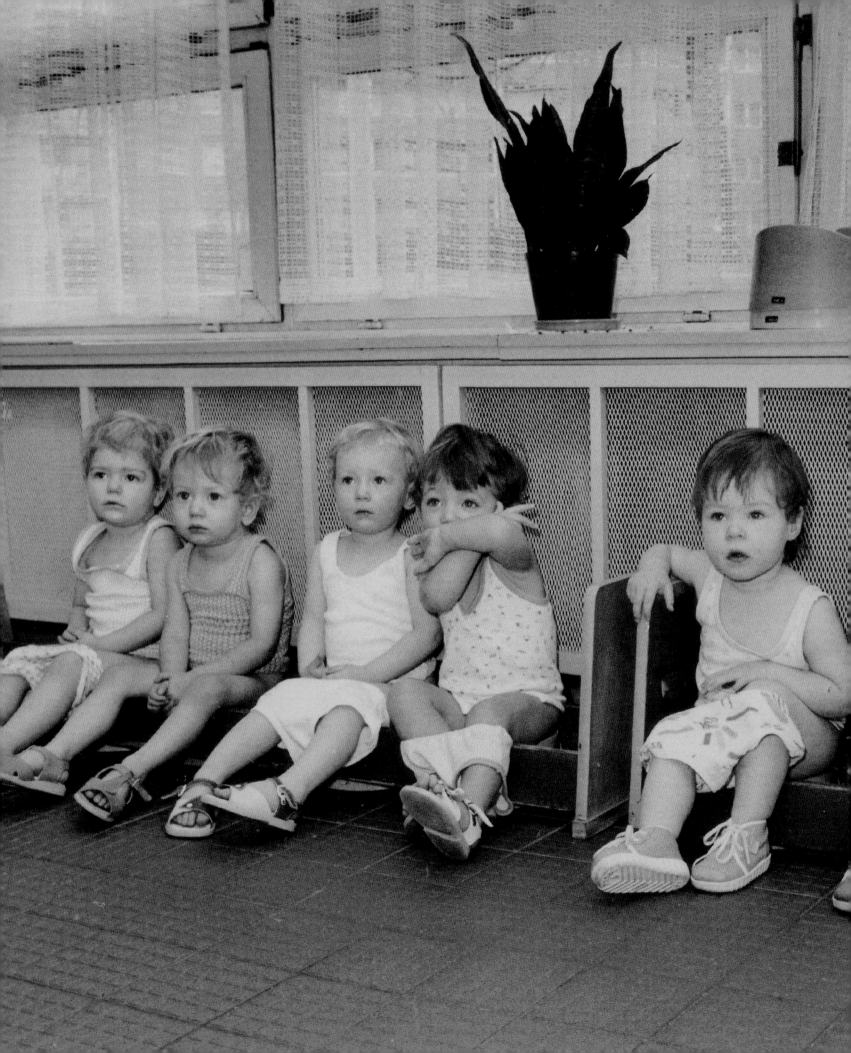

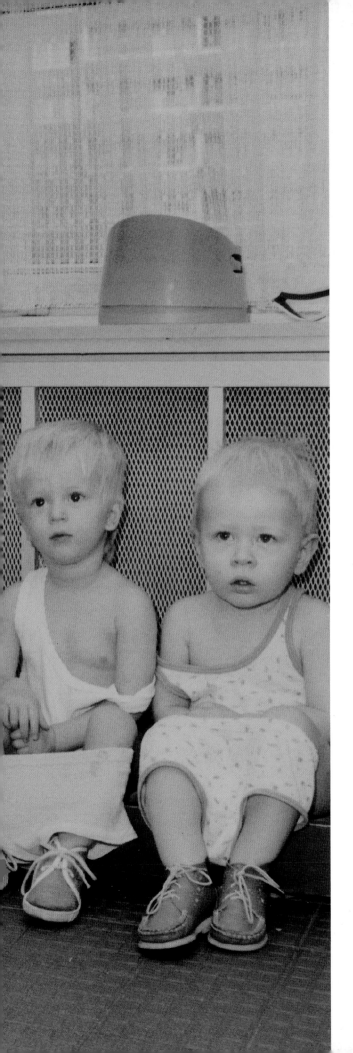

Basic functions

The "invention" of the nursery in the
seventeenth century, and of furniture
designed specifically for it, brought
highchairs and a proliferation of other
designs relating to the daily care of children –
supporting feeding, toilet training, bathing,
grooming, nappy changing and storage. As
children began to be seen to have rights
alongside adults, furniture for their daily care
gradually broadened from being miniaturised
versions of adult furniture, developing in
adaptability while maintaining scope to
control. Enabling participation in the adult
world, which babycare designs can curtail by
estrangement, starts at birth. The vast
inventory of childcare products of the
industrialised nations, which can turn homes
into hospital wards, is not prevalent in non-
Western cultures like the Iatmul of Papua
New Guinea, where the encouragement of
personal initiative, through food gathering
and preparation, and autonomous activities,
are traditional features of everyday life. L.B.

2.1

Baby seat, 1701, The Netherlands, painted wood (63.5 x 38.1 x 33cm) [The Open Museum, Glasgow]

This winged wooden seat enclosed within a wooden box was known as a Dutch "going-chair"; often they included a playing board and wheels. Their form allowed the child to be firmly wedged in, with little room for leg movements, as if in state on its personal throne. The boxy base allows for a chamberpot or hot brick to be concealed inside the chair. The painted Dutch landscapes and ornate flowers suggest a pastoral idyll of which the child might well have preferred first-hand experience. L.B.

2.2

Children's dining chair no. 3, highchair, before 1888, designed and manufactured by Gebrüder Thonet, Vienna, bent beechwood, basketwork (94 x 61 x 53 cm) [Peter W. Ellenberg, Freiburg]

The eating tray is removable. Thonet delivered this piece in three different versions; no. 2 had wheels and was called the Children's push chair. After many attempts at designing versions of their furniture specially for children,

Thonet finally settled on a proportion of 70 per cent of standard adult dimensions – i.e. a seat height of 32 cm, armrest height of 63 cm and seat diameter of 32 cm. The price of the children's models was 66 per cent of the adult ones. The children's range became immensely successful, eventually amounting to 3 per cent of the company's production volume. Thonet was the first innovative and successful manufacturer of mass-produced furniture for children.

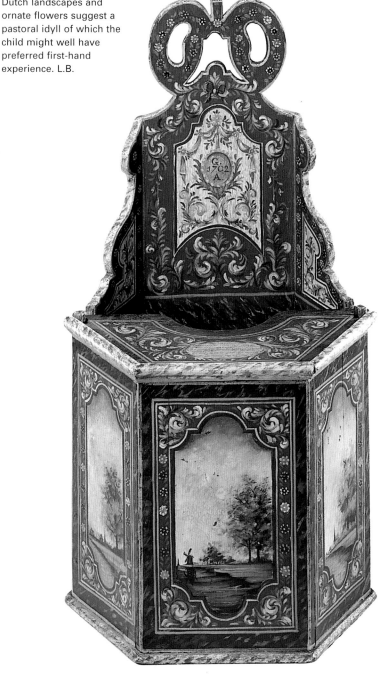

2.3
Highchair, 1889, Wales, oak, iron and wool, back support carved in the shape of an angel, upholstered seat and arms, twisted ironstrap work supporting footplate
(105 x 42 x 56 cm)
[Museum of Welsh Life, Cardiff]
This oak highchair, made by David Nicol for his son David Bruce, whose name he has carved on the foot plate, is an interesting and unique example of Victorian middle-class design. Its elaborate and probably rather uncomfortable back, carved in the shape of a doll-like guardian angel, and standing lion handrests introduce a somewhat whimsical symbolism relating to protection and spiritual upliftment. The desire to be a good "guardian" is embodied in its form, which draws on the strong woodcarving tradition of Wales. L.B.

2.4
Highchair, c. 1880, wood, (960 x 355 x 540 cm)
[York Castle Museum, York]
This unusual piece with its urn-shaped back decorated with cresting and inlay, is thought to be a cabinet maker's one-off, probably made for quite a wealthy family. The integral play board or attached tray was a refinement to highchairs later in the nineteenth century, and many models could be converted into several positions, this one to a low chair on runners, so that they catered for mealtimes and playtime. L.B.

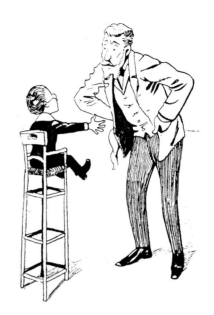

2.5
Caran d'Ache, family scene with highchair, Paris, 1886.

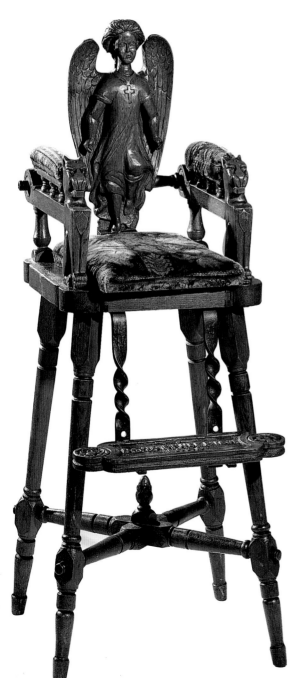

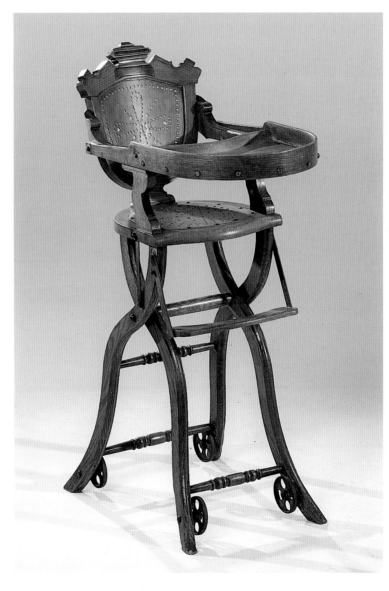

2.6 and 2.6.1
Riding and rolling highchair, undated, twentieth century, Dutch, moulded plastic frame, plastic plate seat and back, upholstered with foam cloth and plastified cloth (84 x 42 x 53 cm) [Technische Universiteit, Delft]
The use of plastic in the making of highchairs requires the consolidation of the moulded frame along the edges to obtain the required degree of strength. This unusually shaped dark pink highchair is made wholly in plastic, and adheres to the same versatility of those of wood, with a twist on the traditional rocking theme. When placed horizontally on the four wheels, it can be used as a riding and rolling chair with a tabletop. L.B.

2.7
Nursing chair, 1900, designed and manufactured by Gebrüder Thonet, Vienna, bent beechwood, basketwork (75 x 50 x 46 cm) [Peter W. Ellenberg]

240

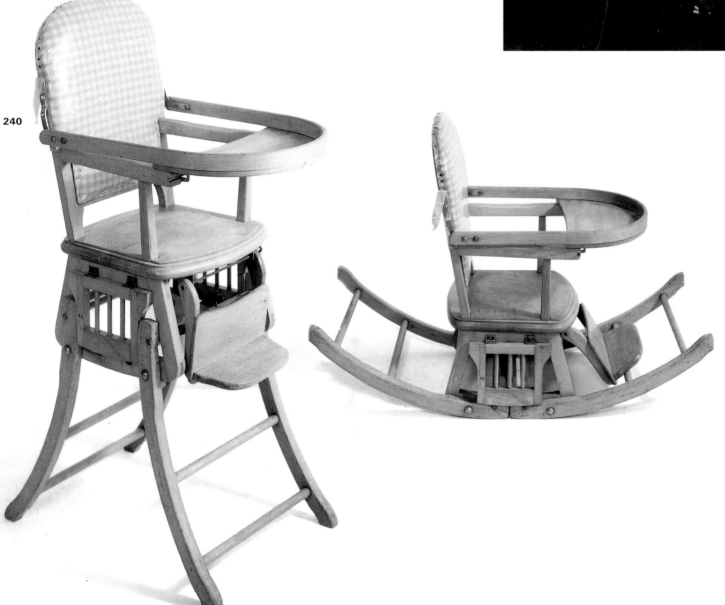

2.8
Zigzag high chair, designed
by Gerrit Rietveld, 1940, oak
(86 x 42.5 x 44 x 53 cm)
[Stedelijk Museum,
Amsterdam]

Not illustrated
Jesse zigzag high chair,
designed by Gerrit Rietveld,
1944, wood, multiplex
(133 x 60.5 x 60.5 cm)

The various zigzag chairs
designed by Gerrit Rietveld did
not create the same revolution
as his famous red and blue

chair of 1918, although the
design has the same simple
aesthetics and construction.
Most models were made and
sold for the exclusive Metz
department store, although
Rietveld also made some
unique pieces for private
buyers. The Jesse highchair,
made for the Jesse family, has
been made in a number of
versions, with and without
decorations. It is actually too
narrow for a child to sit in and
eat with comfort, but the earlier
zigzag chair in oak is more
generously proportioned. L.B.

2.9
Highchair, designed by
Gerrit Rietveld, 1919, wood,
leather (90 x 35 x 40 cm)
[Haags Gemeentemuseum,
The Hague]
This chair is a good example
of Rietveld's design during
his De Stijl period, related to
the radical red and blue
chair of 1918. It has no mass
or volume, but forms a
spacious composition from
its individual horizontal and
vertical elements. In spite of
the populist intentions of
architects and designers of
the Modern Movement, this
chair remained an item
exclusively for the wealthy.
L.B.

2.10
Highchair, white painted
wood, designed by
Paul Wintermans, 1978
(75 x 54 ø x seat height
46 cm)
[Stedelijk Museum,
Amsterdam]
The architect Paul
Wintermans painted his
highchair white so you could
not see the construction, but
just the object. Perhaps a
reference to the widespread
whiteness of early 20th
century nursery furniture,
this unusual piece which
plays on scale, is open to
different interpretations. A
small chair emerging from a
larger, circular form is one
symbol, of new life. L.B.

2.11
Highchair, c. 1957, green
painted wood with plastic
upholstery and tray
(945 x 510 x 510 cm)
[York Castle Museum, York]
This lime green highchair
combines an old design for
a wooden high chair from
the turn of the century with
a fabric-style plastic
upholstered back and seat
and kidney shaped plastic
tray. Its original purchase
price was relatively
expensive for a high chair.
This form with its wide base
was first introduced as a
space-saving design, as its
hinged structure is
convertible to a low chair.
Its ungainliness did not stop
it being used for over fifty
years, primarily due to the
lack of alternatives. L.B.

2.12
Rocking/highchair, twentieth
century, beechwood frame,
upholstered back and plastic
sheet (104 x 41 x 56 cm)
[Technische Universiteit,
Delft]
This convertible highchair
can be transformed into a
rocking chair by swinging
the chair legs. It is
upholstered in traditional
Dutch Brabant cotton cloth,
protected with plastic sheet,
enhancing both its comfort
and ease of cleaning. L.B.

242

2.13
Dino highchair, designed by
Charlotte Rude and Hjördis
Ohlsson-Une, 1969, tubular
metal structure, plastic seat,
manufactured by IKEA of
Sweden, Älmhult
(72 x 55 x 30 cm)
This classic 1970s concept,
with its distinctive sloping
metal tube structure and
basket or pouch-like plastic
seat, looks almost more like
a bar stool or a basketball
net. It was designed by two
young Danish designers
who worked with IKEA's test
laboratory manager. His
research into children's
highchairs concluded that
the safest construction
involved removing the
footrest and incorporating a
large circular shape at the
base of the chair, connecting
it to the seat section with an
angled tubular steel

construction. A baby can sit
up without back support at
around six months, and
although Dino does not have
the help of a kidney-shaped
tray to catch food and drink,
it clearly gives an early
opportunity to sit at table
with the adults. L.B.

Not illustrated
Highchair, 1904, birchwood,
metal wheels, manufactured
by Gemla, Diö, Sweden
(95 x 52.5 x 52.5 cm)
[Nordiska Museum,
Stockholm]
This style of wooden
highchair from the turn of
the century retained its
popularity in Sweden for
over fifty years. Industrially
produced in Stockholm, the
bottom section adapts into a
playboard table with small
metal wheels. A wooden bar
with seven turned wooden

beads sits across the arms.
Making it convertible for
play functions was a
refinement from the later
part of the nineteenth
century; some chairs offered
up to four different
positions, becoming go-carts
or rocking chairs. L.B.

2.14
Setzling highchair,
manufactured by Studio
Böhm, Gelnhausen,
Germany, 1990, beechwood,
adjustable table top (three
positions) and foot rail (two
positions), comes in two
parts (85 x 52 x 52 cm)
The top and bottom part can
be assembled into a
children's table and chair.
These two elements can also
be combined with a rocking
base or a baby bed.

243

2.15
Hooks (samban), Yarangei and Palimbei, central Sepik, Papua New Guinea, wood (61 x 29 x 10 cm and 36 x 16 x 5 cm)
Three small food baskets, Sepik, Papua New Guinea, plant fibre (30 x 40 x 5 cm, 45 x 20 x 9 cm, 40 x 25 x 9 cm)
[Florence Weiss, Basel]
Net basket, Aibom, central Sepik, Papua New Guinea, manji bark, hourglass looping (60.5 x 30 x 29 cm, plus 71-cm strap)
Woven bag for sago cakes (naugumbi), Aibom, central Sepik, Papua New Guinea, plant fibre (60 x 35 x 2 cm)
[Museum der Kulturen, Basel]
The smaller of the two hooks was made by 14-year-old Kumbal, depicting the magician

Agitndaua.
The small food baskets, into which the mother places portions of food for each family member, hang from the hooks. The family members rarely eat together.
The net baskets are exclusively for girls and women, the simpler versions being made by young girls. They are used for transport and storage for wood, sago cakes, etc.

2.16
Basket, Burkina Faso, basketwork (55 x 35 x 38 cm)
[Vitra Design Museum collection]
Every family member has a personal basket for the storage of clothes; today, these are sometimes replaced by metal boxes or suitcases.

2.17
Slotted drum with drum stick, Kararau, central Sepik, Papua New Guinea, wood (drum 31 x 124 x 30 cm, drum stick 3 x 88 cm)
[Museum der Kulturen, Basel]
Many families have a drum in their house, since every member has a personal drum signal for the relay of messages. The top of this drum stick depicts an animal head with ears.

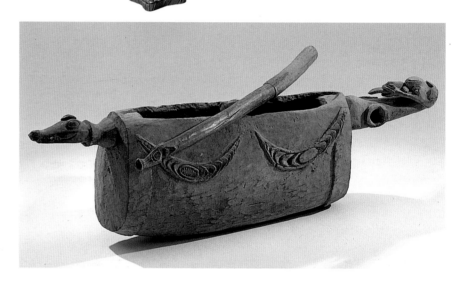

244

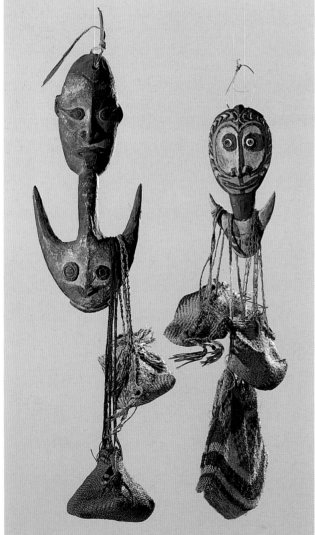

2.18
Baby bath and stand, c. 1950s, UK, blue plastic bath and yellow enamel painted metal folding stand (bath: 250 x 355 x 760 cm ; frame: 620 x 430 x 810 cm) [York Castle Museum, York] The stand was used as base for both a carrycot and a bath in an urban middle class family in the north of England. It was a light, cheap and practical solution. L.B.

2.19
Bathtime in the garden, early twentieth century, Germany.

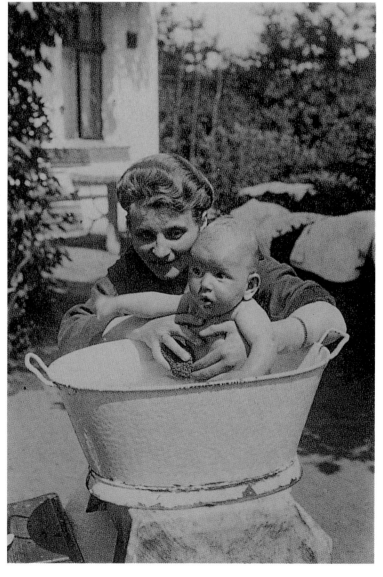

2.20
Bathtub with seat for
children, c. 1875, China,
varnished wood, wheels
(52 x 46 x 66 cm)
[Alexander von Vegesack
collection]

2.21
Baby bath chair, designed
by Hiraku Kusubayashi,
Milan, 1987, expanded
polypropylene and nylon
net, prototype made by
Combi Corporation,
Saitama, Japan
(61 x 39 x 34 cm)
Japanese bathing customs
involve communal family
use of a watery, tiled
bathroom space. A deep tub
is kept full of hot water and
washing is carried out
standing on a tiled floor.
Families in Japan mostly
bathe new babies separately
until the age of three
months, when they join the
rest of the family. The baby
bath chair gives the baby a
secure resting place in this
slippery environment while
its parents wash themselves.
L.B.

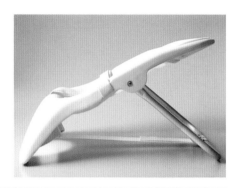

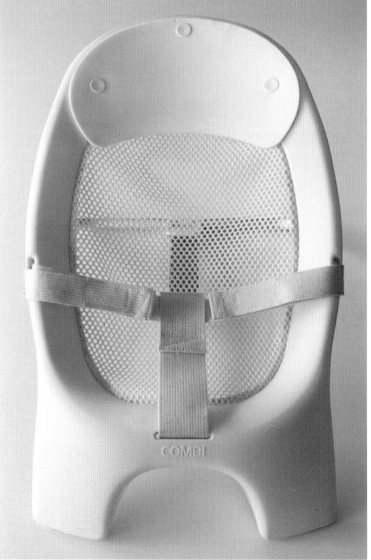

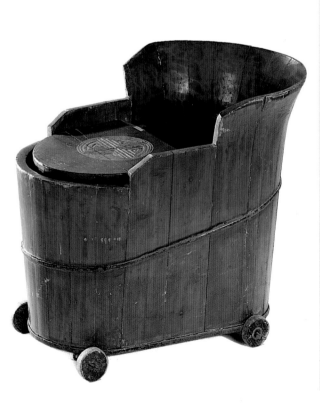

2.22
Nappy-changing chest, designed by Alma Buscher, 1924, Bauhaus Weimar, wood, partly varnished in different colours (see also 3.32)
As well as its aesthetic appeal, this chest is also extremely practical: it has considerable storage space and a small pull-out tray for a baby's bathtub or for the mother to sit on.

2.23 and 2.23.1
Nappy-changing table, designed and prototype manufactured by Thomas Wendtland, 1988, Hamburg, wood, metal (chest 90 x 110 x 45 cm)
Once it has served its purpose, the table can be turned into a play table for children up to five (height 45 cm) and later into a desk for children up to ten (height 72 cm).

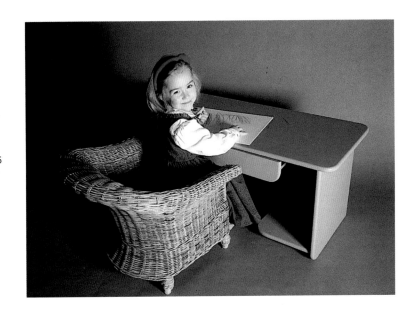

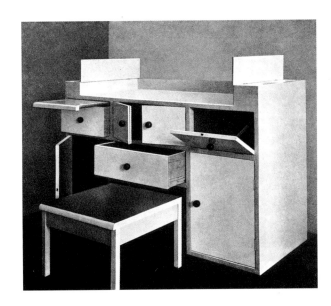

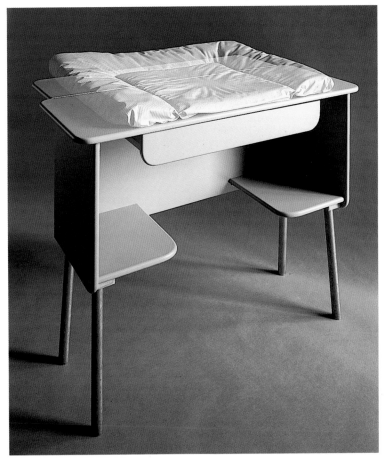

2.24
Rocking commode chair with recess for potty, c. 1730, maple, mahogany, with leather tray attached to arms by leather thongs (66 x 50 x 60 cm) [Museum of Welsh Life, Cardiff]
Small "close" chairs for children were used in Europe from the seventeenth century, with a hole in the middle to hold a chamberpot. These also appeared as wing rocking chairs, as seen here, with a hole cut out in the back to create a carrying handle. This piece, from an upper-class family household, handed down through the generations, combines practical and play functions, but would have been too expensive for most families. L.B.

2.25
Toilet chair, c. 1935, wood varnished green (57 x 36 x 28 cm) [Vitra Design Museum collection]

2.26
Potty, with painted flower motifs and "For your memory" inscription, c. 1880, Bohemia, stoneware (19 x 15 x 11.5 cm) [Zentrum für außergewöhnliche Museen, München]

2.26

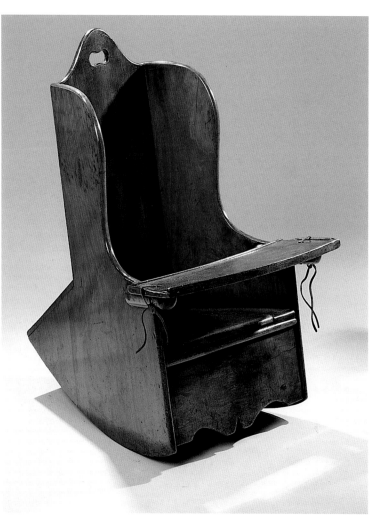

2.24

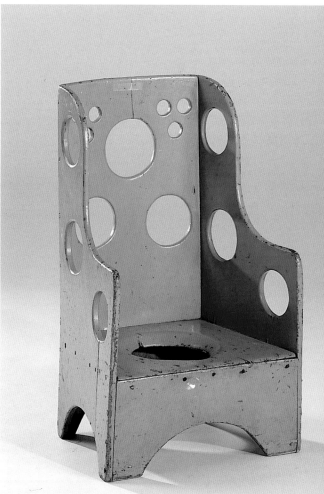

2.25

2.27
Highchair, with potty
opening, c. 1840, Germany,
padded leather seat, walnut,
leather (90 x 50 x 41 cm)
[Zentrum für
außergewöhnliche Museen,
München]
In the past, children were
often confined to sit for
hours on highchairs.

2.28
Swivel chair for children,
c. 1940–50, Italy,
manufactured by Amata,
metal, plastic, height-
adjustable (110 x 48 x 68 cm)
[Vitra Design Museum
collection]

2.29
Swivel chair for children,
c. 1900, designed and
manufactured by Gebrüder
Thonet, Vienna, bent
beechwood, wickerwork,
height-adjustable
(84 x 45 x 39 cm)
[Peter W. Ellenberg]

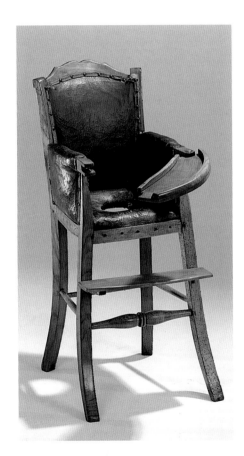

2.30
Cupboard for children, 1947,
designed and manufactured
by Gerrit T. Rietveld,
Utrecht, wood varnished in
different colours
(131 x 123 x 39 cm)
[Alexander von Vegesack
collection]

2.31
Hang it all clothes hook,
designed by Charles and
Ray Eames, 1953,
manufactured by Tigrett
Enterprises Playhouse
Division, Jackson,
Tennessee, wood, steel
(39 x 50.5 x 16.5 cm)
[Vitra Design Museum
collection]
A similar construction and
welding technique was
employed in Eames' wire
chairs and low table bases.

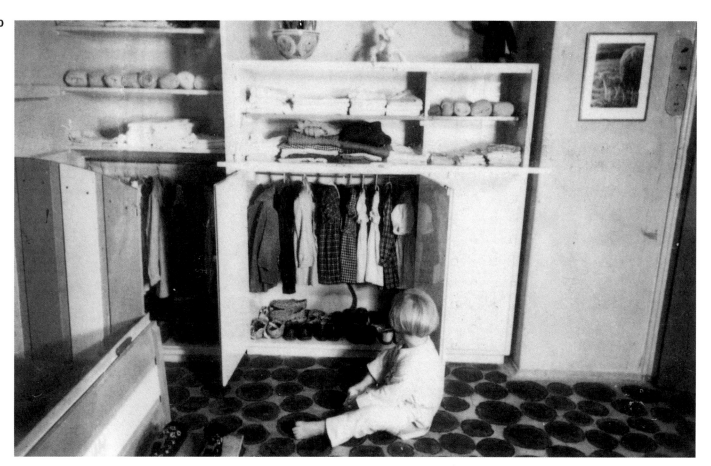

2.32
Nursery cupboard on wheels, German, designed by Johannes Trüstedt, manufactured by Kolonne, Munich (125 x 138 x 77.5 cm) [Johannes Trustedt, Munich] Seven cabinetmakers, most of them fathers, work together as Kolonne, and have made various items of furniture for children in small batches. Recalling their own childhood activities of building and rebuilding forms, they favour modules that can be combined, and like to create designs that are not just about play, but have a basic function. This cupboard on wheels has a step-like effect.

Children can climb up and sit perched on top of their mobile storage "vehicle". The gap in the wardrobe door prevents pinched fingers. L.B.

2.33
Baby Tambour chair, designed by Simon Maidment, 1993–94, birch plywood body and tambour (roll top) in solid beech hardwood finished in coloured plastic laminate, manufactured by space, London (52 x 34 x 46 cm) [Sam Design Ltd, London] A child's version of a design for a chair providing seating and storage. Maidment's childhood memory of storing his Lego in a cardboard box which gradually deteriorated inspired him to create a more durable and personal alternative with a lockable roll top. L.B.

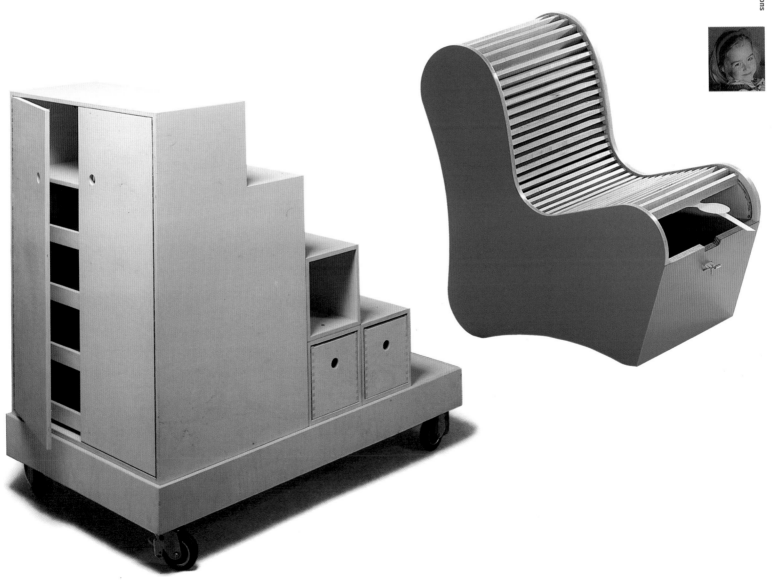

2.34
Chair for children, c. 1800, probably Bremen, beech and wickerwork (96.5 x 33 x 29 cm) [Focke Museum, Bremen] Back-straightening chairs with high back-rests were very common at this period in the homes of the bourgeoisie.

2.35
Shaker rocking chair for children, 1997, Mount Lebanon, New York, manufactured by Habit, Ulrich Lodholz, Kürten-Engeldorf, Germany, maple, woven cotton (73 x 41 x 50 cm, seat height 31 cm)
The Shakers are followers of an English textile worker Mother Ann Lee who led a sect of 'Shaking Quakers', to the United States, settling on the east coast in 1774, and evangelizing thousands in New England between 1780 and 1784. Shaker communities were close-knit, communal groups who maintained a rural, spiritual lifestyle and strong ties with the industrialised, secular world. Although celibate, they have always included children of converts, orphans and wards in their community. Their

inventiveness is demonstrated by furniture and tools notable for its functionality and spare simplicity. This rocking chair was made for children of three to seven years of age; all design details are scaled-down equivalents to those incorporated in the adult models. L.B.

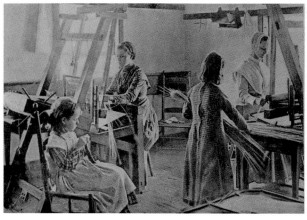

2.36
Canaan Upper Family of Shakers, Mount Lebanon, weaving straw mats and making garments, reproduced from Harper's Bazaar, vol. 27, no. 43, 27 October 1894

2.37
Tschimbud stool, central Sepik, Papua New Guinea, wood (15 x 19 x 19 cm) [Museum der Kulturen, Basel]
This stool emphasises gender differences: Iatmul girls and women sit on the ground, while boys and men sit on small stools.

2.38
Mats, modern, Africa, plant fibre, multi-functional use (rolled 175 x 118 cm, unrolled 232 x 110 cm) [Vitra Design Museum collection]

2.39
Furniture designed by Günter Beltzig, 1966, manufactured by Brüder Beltzig, Wuppertal, Germany, fibreglass-reinforced polyester in different colours, stackable. Table (48 x 75 x 52 cm) Matching chair (70 x 25.5 x 28 cm) Matching stool (27 x 35 x 30 cm)) [Günter Beltzig, Hohenwart] (see also OKM-1071)

2.40
Grandchild chair and stool, designed by John Kandell, 1963, mahogany and leather (chair), mahogany and cowhide (stool), manuf. Källemo AB, Värnamo, Sweden (chair 45 x 35 x 27 cm; stool 25 x 33 x 33 cm) John Kandell, who died in 1991, was known for his refined proportions, vigorous line and exquisite handling of materials. He felt that children as well as adults should be entitled to good, long-lasting design. Children's furniture in Sweden was often made of durable, natural materials like wood and leather. The Grandchild set was designed to mark the birth of one of Kandell's children, and represents his desire to create a family heirloom for the second half of the twentieth century, perhaps one acquired by grandparents for their grandchildren. L.B.

2.41
Anna table and chair, designed by Karin Mobring, 1963, manufactured by IKEA of Sweden, beechwood (table 76 x 46 cm, chair 38 x 40 x 30 cm) In the 1960s IKEA's range of children's products had a very basic, functional touch, and wood predominated as with Swedish furniture design for children generally. This simple table and chair set typifies this approach, and was retained into the 1970s when the types of materials used widened considerably. L.B.

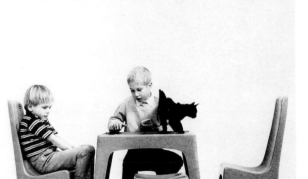

2.38

2.40

2.39

2.41

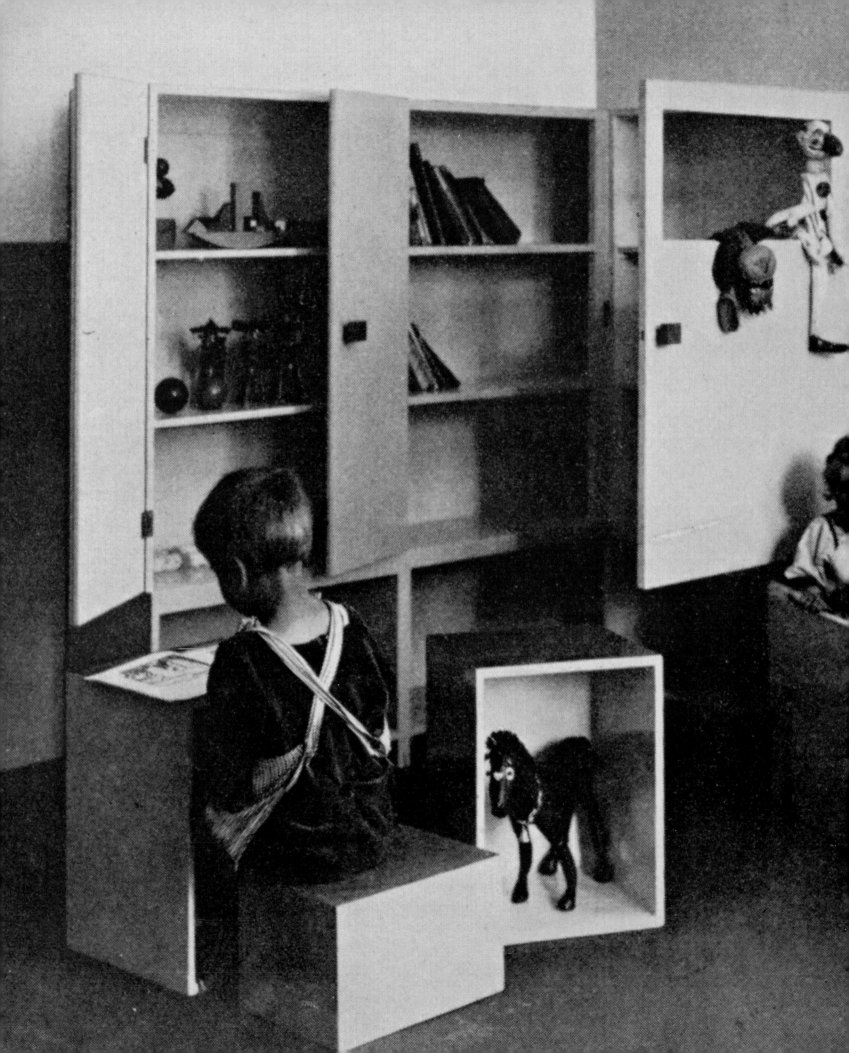

Children the world over play as a matter of
necessity, stimulating their imagination and
shaping their psychic identity. Without the
tangible, commercial objects of play, they
draw on their own resources, using
indigenous raw materials and found objects
from the external environment. In
industrialised cultures, arrays of play
furniture are provided within interior settings
often geared to adult use. Their hybrid nature
erases the boundaries between practicality
and play, between furniture and toy, and
ideally encourages spontaneity of use.
Assemblages, or rocking or constructional
forms, which sometimes double up as
practical items such as highchairs or cots,
assist motor skills, logic, role-play, eye–hand
coordination and creativity. Improvisational
play, with its lack of reliance on a pre-defined
programme, reinvents the adult order. L.B

3.1
The Dapple Grey rocking
horse, 1997, manufactured
by Stevenson Bros.,
Ashford, wood, leather,
horsehair (122 x 142 x 46 cm)
Adapted safety version of
the classic Victorian rocking
horse.

3.2
Playing in a rocking seat,
from At Home, by John
Sowerby and Thomas
Crane, 1881, London

3.3
Mickey Mouse rocking
animal, c. 1938, Germany.

3.4
Mechanical horse, designed
by Charles and Ray Eames,
1944, Eames Office, Venice,
California, wood, metal
(55 x 34 x 67 cm)
[Vitra Design Museum
collection]
The horse is moved forward
through distributing the
body weight alternately to
right and left.

3.2

256

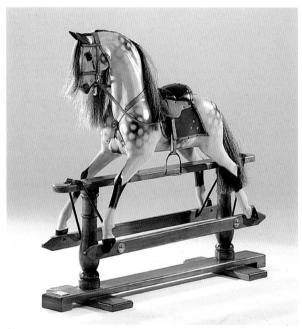
3.1

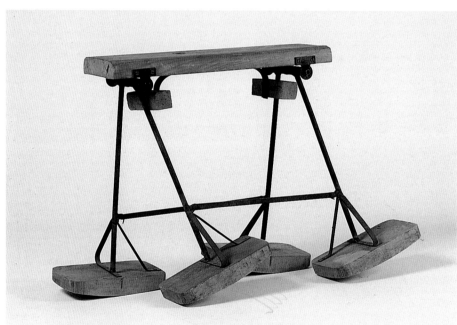
3.4

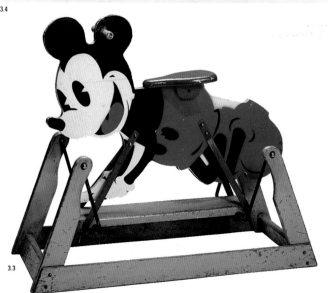
3.3

3.5

17M/L (Bathtub) pedal car,
c. 1955, Germany,
manufactured by Ferbedo,
Nürnberg, Germany, steel,
plastic (45 x 114 x 48 cm)
[Zentrum für
außergewöhnliche Museen,
München]
Fashioned after the famous
Ford 17M of the 1950s, this
small version is equipped
with an all-steel chassis,
electric lights, electric horn,
windscreen, rear mirror and
spoked wheels.

3.6

Alvar and Aino Aalto's
children with a friend in
their house in Turku,
Finland, c. 1931.

3.7

The Toy modular play kit,
designed by Charles and
Ray Eames, 1951,
manufactured by Tigrett
Enterprises Playhouse
Division, Jackson,
Tennessee, paper, wood
(pack 76.2 x 8.9 cm)
[Vitra Design Museum
collection]

According to the information
on the box, this is a "big,
colourful, easy-to-construct
kit for the creation of a light,
bright and modular world,
large enough to play within
or outside it." It was
designed for adults,
adolescents and children as
well as for amateur
dramatists, parties, etc.

While The Toy was intended
for play "within" the kit, The
Little Toy, designed in 1952,
was intended to be played
"with". The coloured plates
were no longer made from
paper but from rigid
cardboard.

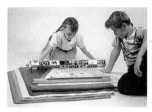

3.7

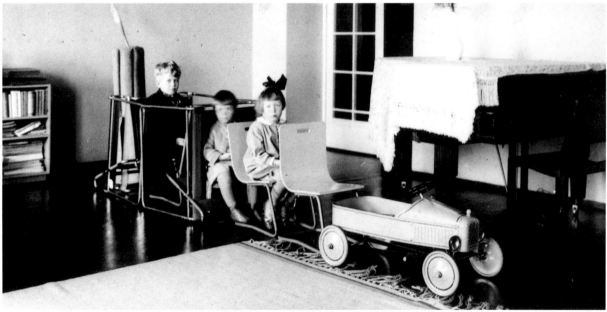

3.6

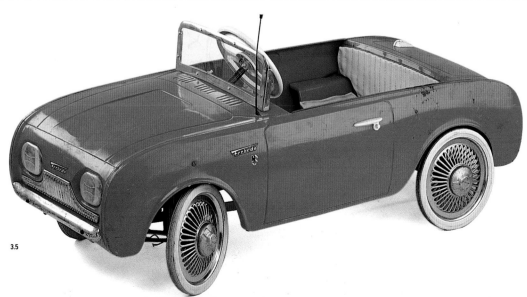

3.5

3.8
Rocking object, 1950–55, manufactured by Creative Playthings, Princeton, New Jersey, pre-formed plywood, plastic (48 x 30.5 x 64.5 cm) [Alexander von Vegesack collection]
This abstract version of a rocking horse was designed for children up to two and a half. Unlike most conventional rocking horses, this one can be easily mounted by the child without assistance.

3.9
Rocking sculpture, designed by Walter Pabst, 1954, manufactured by Wilkhahn, Bad Münder, Germany, plastic (53 x 81 x 45 cm) [Wilkhahn, Bad Münder]

3.10
Rocking tub, designed by Günter Beltzig, 1966, manufacture by Brüder Beltzig, Wuppertal, Germany, fibreglass-reinforced polyester in primary colours (37.5 x 103.5 x 98 cm)
[Günter Beltzig, Hohenwart]
This range of play furniture for children includes a table, stool and chair (see OKM-1067) as well as a slide and a seesaw. Moulded plastic, which emerged in the 1960s, was ideally suited for children's furniture: it was light, weatherproof and colourful and could be used indoors and outdoors. One of the first collections of polyester furniture for children, this was made only in small-batch production.

3.11
Rocking seat, designed by Piet Hein Stulemeyer, 1967, The Netherlands, wood, iron bars, manufactured by Placo Esmi Meubelen, Vessem (90 x 40 x 40 cm) [Stedelijk Museum, Amsterdam]
A robust design from the 1960s by a little-known Dutch designer (see also OKM-1116, a highchair), realised when he was twenty six, with a low flat structure, that is clearly made to withstand strong rocking movements by children. Its iron bars make it look like a more restricting, backwards seated version of the lighter, more open-structured "fun boat", made in tubular steel with canvas seats in the late 1930s. L.B.

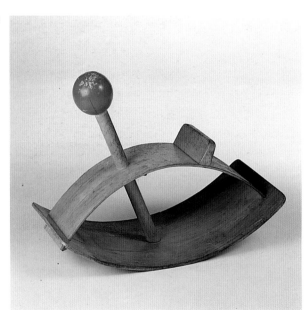

3.8

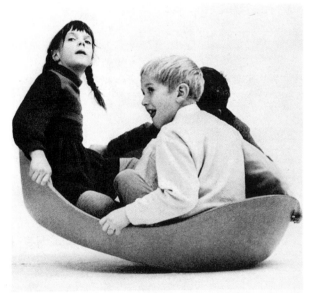

3.10

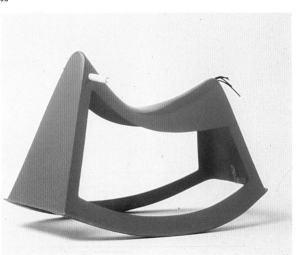

3.9

3.11

3.12

Tomte stool, designed and manufactured by Gunter König, Hamburg, 1996, beech, plywood, felt (34 x 29 x 34 cm; weight 1.9 kg)
The round shape, a trigger for the child's imagination and fantasy, has been ergonomically designed. Turned upside down, the chair can be used as a swing. Recipient of an award in 1996 at the International Furniture Design Competition of the Japanese Ministry of Commerce.

3.13

Toblos play furniture, designed by Alexandra Reinhold, 1994, impregnated plywood, hemp rope, steel and velvet, prototype (wooden disc diameter 100 cm, steel rod 80 x 19 cm) [Alexandra Reinhold, Berlin]

These toy discs help the child discover and develop a sense of balance through play, promoting the interaction of sensory perception, the brain and motor coordination. This modular play system, suitable for children aged between twenty months and six years, has snap-in sockets for additional elements, enhancing scope for movement. Children with a disturbed sense of balance can use the discs to improve their motor skills without the fears typically associated with medical devices. L.B.

3.14

Måne rocking chair, 1996, designed and manufactured by IKEA of Sweden, Älmhult, foam with removable cotton cover (95 x 28 x 43 cm)
This abstract, sculptural form is a simple and robust design. It combines two functions in one, being both comfortable to sit in as a chair and inviting to play with as a toy, helping to develop a child's sense of balance. L.B.

3.15

Almost as wonderful as flying!

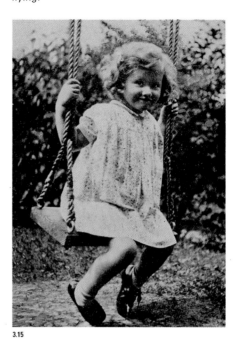

3.15

3.12

3.13

3.14

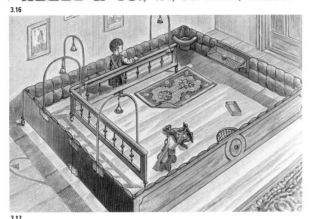

3.16

3.17

260

3.19.1

3.19

3.16
Advertisement for The Baby's Playground, 1902, manufactured by Abell & Co., Duffield, Derby.

3.17
Miniature children's room kit, 1908.

3.18
Play pen, early 1950s, wood. [York Castle Museum, York] Playpens originally took the form of a cage, sometimes with a built-in floor, later becoming structures that folded flat for space-saving storage. They were originally used in day nurseries and other institutions, where one adult had to look after more than one child, but where strapping a child to a high chair was not deemed acceptable for longer periods. In the twentieth century they were often used by middle income Western parents with the space to put them out. Wood is robust but results in more knocks and bruises than with the more recent "lobster pot" pens, made of nylon mesh on a metal frame; these are softer, but nearly always smaller in area. L.B.

3.19 and 3.19.1
Penta play pen, designed by Maria Teresa Sucre, 1994, Caracas, Venezuela, aluminium tubing, plastic, with a lateral safety device (diameter open 120 cm, folded 32 cm) [Maria Teresa Sucre, Caracas] This play pen is easily folded and can be taken anywhere.

3.18

3.20
Shaggy bean bag, designed by Tom Dixon and Hikaru Noguchi, 1991, machine-knitted wool with hand-tufted locks over polystyrene beads (30 x 150 x 150 cm) [Eurolounge, London]
The bean bag, a standard fashionable mode of sitting for adults in the 1960s, is ideal for children: it is soft and therefore safe, robust and easy to cuddle or wrestle with. This one is formed like a doughnut, and has a textured fabric suggesting an anemone with dreadlocks, which gives it personality. Both utilitarian and simply decorative, it is versatile enough to enjoy a long life, changing its role as the child grows. It can be used as a playpen with soft walls for a baby, later as social furniture for two to three infants, and then for teenagers to lie in and watch television. L.B.

3.21
Play table, early twentieth century, China, wood (70 x 92 x 45 cm) [Vitra Design Museum collection]
This kind of play table was very common in China until well into the 1980s. In southern China it was predominantly made of bamboo, in northern China of wood. Two children can sit facing each other on the seats.

3.22
Furniture for children, designed by Kristian Vedel, 1956–57, manufactured by Torben Orskov, Copenhagen, bent plywood (41.5 x 61 x 44 cm) [Vitra Design Museum collection]
The seat and table are adjustable in five positions, and can be used as chair, play table and swing. The complete system consists of one play table and four chairs.

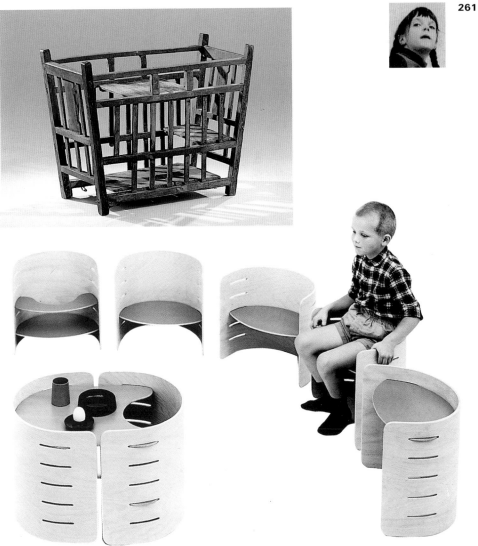

3.23
Play table, designed by Stig
Lonngren, 1963, Sweden
(73 x 65 x 70 x 55 cm)
[Stedelijk Museum,
Amsterdam]
An extraordinary, space-
swallowing play table by
a little known Swedish
designer that looks as if was
inspired by playing with
paper cones. In form it is an
interconnected cylinder and
circle, with an inserted seat,
ample surface space for
play, and wide cut outs
creating openings for the
legs at the front and a secret
hideaway spot underneath
at the back. L.B.

3.24
Play table/highchair,
early twentieth century,
beechwood
(95 x 48 x 55 cm)
[Vitra Design Museum
collection]

3.25
Tripp Trapp chair for
children, designed by
Peter Opsvik, 1973,
manufactured by Stokke,
Aalesund, beechwood
(97 x 46 x 50 cm)
The seat height can be
adjusted in fourteen
positions from 10 cm to 57
cm; a seat cushion and play
table are also available. The
design is formally rooted in
Rietveld's Zig-zag chair: the
reduction of the design to
the structure reduces the
weight.

262

3.23

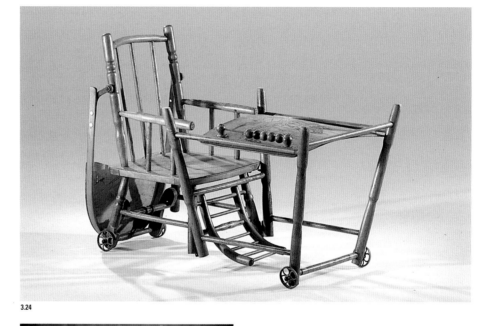

3.24

3.25

3.26

Play table and "tree" chair, designed by Makis E. Warlamis, 1988/9, Austria, manuf. Vienna Collection, Schrems, painted spruce wood (table 47 x 105 x 60 cm; chair 32 x 29 x 85 cm) These pieces are part of a pedagogical, didactic children's furniture programme launched in the late 1980s in which fairytale symbolism is applied as an instrument of fantasy play. Using the building forms on the table, play elements that fit into holes, space planners of all ages can mix urban and rural in a variety of landscapes on the semi-circular table top. The tree crown back of the chair is at the centre of the "adventure park", and one of the programme's many symbolic references to nature. L.B.

3.27 and 3.27.1

Chair for children, designed by Karin Kremser, 1994, Darmstadt, Germany, prototype, wood, slate plate, table-top pivots
(62 x 35 x 56 cm)
Matching table
(58 x 55 x 60 cm)
Designed predominantly for use in the kindergarten, where flexible and ergonomic seating is a prime concern. When the child sits backwards on the chair, it gains a small playing surface. The backrest can be bent right down to the floor, creating a sort of "stool slide". A swivelling tray increases the table size and can be used for drawing.

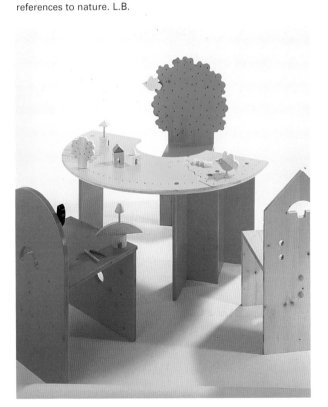

3.28
Small bench for children,
1920–30, wood
(68 x 80 x 50 cm)
[Focke Museum, Bremen,
Germany]

3.29
Erni chair for children,
Wybert, Lörrach, 1990,
varnished wood
(76 x 26.5 x 32 cm)
Seat flips up; features
storage space.

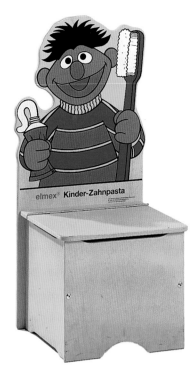

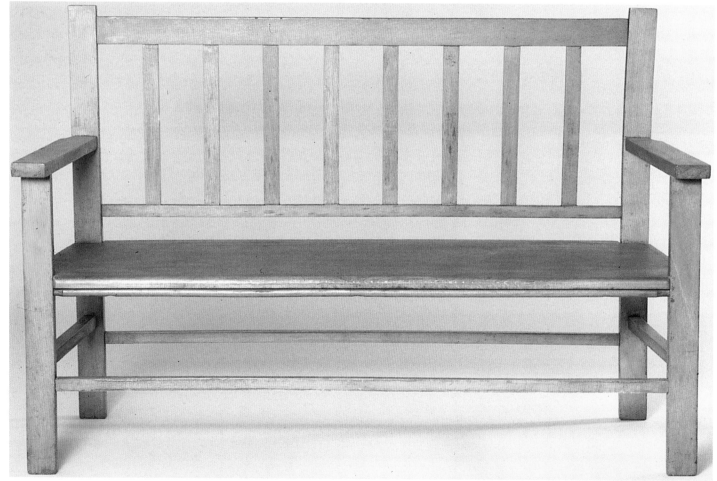

3.30 and 3.30.1
Zocker chair for children,
designed by Luigi Colani,
1972, manufactured by Top
System Burkhard Lübke,
Gütersloh, Germany,
polyethylene, stackable and
able to float in water
(50 x 32 x 57 cm, seat
height 29.5 cm)
[Vitra Design Museum
collection]
An integral seat–desk
combination, ergonomically
designed, which led to a
larger adult version.

3.31
Filius seating, designed by
Günter Beltzig, 1974,
manufactured by Brüder
Beltzig, Wuppertal,
Germany, polyester,
stackable
(54.5 x 144 x 144 cm)
[Günter Beltzig, Hohenwart]
The integral seat–table
combination can be used in
a variety of environments:
children's rooms, nurseries,
private gardens and
restaurant terraces.

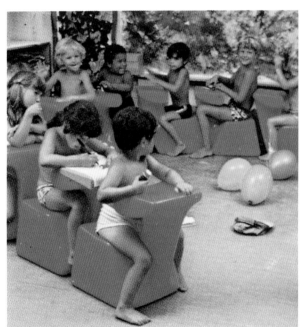

3.30

3.30.1

3.3.1

3.32
Play cupboard, designed by Alma Buscher, 1923, Germany, wood partly varnished in different colours, linoleum (180 x 158 x 92 cm), reproduction [Vitra Design Museum collection]
Alma Buscher, Bauhaus student, designed a complete children's room for the showpiece "Haus am Horn", containing beautifully shaped and functional objects. The play cupboard can be placed around a corner. One of the three segments has an opening for puppet shows; a second (open) and a third (closed) segment are used to store toys and books. Mobile play boxes invite the children to sit on or in them; after playing, the children can store their toys in these

boxes, which in turn can be placed in front of the cupboard to act as steps. Many of these play cupboards were made on private commission.

3.33
Children's room, Le Corbusier, 1954, Unité d'Habitation, Marseille. A board serves as room-divider.

3.34
Children's door, 1995, designed by Dominic Jones, UK, customised shelf wood panel door, plastic porthole (198 x 76 x 3.5 cm) [Dominic Jones, Worthington] This door, designed for a child's play room or bedroom, encourages role-play by providing children with a personalised entrance to any number of imaginary situations. The porthole gives a sense of security, letting small dots of light into the room at night, and allows parents to hear and check on their child once it has gone to bed. A coat-hook doubles as a door-knocker. L.B.

3.35
Boardrobe playscreen/ensemble (Kind Size collection), designed by Daniel Weil and Gerard Taylor, 1991, lacquered beech, manufactured by Anthologie Quartett, Bad Essen. wardrobe: 46 x 48 x 135 cm; Punch and Judy show: 45.5 x 11.8 x 5.5 cm ; cabinet: 46 x 48 x 11.9 cm ; bookshelf: 48 x 23 x 11.5 cm ; blackboard: 46 x 99.5 x 3 cm
Weil, who is Argentinian, and Taylor, Scottish, combined forces to design an ensemble of interconnected play and storage elements for use in a children's room or nursery. These include a cabinet, toy box, chalkboard, magnetic letters, Punch and Judy show and bookshelves. It is an adaptable play centre

incorporating some traditionally popular play forms. The interchangeability and simplicity of elements and small palette of juxtaposed colours give the design a versatility in function so that it can grow with the developing child. L.B.

266

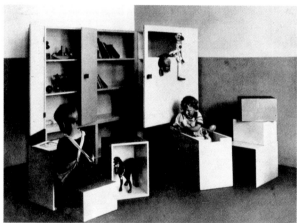
3.32

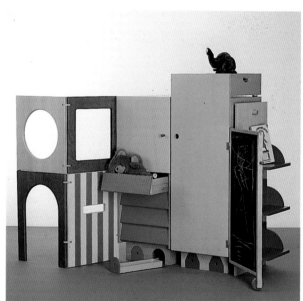
3.35

3.34

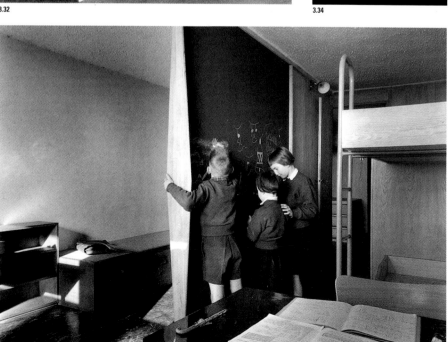
3.33

3.36
Play screen, designed by
Stephan Gip, c. 1970, wood
with white plastic coating,
manufactured by Scrivit,
Sollentuna
(120.5 x 67 x 67 cm)
[Museum für Angewandte
Kunst, Cologne]
Stephan Gip was one of
Sweden's leading designers
of children's furniture and
equipment, whose degree
show project at the
Konstfack was for a
combined bunkbed and play
centre. His commercial
ranges for Scrivit from the
early 1960s were designed
for both home and nursery.
This was a cross-disciplinary
approach, developed with
child psychologist Stina
Sandels of Stockholm
University, which attracted
much media attention. Gip's
folding screen is highly
adaptable and has multiple
uses – as a cupboard, for
puppet shows and other
forms of play. L.B.

3.37
Cart, designed by Iwao
Shibata, c. 1963, wood,
Japan (34 x 29.5 x 52 cm)
[Stedelijk Museum,
Amsterdam]
Nothing is known about
Shibata, who designed this
simple wooden play cart.
A bit like a luggage trolley
or wheel barrow with big
wheels, it encourages
children to push each other
and things around, and can
be parked upright on its
legs. On its side, it looks like
a bed, and parked against a
wall, perhaps it was used as
such in a small space. L.B.

3.38
Tröfast wall bar, designed
by Torbjörn Eliasson, 1996,
manuf. IKEA of Sweden,
Älmhult, waxed wood
(205 x 60 x 12 cm)
Combining play, exercise
and height monitoring
functions, the wall bar
incorporates a cm and inch
height measure, to save
using the wall itself. L.B.

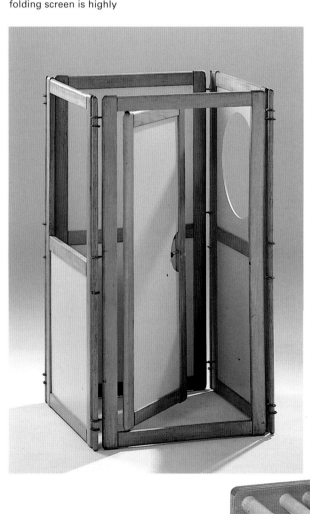

3.39
Play case, designed by Emil
Guhl, 1950, beechwood,
slate, fabric (unfolded
95 x 59 x 37 cm, folded
8 x 56 x 30 cm)
[Emil Guhl, Stein am Rhein]
The unfolded case turns into
a play table with an
integrated slate board for
drawing on. With a canopy
fixed, the table can also be
used as a toy shop.

3.40
Drawing table, designed by
Djoke de Jong for Droog
Design, 1993–94, fibreboard
with chalkboard surface
lacquered in black,
manufactured by DMD
(50 x 75 x 58 cm)
[DMD, Voorburg]
The table was designed as
part a college project about
multi-functional objects: it is
both table and chalkboard,
suitable for four- to six-year-
olds to use for play and
drawing in domestic
settings, nursery schools,
hospitals and crèches. The
construction is hollow to
ensure a flat surface and to
allow it to be turned over,
and the top has rounded
corners. De Jong favoured
the chalkboard as a surface,
observing that children
often prefer the transient
substance of chalks on
boards to paints and pens.
L.B.

3.41
Trisserne children's stools,
designed by Nanna Ditzel,
1962, stained hevea,
originally produced in
Oregon pine by Kolds
Savvaerk, Kerteminde, now
by Trip Trap Denmark A/S
(Trisserne series)
(28 x 35 cm Ø)
[Nanna Ditzel, Copenhagen]
The Trisserne [Bobbin] was
designed as a toy that rolls
and stacks. Nanna Ditzel, the
leading Danish designer,
does not feel that a child's
chair should be a copy of a
chair for adults – "children
do not sit still, they move
and run around" – and
accordingly the stool, made
in various sizes including a
larger, table version, is
intended for active use in
play, with sitting as an
option. When children are
older it serves as a useful
table or seat. L.B.

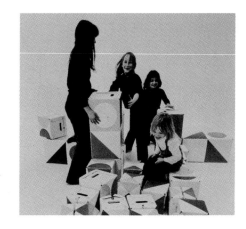

3.42
Papperlapapp [Nonsense]
seat and play dice, 1973,
manufactured by 3h design,
Stuttgart, hardboard with
PVC lining, three sizes.

3.39

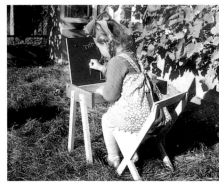

3.40

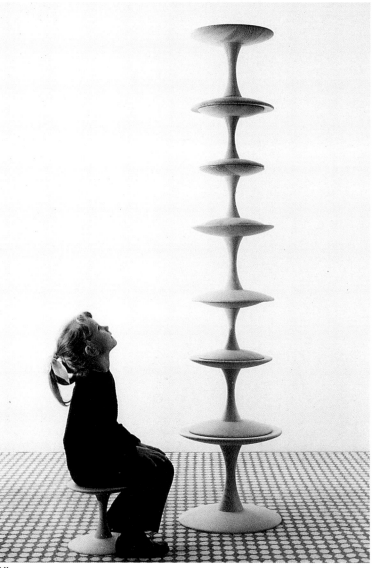

3.41

3.43
Mobilix modular play kit,
designed by Harald Zagatta
and Detlef Klein, 1971–72,
manufactured by
Kinderlübke, Gütersloh,
Germany, plastic (each
plate 40 x 40 cm)
[Burkhard Lübke, Gütersloh]
By inserting white cross-
tracks into the grooved
edges of the plates, they can
be assembled to make entire
rooms: the possibilities of
construction are virtually
endless. Castors, wheels,
boxes and foam cushions
are available for making a
bed. It is possible to draw on
the plates with a water-
soluble pen. Relatively
expensive and requiring
considerable storage space
at retail outlets, it was
commercially unsuccessful.

3.44
Bau-mobil construction kit,
designed by Rouge
Ekkehard Fahr, 1968–70,
manufactured by
Holzverarbeitungswerk
Trautwein, Weingarten bei
Karlsruhe, Germany, painted
wood (box 80 x 100 x 50 cm)
[Rouge Ekkehard Fahr,
München]
Eighty bricks in eight
different shapes and colours
within a plywood box with
round edges, and holes for
rope, axles and wheels. A
long rope for a boat, crane
or funicular, and rubber
tyres for the wooden wheels
of a cart, train or car are also
included. Awarded the
Federal Prize for Excellence
in Design for Children
(Germany) in 1971 and the
Spiel gut award for
impeccably designed toys.

3.45
Mobs Wackeln toy animal,
designed by Hans-Peter
Oehm and Peter Brandeis,
1992, manufactured by MOB
Design GmbH, Leverkusen,
Germany, varnished
beechwood, rubber, felt
(97 x 91 x 30 cm)
Intended as an alternative to
the conventional rocking
horse, might the
interchangeable insertion
elements be designed to
encourage children to help
with domestic chores?

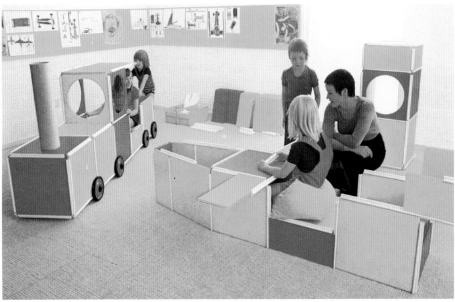

3.43

3.44

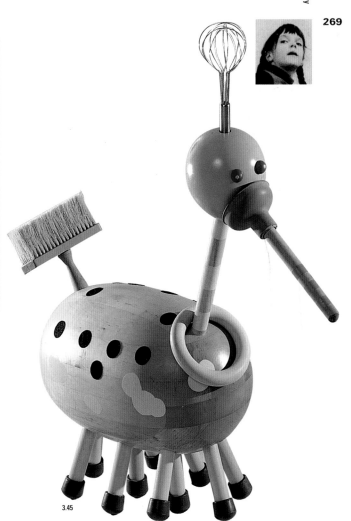

3.45

3.46
Toy shop, c. 1950, Germany,
wood, plastic
(116 x 88 x 80 cm)
[Vitra Design Museum
collection]

3.47
US kindergarten, c. 1950.
The children copy adults
during role-play: domestic
chores are carried out with
particular seriousness.

3.48
Police motorcycle, 1990s,
manufactured by Agostini
Toys, Pievestina di Cesena,
Italy, plastic
(89 x 98 x 57 cm)
[Toys 'R' Us, Weil-am-Rhein]
Electric motorcycle with
rechargeable batteries,
intended for children of up
to seven.

3.49
Indian chief on his horse.

3.50
Hachi [Rider] mobile doll,
Chileka, Malawi, wire, fabric
(64 x 100 x 19 cm)
[Moya A. Malamusi,
Museum of Ethnographic
Objects, Malawi]
Made by a 13-year-old boy.

3.49

3.48

270

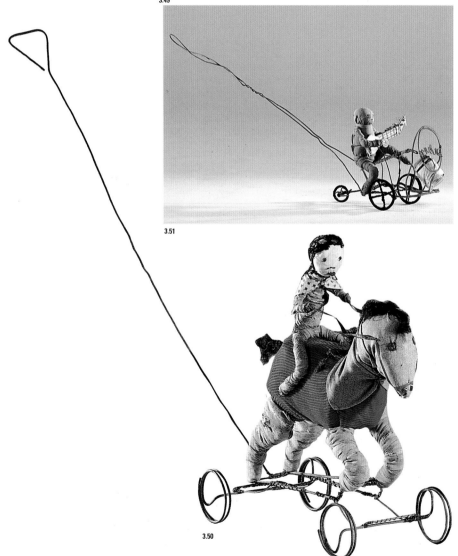
3.51

3.46

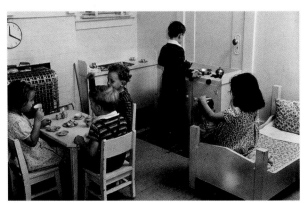
3.47

3.50

3.51

Sholisho mobile music doll, origin Chileka, Malawi, Africa, wire, textile (42 x 95 x 23 cm) [Moya A. Malamusi, Museum of Ethnographic Objects, Malawi]
Made by a 13-year-old boy, the doll represents a musician playing drum and banjo. A mechanical device makes the doll's arm move; when it is pushed, drum beats are heard.

3.52

Man with wheel barrow (20 x 13.5 x 12.5 cm)
Banjo player (20 x 13.5 x 12.5 cm)
Two board game players (14 x 12 x 18 cm)
Monkey (11.5 x 8.5 x 7 cm)
Sculptures, origin Chileka, Malawi, Africa, clay, partly painted
[Moya A. Malamusi, Museum of Ethnographic Objects, Malawi]
Sculptures made by boys and girls of different ages, playing during the rainy season.

Not illustrated

Froebel gifts nos. 2, 3, 4, 5, 6 and gridded table [Nationaal School Museum, Rotterdam]

3.53

ABC con fantasia [ABC with imagination], designed by Bruno Munari, 1960, produced by Danese, Milan (17 x 17 x 1.5 cm and 33 x 33 x 2.5 cm)
[Jacqueline Vodoz and Bruno Danese, Milan]
Yellow, pink and orange non-toxic plastic forms which can be used to compose capital letters and other imaginative shapes, for children aged three to five. Commissioning games like these from Munari and other designers like Enzo Mari gave the Daneses the chance to combine art with education. They consider the right kind of game to provide an education in visual quality and stimulates the pleasure of knowledge.
L.B.

3.54

I PreLibri [The PreBooks], designed by Bruno Munari, 1979, produced by Danese, Milan (25.5 x 36.5 x 3.5 cm)
[Jacqueline Vodoz and Bruno Danese, Milan]
Twelve books made of paper card, cardboard, wood, cloth, wettex, frisellina and transparent plastic, each with a different binding, for children aged three to six.
L.B.

3.52

3.53

3.54

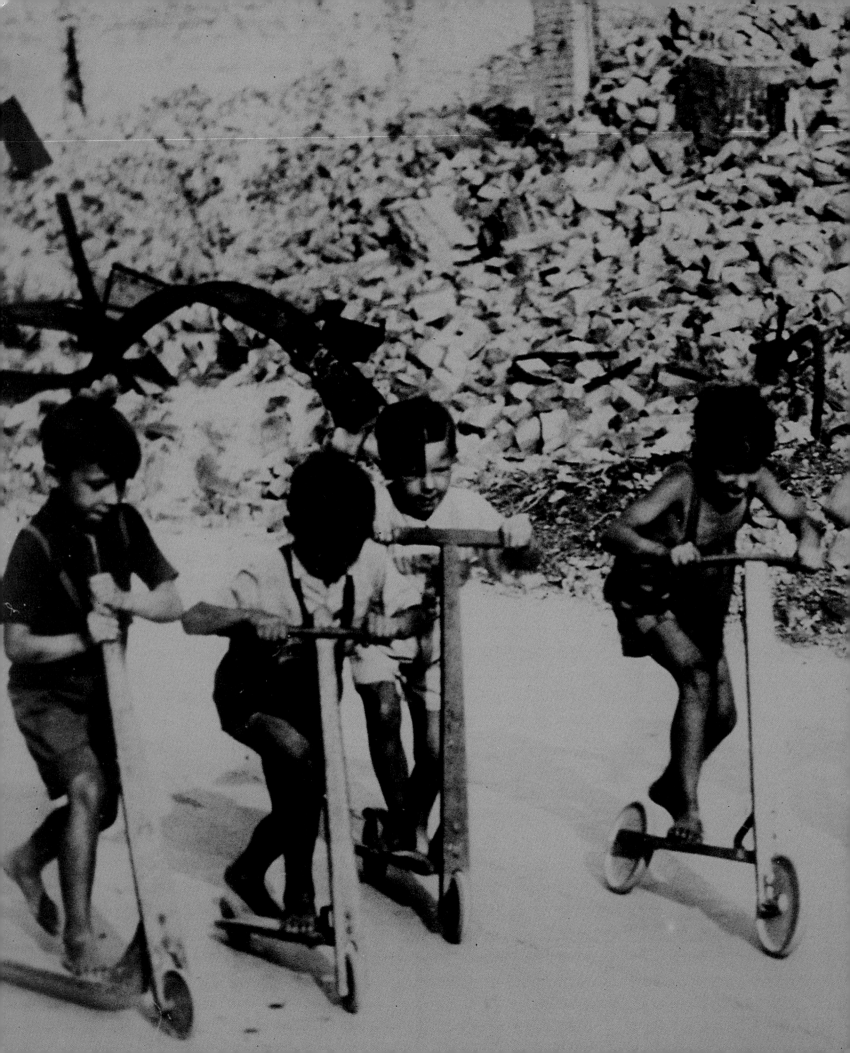

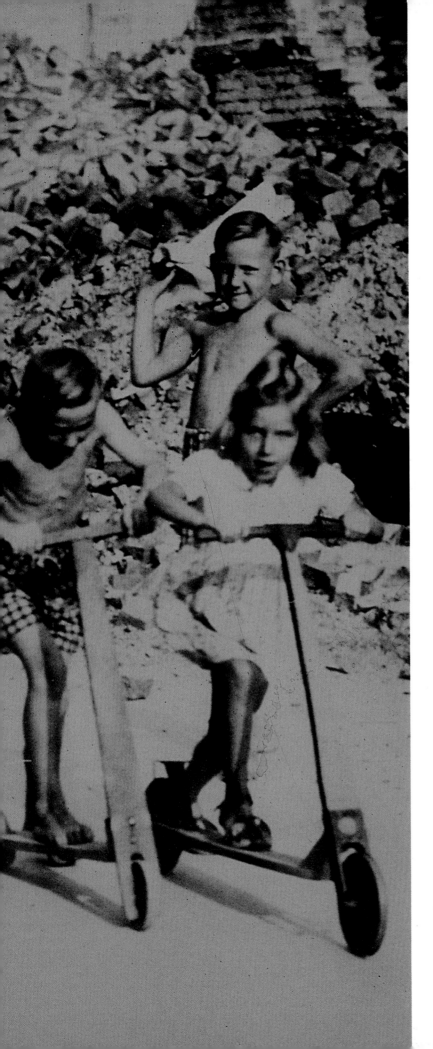

The pram, the sling and buggy, like the
idiosyncratic forms of the baby walker known
since medieval times, are all vehicles
facilitating the mobility of the child with their
own history and culture. The classic
coach-built pram, well-upholstered
and elegantly gleaming, often bought as a
family investment, has been overtaken
by the lightness and convenience of
carrycots and transporters which separate
and fold down for storage and for travelling,
and also by the slings and baby carriers
originating in many non-Western cultures
where the younger child is kept physically
close to its mobile parents. The sling
attunes children to rhythms of the adult
world; the pram positioned them at arm's
length from their carers: in the Western
world, both are social statements. L.B.

4.1
Baby walker, mid-nineteenth
century, Wales, wood
(43 x 49 x 49cm)
[The Museum of Welsh Life,
Cardiff]
A very standard type of
baby walker, made and used
in the industrial town of
Blackwood, Monmouthshire
at a relatively late stage of
the nineteenth century. The
traditional perception that
crawling was base, and that
containment was needed to
give support from six
months onwards, was deep-
seated, and baby walkers
were used very widely
throughout Europe from
the fifteenth century
onwards. L.B.

4.2
Considerate Sister, oil on
canvas by Carl Böheim, c.
1867, Osterreichische
Galerie, Vienna

4.3
Walking frame, c. 1900,
wood (43 x 105 x 60 cm)
[Alexander von Vegesack
collection]

4.4
Walking frame, c. 1850,
turned walnut
(51 x 66 x 66 cm)
[Historisches Museum,
Basel]

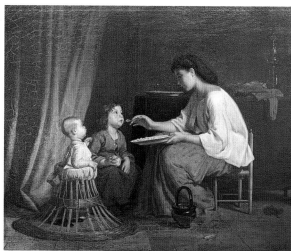

4.2

4.3

4.1

4.4

4.5
Barouche for children
(summer model), c. 1820,
Basel, walnut
(82 x 150 x 75 cm,
plus 128-cm shaft)
[Historisches Museum,
Basel]
A detailed copy of an adult
model, with a chassis
suspended on leather straps
connected to C-springs.
Featuring a veritable gallery
of turned half-columns, it is
a particularly fine piece in
the Empire style, with seats
for two children facing each
other.

4.6
Sunday outing in Basel
in front of the
Stachelschützenhaus,
watercolour by Johann
Jacob Schneider, c. 1860.
In the foreground, right, and
in the centre, children can
be seen sitting in their
barouches.

4.7
Double mail-cart buggy,
c. 1900, wood, with four
wheels, metal foot rail and
steamed ash handles
(137.1 x 68.6 x 97.16cm)
[The Open Musem,
Glasgow]
The four-wheeled mailcart
of the Edwardian era
developed from the mid-
Victorian pushchair for older
children to sit up in, and was
adapted from the single,
two-handled postman's cart.
The major change towards
the modern pram took place
before this in the 1840s, with
the introduction of baby
carriages shaped like
bath-chairs, and intended
for pushing by the
perambulator (the person
doing the pushing, later
used for the vehicle itself),
so that the child could be
kept in view while being at
arm's length. This weighty-
looking double buggy has
two small back wheels to
cope with kerbstones; high,
open sides like a wagon to
protect the child from falling
out, but a total lack of
weatherproofing. The fixed
foot rail makes it suitable for
a toddler who can sit up
unsupported. L.B.

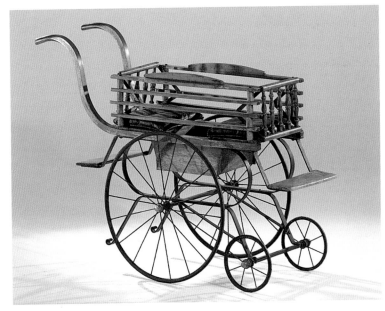

4.8 and 4.8.1
Perambulator, c. 1905,
manufactured by Baumann
et Cie, Colombier-Fontaine,
bent beechwood, steel, linen
(90 x 53 x 107 cm; weight
8 kg)
[Alexander von Vegesack
collection]
One of the first foldaway
perambulators, available
with or without top or
parasol.

4.8

4.9
Perambulator for interior
use, c. 1900, Basel,
beechwood, wicker basket,
iron roof construction and
sliding device
(114 x 55 x 98 cm)
[Historisches Museum,
Basel]

4.10
Family life in the
Reichsheimstätte Mahle-
Siedlung Stuttgart, 1936.

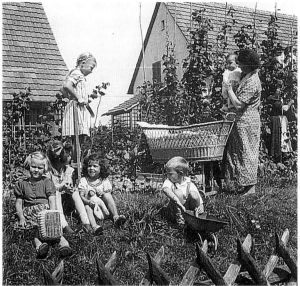

4.10

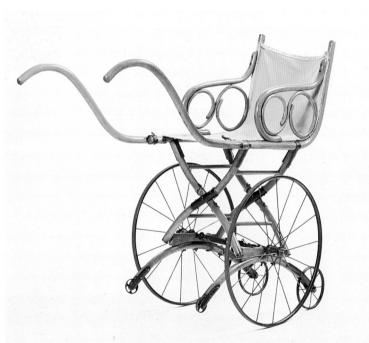

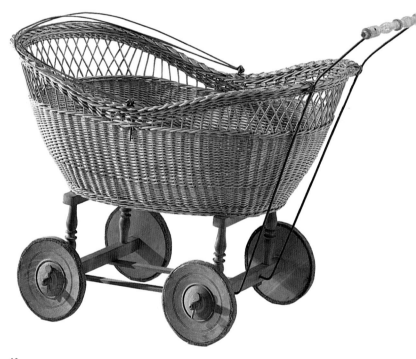

4.8.1

4.9

4.11
Handcart, c. 1900,
Switzerland, wood, iron
(77 x 100 x 62 cm, plus
109-cm shaft)
[Schweizer Sportmuseum,
Basel]
This handcart was made
specially for transporting
children; other simple carts,
not primarily intended for
children, were more
common.

4.12
Children playing in a
handcart, by Paul Anker,
nineteenth century.

4.13
Silver Cross pram,
undated,1930s, developed
by William Wilson, Leeds,
UK, black upholstery, sprung
chassis and rubber wheels
[York Castle Museum, York]
In the 1880s William Wilson,
English inventor and
perambulator spring smith,
invented a Hammock
Sprung Pram which
advanced the spring
suspension of the pram and
revolutionised the baby's
comfort. With its smart
leather upholstery and
coachbuilt, hard body in
solid wood and aluminium,
and accessories like brass
carriage lamps, it rapidly
became a status symbol for
late nineteenth-century
nannies. Hoods were
originally hinged in the
middle, later becoming fixed
at one end, folding and

reversible. This model from
the long-surviving Silver
Cross works is probably
from the 1930s, and has the
classic boat shape. The
sprung chassis finished by
blacksmiths and size of the
wheels made them easy to
push, even through fields.
L.B.

4.14
Perambulator, c. 1950–60,
Germany, metal, plastic,
chrome bumpers and hubs,
egg-shaped chassis (93 x
127 x 54 cm)
[Private collection, Hubertus
Brörmann, Bohmte]
Reminiscent of the VW
Beetle, the egg shape is
typical of 1950s
perambulators; the car
connection is underlined by
chrome bumpers and hubs.
At the bottom in the front is
a small storage
compartment. On some
models, the closed-off
chassis could be replaced
with an open-top one.

4.15
East German fabric factory
crèche on a day-trip, Zittau,
1960.

4.11

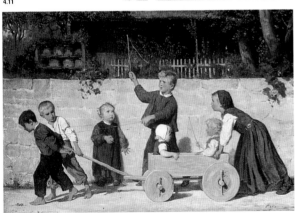

4.12

4.13

4.14

4.16 and 4.16.1
Two-seat perambulator,
China, wood
(90 x 50 x 104 cm)
[Vitra Design Museum
collection]
Similar in style to the
Chinese play table (MKM-
1003), this kind of pram was
very common in China until
well into the 1980s,
particularly in cities. Today,
it has largely been replaced
by the Western-style pram.

4.17
The Trekker all-terrain
pushchair, c. 1995,
aluminium frame, nylon
cordura seat, 12-inch
pneumatic wheels,
manufactured by PCD Ltd,
Tavistock (94 x 24 x 50 cm)
The three-wheeled
pushchair concept
originated in the US in
about 1984, when a couple
who were keen runners had
a baby. They did not want to
stop training, so they made
a pushchair with 20-inch
bicycle wheels. This British
version, initially imported
and later refined, has 12-
inch pneumatic wheels so it
can be used off-road, like a
mountain bike. It also built
in improvements suggested
by users: widening the
space for the child's legs
and simplifying mouldings.

It folds flat, is very light and
manoeuvrable even in
crowded shopping areas,
and has been seen used by
couples skating in the park.
L.B.

4.18 and 4.18.1
Pushchair, designed by
Stephen Kuester, 1997,
lightweight structure with
aluminium frame, Cordura
DuPont seat fabric with
fleece liner and plastic
components, pre-production
prototype (55 x 97 x 104 cm)
[Stephen Kuester, Bloxham]
The pushchair includes an
air filter system to protect
infants from vehicle exhaust
emissions, dust, pollen, etc.
It is designed to suit a
newborn to a four-and-a-
half-year-old child (the fabric
seat structure converts from
a lying position), and to be
simple to use. Its modern
materials and colour
emphasise functionality; the
air filter underlines parental
responsibility towards
environmental issues. L.B.

278

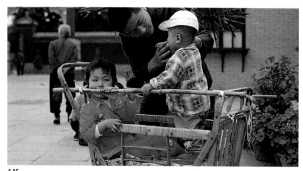

4.16

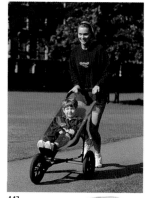

4.17

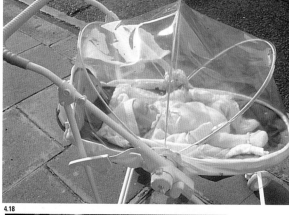

4.18

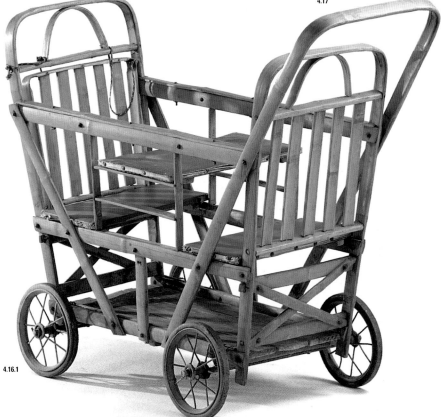

4.16.1

4.18.1

4.19
Car safety seat, designed by Kenneth Grange and Johan Santer of Pentagram Design, 1990, high duty plastics, manuf. Takata Corporation, Tokyo, Japan (62 x 47 x 44 cm) [Kenneth Grange/Pentagram, London]
Adequate but utilitarian car seats for children are very common. British industrial designer Kenneth Grange made this car seat for the Japanese market to the highest ergonomic standards, aiming to create a product in keeping with the aesthetics of the family car. The seat's appearance, with its strongly curved sliding rail, declares its function of protection and adjustment. It can be fitted either forward or to rear,

facing to rear or front seats. The chest protection pad is plugged into a quick release catch between the child's legs, not accessible to the child; the seat adjusts to accommodate children from nine months to four years of age. L.B.

4.20
Bicycle saddle, China, wood, front seat (47 x 38 x 29 cm) Rear seat (53 x 32 x 24 cm) [Vitra Design Museum collection]
Because the bicycle remains the most important means of transport for short trips in China, this kind of seat is still very common, although it has recently been banned in Beijing for safety reasons. It exists in all sorts of shapes and can be made from a variety of materials.

4.21
Trekkar handcart, designed by Gerrit T. Rietveld, c. 1923, Netherlands, wood (55 x 118 x 65 cm), reproduction [Vitra Design Museum collection]
Built for one of Rietveld's own children, this handcart is constructed according to the theories of De Stijl. It was also available in with a fabric folding roof.

4.22
Push-and-pull sleigh, c.
1850, origin environs of
Basel, Switzerland, wood,
iron, brass (91.5 x 165 x 62
cm, plus 90-cm shaft)
[Schweizer Sportmuseum,
Basel]
An ice-sleigh for one or two
children.

4.23
Innsbrucker Rodel sleigh
with strap seat, c. 1890,
Switzerland, wood, iron,
fabric (50 x 92 x 29.5 cm)
[Schweizer Sportmuseum,
Basel]
With an unconventionally
reclined seat, the centre of
gravity in this sleigh has
been moved slightly to the
rear, enabling extra speed.

4.24
Children's penny-farthing, c.
1875, France, steel wheels,
frame steering, rubber tyres,
saddle on steel spring bar
(86 x 65 x 97 cm, front wheel
diameter 60 cm, rear wheel
diameter 35 cm, frame
height 64 cm)
[Schweizer Sportmuseum,
Basel]

4.25
Tricycle, c. 1950, wood,
metal, rubber
(86 x 94 x 47 cm)
[Vitra Design Museum
collection]

280

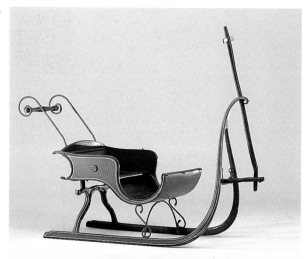

4.22

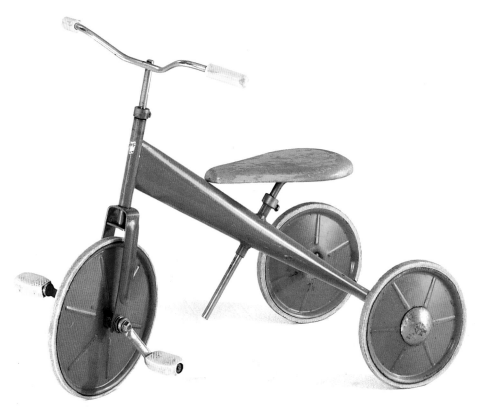

4.25

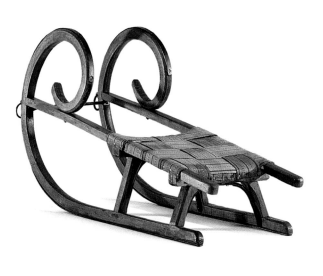

4.23

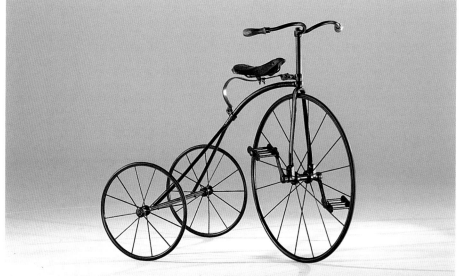

4.24

4.26
Holländer children's vehicle, c. 1925, UK, wood
(61 x 77 x 41 cm)
[Zentrum für außergewöhnliche Museen, München]
This scooter is steered with the driver's feet on the front axle and propelled by moving the upright handlebars to and fro.

4.27
144 pedal scooter with chain-drive, 1958, manufactured by Ferbedo, Nürnberg, steel, plastic
(64 x 98 x 42 cm)
[Zentrum für außergewöhnliche Museen, München]
This scooter is equipped with stabilizers, headlight, horn, luggage rack and spare wheel.

4.28
Scooter, c. 1950, wood, metal, rubber
(86 x 94 x 47 cm)
[Schweizer Sportmuseum, Basel]

4.29
Scooter race in post-war Berlin in specially cleared streets, 1947.

4.30
Children playing in a Hamburg back yard, nineteenth century.

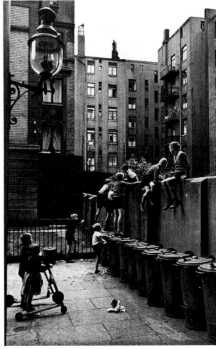

4.30

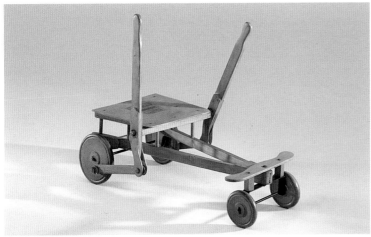

4.26

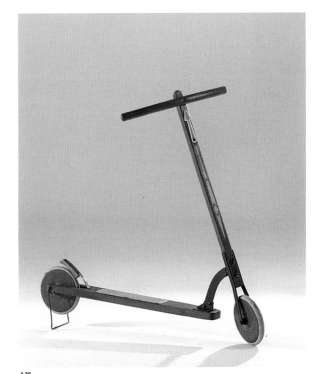

4.28

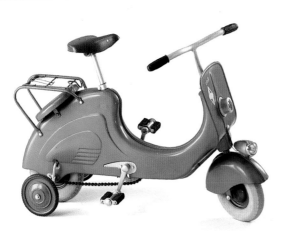

4.27

4.29

4.31
Wide sling for carrying small children, Bolivia, wool, complementary weave and warp-faced plain weave (240 x 75 cm)
[Annemarie Seiler-Baldinger, Basel]
Aymara and Quechura women wear these slings over the shoulder, usually tied at the front or fastened with a needle.

4.32
Wide sling of the Campa-Ashaninka, Gran-Pajonal, Peru, cotton, warp-faced plain rib weave, engraved animal bone plates (56 x 32 cm). Compare pl. 12, p. 106
[Annemarie Seiler-Baldinger]

4.33
Wide sling, coastal region of Equador, cotton with ikat (chain), long thread-woven macramé fringes with floral pattern (177 x 101 cm)
[Annemarie Seiler-Baldinger, Basel]

4.34
Wide bag for carrying small children of the Chulupi, Gran Chaco, Paraguay, bromeliad fibre, hour-glass weave (50 x 80 cm)
[Annemarie Seiler-Baldinger, Basel]

4.35
Sling (Faja) from Laima, Bolivia, with patterns originating from the Inca period, wool (4 x 150 cm)
Sling of the Ayoreode, Gran Chaco, Paraguay, bromeliad fibre, half weave (4 x 66 cm)
The slings were worn diagonally over the shoulder and hip, with the child placed in the sling at the hip. Compare pl. 11, p. 105.
Araukan belt for wrapping up children, Chile, wool, double weave in green, cream, pink, red and black with cjocha motif (230 x 8 cm)
[Annemarie Seiler-Baldinger, Basel]

282

4.31

4.33

4.34

4.32

4.36 and 4.36.1
Sleeping bags, designed by Terri Pecora and Marion de Rond, 1997, weather-resistant nylon with a cotton drill interior, manufactured by T.P. Rond, Milan (closed: 87 x 42 cm; open as play rug: 87 x 95 cm)
[Terri Pecora, Milan]
Two designers, the American Terri Pecora and her Dutch partner Marion de Rond, created Plumcake Kids, a new collection of products for children to fill what they see as a neglected area in the marketplace. The sleeping bag is a multi-use item geared to mobile lifestyles, designed to a minimal aesthetic with rigorous attention to technical details. The small sack zips up to allow the baby to be transported warmly in its buggy, rolls into a small bag for ease in travelling, opening up to become a soft rug for the baby to play on. It includes a toy wooden teething ring, attached by Velcro. L.B.

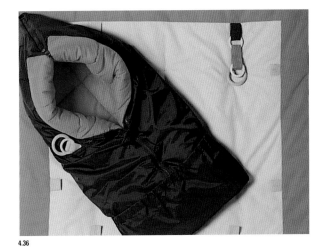

4.36

4.36.1

4.37
Bag for carrying small children of the Ijca, Sierra Nevada de Santa Marta, Columbia, wool, simple weave, strap made of loop weave
[Annemarie Seiler-Baldinger, Basel]

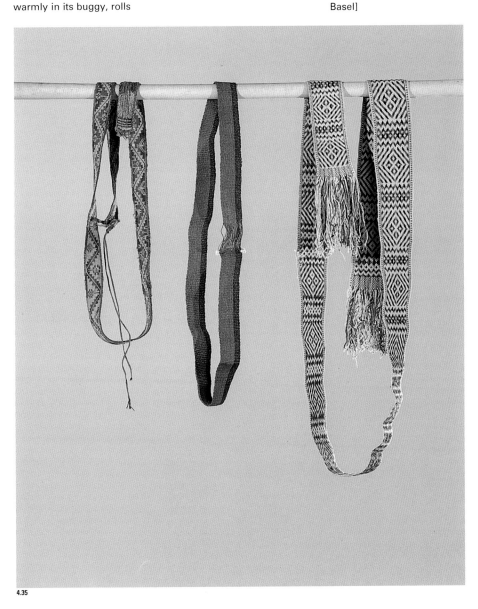

4.35

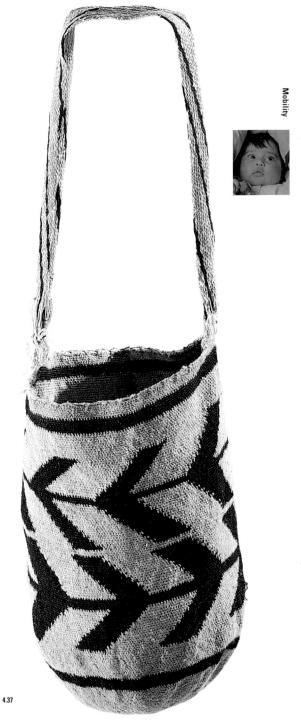

4.37

4.38
Father with child in a
pannier, Switzerland.

4.39
Father with child in a
basket-carrycot, China.

284

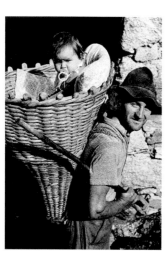

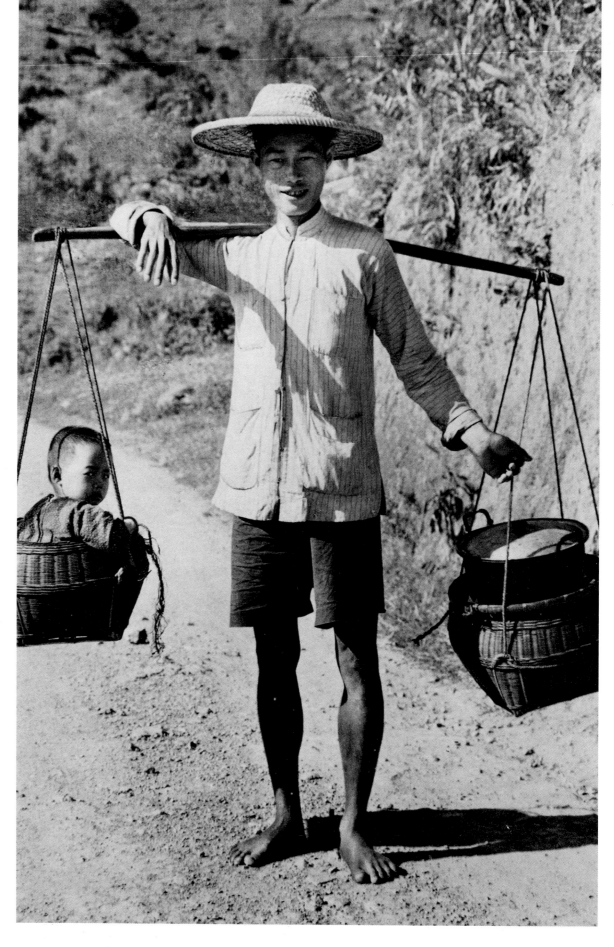

4.40

Baby carrier from Borneo, Indonesia (29 x 38 x 19 cm) [Museum der Kulturen, Basel]

A semi-circular screen made of split rotang, with a black and yellow pattern, is woven on to a small semi-circular board. The strong piece of wood is wrapped in bark and fitted with two straps for the mother. This kind of baby carrier, worn on the back like a rucksack, can still be found in remote areas of Borneo.

4.41

Baby carrier, wood, rattan, beadwork, shell, dog's teeth, c. 1900, East Kalimantan, Kenyah Dayak, Indonesia (31 x l38 cm) [Museum voor Volkenkunde, Rotterdam]

This baby carrier is an example of a benin or awat. The young children of East Kalimantan are carried on the backs of women while working in the fields. The traditional motifs are the stylised outline of an animal which, together with the teeth and shells, symbolise protection and good fortune. L.B.

4.42

Child in a baby carrier, 1975, Sarawak, Borneo, Malaysia

4.40

4.41

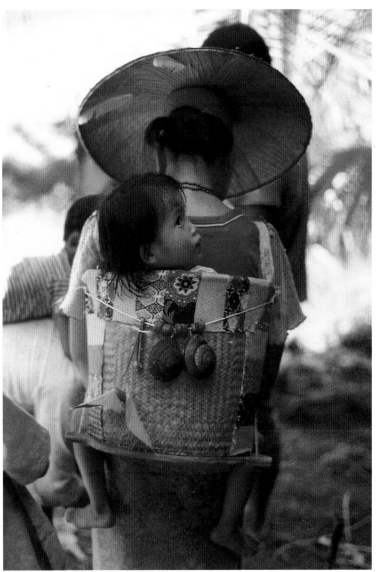

4.42

4.43
Basket for Pemón girls,
Estado Bolivar, Venezuela,
manare (split liana),
diagonal weave
(45 x 25 x 17 cm)
[Annemarie Seiler-
Baldinger]
The girls use these baskets
to bring home fruit.

4.44
Sling for carrying children
fom Yunan, China,
wool, embroidered
(40 x 62 cm without straps)
[Marianne Dürr, Zürich]

4.45
A Bai couple on their way to
the market, Yunan, China.

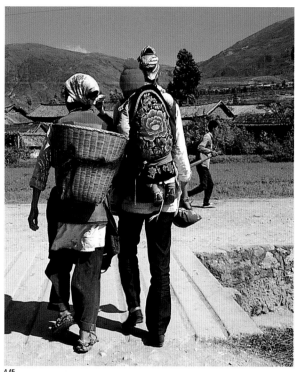

4.45

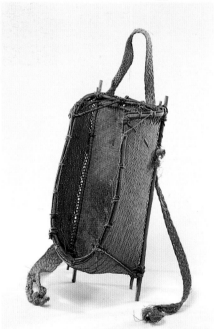

4.43

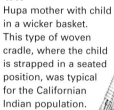

4.44

4.46
Cradle basket of the Hupa,
c. 1920, North America,
wickerwork, pearls
(17 x 31 x 75 cm)
[Indianermuseum der Stadt
Zürich]
All the North American
Indian tribes have carried
their newborn babies in
slings of this kind. They
have specific cultural
differences, but all dry nurse
their papooses (infants).
Decoration with amulets and
beads are common, the
latter indicating the wealth
of the family. Traditional
slings like this have been
replaced by modern ones,
although craftsmen still
practice the old methods,
making pieces for the tourist
industry.

4.47
Hupa mother with child
in a wicker basket.
This type of woven
cradle, where the child
is strapped in a seated
position, was typical
for the Californian
Indian population.

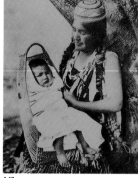

4.47

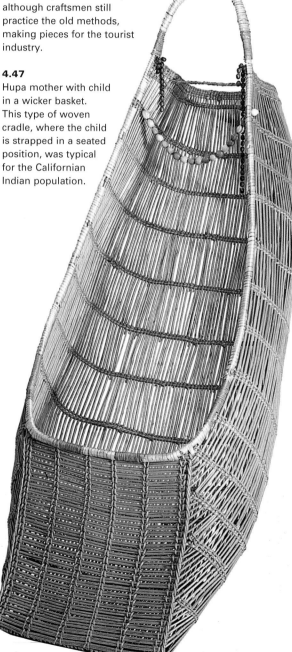

4.46

4.48

A mother, with a baby in a wooden cradle suspended from a tree, Sverige, Lapland, 1916.

4.49

Cradle from Celebes, Indonesia, wood, plant fibre (14 x 113 x 34 cm) [Museum der Kulturen, Basel]

This is an old family piece from a noble family. The devices for keeping the head and chest of the child level and the addition of a doll (presumably dating from the same period) are particularly interesting. Cradles such as these are no longer in use today.

4.50

Litter for children of the Cheyennes, c. 1930, Prairie/Plains, North America, leather, pearls, cotton, wood (24 x 30 x 100 cm) [Indianermuseum der Stadt Zürich]

This type of litter, consisting of a richly embroidered leather bag or pouch stabilised by two wooden slats, is typical for the region Prairie/Plains. Wrapped in soft fur or leather, the children spent most of the day in it, to be taken out at night to sleep. Moss, bark bast or small flakes of bark were used for cleanliness.

4.51

Bag with doll, North America, suede, wool (47 x 18 x 10 cm) [Indianermuseum der Stadt Zürich]

Intended as a toy for children.

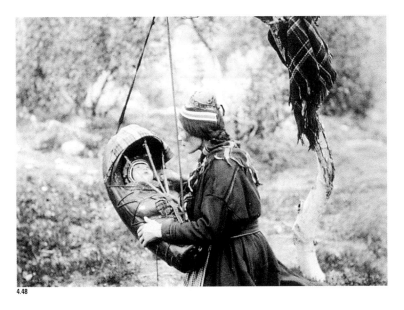

4.48

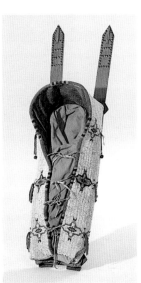

4.50

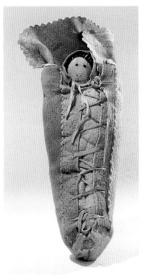

4.51

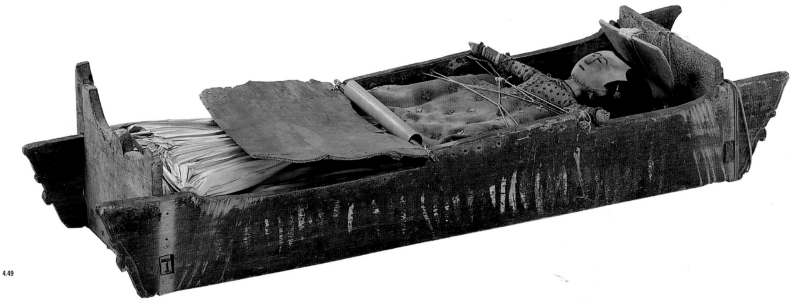

4.49

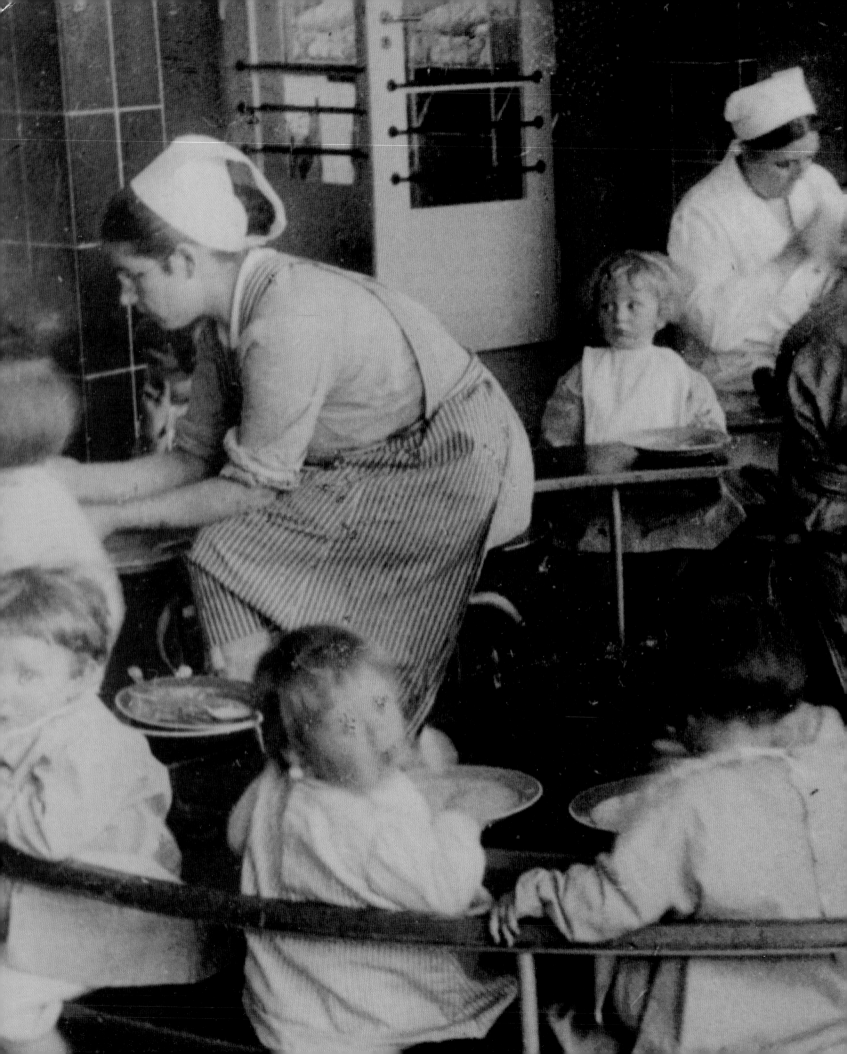

Formal learning

The kindergarten or day nursery might best be described as an extension of the home, not a substitute for it. This context for the child's first social relationships outside the home has produced various communally used designs. Desks for formal learning are not universal; nor are schoolrooms. In fact, a long period of compulsory schooling is a recent Western invention. In previous centuries not all children went to school, nor do they now in some cultures. The organisation of space for learning, whether at school or in the home, reflects widely varying definitions of "education". Conforming patterns of provision have been increasingly broken by the initiatives of designers keen to explore design solutions supporting learning that is informal, personal and, as a result, usually fun. L.B.

5.1
Nursery chair, designed by
Piet Zwart, 1921, wood
(70 x 32 x 40 cm)
[Antiquariaat Vloemans,
The Hague]
The Dutch photographer,
graphic and industrial
designer Piet Zwart is known
mostly for his modernist
graphic work for the Dutch
post office. Around 1918 he
met several members of De
Stijl and found an affinity
with their ideas. Zwart
probably wanted to put this
chair on the market as a do-
it-yourself kit, similar to the
crate furniture of Gerrit
Rietveld. This little-known
chair was used in a
Montessori school in The
Hague.

5.2
Municipal kindergarten in
Munich, 1928.

Not illustrated
Kindergarten chairs, 1936/7,
designed by Giuseppe
Terragni for the Asilo
Sant'Elia, Como, Italy
[Terragni Foundation,
Como]

5.3
Kindergarten by Le
Corbusier in Nantes, France,
c. 1954.

5.4
Circular eating table for
children, made by Ferdinand
Kramer, public kindergarten,
Bruchfeldstraße, Frankfurt
am Main, 1928.

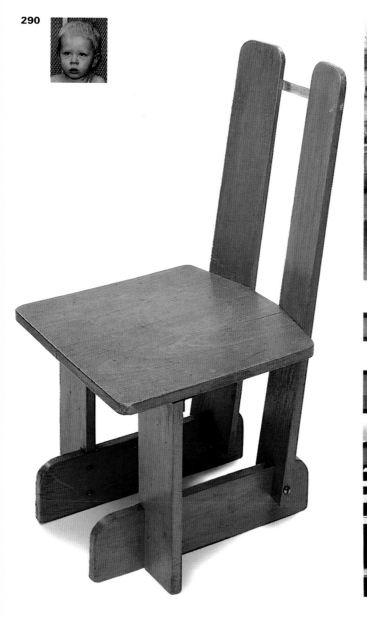

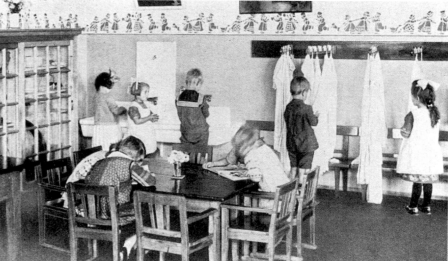

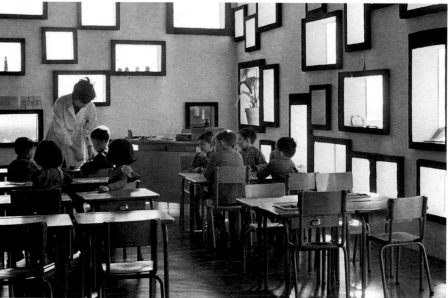

5.5 and 5.5.1
Joker, an expandable series of easy to assemble furniture designed by Swedish designers Börge Lindau and Bo Lindekrantz, 1965, (manuf. Karl Ruthers AB), for a day nursery in the Drottninghod district of Helsingborg. It was subsequently developed for use in schools, as well as furnishings for the new city library in Norrkoping, 1969, where every element was a variation on the same theme. L.B.

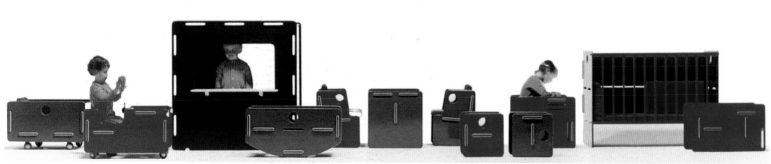

5.6
Measuring tray 1970-80,
DDR, wood (19 x 80 x 37cm)
[Museum der
Kindertagesstätten in
Deutschland – Kita Museum,
Potsdam]
To weigh and monitor
children on their arrival at
kindergarten.

5.7
Camp bed, 1960-80, DDR,
wood, fabric straps
(25 x 130 x 48 cm)
[Museum der
Kindertagesstätten in
Deutschland – Kita Museum,
Potsdam]
More time-consuming to
assemble than a
conventional bed.

5.8
Six-seater handcart, 1974-92,
DDR, wood, plastic, rubber
(66 x 153 x 85 cm)
[Museum der
Kindertagesstätten in
Deutschland – Kita Museum,
Potsdam]
For taking children on
excursions.

5.9
Potty-bench, 1970-80, DDR,
wood, plastic
(35 x 100 x 33 cm)
[Museum der
Kindertagesstätten in
Deutschland – Kita Museum,
Potsdam]
For toilet training.

5.10
Elfte Kinderkombi Marzahn,
crèche and kindergarten in
Kienbergstraße, East Berlin,
1990. Communal toilet time
just before bed.

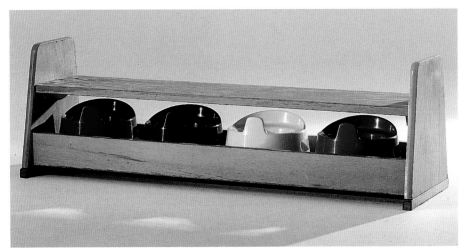

5.11
Feeding table/safety
table/eating and play table,
1975-90, DDR, wood, metal
(70 x 156 x 156 cm)
[Museum der
Kindertagesstätten in
Deutschland – Kita Museum,
Potsdam]

5.12
Play chest, 1970-80, DDR,
wood (53 x 114 x 35cm)
[Museum der
Kindertagesstätten in
Deutschland – Kita Museum,
Potsdam]

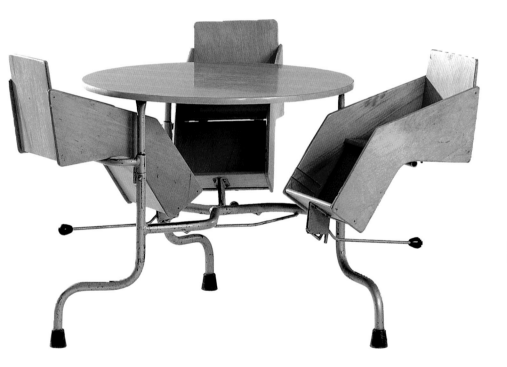

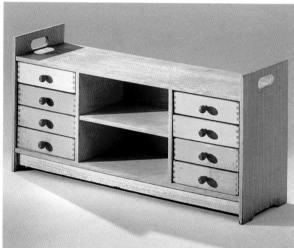

5.13

Kin-der-link stools, designed by Bashir Zivari, 1993, maple bent plywood, manufactured by Skools, Inc., New York City (30.4 x 53.3 x 45.7 cm) [Judith and Riaz Jurney, New York City]

The Kin-der-link range is intended for children aged three to eight, for use in schools, childcare centres and libraries as well as at home, giving them scope to define their own spaces. One standard module – a sturdy stool with rounded edges that doubles as a seat and a desk (now also made in polypropylene) – can be linked together in three different ways like building blocks, depending on the slot and leg configurations. This prompts a range of possibilities: an eight-foot wide circle, a "snake", arcs, a love-seat or a stool. For Zivari, who first designed Kin-der-link as an architectural student, the system does not pretend to be mini-adult furniture, nor does it overstate the case that it is for children. L.B.

5.14

The Kin-der-Link computer desk in the shape of a chariot, 1996, designed by Riaz Jurney, white birch, manuf. Skools, Inc., New York City

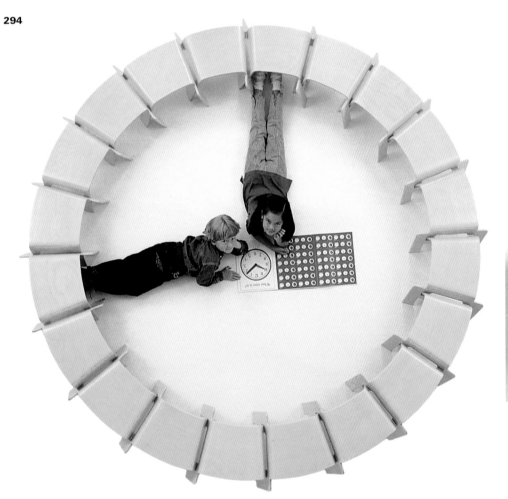

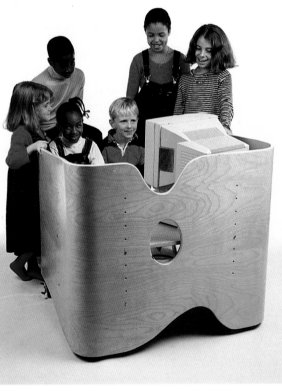

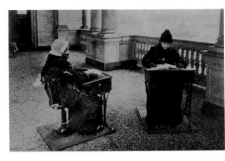

5.15
A class in Boston, early twentieth century. The school equipment consisted of warm winter clothing as well as padded sacks to keep the children warm.

5.16
School desk, 1880–1900, manufactured by The Bennet Furnishing Company, Glasgow, iron or steel, oak, flip-up height-adjustable seat
(83 x 61 x 81 cm)
[Vereinigte Spezialmöbelfabriken, Tauberbischofsheim, Germany]
This standard style of school desk could become a lectern for the older pupil, in which case the underside of the desk flap was lined with black varnish and could be used as a mini-chalkboard. Desks like these were common in parts of the UK during the twentieth century. The writing surface of this example is too high because the desk box was too big, a design fault that was later improved.

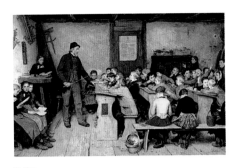

5.17
The Village School, oil on canvas by Albert Anker, 1896. Kunstmuseum Basel.

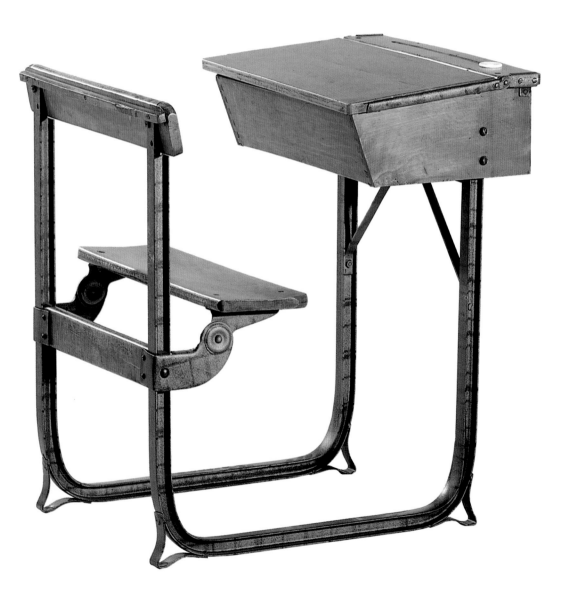

5.18
School desk, designed by
Henri Liber, France, 1937.
The tables and chairs are
fixed to a metal double-T
bar, a design informed by
architectural criteria.

5.19
School desk, designed by
Jean Prouvé, France,
1949–50, manufactured by
Atéliers Jean Prouvé,
Nancy/Maxéville, varnished
sheet steel, wood
(72 x 115 x 88 cm)
[Vitra Design Museum
collection]
Construction, functionality
and the right proportions
were more important
concerns for Prouvé than
aesthetics. His school
furniture was in use until the
late 1960s. Apart from this
fixed desk, several height-
adjustable and swivelling
versions were available.

5.20
Result chair, designed by
Friso Kramer, 1958, sheet
steel frames, plastic,
manufactured by Cirkel,
Amsterdam
(75 x 70 x 50.5 cm)
Matching chair
(80 x 53 x 42 cm)
[Stedelijk Museum,
Amsterdam]
This award-winning school
set was designed by the
Dutch designer Friso Kramer
ten years after he began
working for De Cirkel,
manufacturers of steel office
furniture in 1948, and
became a widely used
design classic in Holland.
Kramer did not like to make
ergonomics the starting
point in his designs: their

practicality stemmed from
their sound design
approach. The set is made
out of sheet steel folded into
functional proportions,
which allows torsion, and
the chair profile connects
the under-seat frame,
making it very strong. The
table's pared-down frame is
mounted with a top in
melamine plastic with a rim.
The tutor's version was
given a sheet steel drawer.
L.B.

5.21
Chair for children, designed
by Marco Zanuso and
Richard Sapper, 1964,
Germany/Italy, low-pressure
injection-moulded
polyethylene, in white,
yellow, blue and red
The three elements of this
chair (seat, legs, slide) are
assembled by pressure.
Designed for nurseries and
primary schools, it could
also be used as a toy
construction kit.

296

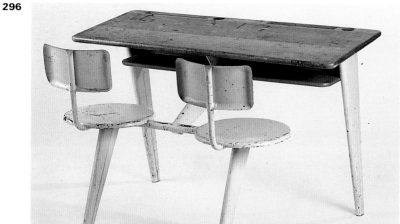

5.19

5.20

5.21

5.22, 5.22.1 and 5.22.2
Campus table, designed by
Studio de Lucchi, 1995,
metal tubing, steam-formed
plywood, injection-moulded
plastic, cast metal joiners,
moulded plastic rim on
tabletop, manufactured
by Casala, Lauenau
(650 x 750 x 800 cm)
Matching chair
(550 x 550 x 850 cm)
Mobility and maximum
organisational adaptability
were the main guiding
principles in the design of
the Campus school furniture
system for the longstanding
school furniture producers
Casala. Its development was
an opportunity to consider
how ideas about working
environments of all kinds,
including educational
settings, are changing.
Designer Michele de Lucchi
feels that the design of
classroom furnishings

should offer easy
reconfiguration for greater
flexibility. The old
educational typologies
which stressed hierarchy
and efficiency are replaced
by a more fluid and playful
design vocabulary. The
desks are fitted with wheels,
and the desk surface can be
inclined at three different
heights with an adapting
mechanism. L.B.

5.23
Desk for children, c. 1790, mahogany, rosewood, oak and maple, brass fittings (125.5 x 56 x 36 cm), pedestal not original [Focke Museum, Bremen] The base has three pull-outs and a tilted surface as desktop, above a two-door cupboard with a broken gable crown. This miniature version of an adult piece of furniture is typical of the attitude towards children at this time.

5.24
Desk for children, c. 1884, designed and manufactured by Gebrüder Thonet, Vienna, bent beechwood (87 x 42 x 58 cm, desk height 45 cm, seat height 25 cm) [Vitra Design Museum collection]

5.25
Desk for children, for use at home, early twentieth century, France, wood (70.5 x 57 x 42 cm) [Alexander von Vegesack collection] Includes manual calculator, flip-up desk top and foot rest.

5.26
Collapsible construction with table, chair and shelves for Yujiro Yamagichi's small flat, c. 1950, Japan.

5.27
School furniture designed by Pierre Chareau, France, 1937. The individual parts can be disassembled and stacked to save space.

298

5.24

5.25

5.28
High chair, designed by Piet Hein Stulemeijer, 1968, painted blue wood, the Netherlands
(80 x 45 x 40 cm)
[Stedelijk Museum, Amsterdam]
A high chair with a serious atmosphere of study about it, that plays on geometric forms, creating a somewhat curious, raised, free-standing seat structure. The seat (free of a back rest), desk/play surface and in-built foot rest are all identically painted rectangular elements. See also OKM-1056, a rocking seat. L.B.

5.29
Desk with a tractor seat, designed by Marc Berthier, 1972, steel tubing, white plastic, red painted metal, produced by Roche et Bobois, Paris
(62–70 x 50 x 70 cm)
[Museum für Angewandte Kunst, Cologne]
This French design from the early 1970s was made as a one-off prototype, for children of five and older. Both the height of the desk and seat can be adjusted, and the angle of the desk adjusted. The combination of red-painted metal tractor seat punched with small holes, white plastic desk, and steel tubing is unusual, linking the formal language of a play vehicle with a cantilevered desk design, both of which give the piece movement. L.B.

5.30
Buricito desk for children and adolescents, designed by Markus Harm and Karl-Heinz Weiss, 1994, beechwood, distributed by XS Möbel für Kinder, Kernen i.R., manufactured by Holzwerkstatt Biiraboom, Kernen i. R., Germany
(107 x 75 cm, height adjustable from 55 to 77 cm).
By slightly lifting the desktop, the height and tilt can be adjusted. To reverse the adjustment, the top is lifted again and the lock released with a button. Recipient of international design award, Baden-Württemberg, 1996–97.

5.31
Grillo desk for children, designed by Roberto Pamio, Renato Toso and Noti Massari, 1969, Italy, wooden board on blue, red or white collapsible base.

5.28

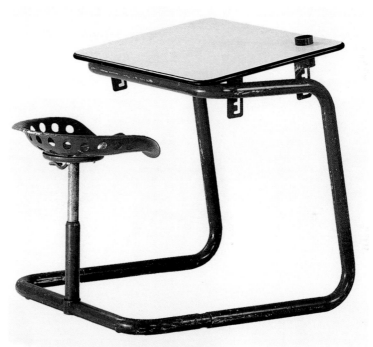

5.29

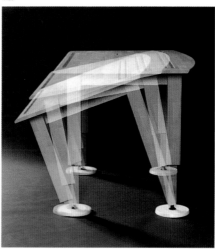

5.30

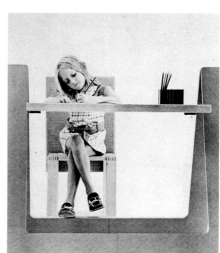

5.31

6.1
Louis XV armchair for children, 1750–60, wood, fabric padding
(70 x 45 x 47 cm)
[Vitra Design Museum collection]

6.2
Chair for children, designed by Marcel Breuer, 1923, manufactured by Bauhaus Weimar, varnished wood and plywood
(59 x 26.5 x 32 cm)
[Vitra Design Museum collection]

6.3
Collapsible chair for children, 1925–28, manufactured by Thonet, Vienna, bent beechwood, moulded plywood
(62 x 39 x 39 cm)
[Vitra Design Museum collection]

6.4
Armchair for children, designed by Erich Dieckmann, 1928, manufactured by Staatliche Bauhochschule Weimar, varnished beechwood and plywood
(33.5 x 61 x 44 cm)
[Alexander von Vegesack collection]

6.5
Armchair for children, designed by Erich Dieckmann, 1930–31, manufactured by Korbmacher-Verein Tannroda, basketwork
(52.5 x 42 x 47.5 cm)
[Alexander von Vegesack collection]

6.6
No. 103 chair for children, designed by Alvar Aalto, 1931–32, manufactured by Hounekalu-ja Rakennustyödehdas AB, Turku, Finland, bent laminated birchwood, bent plywood (58 x 34 x 49 cm)
[Vitra Design Museum collection]

6.7
Armchair for children, probably 1930–35, basketwork
(60 x 48 x 43 cm)
[Alexander von Vegesack collection]

6.8
Chair for children, part of a series of experiments by Charles and Ray Eames, 1945, manufactured by Molded Plywood Division, Evans Products Company, Venice, CA, moulded plywood
(36.5 x 35 x 28 cm)
[Vitra Design Museum collection]

6.9
Experimental chair for children, designed by Charles and Ray Eames, 1950–51, manufactured by the Eames Office, Venice, CA, fibreglass, steel wire
(50 x 38.5 x 34.5 cm)
[Vitra Design Museum collection]

6.10
Chair for children, designed by Harry Bertoia, 1952, manufactured by Knoll Associates, New York, coated steel wire, vinyl cushion (50 x 33 x 34 cm)
[Vitra Design Museum collection]

300

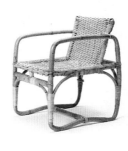
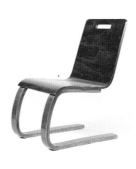

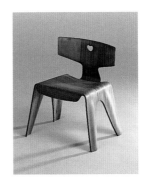

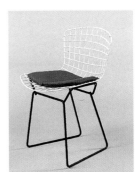
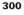

6.11
Rocking chair for children, probably 1950–55, varnished sheet steel and steel tube (54.5 x 32 x 47.5 cm) [Alexander von Vegesack collection]

6.12
Chair for children, 1950–55, varnished steel tube and wood (57.5 x 34 x 43 cm) [Vitra Design Museum collection]

6.13
Collapsible chair for children, 1955–60, chrome steel tube, plastic (54 x 41 x 46 cm) [Alexander von Vegesack collection]

6.14
Armchair for children, 1956, manufactured by Hedstrom Union Company, Dothan, Alabama, varnished steel, rubber (65.5 x 46 x 45 cm) [Vitra Design Museum collection]

6.15
Armchair for children, designed by Nguyen Manh Khanh, 1967–69, manufactured by Quasar, Paris, PVC, inflatable (47 x 56 x 56 cm) [Vitra Design Museum collection]

6.16
Short Rest armchair for children, designed by Stiletto Studios, Berlin, 1990, manufactured by Brüder Siegel GmbH & Co. KG, Leipheim, coated steel wire, plastic (56.5 x 40 x 51 cm) [Vitra Design Museum collection]

6.17
Rocking chair for children, designed by Verner Panton, Basel, 1994, wood, plastic, manufactured by PP Mobler, Allerod, Denmark (49.5 x 36 x 45 cm) [Verner Panton, Basel]

6.18
Vorwitz chair for children, designed by Robert A. Wettstein, Zürich, 1995, manufactured by Designvertrieb, Berlin, birch, coated foam (75 x 25 x 45 cm) [Designvertrieb, Berlin]

6.19
Chair for children from Indonesia, 1996, rattan (72 x 47.5 x 41 cm) [Burkard Engesser, Basel]

6.20
Musical playchair by Fisher-Price, 1997, manufactured by Fisher-Price, plastic (41 x 42 x 41 cm) [Toys 'R' Us, Weil-am-Rhein]

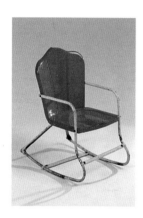

Bibliography

Further Reading (English)

Ariès Philippe, Centuries of Childhood. Librairie Plon, Paris 1960 and Jonathan Cape, London 1962

Bachelard Gaston, The Poetics of Reverie: Childhood, Language, and the Cosmos. Presses Universitaires de France, Paris 1960 and Beacon Press, Boston, 1971

Benjamin Walter, Kulturgeschichte des Spielzeugs. In: Gesammmelte Schriften, vol. III. Ed. by Tiedemann Rolf and Schweppenhäuser Hermann, Suhrkamp, Frankfurt am Main 1977; Illuminations. Ed. and intro. by Hannah Arendt, trans. by Harry Zohn. Harcourt, New York 1968 and Fontana, London 1992

Bernstein B., Class, Codes and Control, vols. 1, 2 and 3. Routledge and Kegan Paul, London 1971–73

Boas G., The Cult of the Child. Warburg, London 1966

Boswell J., The Kindness of Strangers: the Abandonment of Children in Western Europe from late Antiquity to the Renaissance. Penguin, Harmondsworth 1988

Bowlby John, Attachment and Loss, vol. 1: Attachment. Hogarth, London, 1969

Bradley Ben, Visions of Infancy. Polity Press, Cambridge and Basil Blackwell, Oxford 1989

Bronfenbrenner Urie, The Ecology of Human Development: Experiments in Nature and Design, Harvard University Press, Cambridge 1979

Bronfenbrenner Urie, The Uses of Enchantment. Vintage Books, New York 1977

Bronfenbrenner Urie, Two Worlds of Childhood – US and USSR. Touchstone Books, New York 1972

Bruner Jerome and Haste Helen (eds.), Making Sense: the Child's Construction of the World. Methuen, London 1987

Canter David, The Psychology of Space. Architectural Press, London 1977

Children's Environments Quarterly. City University of New York, New York, 1984–

Coles Robert, The Spiritual Life of Children. Houghton Mifflin, Boston 1990

Coveney P., The Image of Childhood. Penguin, Harmondsworth 1967

Crozier Ray, Manufactured Pleasures: psychological responses to design. Manchester University Press, Manchester 1994

Cunningham Hugh, The Children of the Poor: the Representation of Childhood since the 17th century. Blackwell, Oxford 1991

DeMause Lloyd (ed.), The History of Childhood. Souvenir Press, London 1976

Demos John, Present, Past and Personal. Oxford University Press, Oxford 1986

Elder Glen, Modell Jon and Parke Ross (eds.), Children in Time and Place: Developmental and Historical Insights. Cambridge University Press, Cambridge 1993

Elshtain J., The Family in Political Thought. University of Massachusetts Press, Amherst 1982

Erikson E. H., Childhood and Society. 2nd edn, Norton, New York 1963

Foucault Michel, Discipline and Punish. Allen Lane, London 1977

Hawes Joseph and Hiner Ray, Children in Historical and Comparative Perspective: an International Handbook and Research Guide. Greenwood Press, New York 1991

Hoyles Martin (ed.), Changing Childhood. Writers and Readers Publishing Cooperative, London 1977

Hoyles Martin, The Politics of Childhood. Journeyman Press, London 1989

Huizinga Johann, Homo Ludens: a Study of the Play Element in Culture. Routledge and Kegan Paul, London 1949

Hunt D., Parents and Children in History. Harper Row, New York 1972

Isaacs Susan, Social Development in Young Children: a Study of Beginnings. Routledge and Kegan Paul, London 1933

James A., and Prout (eds.), Constructing and Reconstructing Childhood. Falmer, Basingstoke 1990

James A., Childhood Identities: Self and Social Relations in the Experience of the Child. Edinburgh University Press, Edinburgh 1993

Jenks Chris, Childhood. Routledge, London 1996

Jenks Chris, The Sociology of Childhood: Essential Readings. Batsford, London 1982

Kagan Jerome, Change and Continuity in Infancy. John Wiley, New York 1971

Kagan Jerome, The Nature of the Child. Basic Books, New York 1984

Kessel F. and Siegal A. (eds.), The Child and other Cultural Inventions. Praeger, New York 1983

Klein Melanie, Our Adult World and its Roots in Infancy. Tavistock, London 1959

Konner Melvin, Childhood: a Multicultural View. Little, Brown, Toronto 1991

Kuhn Reinhard, Corruption in Paradise. The Child in Western Literature. Brown University Press/ The University Press of New England, Hannover, Pennsylvania 1982

La Cecla Franco (ed.), Perfetti e Invisibili. Pitti Imagine, Skira, Milan 1996

Laslett P. and Wall R., Household and Family in Past Times. Cambridge University Press, Cambridge 1972

Liedloff Jean, The Continuum Concept. Duckworth, London 1975

Markus Thomas A., Buildings and Power: Freedom and Control in the Origin of Modern Building

Types; chapter 3, Formation. Routledge, London 1993

Mead Margaret and Wolfenstein M., Childhood in Contemporary Cultures. Chicago University Press, Chicago 1954

Mead Margaret, Early childhood experience and later education in complex cultures. In: Wax M. et al (eds.), Anthropological Perspectives on Education. Basic Books, New York 1971

Mead Margaret, Growing up in New Guinea. Penguin, Harmondsworth 1954

Opie Iona and Peter, The Lore and Language of Schoolchildren. Oxford University Press, Oxford 1959

Piaget Jean, Play, Dreams and Imitation in Childhood. Routledge and Kegan Paul, London 1951

Piaget Jean, The Child's Conception of the World. Routledge and Kegan Paul, London 1929

Piaget Jean, The Child's Construction of Reality. Routledge and Kegan Paul, London 1937

Piaget Jean, The Language and Thought of the Child. Routledge and Kegan Paul, London 1977

Pollock Linda, A Lasting Relationship: Parents and Children over Three Centuries. Cambridge University Press, Cambridge 1987

Pollock Linda, Forgotten Children: Parent–Child Relations from 1500 to 1900. Cambridge University Press, Cambridge 1983

Postman Neil, The Disappearance of Childhood. Vintage Books, New York 1992

Qvortrup J., Childhood as a Social Phenomenon. The European Centre, Vienna 1993

Ritchie O. W. and Kollar M. R., The Sociology of Childhood. Appleton–Century–Crofts, New York 1964

Rousseau Jean-Jaques, Emile: on Education, 1st edn 1762. Trans. B. Foxley, E. P. Dutton, New York 1911

Scarr Sandra, Mother Care – Other Care. Basic Books, New York 1984

Shahar Shulamith, Childhood in the Middle Ages. Routledge, London 1990

Shorter E., The Making of the Modern Family, Collins, London 1976

Sommerville John, The Rise and Fall of Childhood. Vintage, New York 1990

Steedman Carolyn, Childhood, Culture and Class in Britain: Margaret McMillan 1860–1931. Virago, London 1990

Steedman Carolyn, Strange Dislocations: Childhood and the Idea of Human Interiority, 1780–1930. Virago, London 1995

Steedman Carolyn, The Tidy House. Virago, London 1982

Stephens Sharon (ed.), Children and the Politics of Culture. Princeton University Press, Princeton 1995

Stone Laurence, The Family, Sex and Marriage in England 1500–1800, Harper and Row, New York 1980

Suransky Valerie, The Erosion of Childhood. University of Chicago Press, Chicago 1982

Sutton-Smith Brian, Toys as Culture. Gardner Press, New York 1986

Trumbach Randolph, The Rise of the Egalitarian Family: Aristocratic Kinship and Domestic Relations in the Eighteenth Century. Academic Press, London 1978

Tuan Yi-Fu, Topophilia: a Study of Environmental Perception, Attitudes and Values. Prentice-Hall, New Jersey 1974

Vygotsky Lev Semyonovich, Thought and Language. MIT Press, Boston 1962

Walvin James, A Child's World: a Social History of English Childhood, 1880–1914. Penguin, Harmondsworth 1982

Ward Colin, The Child in the City. Architectural Press, London 1978

Whiting Beatrice and Pope Edwards Carolyn, Children of Different Worlds: the Formation of Social Behaviour. Harvard, Cambridge 1988

Wilde Astington Janet, The Child's Discovery of the Mind. Fontana, London 1994

Winnicott D. W, Playing and Reality. Penguin, Harmondsworth 1971

Winnicott D. W., The Child, The Family and the Outside World. Pelican, London 1957

Wood David, How Children Think and Learn. Blackwell, Oxford 1988

Zelizer Viviana A., Pricing the Priceless Child: the Changing Social Value of Children. Basic Books, New York 1985

Further Reading (German)

Andritzky Michael und Selle Gert (eds.), Lernbereich Wohnen. 2 vols. Reinbek bei Hamburg 1979

Ariès Philippe, Geschichte der Kindheit. Deutscher Taschenbuch Verlag, 11th edn., Munich 1994

Ariès Philippe and Duby George. S. Fischer (eds.), Geschichte des privaten Lebens, vols. 1–4. Frankfurt am Main 1989

Aus Münchner Kinderstuben 1750–1930. Exhibition at the Münchner Stadtmuseum 3 December 1976–11 April 1977

Behler Wolfgang (ed.), Das Kind. Eine Anthropologie des Kindes. Herder, Freiburg 1971

Benjamin Walter, Über Kinder, Jugend und Erziehung. Suhrkamp, Frankfurt am Main 1969

Berg Christa (ed.), Kinderwelten. Suhrkamp, Frankfurt am Main 1991

Bettelheim Bruno, Ein Leben für Kinder. Erziehung in unserer Zeit. Stuttgart 1987

Bettelheim Bruno, Zeiten mit Kindern. Herder, Freiburg 1994

Burghardt Christa and Kürner Peter (eds.), Kind und Wohnen. Leske und Budrich, Opladen 1994

Burkhard Christoph, Stadtkinder. Stadtentwicklungspolitische Aspekte veränderter Lebenslagen von Kindern. Duisburg 1992

De Mause Lloyd (ed.), Hört ihr die Kinder weinen? Eine psychogenetsiche Geschichte der Kindheit. Suhrkamp, Frankfurt am Main 1977

Dessai Elisabeth (ed.), Wohnen mit Kindern – heute und morgen. Fischer, Frankfurt am Main 1986

Dessai Elisabeth and Alt-Rosendahl R., Wohnen und Spielen mit Kindern. Alternativen zur familienfeindlichen Architektur. Econ, Düsseldorf und Wien 1976

Duché Didier-Jaques, Das Kind in der Familie. Klett-Cotta, Stuttgart 1987

Elias Norbert, Über den Prozeß der Zivilisation. Suhrkamp, Frankfurt am Main 1977

Elschenbroich D., Kinder werden nicht geboren. Studien zur Entstehung der Kindheit. Pädagogischer Extra Buchverlag, Bensheim 1977

Flade Antje, Wohnen psychologisch betrachtet. Bern 1987

Flandrin Jean-Louis, Familien. Soziologie, Ökonomie, Sexualität. Ullstein, Frankfurt am Main/ Berlin/Wien 1978

Gerhardt Ute et al. (eds.), Familie der Zukunft. Lebensbedingungen und Lebensformen. Leske und Budrich, Opladen 1995

Grefe Christiane, Ende der Spielzeit. Wie wir unsere Kinder verplanen. Rowohlt, Berlin 1995

Hardach-Pinke Irene and Hardach Gerd (eds.), Deutsche Kindheiten. 1700–1900. Anton Hain, 3rd edn., Frankfurt am Main 1992

Haupt Heinz-Gerhard (ed.), Orte des Alltags. Miniaturen aus der europäischen Kulturgeschichte. Beck, Munich 1994

Hengst Heinz (ed.), Kindheit in Europa. Zwischen Spielplatz und Computer. Suhrkamp, Frankfurt am Main 1985

Hengst Heinz et al. (eds.), Kindheit als Fiktion. Suhrkamp, Frankfurt am Main 1981

Herrmann U. et al, Bibliographie zur Geschichte der Kindheit, Jugend und Familie. Juventa, Munich 1980

Hille Barbara, Kindergesellschaft? Wie unsere Kinder aufwachsen. Cologne 1980

Hinkel Hermann, Kinderbildnisse. Vista Point, Cologne 1988

Horkheimer Max, Autorität und Familie. Frankfurt am Main 1960

Janov Arthur, Das befreite Kind. Grundsätze einer primärtherapeutischen Erziehung. Fischer, Frankfurt am Main 1986

Johansen Erna M., Betrogene Kinder. Eine Sozialgeschichte der Kindheit. Fischer, Frankfurt am Main 1978

Kähler Gert (ed.), Geschichte des Wohnens, vol. 4: 1918–1945. Reform, Reaktion, Zerstörung. Deutsche Verlags-Anstalt, Stuttgart 1996

Kaysel Roger, Pestalozzi, Fröbel, Montessori. Schweizer Kindermuseum, Baden 1996

Kinder und Erwachsene im Bildnis. Exhibition catalogue. Ed. by Gallwitz Klaus and Städtische Galerie im Städelschen Kunstinstitut, Frankfurt am Main 1978

Kindheit in Köln. Die Bestände des Kölnischen Stadtmuseums. Rev. by Hane Helmut. Cologne 1989

Köstlin Konrad et al. (eds.), Kinderkultur. 25th Deutscher Volkskundekongreß, Bremen 7–12 October 1985. Bremen 1987

Kunz Torsten, Weniger Unfälle durch Bewegung. Mit Bewegungsspielen gegen Unfälle und Gesundheitsschäden bei Kindergartenkindern. Motorik series, vol. 14. Schorndorf 1993

Lenzen Klaus-Dieter, Kinderkultur – die sanfte Anpassung. Fischer, Frankfurt am Main 1978

Liedloff Jean, Auf der Suche nach dem verlorenen Glück. Beck, Munich 1993

Loux Françoise, Das Kind und sein Körper in der Volksmedizin. Eine historich–ethnographische Studie. Frankfurt am Main 1991

Markefka Manfred and Nauck Bernhard (eds.), Handbuch der Kindheitsforschung. Luchterhand, Neuwied/Kriftel/Berlin 1993

Markowsky Barbara, Kindermöbel und Spielobjekte. Exhibition catalogue, Kunstgewerbemuseum der

Stadt Köln 22 February–23 April 1973

Meier-Oberist Edmund, Kulturgeschichte des Wohnens. Ferdinand Holzmann, Hamburg 1956

Meyer Sibylle and Schulze Eva (eds.), Technisiertes Familienleben. Blick zurück und nach vorn. Berlin 1993

Mollenhauer Klaus, Vergessene Zusammenhänge. Kultur und Erziehung. Juventa, 2nd edn., Weinheim and Munich 1985

Petsch Joachim, Eigenheim und gute Stube. Dumont, Cologne 1989

Postman Neil, Das Verschwinden der Kindheit. Fischer, 11th edn., Frankfurt am Main 1985

Renner Erich (ed.), Kinderwelten. Pädagogische, ethnologische und literaturwissenschaftliche Annäherungen. Deutscher Studien Verlag, Weinheim 1995

Retter Hein, Spielzeug. Handbuch zur Geschichte und Pädagogik der Spielmittel. Weinheim and Basel 1979

Riché Pierre und Alexandre-Bidon Danièle, L'enfance au Moyen Age. Seuil/Bibliothèque nationale de France, Paris 1994

Rutschky Katharina, Deutsche Kinderchronik. Wunsch- und Schreckensbilder aus vier Jahrhunderten. Kiepenheuer and Witsch, Cologne 1983

Rutschky Katharina (ed.), Schwarze Pädagogik. Quellen zur Naturgeschichte der bürgerlichen Erziehung. Ullstein, 6th edn., Frankfurt am Main 1993

Schäfer Gerd E., Spielphantasie und Spielumwelt. Juventa, Weinheim und München 1989

Schäfer Gerd E., Bildungsprozesse im Kindesalter. Juventa, Weinheim and München 1995

Schiffler Horst and Winkler Rolf, Tausend Jahre Schule. Eine Kulturgeschichte des Lernens in Bildern. Belser, Stuttgart and Zürich 1985

Selle Gert and Boehe Jutta, Leben mit den schönen Dingen. Anpassung und Eigensinn im Alltag des Wohnens. Rowohlt, Reinbek bei Hamburg 1986

Shorter Edward, Die Geburt der modernen Familie. Rowohlt, Reinbek bei Hamburg 1983

Tenorth H.-E., Geschichte der Erziehung. Juventa, Weinheim and München 1988

Trommsdorff Gisela (ed.), Kindheit und Jugend in verschiedenen Kulturen. Entwicklung und Sozialisation in kulturvergleichender Sicht. Juventa, Weinheim und München 1995

Van de Loo Marie-José and Reinhart Margarete (eds.), Kinder. Ethnologische Forschungen in fünf Kontinenten. Trickster, Munich 1993

Vater–Mutter–Kind. Bilder und Zeugnisse aus zwei Jahrhunderten. Münchner Stadtmuseum, Munich 1987

Vavra Elisabeth (ed.), Familie. Ideal und Realität. Exhibition catalogue, Niederösterreichische Landesausstellung im Barockschloß Riegersburg, Berger, Horn 1993

Vester Frederic, Denken, Lernen, Vergessen. Deutscher Taschenbuch Verlag, 14th edn., Munich 1978

Ward Colin, Das Kind in der Stadt. Frankfurt am Main 1978

Weber-Kellermann Ingeborg, Die deutsche Familie. Versuch einer Sozialgeschichte. Suhrkamp, Frankfurt am Main 1974

Weber-Kellermann Ingeborg, Die Kindheit. Kleidung und Wohnen, Arbeit und Spiel. Eine Kulturgeschichte. Insel, Frankfurt am Main 1989

Weber-Kellermann Ingeborg, Die Familie. Insel, 2nd edn., Frankfurt am Main 1990

Wie Kinder wohnen. Wohnsituation, Wohnwünsche, soziale Einflüsse auf das Wohnen der Kinder in Deutschland. Ed. by Schöner Wohnen. Gruner und Jahr, Hamburg 1974

Will Cornelia, Für Hahnemann und andere Kinder. Möbel rund ums Bauhaus. Exhibition catalogue, Deutsches Schloß- und Beschlägemuseum Velbert 17 September–26 November 1995

Zimmer Renate, Schafft die Stühle ab! Bewegungsspiele für Kinder. Herder, Freiburg 1995

Zimmer Renate, Handbuch der Bewegungserziehung. Herder, 5th edn., Freiburg 1996

Zimmer Renate, Kreative Bewegungsspiele. Herder, 8th edn., Freiburg 1996

Authors' bibliographies
Lucy Bullivant

Ariès Philippe, Centuries of Childhood. Librairie Plon, Paris 1960 and Jonathan Cape, London 1962

Bachelard Gaston, The Poetics of Reverie: Childhood, Language, and the Cosmos. Presses Universitaires de France, Paris 1960 and Beacon Press, Boston, 1971

Beck Ulrich, Risikogesellschaft: Auf dem Weg in eine andere Moderne, 1986. Trans. as: Risk Society: Towards a New Modernity. Sage Publications, London 1992

Benjamin Walter, Kulturgeschichte des Spielzeugs. In: Gesammmelte Schriften, vol. III, Suhrkamp, Frankfurt am Main 1977

Bradley Ben, Visions of Infancy. Polity Press, Cambridge and Basil Blackwell, Oxford 1989

Bruner Jerome and Haste Helen (eds.), Making Sense: the Child's Construction of the World. Methuen, London 1987

Cass Joan, The Significance of Children's Play. Batsford, London 1971

Crozier Ray, Manufactured Pleasures: psychological responses to design. Manchester University Press, Manchester 1994

Dudek Mark, Kindergarten Architecture: Space for the Imagination. Spon/Chapman and Hall, London 1996

Elder Glen, Modell Jon and Parke Ross (eds.), Children in Time and Place: Developmental and Historical Insights. Cambridge University Press, Cambridge 1993

Forty Adrian, Objects of Desire: Design and Society 1750–1980. Thames and Hudson, London 1986

Gelles Edward, Nursery Furniture. Constable, London 1982

Haskell A. L. and Lewis M., Infantilia: the Archaeology of the Nursery. Dobson, London 1971

Heller Steven and Steven Guarnaccia, Designing for Children. Watson-Guptill, New York 1994

Hoyles Martin, The Politics of Childhood. Journeyman Press, London 1989

Jordanova Ludmilla, New Worlds for children in the 18th century: problems of historical explanation, History of the Human Sciences, vol. 3, no. 1, 1990

Kagan Jerome, The Nature of the Child. Basic Books, New York 1984

Konner Melvin, Childhood: a Multicultural View. Little, Brown, Toronto 1991

Kindermöbel und Spielobjekte, Kunstgewerbemuseum, Cologne 1973

Liedloff Jean, The Continuum Concept. Duckworth, London 1975

Malaguzzi Loris, I Cento Linguaggi dei Bambini [The Hundred Languages of Children]. Exhibition catalogue, Modena, Reggio Emilia 1987

Mead Margaret, Male and Female, Gollancz, London 1949

Mertins Detlef, Playing at Modernity. In: Toys and the Modernist Tradition. Exhibition catalogue, Canadian Centre for Architecture, Montreal 1993

Norén-Björn Eva, Why? The Impossible Playground, vol. 1, A Trilogy of Play. Leisure Press, New York 1982

La Cecla Franco (ed.), Perfetti e Invisibili. Pitti Imagine, Skira, Milan 1996

Pollock Linda, Forgotten Children: Parent–Child Relations from 1500 to 1900. Cambridge University Press, Cambridge 1983

Postman Neil, The Disappearance of Childhood. Vintage Books, New York 1992

Rowland Anna, Business Management at the Weimar Bauhaus. In: Journal of Design History, vol. 1, nos. 3, 4, Oxford University Press, Oxford 1988

Self Will, P is for Parenting, Encyclopedia of our Times, vol. 2. In: The Observer, London, 10 October 1996

Sennett Richard, The Conscience of the Eye: the design and social life of cities, Faber and Faber, London 1990

Steedman Carolyn, Strange Dislocations: Childhood and the Idea of Human Interiority, 1780–1930. Virago, London 1995

Van de Loo and Reinhart Margarete, Kinder Ethnologische Forschungen in fünf Kontinenten. Trickster, Munich 1993

Ward Colin, The Child in the City. Architectural Press, London 1978

Wilde Astington Janet, The Child's Discovery of the Mind. Fontana, London 1994

Winnicott D. W., The Child, The Family and the Outside World. Pelican, London 1957

Wood David, How Children Think and Learn. Blackwell, Oxford 1988

Wright Lawrence, Warm and Snug: the History of the Bed, Routledge and Kegan Paul, London 1962

Zelizer Viviana A., Pricing the Priceless Child: the Changing Social Value of Children. Basic Books, New York 1985

Ingeborg Weber-Kellermann

Ariès Philippe, Geschichte der Kindheit. [Librairie Plon, Paris 1960] Munich and Vienna 1975. Trans. as: Centuries of Childhood. Jonathan Cape, London 1962

Brust Waldemar, Kinder der Koppenstraße. Berlin 1989

Conzett Verena, Erstrebtes und Erlebtes. Ein Stück Zeitgeschichte. Leipzig and Zürich 1929

Corvin Otto von, Erinnerungen

aus meinem Leben, vol. 1, Leipzig 1880

De Beauvoir Simone, Mémoires d'une jeune fille rangée. Gallimard, Paris 1958.

Eberty Felix, Jugenderinnerungen eines alten Berliners. Berlin 1925

Grillparzer Franz, Selbstbiographie. In: Werke. Cotta, Stuttgart, vol. 7, pp. 1–205

Gutzkow Karl, Aus der Knabenzeit. Frankfurt am Main 1852

Herdan-Zuckmayer Alice, Das Kästchen. Fischer-Taschenbuch no. 733, Frankfurt am Main 1973

Hetzer Hildegard, Kindheit und Armut. Leipzig 1937

Kästner Erich, Als ich ein kleiner Junge war. Berlin 1975

Key Ellen, Barnets Århundrade [The Century of the Child]. Stockholm 1927. Trans. as Das Jahrhundert des Kindes. Königstein, 1978

Mann Thomas, Doktor Faustus, 1947

Popp Adelheid, Jugendzeit einer Arbeiterin. Berlin and Bonn 1977

Schad Johann Baptist, Lebensgeschichte. 3 vols., Altenburg 1828.

Scheidig Walther, Die Holzschnitte des Petrarca-Meisters. Augsburg 1532, repr. Berlin 1955

Stifter Adalbert, Der Nachsommer. Berlin n.d

Struve Johannes, Über die körperliche Erziehung. Züllichau 1781

Voltz Johann Michael, Bilderbuch für Knaben und Mädchen [A Picture-book for Boys and Girls], Renner und Schuster, Nuremberg. Also published as: Kinderbilder zur Unterhaltung und mündliche Belehrung [Children's Pictures for Entertainment and Oral Instruction], vol. 1, Heft für Knaben; vol. 2, Heft für Mädchen. Herzberg art dealers, Augsburg, repr. Berlin 1983

Weber-Kellermann Ingeborg, Die Familie. Frankfurt am Main 1984; 3rd edn. 1989

Weber-Kellermann Ingeborg, Der Kinder neue Kleider. 200 Jahre deutsche Kindermoden. Frankfurt am Main 1985

Weber-Kellermann Ingeborg, Das Weihnachtsfest. Munich 1987, 2nd edn.

Weber-Kellermann Ingeborg, Landleben im 19. Jahrhundert. Munich 1988, 2nd edn.

Weber-Kellermann Ingeborg, Die Kindheit. Frankfurt am Main 1989, 2nd edn.

Noreen Marshall

Alcott Louisa May, An Old-Fashioned Girl. 1st edn. Sampson, Low and Co., London 1870, reissued Blackie, London and Glasgow [1950]

Ariès Philippe, L'Enfant et la vie familiale sous l'Ancien Régime. Librairie Plon, Paris 1960

Barrie J. M. Peter Pan. 1904

Frankenberg Mrs S. Common Sense in the Nursery. Pelican, London 1947

Giggling in the Shrubbery. Ed. by Marshall Arthur. Collins, Glasgow 1985

Harris Mary K., Crafts, Customs and Legends of Wales. David and Charles, Newton Abbott 1980

Hersom Kathleen, The Half Child. Simon and Schuster, London 1989

Hoffman E. T. A., Nutcracker and Mouse-King. Trans. Hope Ascott R. T. Fisher Unwin, London 1892

Housman Laurence, The Traveller's Shoes. Repr. in: Moonlight and Fairyland. Jonathan Cape, London 1978

Jacobs Joseph, Molly Whuppie. In: English Fairy Tales. 1st edn 1890, reissued The Bodley Head, London 1968

Juvenilia of Jane Austen and Charlotte Brontë, The. Ed. by Beer Frances. Penguin, Harmondsworth 1986

MacDonald George, Little Daylight. In: The Light Princess and Other Stories. Repr. in: Sinclair-Stevenson Christopher, A Book of Princes. Puffin, Harmondsworth 1964

Nesbit E., Melisande. In: Nine Unlikely Tales. 1st edn 1901, repr. in: Patrick Johnson Sally, A Book of Princesses. Puffin, Harmondsworth 1962

Opie Iona and Peter, The Classic Fairy Tales. Oxford University Press, Oxford 1974

Pollock Linda, A Lasting Relationship: Children and Parents over Three Centuries. Fourth Estate, London 1987

Stone Lawrence, The Family, Sex and Marriage in England 1500–1800. Weidenfeld and Nicolson, London 1977

Wright Lawrence, Warm and Snug. Routledge and Kegan Paul, London 1962

Sally Kevill-Davies

Ballin Ada, From Cradle to School, a Book for Mothers. London 1902

Chavasse Henry Pye, Advice to Mothers. New York 1839

Crane Walter, The Baby's Bouquet. London 1877

Dick Diana, Yesterday's Babies. London 1987

Gathorne-Hardy Jonathan, The Rise and Fall of the British Nanny. London 1972

Hampshire Jack, Prams, Mailcarts and Bassinets. Speldhurst, Kent 1980

Hardyment Christina, Dream Babies. London 1983

Harland Marion, Common Sense in the Nursery. Glasgow 1886

Holt Luther Emmett, Care and Feeding of Children. New York 1894

Kevill-Davies Sally, Yesterday's Children. Woodbridge 1991

King Sir Frederick Truby, Feeding and Care of Baby. New Zealand 1913

Lancaster Robert, All Done from Memory. London 1963

Linton Eliza Lynn, The Girl of the Period, and Other Social Essays. In: The Saturday Review. London 1883

Luiken, Des Menschen Begin, Midden en de Einde. Amsterdam 1712

Mauriceau François, The Accomplisht Midwife. Trans. Chamberlen Hugh. J. Darby, London 1673

Mauriceau François, The Diseases of Women With Child and in Childbed. 1st edn 1668. Trans. Chamberlen Hugh. London 1683

Metlinger Bartholomaeus, Ein Regiment der gesundheit fur die jungen Kinde. Frankfurt 1550

Rousseau Jean-Jacques, Emile: On Education. Paris 1762

Schama Simon, The Embarrassment of Riches. London 1987

Sitwell Osbert, Left Hand Right Hand. London 1945

Smith John Thomas, Nollekens and His Times. 1st edn 1828, repr. London 1986

Spaulding Mary and Welch Penny, Nurturing Yesterday's Child. Toronto 1994

Walsh John Henry, Manual of Domestic Economy. Rev. edn. George Routledge and Sons, London and New York 1879

Mike Scaife

Bruner Jerome S., The Relevance of Education. George Allen and Unwin, London 1971

Gardner Howard, Art, Mind and Brain. Basic Books, New York 1982

Erikson Erik, Childhood and So-

ciety. 2nd edn, Norton, New York 1963

Lave Jean, Tailor-made experiments and evaluating the intellectual consequences of apprenticeship training. In: The Quarterly Newsletter of The Institute of Comparative Human Development, 1, 1977, pp. 1–3.

Leontiev Aleksei Nicolaevich, Problems of the Development of Mind. Progress Publishers, Moscow 1981

Piaget Jean, Play, Dreams and Imitation in Childhood. Routledge and Kegan Paul, London 1962

Vygotsky Lev Semyonovich, Thought and Language. MIT Press, Boston 1962

Wallon Henri, Les origines du Caractère chez l'enfant. Presses Universitaires de France, Paris 1949

Franco La Cecla

Bambini per strada. Ed. by La Cecla Franco. Franco Angeli, Milan 1996

Barthes Roland, Mythologies. Paris 1952. Sel. and trans. by Lavers Annette. Vintage, London 1993

Benjamin Walter, Gesammelte Schriften. Ed. by Tiedemann Rolf and Schweppenhäuser Hermann. Suhrkamp, Frankfurt-am-Main 1972. Schriften trans. as Illuminations, Walter Benjamin. Ed. and intro. by Hannah Arendt, trans. by Harry Zohn. Harcourt, New York 1968 and Fontana, London 1992

Benjamin Walter, Das Passagen-Werk. Ed. by Tiedemann Rolf. Suhrkamp, Frankfurt-am-Main 1982

Children and the Politics of Culture. Ed. by Stephens Sharon. In: Princeton Studies in Culture/Power/History. Princeton University Press, Princeton, New Jersey 1995

Schlegal A. and Barry H. Adolescence: an Anthropological Inquiry. The Free Press, New York 1991

Perfetti e Invisibili, l'immagine dei bambini nei media tra manipolazione e realtà. Ed. by La Cecla Franco. Skira, Milan 1996

Youth Cultures, a Cross-Cultural Perspective. Ed. by Amid-Talai Vered and Wulff Helena. Routledge, London and New York 1995

Annemarie Seiler-Baldinger

Burgos Lingan Maria Ofelia, Das Neugeborene im andinen Raum. In: Curare, Sonderband 9, 1966, pp. 143–63

Califano Mario, Etnografia de los Mashco de la Amazonia sudocci-

dental del Perú. Fecie, Buenos Aires 1975

Cartier, J., de Champlain, S., Sagard, G.: Trois voyages au Canada (1534–1624). Ed. by Guégan B., Paris

Casevitz F.-M., Inscriptions: Un aspect du symbolisme Matsiguenga. In: Journal Société des Américanistes, vol. lxvii, Paris 1980–81, pp. 261–95

Codex Mendoza. Manuscrit Aztèque. Commentaires de K. Ross. Productions Liber, Fribourg 1978

Eickhoff Hajo, Himmelsthron und Schaukelstuhl: Die Geschichte des Sitzens. Hauser, Munich and Vienna 1993

Fenelon Costa Maria Heloisa, Arte e o artista na sociedade Karajá. Fundação Nacional do Indio, Brasilia 1978

Gebhardt-Sayers Angelika, Die Spitze des Bewusstseins. Klaus Renner, Hohenschäftlarn 1987

Harner Michael J., The Jivaro: People of the Sacred Waterfalls. Anchor Books, New York 1973

Hissink Karin and Hahn Albert, Chimane: Notizen und Zeichnungen aus Nordost-Bolivien. Franz Steiner, Stuttgart 1989

Illius Bruno, Ani Shinan: Schamanismus bei den Shipibo-Conibo. Verlag Science Fiction, Tübingen 1987

Jones R. L. and Whitemore-Ostlund C., Cradles for Life. In: American Indian Art Magazine, vol. 5(4), 1980, pp. 36–41

Keplinger Klaus, Das Shevatori. Volders, unpublished manuscript 1993

Koch-Grünberg Theodor, Zwei Jahre unter den Indianern. Reisen in Nordwest-Brasilien (1903/1905), vol. 2. Strecker und Schröder, Stuttgart 1910

Lafitau Joseph François, Moeurs des sauvages américains. In: Maspéro, vol. 1, Paris 1983

Landa Diego de, Yucatan before and after the conquest. 1st edn. 1566. New edn. ed. by Gates W., Dover, New York 1978

Léry Jean de, Brasilianisches Tagebuch. 1st edn. 1557. New edn. Erdmann, Tübingen 1967

Lith A. R., Rockin' the Cradle: Kinterzorg bij de indianern in Nord-Amerika. In: Lieve Lasten. Ed. by Hout van I. C., Tropenmueum, Amsterdam 1994, pp. 71–82

Lopez de Gomorá Francisco, Historia general de las Indias, 1st edn. Zaragoza 1552. New edn. ed. by Iberia, Barcelona 1966

Murua Martín de, Historia general del Perú. 1st edn. 1590. New edn. Historia 16, Madrid 1987

Nordenskiöld Erland, Indianer und Weisse. Strecker und Schröder, Stuttgart 1922

Nordenskiöld Erland, Indianerleben. Albert Bonnier, Leipzig 1912

Ocaña Diego de, A través de la América del Sur. 1st edn. 1599. New edn. Historia 16, Madrid 1987

Renard-Casevitz Marie-France, Inscriptions: Un aspect du symbolisme Matsiguenga. In: Journal Société des Américanistes, tome lxvii, Paris 1980–81, pp. 261–95

Sahagún Bernardino de, Historia general de las cosas de la Nueva España. 1st edn. 1524. New edn. Historia 16, Madrid 1990

Schindler Helmut, Bauern und Reiterkrieger. Munich, Hirmer 1990

Seiler-Baldinger Annemarie, Träume in der Schwebe: zur Kulturgeschichte der Hängematte, unpublished manuscript, Basel 1994

Signorini Halo, La familia etnolinguistica Pano. Ricercher, Rome 1968

Staden Hans, Wahrhaftige Historia. 1st edn. 1557. New edn. Erdmann, Stuttgart 1982

Stirling Matthew, Historical and ethnographical material on the Jivaro Indians. Smithsonian Institution Bureau of American Ethnology, Bulletin 117, Washington 1937

Tessmann Günther, Die Indianer Nordost-Perus. Strecker und Schröder, Hamburg 1930

Tessmann Günther, Menschen ohne Gott. Erdmann, Stuttgart 1928

Testimonio de la antigua palabra. 1st edn. 1570. New edn. ed. by Portilla M. León and Galcano L. Silva, Historia 16, Madrid 1990

Titiev Mischa, Araucanian culture in transition. Occasional Contributions from the Museum of Anthropology, University of Michigan, Ann Arbor 1951

Torre Mario de la (ed.), Hegi. La vida en la Ciudad de México 1849–58. Banereser, Mexiko 1989

UNESCO, Les arts de l'amérique latine. Exposition itinérante de l'UNESCO, Paris 1977

Gerhard Kubik

Dias António Jorge and Margot, Os Macondes de Mocambique, iii: Vida social e ritual de Investigacoes do Ultrarnar. Centro de Estudos de Antropologia Cultural, Lisbon 1970

Kubik Gerhard, Erziehungssysteme in ost- und zentralafrikanischen Kulturen – Forschungsansätze, -methoden und -ergebnisse. In: Mitteilungen der Anthropologischen Gesellschaft in Wien, Bd. 112, Berger, Wien and Horn 1982

Kubik Gerhard, Aló – Yoruba chantefables: An integrated approach towards West African music and oral literature. In: African Musicology, Current Trends: Festschrift for J. H. Kwabena Nketia, vol. 1. Ed. by Codgell Jacqueline, Carter Jeje and William G. African Studies Center, University of California, Los Angeles 1988, pp. 129–82

Kubik Gerhard, A Luchazi riddle session: Analysis of recorded texts in a south-central African Bantu language. In: South African Journal of African Languages, 12 (2), pp. 51–83, Bureau for Scientific Publications, Pretoria May 1992

Kubik Gerhard, Makisi – Nyau – Mapiko. Maskentraditionen im Bantu-sprachigen Afrika. Trickster bei Hammer, Wuppertal 1993

Kubik Gerhard, Kindheit in außereuropäischen Kulturen: Forschungsansätze, -methoden und -ergebnisse. In: Kinderwelten. Pädagogische, ethnologische und literaturwissenschaftliche Annäherungen, ed. by Renner Erich. Deutscher Studien Verlag, Weinheim 1995

Malamusi Moya Aliya, Sholisho, cover illustration, African Music, 6 (4), Swets & Zeitlinger, Amsterdam 1987

Murdock George Peter, Ethnographic Atlas. University of Pittsburgh Press, Pittsburgh 1967

Mwondela William R., Mukanda and Makishi: Traditional education in Northwestern Zambia. Neczam, Lusaka 1972

Mwondela William R., Chiseke. Neczam, Lusaka 1972

Ocitti J. P., African Indigenous Education, as practised by the Acholi of Uganda. East African Literature Bureau, Nairobi 1973

Paul Sigrid, Afrikanische Puppen. Basler Archivs, Book 6, new series. Dietrich Reimer, Berlin 1970

Paul Sigrid, Sozialisierung afrikanischer Kinder durch Rollenspiele. In: Siegfried Wolf zum 65. Geburtstag. Abhandlungen und Berichte des Staatlichen Museums Dresden. Akademie Verlag, Berlin 1975, pp. 227–62

Paul Sigrid, Hintergründige Verknüpfungen. Spiel und Leben im alten Afrika. In: Academia – Zeitschrift für Politik und Kultur, 33 (5),1982, pp. 29–52

Renner Erich, ed., Kinderwelten. Pädagogische, ethnologische und literaturwissenschaftliche Annäherungen. Deutscher Studien Verlag, Weinheim 1995

Van de Loo Marie-José and Reinhardt Margarete, eds., Kinder: ethnologische Forschungen in fünf Kontinenten. Trickster bei Hammer, Wuppertal 1993

Weiss Florence, Kinder schildern ihren Alltag. Die Stellung des Kindes im ökonomischen System einer Dorfgemeinschaft in Papua Neuguinea. In: Basler Beiträge zur Ethnologie, Bd. 21, Wepf, Basel 1981

Weiss Florence, Von der Schwierigkeit über Kinder zu forschen. Die Iatmul in Papua-Neuguinea. In: Kinder: ethnologische Forschungen in fünf Kontinenten. ed. by Van de Loo Marie-José and Reinhardt Margarete. Trickster bei Hammer, Wuppertal 1993, pp. 96–153

Wembah-Rashid John A. R., The Ethno-history of the Matrilineal Peoples of South-East Tanzania. In: Acta Ethnologica et Linguistica, no. 32, Series Africana 9, Föhrenau. E. Stiglmayr, Vienna 1970

Tina Wodiuning

Ba Jin, Die Familie. Berlin 1985

Chin Ann-Ping, Children of China. Voices from Recent Years. New York 1989

Beaurdeley Michel, u.a., Chinesische Möbel. Fribourg 1979

Böckel Bärbel, u.a., Chinas kleine Sonnen. Ein-Kind-Familienpolitik, Einzelkind- und Sexualerziehung. Münster 1989

Der Traum der Roten Kammer. Aus dem Chinesischen von Franz Kuhn (1932). Nachdruck Berlin 1977

Dupont Maurice, Chinesische Möbel. Stuttgart 1926

Ellsworth R.H., Chinese Furniture. Hardwood Examples of the Ming and Early Ch'ing Dynasties. New York 1970

Fong Wen C., Beyond Representation. Chinese Painting and Calligraphy 8th-14th Century. The Metropolitan Museum of Arts, New York 1992

Leutner Mechthild, Geburt, Heirat und Tod in Peking. Volkskultur und Elitekultur vom 19. Jahrhundert bis zur Gegenwart. Berlin 1989

People's Republic of China Year Book 1989/90. Beijing/Hong Kong 1989

Robinson Jean C., Of Women and Washing Machines. Employment, Housework and the Reproduction of Motherhood in Socialist China. In: China Quarterly 101.1985, S. 32-57

Sidel Ruth, Women and Child Care in China. London 1974

Tobin Joseph J., u.a., Preschool in Three Cultures. Japan, China, and the United States. New Haven and London 1989

Wolf Margery, Child Training and the Chinese Family. In: Studies in Chinese Society. Hrsg. von Wolf Arthur P. Stanford 1978

Florence Weiss

Barry Herbert, Child Irvin L. and Bacon Margaret K., Relation of Child Training to Subsistence Economy. In: American Anthropologist, vol. 61, no. 1, 1959

Hüttenmoser Marco and Degen-Zimmermann Dorothee, Empirische Untersuchung zur Bedeutung des Wohnumfeldes für den Alltag und die Entwicklung der Kinder. Edition Soziothek, Könitz 1996

Meyer Sibylle and Schulze Eva, Technik im Familienalltag. Vontobel-Stiftung, Zürich 1994

Morgenthaler Fritz, Weiss Florence and Morgenthaler Marco, Gespräche am sterbenden Fluß. Ethnopsychoanalyse bei den Iatmul in Papua-Neuguinea. Fischer, Frankfurt am Main 1984. Trans. as: Conversations au bord du fleuve mourant. Ethnopsychoanalyse chez les Iatmouls de Papouasie/Nouvelle-Guinée. Zoe, Geneva 1987

Rutschky Katharina, Schwarze Pädagogik. Quellen zur Naturgeschichte der bürgerlichen Erziehung. Ullstein, Frankfurt am Main 1977

Stanek Milan, Geschichten der Kopfjäger. Mythos und Kultur der Iatmul auf Papua-Neuguinea. Eugen Diederichs, Cologne 1982

Stanek Milan, Sozialordnung und Mythik in Palimbei. Bausteine zur ganzheitlichen Beschreibung einer Dorfgemeinschaft der Iatmul, East Sepik Province, Papua New Guinea. In: Basler Beiträge zur Ethnologie, Bd. 23, Wepf, Basel 1983

Stanek Milan, Einführung in das Ritualsystem der Iatmul, Mittelsepik, Papua-Neiguinea (mit Verzeichnis der Ritualobjekte). Museum für Völkerkunde, Basel 1984

Stanek Milan, Die Männerhausversammlung in der Kultur der Iatmul, Ost-Sepik-Provinz, Papua-Neuguinea. In: Neuguinea, Nutzung und Deutung der Umwelt, Bd. 2. Ed. by Münzel M. Museum für Völkerkunde, Frankfurt am Main 1987

Weber-Kellermann Ingeborg, Die Kinderstube. Insel, Frankfurt am Main 1991

Weiss Florence, Kinder schildern ihren Alltag. Die Stellung des Kindes im ökonomischen System einer Dorfgemeinschaft in Papua-Neuguinea (Palimbei, Iatmul, Mittelsepik). In: Basler Beiträge zur Ethnologie, Bd. 21, Wepf, Basel 1981

Weiss Florence, The Child's Role in the Economy of Palimbei. In: Sepik Heritage: Tradition and Change in Papua New Guinea. Ed. by Lutkehaus Nancy. Carolina Academic Press, Durham, Carolina 1990

Weiss Florence, Frauen in der urbanethnologischen Forschung. In: Ethnologische Frauenforschung. Ansätze, Methoden, Resultate. Ed. by Hauser-Schäublin Brigitta. Reimer, Berlin 1991, pp. 250–81

Weiss Florence, Von der Schwierigkeit über Kinder zu forschen. Die Iatmul in Papua-Neuguinea. In: Kinder: ethnologische Forschungen in fünf Kontinenten. Ed. by van de Loo Marie-José and Reinhardt Margarete. Trickster bei Hammer, Wuppertal 1993, pp. 96–153

Weiss Florence, Zur Kulturspezifik der Geschlechterdifferenz und des Geschlechterverhältnisses. Die Iatmul in Papua-Neuguinea. In: Das Geschlechterverhältnis als Gegenstand der Sozialwissenschaften. Ed. by Becker-Schmidt Regina and Knapp Gudrun-Axeli. Campus, Frankfurt am Main 1995, pp. 47–84. Trans. into French as: Rapports sociaux de sexe et structures socio-économiques dans la société Iatmul. In: Recherches et travaux en anthropologie, no. 5, pp. 3–55, Institut d'anthropologie et de sociologie, Université de Lausanne.

Weiss Florence, Die dreisten Frauen. Eine Begegnung in Papua-Neuguinea. In: Die Frau in der Gesellschaft. Fischer, Frankfurt am Main 1996

J. S Bhandari

Bhandari J. S., Kinship Affinity and Domestic Group. A Study Among the Mishing of Brahmaputra Valley. Gyan, New Dehli 1992

Desai I. P., The joint-family in India. An Analysis. In: Socological Bulletin, 5, pp. 144–56, 1956

Kapadia K. M., Marriage and Family in India. Oxford University Press, Bombay 1958

Karvey Iravati, Kinship Organization in India. Asia Publishing House, Bombay 1958

Lewis Oscar, Village Life in Northern India. Studies in a Delhi Village. University of Illinois Press, Urbana, Illinois 1958

Madan T. N., Family and Kinship. A Study of the Pandits of Rural Kashmir. Asia Publishing House, Bombay 1965

Majumdar D. N., Caste and Communication in an Indian Village. Asia Publishing House, Bombay 1958

Prabhu Pandharinath H., Hindu Social Organization. Popular Prakashan, Bombay 1940

Shah A. M., The Household Dimensions of the Family in India. Orient Longman, New Dehli 1973

Sriniwas M. N., Religion and Society among the Coorgs of South India. Clarendon Press, Oxford 1952

Barbara Fehlbaum

Berry J. W., Acculturation and Mental Health. In: Berry, Poortinga, Segall and Dasen, Cross-Cultural Psychology. Cambridge University Press, Cambridge 1992

Bucher A., Entstehung religiöser Identität. University of Freiburg, Freiburg 1985

Certes M., History of Pangasinan. University Press of the Philippines, Quezon 1974

Fehlbaum Barbara, Asin, ein philippinisches Barangay. University of Zürich, Zürich 1982

Fehlbaum Barbara, Erhebung des religiösen Urteils in Thailand und den Philippinen. University of Zürich, Zürich 1987

Himes R., Tagalog, Concepts in Causality. Ateneo de Manila University Press, Quezon 1974

Jahoda G., Supernatural Beliefs and Changing Cognitive Structures. Methuen, London 1975

Minturn L. and Lambert W. W., Mothers of Six Cultures. New York 1964

Orendain A., Barangay Justice. Alpha Omega Publications, Manila 1978

Owen N., Cumpadre Colonialism, Center for South and Southeast Asian Studies. University of Michigan, Michigan 1971

Poortinga Y., Cultural Transmission and Development. In: Berry, Poortinga, Segall and Dasen, Cross-Cultural Psychology. Cambridge University Press, Cambridge 1992

Sinha Durganand, Indiginizing Psychology. In: Berry, Poortinga and Pandey, Cross-Cultural Psychology. Allyn and Bacon, Needham Heights, Massachusetts 1996

Veerland, N., Area Handbook for the Philippines. US Government Print Office, Washington 1976

Whiting, J. W. M., Socialisation Process and Personality, Psycho-logical Anthropology. Homewood, Illinois 1961

Eileen Adams

Adams Eileen, Learning through Landscapes. In: Landscape Design, Journal of the Landscape Institute, no. 181, June 1989, pp. 16–19

Adams Eileen, School Grounds and the Local Area: Their Use as an Educational Resource. In: A Common Purpose: Environmental Education in the School Curriculum, World Wildlife Fund (UK) 1989

Adams Eileen, Learning through Landscapes: a report on the use, design, management and development of school grounds. Learning through Landscapes Trust, Winchester 1990

Adams Eileen, School's Out! New Initiatives for British School Grounds. In: Children's Environments, 10 (2), E. & F. N. Spon, London, pp.180–91

Adams Eileen, Making the Playground: a Key Stage 2 project in design technology, art, English and mathematics. Trentham, Stoke-on-Trent 1992

Adams Eileen, Learning through Landscapes. In: Ecology in Education. Ed. by Hale Monica, Cambridge University Press, Cambridge 1993

Ageyman J., People, Plants and Places. Southgate Publishers, 1996

Allen of Hurtwood Lady Marjorie, Planning for Play. Thames and Hudson, London 1986

Ask the Kids, Planning the School Site Research Project. Institute of Advanced Studies, Manchester Polytechnic, Manchester 1975

Baynes Ken, Design Education. Paper read to the Royal College of Art, London 1982

Blatchford P., Playtime in the Primary School: Problems and Improvements. National Foundation for Educational Research/Nelson, London 1989

Challenge of the Urban School Site, The. Learning through Landscapes, 1996

Court L., Ground Rules: a practical guide to planning site projects and using the School Development Plan. Community Design for Gwent, 1994

Hart R., Children's Experience of Place. Irvington Publishers, 1979

Katz C. and Hart R., The Participatory Design of Two Elementary Schoolyards in Harlem, PS 185 and PS 208. In: Children's Environments, New York 1990

308

Keaney B. and Lucas B., The Outdoor Classroom. In: Bright Ideas series, Scholastic Publications, 1992

Moore Robin, The Environmental Yard, 1997

Poulton P. and Symons G., Eco School. World Wildlife Fund (UK) [n.d.]

Renton L., The School Is Us. World Wildlife Fund (UK) 1993

Ross C. and Ryan A., Can I Stay In Today Miss? Improving the school playground. Trentham Books, 1990

Scoffham S., Using the School's Surroundings. Topman, 1980

Titman W., Special Places, Special People. World Wildlife Fund (UK) 1994

Ward C., The Child in the City. Bedford Square Press, 1990

A list of publications on the use of school grounds is obtainable from Learning through Landscapes, Third Floor, Southside Offices, The Law Courts, Winchester, Hampshire SO23 9DL.

Vedran Mimica and Kelly Shannon

Banham Reyner, The Age of the Masters: A Personal View of Modern Architecture. Harper and Row, New York 1975

Buchanan Peter, Herman Hertzberger. In: Architectural Review. London, January 1987

Frampton Kenneth, The Structural Regionalism of Herman Hertzberger. In: Archis, vol. 12, Rotterdam 1986

Hertzberger Herman, Montessori Primary School in Delft, Holland. In: Harvard Educational Review, vol. 3, no. 4, Cambridge, Massachusetts 1969

Hertzberger Herman, Montessori and Ruimte. In: De Architectur va de Montessori School. Stichting Montessori Uitgeverij, Amsterdam 1985

Marciani A. F., Giuseppe Terragni: opera completa 1925–1943. Officina Edizioni, Milan 1980

Montessori Maria, Spontaneous Activity in Education. Schocken Books, New York 1965

Page Marian, Furniture Designed by Architects. Architectural Press, London 1980

Schumacher Thomas, Surface and Symbol: Giuseppe Terragni and the Architecture of Italian Rationalism. Princeton Architectural Press, New York 1991

Zevi Bruno, Omaggio a Terragni. In: L'Architettura. Milan 1968

Jutta Oldiges

Buytendijk F. J. J., Erziehung zur Demut. Ratingen 1962

Esser Barbara and Wilde Christiane, Montessori-Schulen. Rowohlt, Reinbek bei Hamburg 1996

Oswald Paul and Schulz-Benesch Günter (eds.), Grundgedanken der Montessori-Pädagogik. Herder, Freiburg 1967, repr. 1993

Grundwald Clara, Das Kind ist der Mittelpunkt. Ed. by Holtz Axel. Kinders, Ulm and Klemm und Oelschläger, Ulm and Münster 1995

Heiland Helmut, Maria Montessori. Rowohlt, Reinbek bei Hamburg, 5th edn 1996

Holtstiege Hildegard, Maria Montessori und die reformpädagogische Bewegung. Herder, Freiburg 1986

Holtstiege Hildegard, Maria Montessori Neue Pädagogik. Princip Freiheit – Freie Arbeit. Herder, Freiburg 1987

Helming Helene, Montessori–Pädagogik. Herder, Freiburg, 14th edn 1992

Materialgeleitetes Lernen. Elemente der Montessori–Pädagogik in der Regelschule – Grandschulstufe. Ein Fortbildungsmodell der Akademie für Lehrerfortbildung Dillingen. Manz, Munich 1991

Mimica Vedran, Notes on Children. Environment and Architecture. Publikartiebüro Bonurkunde, Delft 1992

Montessori Maria, The Clio Montessori Series, Oxford, 1989 onwards

Montessori Maria, Die Entdeckung des Kindes. Ed. by Oswald Paul and Schulz-Benesch Günter. Herder, Freiburg 1969, 10th edn 1991

Montessori Maria, Grundlagen meine Pädagogik. Besorgt von Michael Berthold. Quelle und Meyer, Heidelberg 1968

Montessori Maria, Das Kind in der Familie. Vienna 1923, new edn Klett-Cotta, Stuttgart 1954

Montessori Maria, Kinder sind anders. Klett-Cotta, Stuttgart 1952, 12th edn 1988

Montessori Maria, Über die Bildung des Menschen. Ed. by Oswald Paul and Schulz-Benesch Günter. Herder, Freiburg 1966

Montessori Maria, Schule des Kindes. Ed. by Oswald Paul and Schulz-Benesch Günter. Herder, Freiburg 1976

Montessori Maria, Das kreative Kind. Ed. by Oswald Paul and Schulz-Benesch Günter. Herder, Freiburg 1972, 9th edn 1992

Montessori Maria, Frieden und Erziehung. Ed. by Oswald Paul and

Schulz-Benesch Günter. Herder, Freiburg 1973

Montessori Maria, Von der Kindheit zur Jugend. Ed. by Oswald Paul. Herder, Freiburg 1966, 2nd edn 1973; From Childhood to Adolescence. Schocken Books, New York 1976

Montessori Maria, Spannungsfeld Kind – Gesellschaft – Welt. Ed. by Schulz-Benesch Günter. Herder, Freiburg 1979

Montessori Maria, The Secret of Childhood, Sangam, London 1983

Montessori Maria, Kinder lernen schöpferisch. Ed. by Becker-Textor Ingeborg. Herder, Freiburg, 5th edn 1996

Montessori Mario, Erziehung zum Menschen. Montessori–Pädagogik heute. Fischer, Frankfurt am Main 1991

Montessori Renilde and Schneider-Henn Karin, Uns drückt keine Schulbank. Klett-Cotta, Stuttgart 1983

Orem R. C., Montessori Today. Capricorn, New York 1971

Steenberg Ulrich, Kinder kennen ihren Weg. Kinders, Ulm and Klemm und Oelschläger, Ulm and Münster 1993

Denise Hagströmer

Ahlman Lis, Om den forstolade barndom, Børn. Miljø. Sikkerhed. Boligtrivsel i centrum, Copenhagen 1989

Åkerman Brita, Familjen som växte ur sitt hem [The Family that Outgrew its Home]. Stockholm 1941

Åkerman Brita ed., Den okända vardagen [The Unknown Everyday]. Stockholm 1983

Bergström Matti, Hjärnans resurser – en bok om ideernas uppkomst [The Resources of the Brain – a Book on the Origination of Ideas]. Brain Books, Jönköping 1992

Boman Monica, Svenska Möbler 1890–1990 [Swedish Furniture 1890–1990]. Lund 1991

Eklund-Nyström Sigrid, Möbelarkitekt på 1930–talet [Furniture Design in the 1930s]. Nordiska Museet, Stockholm 1992 (English summary)

Form (Journal of the Swedish Society of Crafts and Design), issues 8–9, 1975; 2–3, 1977; 1, 1979

Janfalk Susanna A., Ingeborg Waern Bugge, arkitekt. Unpub. dissertation, Department of Art History, University of Uppsala 1995

Key Ellen, Barnets Århundrade [The Century of the Child]. Stockholm 1927

Laike Torbjörn, Vanliga barn i sina vardagliga miljöer [Ordinary Children in their Ordinary Environments]. In: Forskningen Fortsätter, Jubileumsbok–Arkitekturskolan 30 år. Lund 1995

Larsson Lena, Barnens Vrå [The Children's Corner], Stockholm 1956

Larsson Lena, Varje människa är ett skåp. Stockholm 1991 (autobiography)

Lönnqvist Bo, Ting, rum och barn. Helsinki 1992 (English summary)

Lundahl Gunilla, Hus och rum for små barn [Houses and Rooms for Small Children], Stockholm 1995

Mobilia, no. 97, nk-Bo-Nu, August 1963 (English, French, German, Swedish)

Myrdal Alva and Myrdal Gunnar, Kris i befolknbingsfrågan [Crisis in the Population Question]. Stockholm 1934

Myrdal Alva, Riktiga Leksaker [Real Toys]. Stockholm 1935

Myrdal Alva, Stadsbarn [City Children], Stockholm 1935

Myrdal Alva, Nation and Family: The Swedish Experiment in Democratic Family and Population Policy. New York 1940

Nilsson Jan Olov, Alva Myrdal – en virvel i den moderna strömmen [Alva Myrdal – an Eddy in the Modern Current]. Stockholm 1994 (English summary)

Nordiska Museet, Fataburen, 1992 (annual; English summary)

Norén-Björn Eva, Lek, lekplatser, lekredskap. Stockholm 1977; trans. as The Impossible Playground. New York 1979

Norlin Margareta, Barnets Århundrade – vart tog det vägen? [Whatever Happened to the Century of the Child?]. Stockholm 1994

Rasmusson Bodil, Barn och byggd miljö; en kunskapsöversikt [Children and the Built Environment]. Barnmiljörådet, Stockholm 1993

Schlyter Brita, Lek och leksaker [Play and Toys]. Stockholm 1951, rev. 1961

Wickman Kerstin, Barns liv, rum och ting i nordiskt perspektiv [The Life, Space and Objects of children – a Nordic Perspective]. Capellaakademin, Kalmar 1992

Elisabeth Dessai

Dessai Elisabeth, Kinderfreundliche Erziehung in der Stadtwohnung [Child-Friendly Education in Urban Living]. Fischer, Frankfurt am Main 1975

Dessai Elisabeth et al., Wohnen und spielen mit Kindern. Alternativen zur familienfeindlichen

Architektur. Econ, Düsseldorf 1976

Dessai Elisabeth, "Kinder? höchstens eins[Children – One at the Most]". Vom Geburtenrückgang zur künstlichen Menschenproduktion? Rowohlt, Reinbek bei Hamburg 1985

Dessai Elisabeth, Wohnen mit Kindern – heute und morgen [Living with children – today and tomorrow]. Fischer, Frankfurt am Main 1986

Dessai Elisabeth, Zurück zur Wohnküche [Back to the Kitchen-cum-Living Room]. Aragon, Moers 1997

Günter Bettina, Schonen, schützen, scheuern [Preserve, Protect, Polish]. Wachsmann, Münster 1995

Kastorff-Viehmann Renate, Küche und Haus – das Reich der Frau [Kitchen and House – The Young Woman's Profession]. In: Beruf der Jungfrau. Henriette Davidis und das bürgerliche Frauenverständnis im 19. Jahrhundert. Museum für Kunst und Kulturgeschichte Dortmund, Oberhausen 1988, pp. 71–90

Krausse Joachim, Die Frankfurter Küche [The Frankfurt Kitchen]. In: Oikos. Annabas, Giessen 1992, pp. 96–114

Muthesius Hermann, Kleinhaus und Kleinsiedlung [Small House and Small Settlement]. Munich 1920

Oikos. Von der Feuerstelle zur Mikrowelle [From the Fireplace to the Microwave]. Haushalt und Wohnen im Wandel. Ed. by Andritzky Michael. Design Center Stuttgart, Giessen 1992

Petsch Joachim, Eigenheim und Gute Stube [A Home of One's Own and the Best Room]. Dumont, Cologne 1989

Tränkle Margret, Fliegender Wechsel zwischen Fast Food und Feinkost [Rapid Changes between Fast Food and Delicatessen]. In: Oikos. Giessen 1992, pp. 393–410

Maasimo Alvito and Giulia Reali

Virtual pet-raising games. In: Nikkei Weekly, Nihon Keizai Shinbun, 1 February 1997

"Virtual Pet" craze sweeps Japan. In: Reuters, 22 January 1997

Ajinkya Leena, One adult and one egg for "The Birdcage" please . . ., In: CNN, 22 January 1997

Alvito Massimo, Mono. On Things. In: Rebus sic . . . F.A.O., Crusinallo 1991

Alvito Massimo, Sguardi giapponesi dal basso. In: Bambini per strada. Franco Angeli, Milan 1995 (1)

Alvito Massimo, La perdita degli spazi pubblici nella Tokyo moderna. In: Archivi di studi urbani e regionali, vol. xxvi, no. 54, 1995 (2)

Alvito Massimo, Tokyo: la metropoli sconnessa. In: La città è nuda. Volontà, no. 2–3, 1995 (3)

Alvito Massimo, Tôkyô no miegakure suru kodotachi (bambini intravisti). In: Perfetti e Invisibili. Skira, Milan 1996

Bensky Xavier and Haque Usman, Tamagocchi: "and they call it puppy love . . ." In: Neo-Tokyo Magazine, 1997

De Certeau Michel, L'Invention du quotidien. 1: Arts de faire. Gallimard, Paris 1990

Doi Takeo, The Anatomy of Depencence. Kodansha, Tokyo 1973

Dugan Jeanne, The toy that ate Tokyo is heading West. In: Business Week, 5 May 1997

Eisemberg Rebecca, Bandai's Golden Egg. In: Pathfinder, 21 March 1997

Fabris Giampaolo, Consumatore e mercato. Le nuove regole. Sperling e Kupfer, Milan 1995

Gomarasca Alessandro and Valtorta Luca, Sole mutante. Mode, giovani e umori nel Giappone contemporaneo. Costa e Nolan, Genoa 1996

Greenfeld Karl Taro, Speed Tribes. Children of the Japanese Bubble. Boxtree, London 1994

Greimas Algirdas Julien, Sémantique structurelle. Larousse, Paris 1966

Lee Martin J., Consumer Culture Reborn. The Cultural Politics of Consumption. Routledge, London 1993

Meirowitz Joshua, No Sense of Place. The Impact of Electronic Media on Social Behavior. Oxford University Press, New York 1985

Morace Francesco, Metatendenze. Percorsi, prodotti e progetti per il terzo millennio. Sperling e Kupfer, Milan 1996

Nakajima Ai, Tamagotchi: Virtual Parenthood Craze Hits Japan. Channel A Newsflash, 31 March 1997

Naisbitt John, Megatrends Asia. Eight Asian Megatrends that are Reshaping Our World. Touchstone, New York 1997

Reali Giulia, Consumo di bambini e bambini di consumo. In: Perfetti e invisibili. Skira, Milan 1996

Sullivan Kelly, Virtual pet-raising games. Cheep thrills: Virtual chickens need care and attention, or they croak. In: Washington Post, 27 January 1997

Ueda Atsushi (ed.), The Electric Geisha: Exploring Japanese Popular Culture. Kodansha, Tokyo 1994

Veblen T., The Theory of Leisure Class. Macmillan, London 1899

White Merry, The Material Child. Coming of Age in Japan and America. University of California Press at Berkeley, Los Angeles, California 1994

Biographies of contributors

Eileen Adams

Eileen Adams is an educationalist and author, specialising in design and the environment. Research Fellow at the South Bank University, London, she lectures internationally and is a consultant to many institutions in the UK and abroad, including the Schools Council; the Royal Institute of British Architects; The Children's Society; London Arts Board; Cooper-Hewitt Museum, New York; National Building Museum, Washington D.C.; New York Botanical Garden (Children's Adventure Project), and the Royal Academy of Arts, London. She directed the research programme Learning through Landscapes (1986–90) and the Schools Council's national curriculum development project Art and the Built Environment (1976–82). In 1995 she lectured in Japan on the theme of children's participation in the design process.

Massimo Alvito

Massimo Alvito is an urban anthropologist born in Cagliari, Italy. He specialises in contemporary Japanese and Korean urban cultures, lifestyles and trends. He has degrees from the University of Bologna, Hosei University, Tokyo, and a doctorate from the Ecole des hautes études en sciences sociales, Paris. He is a visiting professor and researcher to a number of Japanese universities. Since 1990 he has collaborated with the Centro Studi Alessi in Milan on the research and development of the "metaproject" and the anthropology of objects. He has contributed to conferences in Italy and in the Far East since 1992, written for numerous publications, and in 1996 produced a documentary, Bambini Intravisti – Tokyo no miegakure suru kodomotachi, shown within the exhibition Perfetti e Invisibili, Pitti Imagine, Florence. He is co-founder with Giulia Reali of AlmaGreal Intercultural Commmunication Consulting.

Günter Beltzig

Günter Beltzig, designer, was born in 1941 in Wuppertal, Germany, and studied industrial design; he later worked for Siemens AG, Munich. From 1966 to 76 he directed Brüder Beltzig Design, the company he founded with his brother, producing plastic furniture. A specialist in playground and play equipment, his recent projects include the Luisenpark, Mannheim; a playground in Leverkusen; Augustinium therapy centre, Munich; school playground conversions in Bornheim, Berlin, and play concepts for projects in Djerba, Turkey, Italy, Holland and the UK. He does product development in many European countries, and lectures in Germany and abroad. His work is included in exhibitions at the Museum of Modern Crafts, New York; Kunstgewerbemuseum, Cologne; Vitra Design Museum, Weil am Rhein. His publications include Kinderspielplätze mit hohem Spielwert (1987); and articles for md, db-Bauzeitung and Spielraum.

J.S. Bhandari

J. S. Bhandari, born in 1937, is professor at the University of Delhi where he has taught since 1963. He has studied several tribes in the North-Eastern and Northern states of India, in particular the Mishing, the Jaunsaris and the Bhotias. His main contribution has been in the area of kinship and family, tribal and peasant social structure, and studies of change in tribal development. Collections he has edited include Kinship, Affinity and Domestic Groups: transformations of tribal societies in India and Tribal Policy in India. He has been the editor of the Eastern Anthropologist for five years, and is currently editor of the journal of the Indian Anthropological Association.

Lucy Bullivant

Lucy Bullivant is a curator, author and cultural historian who took a Masters degree from the Department of Cultural History of the Royal College of Art, London, in 1984, and has curated and organised numerous exhibitions and events on design, architecture and the visual arts. These include Make or Break: design and British industry in the 1940s, for the Royal College of Art, London, 1985; Leading Edge and 100 designers from the RCA for DAI, which toured Japan in 1987 and 1988; Contemporary View for Christie's, London, 1990; and Spaced Out 3 for the ICA, London, 1996. In 1995–96 she was curator and Commissioner for the British exhibition at the xix Triennale di Milano (The near and the far, fixed and in flux: some design perspectives on the contemporary urban experience). She has written two internationally published books on interior architecture (1991, 1993), and writes on design, architecture and the visual arts for Archis, Blueprint, Intramuros and D.E. driade edizioni.

Elisabeth Dessai

Elisabeth Dessai (1941–97), publicist, founded Wohnen mit Kindern [Living with Children], an association concerned with the child-friendly planning of living environments. She published several books on themes including child-orientated architecture, living with children, education and women. Her latest book was Zurück zür Wohnküche [Back to the Living Kitchen], published in 1997.

Barbara Fehlbaum

Barbara Fehlbaum, born in 1957 in Basel, studied ethnology in Zürich, and trained in psychotherapy, specialising in transcultural psychology. She has completed several transcultural projects and field studies in the Philippines and Thailand, and carried out additional studies in museology at Basel University.

Stina Forsström

Stina Forsström, born in 1965, has a Masters in communication

311

studies and has worked both in Sweden and South East Asia for companies including Orrefors and IKEA. She is a member of the jury for Guldägget, the Swedish annual advertising award, and currently works in advertising in Stockholm.

Denise Hagströmer

Denise Hagströmer, born in Stockholm in 1960, is a writer, curator and lecturer on the history of design. She has an Masters degree in design history from the Royal College of Art, London, and is lecturer at the Konstfack University College of Arts, Crafts and Design, Stockholm. She has taught at a number of colleges in the UK, Ireland and Sweden (including the RCA, London Institute, Kingston University, and the College of Crafts and Design, Gothenburg), specialising in twentieth-century Scandinavian design and its influence on British and American design. She was guest curator of the Scandinavian Ethics and Aesthetics exhibition at the Design Museum, London (1992–93) and is curating an exhibition at the Victoria and Albert Museum, London, on the legacy of Carl and Karin Larsson. She writes for the British and Swedish design press, including Blueprint, Design Review and Form.

Sally Kevill-Davis

Sally Kevill-Davies is a writer, lecturer and broadcaster specialising in the applied arts. She was a ceramics expert at Sotheby's auctioneers, London, 1965–74, and has published many books and articles (in The Times, The World of Interiors, and Antique Collecting) on aspects of the applied arts, and in particular its relationship with the history of childcare. She has lectured for Sotheby's, NAD-FAS, Antique Collectors' Club and the Thomas Coram Foundation. She has worked on special collections at Coughton Court, Warkwickshire, and at the Fitzwilliam Museum, Cambridge.

Gerhard Kubik

Gerhard Kubik, born 1934 in Vienna, is an ethnologist and music ethnologist, and professor at Vienna University. He has conducted field studies in Angola, Zambia and Malawi since 1965, the first of which looked at initiation rites in Mukanda, the subject of his PhD. He is author of numerous music ethnological studies and an active member of the Kachama Brothers (Kwela) Band. He is currently researching in the USA, Malawi and Namibia. His most recent publication, Makisi Nyau Mapiko – mask traditions in Bantu-language Africa, was published in 1993.

Franco La Cecla

Franco La Cecla, born in 1950 in Palermo, is an architect, anthropologist, writer and teacher of anthropology at the University of Bologna. His principal interest is the anthropology of the present, and he has published several books on children and society. His most recent publication, Il malinteso, antropologia dell' incontro (Rome 1997), is about cultural conflicts in multi-ethnic cities and people's strategies to avoid them. He curated Perfetti e invisibili: the image of the child between manipulation and reality, a major exhibition for Pitti Immagine held at the Ospedale degli Innocenti, Florence, in 1996.

Noreen Marshall

Noreen Marshall, born in 1951 in Suffolk, read History of Art and Architecture at the University of East Anglia, has been Curator of the Dress and Nursery Collection at the Bethnal Green Museum of Childhood, London, since 1978. She has lectured and contributed to the national media on various aspects of the history of childhood, and has organised exhibitions including Jolly Hockey Sticks and A Calendar of Childhood Ceremonies.

Vedran Mimica

Vedran Mimica, born in 1954 in Zagreb, graduated in architecture at the University of Zagreb, and worked there as a lecturer and researcher from 1980. In 1984, 1986 and 1991 he was a research fellow in architecture at the University of Technology in Delft, where his studies focused on children, environment and architecture, and were published in The Netherlands. He is a course director at the Berlage Institute, Postgraduate Laboratory of Architecture in Amsterdam, The Netherlands.

Jutta Oldiges

Jutta Oldiges, art historian, was born in Osnabrück in 1962. She has been curator at Vitra Design Museum since 1994, and has worked on exhibitions on Borek Sipek, From the Industrial Product to Furniture Sculpture, and African Seats.

Renato Pedio

Renato Pedio, born in Trieste in 1929, was educated in Italian literature in Milan and Rome, and taught semiotics in Rome before becoming editor-in-chief of the magazine L'Architettura – cronache e storia, a position he held for 35 years. He has written on the designer Enzo Mari, and his poetry has been widely published. His critical writings encompass the fields of literature, film, architecture and design.

Giulia Reali

Giulia Reali, born in Rome, graduated in mass communications from the University of Bologna and is a researcher in communication and consumer culture, semiotics and marketing, and cofounder with Massimo Alvito of AlmaGreal Intercultural Relations Consulting. Her interdisciplinary research focuses on consumer behaviour issues, with particular reference to the child as an influence in contemporary society. She is consultant and project director for public and private institutions including Pitti Immagine, Florence; Fujita Venté, Tokyo, and COOP Italia. She co-authored the exhibition Perfetti e Invisibili (1996) and coordinated Bambini Intravisti, the documentary for the project. She has contributed to Italian publications on children, consumption and the media.

Mike Scaife

Mike Scaife, Senior Lecturer in Child Development at the School of Cognitive and Computing Studies, Sussex University, has a doctorate in experimental psychology from Oxford University; he has held academic appointments at the universities of Oxford, London and California at Irvine, and the Institute for Research on Learning at Palo Alto. His research interests include the development of the child's understanding of natural and artificial forms of life; human–computer innovation; models of the novice users, child and adult; supporting innovation in the school and workplace; the function of external graphical representations in learning and problem-solving, and the design of interactive information systems.

Annemarie Seiler-Baldinger

Annemarie Seiler-Baldinger, born in Zürich in 1942, studied and subsequently lectured in ethnology, classic archaeology and ancient history, and has been head of the American department of the Ethnological Institute, Basel Museum of Mankind, since 1971. She has also lectured on the cultural history of textiles at the University of Dortmund, based on her research work and many subsequent publications on aspects of textiles in South American Indian tribes. Since 1973 she has conducted extensive field studies of Amazon and Orinoco Indians.

Kelly Shannon

Kelly Shannon, born in Rochester, New York, in 1965, received a BA in architecture (minoring in professional writing) from Carnegie-Mellon University in Pittsburg in 1988, and an MA in architecture from the Berlage Institute in Amsterdam in 1994. Currently she is on the graduate faculty at the College of Architecture and Planning in Denver, University of Colorado. She has written extensively for architecture magazines in Europe and the USA.

Ingeborg Weber-Kellermann

Ingeborg Weber-Kellermann (1918–94), German social historian, ethnologist and anthropologist, was professor of European Ethnology at the University of Marburg, and the author of Die Familie (1984); Der Kinder Neue Kleider: 200 Jahre deutsche Kindermoden (1985); Die Kindheit (1989) and Die Kinderstube (1991).

Florence Weiss

Florence Weiss, born in Basel in 1945, studied ethnology, history of art and political philosophy, and is lecturer in ethnology at the University of Basel. Her publications include Kinder schildern ihren Alltag, Ethnologisches Seminar der Universität und Museum für Völkerkunde. She has conducted extensive research on the economy, everyday life and social status of children of the Iatmul in Papua New Guinea. Other special research interests include developments in women's rights and their social status, urban ethnology and ethno-psychoanalysis. She is currently working with Milan Stanek on political and economic restructuring and its impact on the relationship between the sexes.

Tina Wodiunig

Tina Wodiunig, born in Zürich in 1960, studied ethnology, sinology, psychology and museology, and is currently Director of the Indianermuseum, Zürich. She was a primary school teacher for several years, and has conducted field studies in the Chinese province of Yunan.

Picture credits

Lucy Bullivant (pp. 12–23)
1. Humphrey Kelsey, London
2. Dennis Sharp, Tim Benton and Barbie Campbell Cole, Pel and Tubular Steel Furniture of the Thirties, exhibition catalogue, Architectural Association, London, 1977
3. Nanna Ditzel, Copenhagen
4. Jon Burbank, Hutchison Library, London
5. Jane Atfield, London
6. Ham Khan, London
7, 11. AKG London
8. Geffrye Museum, London
9. Basil Harley, Constructional Toys, Shire Publications, Princes Risborough, 1990
10. Hutchison Library, London
12. Lucy Bullivant, London
13. Collections/Andrea Sieveking, London
14, 15. Sally and Richard Greenhill, London

Ingeborg Weber-Kellermann (pp. 24–39)
1. Bayrisches Nationalmuseum, Munich
2. Staatliche Museen Berlin–Dahlem
3. Landesmuseum Oldenburg
4. Münchner Stadtmuseum, Munich
5. Kunsthalle Kiel
6. Gartenlaube 1895
7. Alexander Koch, Handbuch neuzeitlicher Wohnungen, Bd. Schlafzimmer, 1919, p. 174
8, 10. R. I. Docherty, Sozial-dokumentarische Photographie in den USA, Lucerne 1974, pp. 24, 32
11. Hirtenmuseum, Hersbruck

Noreen Marshall (pp. 40–49)
1. Henry Francis du Pont Winterthur Museum, Delaware, N.J., Gift of Mrs Frysinger Evans, Clementon, N.J.
2. Brian Shuel/Collections, London
3. Fine Art Photo Library, London
4. From F. von Zglinicki, Die Wiege, F. Pustet, Regensburg 1979
5. Réunion des Musées Nationaux, Paris
6. The Dean and Chapter of Westminster Abbey, London

7. Witt Library, Courtauld Institute, London
8. Manchester City Art Gallery
9. The Dean and Chapter of Lichfield Cathedral
10. The Bridgeman Art Library, London
11. The British Library and Oxford University Press

Sally Kevill-Davies (pp. 50–59)
1. The Bridgeman Art Library, London
2. The Burrell Collection, Glasgow Museums
3, 9. The Chatsworth Settlement Trustees
4. Norfolk Museum Service, Norwich Castle Museum
5. Cambridge and County Folk Museum
6. Bowes Museum, Barnard Castle, Co. Durham
7. Rijksprentenkabinett, Rijksmuseum, Amsterdam
8. Antique Collectors' Club, London
10. Sotheby's, London
11. Mary Evans Picture Library, London
12–14. Jack Hampshire's Pram Museum, Kent

Mike Scaife (pp. 60–67)
1–4, 6, 8, 10. Anthea Sieveking/Collections, London
5, 7, 9. Sandra Lousada/Collections, London

Franco La Cecla (pp. 68–79)
1, 8–11. Enzo Sellerio, Palermo
2–7. Franco Zecchin, Paris

Renato Pedio (pp. 80–85)
1. Jacqueline Vodoz, Milan
2. The Bridgeman Art Library, London
3, 4. Aldo Ballo, Milan

Günter Beltzig (pp. 86–95)
All illustrations. Günter Beltzig, Hohenwart

Annemarie Seiler-Baldinger
1. Vreni Regher, Gran Chaco
2, 10, 15. Annemarie Seiler-Baldinger, Basel
3, 4. Codex Mendoza, Manuscrit

Aztèque, Commentaires de K. Ross, Fribourg 1978
5. Felipe Guaman Poma de Ayala, El primer nueva corónica y buen gobierno, ed. by John V. Murra and Rolena Adorno, Mexico 1979
6. Theodor Koch-Grünberg, Zwei Jahre unter den Indianern, Reisen in Nordwest-Brasilien 1903–1905, Stuttgart 1910
7. Harald Schultz
8. Bruno Illius, Freiburg i. Brsg.
9. Thomas Dix, Grenzach-Whylen
11. G. Verswijver, Brussels
12 . A. Bant
13. Les Arts de l'Amérique latine. Exposition itinérante de l'Unesco, Paris 1977
14. Benoît Junot
16. Harald Schultz
17, 18 . Maps: Justus Perthes Verlag Gotha GmbH

Gerhard Kubik (pp. 110–17)
1–6. Gerhard Kubik, Vienna
7. Moya Aliya Malamusi, Chileka, Malawi
8. Thomas Dix, Grenzach-Whylen

Tina Wodiunig (pp. 118–27)
1, 3. E. Schulthess, China, SILVA-Verlag, Zurich 1969, pp. 54, 69
2. R. G. Knapp, China's Rural Architecture, Hawaii 1986, p. 113
4, 5, 6, 8, 13. Ruth Sidel, New York
7. Hannes Felder, Küsnacht
9. D. Bonavia, The Great Cities: Peking, Amsterdam 1978, p. 34/Peter Johns Griffiths
10. Tina Wodiunig, Zürich
11. Lyn Gambles, Hutchison Picture Library, London

Florence Weiss (pp. 128–39)
2. Florence Weiss, Kinder schildern ihren Alltag – Die Stellung des Kindes im ökonomischen System einer Dorfgemeinschaft in Papua New Guinea (Palimbei, Iatmul, Mittelsepik), in Basler Beiträge zur Ethnologie, vol. 21, Basel 1993, p. 123
1, 3–14. Florence Weiss, Basel

J. S. Bhandari (pp. 140–45)
2, 3, 4, 10. Thomas Dix, Grenzach-Whylen

313

6, 7, 8, 11. Prof. J. S. Bhandari, Delhi
5. Jean Herbert, Asien, ed. by Migros Genossenschaftsbund, Zürich 1957, p. 47/Organisation mondiale de la santé, Geneva
9. Susanne Slezin and Stafford Cliff, Indian Style, New York 1990, p. 191/David Brittain

Barbara Fehlbaum (pp. 146–53)
All photographs. Barbara Fehlbaum, Basel

Eileen Adams (pp. 154–61)
All photographs. Eileen Adams, London

Vedran Mimica and Kelly Shannon (pp. 162–73)
1, 11, 13–16. Johan van der Keuken, Amsterdam
2–7. Courtesy of the Terragni Foundation, Como
8. G. V. D. Vlugt, Amsterdam
9, 12 . Herman Hertzberger, Amsterdam
10. Frits Dijkhof, Amsterdam

Jutta Oldiges (pp. 174–81)
1, 6. Nationaal Schoolmuseum, Rotterdam
2. AKG, London
3. Dr Thomas Müller, VS Vereinigte Spezialmöbelfabriken, Tauberbischofsheim
4. Kindertagesstätte – erste Begegnung mit der organisierten Umwelt, ed. by Linde, Burkhardt, exhibition catalogue, IDZ Berlin 1976, p. 16
5, 7. Rudolf Schwarz, Montessori-Möbel, in Die Form, Zeitschrift für gestaltende Arbeit, issue 1, 1930, pp. 13–14/Hanns Schwippert
8, 9. Karin Schneider-Henn, Uns drückt keine Schulbank, Stuttgart 1983, pp. 22, 40/Karin Schneider-Henn

Denise Hagströmer (pp. 182–95)
1. Sundahl, Sune, Arkitekturmuseet, Stockholm
2. Statens Konstmuseum, Stockholm
3. C. G. Rosenberg, Arkitekturmuseet, Stockholm
4. Källgrens ateljé, Arkitekturmuseet, Stockholm
5. Ateljé Wahlberg, Stockholm
6. Bergne, Kooperativa Förbundet, Stockholm
7, 9 . Föreningen Svensk Form, Stockholm
8. Trip Trap Denmark A/S, Hadsund
10. Nils Johan Norenlind
11. Okand, Arkitekturmuseet, Stockholm
12. Hans Sandgren Jakobsen, Bronshoj, Denmark
13, 14 . Kim Ellebo, Copenhagen
15. Steen Dueholm Sehested, Copenhagen
16. Bjorn Dahlstrom, Stockholm
17. Robert Metell, Stockholm
18. Nino Monastra, Johanneshov

314

Stina Forsström (pp. 196–201)
1. Nike Peterson, Stockholm
2–6. ikea of Sweden, Älmhult

Elisabeth Dessai (pp. 202–9)
1, 10–12. Elisabeth Dessai, Moers
2. Gert Köhler (ed.), Geschichte des Wohnens/Wüstenrot Stiftung, Deutscher Eigenheimverein e. V. Ludwigsburg, Stuttgart 1996, p. 573
3. Günter Beltzig, Hohenwart
4. Gertrud Benker, Bürgerliches Wohnen: städt. Wohnkultur in Mitteleuropa von der Gotik bis zum Jugenstil, Munich 1984, p. 176/Helga Schmidt-Glassner
5. Historisches Museum Frankfurt, Grafische Sammlung, Frankfurt a. M.
6. L'intérieure d'une cuisine, Michel Martin Drölling, Musée du Louvre, Paris
7–9. 75 Jahre Wohnungsgenossenschaft Düsseldorf-Ost, Düsseldorf, 1994, p. 23

Massimo Alvito and Giulia Reali (pp. 211–21)
1, 3, 6. Massimo Alvito, Florence
2, 9. Tokyo no Miegakure suru Kodomotachi (Tokyo's Children at a Glance), documentary by Massimo Alvito, Pitti Immagine, Florence, 1996
4, 5, 7. Giulia Reali, Florence
8. Mayo Fukui, Yoyogi Elementary School, Tokyo
10, 11, 13, 15. Bandai Digital Entertainment, Japan
12. Neo-Tokyo Magazine
14. http://www.urban.or.jp/home/jun/tama

Catalogue raisonné
All photos. Thomas Dix, Grenzach-Whylen, except for the following:

Patterns of sleeping
1.1
Riché P. and Alexandre-Bidon D., L'enfance au Moyen Age, Paris 1994, p. 66
1.5
Nordiska Museet, Stockholm
1.6
Peter W. Ellenberg, Freiburg
1.7
Haags Gemeentemuseum, The Hague
1.8
Stedelijk Museum, Amsterdam
1.9
Tecta/Stuhlmuseum Burg Beverungen, Lauenförde
1.11 and 1.11.1
Emil Guhl, Stein am Rhein
1.12
Roberti Rattan, Milan
1.13
Photo: Scholl Mfg. Co. Ltd.
Logie Gordon, Furniture from Machines. London 1947, p. 12
1.14

Photo: Schnakenburg & Brahl, Copenhagen
Ole Gjerlov-Knudsen, Gillileje
1.16 and 1.16.1
Photo: Horst Huber
XS Möbel für Kinder/Holzwerkstatt Biiraboom, Kernen i. R.
1.19
Elisabeth Dessai, Moers
1.28
Troeller/Deffarge

Basic functions
2.2
Photo: Kai Mewes, Munich
Peter W. Ellenberg, Freiburg
2.6 and 2.6.1
Technische Hogeschool Delft
2.7
Thonet Leporello, 1936
2.8
Stedelijk Museum, Amsterdam
2.9
Haags Gemeentemuseum, The Hague
2.10
Stedelijk Museum, Amsterdam
2.12
Technische Hogeschool Delft
2.13
IKEA Schweden, Älmhult
2.14
Studio Böhm, Gelnhausen
2.19
Maas Ellen, Tische – Deutschland 1900-1945, Nördlingen 1987
2.21
Hiraku Kusubayashi, Milan
2.22
Bauhausbücher, vol. 7, Munich 1924, p. 37
2.23 and 2.23.1
Thomas Wendtland, Hamburg
2.29
Photo: Kai Mewes, Munich
Peter W. Ellenberg, Freiburg
2.32
Johannes Trüstedt, Munich
2.34
Focke Museum, Bremen
2.36
The Shaker Museum and Library, Old Chatham, New York
2.39
Neue Möbel. Hrsg, ed. by Gerd Hatje and Elke Kaspar. vol. 9, Stuttgart 1969, p. 149
2.40
Källemo, Värnamo

Play
3.2
Mary Evans Picture Library, London
3.3
Münchner Stadtmuseum, Munich
3.4
Vitra Design Museum, Weil am Rhein
3.6
Alvar Aalto Foundation, Jyväskylä
3.7
Neuhart John and Marily, Eames Ray, Eames Design. New York 1989, p. 161
3.8
Vitra Design Museum

3.9
Wilkhahn, Bad Münder
3.10
Neue Möbel, ed. by Gerd Hatje and Elke Kaspar. vol. 9, Stuttgart 1969, p. 149
3.11
Stedelijk Museum, Amsterdam
3.12
Gunter König, Hamburg
3.13
Photo: Hans-Jürgen Herrmann, Offenbach
Alexandra Reinhold, Berlin
3.14
IKEA Schweden, Älmhult
3.15
Happy Days, ed. by Rand McNally, Chicago 1937, p. 37
3.16
Mary Evans Picture Library, London
3.17
Fischer-Dückelmann, Die Frau als Hausärztin, Stuttgart 1908, pl. 220. Münchner Stadtmuseum
3.19 and 3.19.1
Maria Teresa Sucre, Caracas
3.20
Photo: Rob Decelis
Eurolounge, London
3.22
Photo: Ingeman Sorenson
Torben Orskov & Co., Copenhagen
3.23
Stedelijk Museum, Amsterdam
3.25
Stokke, Aalesund
3.26
Vienna Collection, Schrems
3.27 and 3.27.1
Photo: Georg Schuster, Darmstadt
Kathrin Kremser, Darmstadt
3.28
Focke Museum, Bremen
3.30
Vitra Design Museum
3.30.1
Kinderlübke, Gütersloh, company brochure
3.32
Bauhausbücher, vol. 7, Munich 1924, p. 36
3.33
Photo: Lucien Hervé, Paris
© VG Bild Kunst, Bonn 1997 for Le Corbusier
3.34
Dominic Jones, Ohio
3.35
Photo: Alice de Bruyn/Wolfgang Schmid
Anthologie Quartett, Bad Essen
3.38
Stedelijk Museum, Amsterdam
3.39
Photo: E. Maurer, Zürich
Emil Guhl, Stein am Rhein
3.40
Djoke de Jong, Eindhoven
3.41
Photo: K. Helmer-Petersen, Copenhagen
Trip Trap A/S, Hadsund
3.42
Neue Möbel, ed. by Gerd Hatje

and Karl Kaspar, Stuttgart 1966,
p. 133
3.43
Kinderlübke, Gütersloh, "mobi-lix" company brochure
3.44
Rouge Ekkehard Fahr, München
3.47
Photo: Will Connell, USA
3.49
Happy Days, ed. by Rand McNally, Chicago 1937, p. 17
3.53
Aldo Ballo, Milan
3.54
Aldo Ballo, Milan

Mobility
4.2
AKG London
4.6
Bildarchiv Basel-Stadt, pl. 3, 1056
4.8
Baumann & Cie Verkaufskatalog
4.8.1
Vitra Design Museum
4.10
Geschichte des Wohnens, pl. 4. 1918-1945: Reform, Reaktion, Zerstörung, ed. by Gert Kähler. Stuttgart 1996, p. 586
4.12
Christie's Images, London
4.15
Deutsches Historisches Museum, Berlin
4.16.1
Photo: Lyn Gambles, Hutchinson Library, London
4.17
PCD Ltd, Tavistock
4.18 and 4.18.1
Photo: Paul Lapsley Photography Ltd, Warwickshire
Stephen Kuester, Bloxham
4.19
Pentagram, London
4.29
Ullstein
4.30
Photo: Gerd Mingram
Museum der Arbeit, Hamburg
4.36 and 4.36.1
Terri Pecora, Milan
4.38
Das Kind und sein Vater, Munich 1960, Abb. 38
Photo: Axel Poignant
4.39
Photo: Hilmar Pabel
Das Kind und sein Vater, Munich 1960, Abb. 10
4.41
Museum voor Volkenkunde, Rotterdam
4.42
Lieve lasten-hoe kinderen gedragen worden. Koninklijk Instituut voor de Tropen, Amsterdam 1993, p. 101
Photo: H. L. and P. R. Whittier, Michigan
4.45
Lieve lasten-hoe kinderen gedragen worden. Koninklijk Instituut voor de Tropen, Amsterdam 1993, p. 94
Photo: Puck Bramlage, Amsterdam

4.47
Authentische Zeugnisse von den Kindern des großen Geistes: Aus dem Werk des legendären Indianer-Fotografen Edward Sheriff Curtis, Lucerne 1988, p. 93
© Strom Verlag Lucerne
Photo: Edward Sheriff Curtis
4.48
Norsk Folkemuseum, Oslo

Formal learning
5.1
Antiquariat Vloemans, The Hague
5.2
Münchner Stadtmuseum, Munich
5.3
Photo: Lucien Hervé, Paris
© VG Bild-Kunst, Bonn 1997 for Le Corbusier
5.4
Lore Kramer, Frankfurt
5.5 and 5.5.1
Stenbergs Bilder, Bla Station, Arhus Malmö
5.10
Photo: Sabine Sauer
Lichtblick, Berlin
5.13 and 5.14
Skools Inc, New York
5.15
Ayres L. P., Open Air Schools. 1910
5.17
AKG London
5.18
Rassegna. Il progetto del mobile in Francia, issue 26/2, 1919-1939. Bologna 1986, p. 76
5.19
Vitra Design Museum, Weil am Rhein
5.20
Stedelijk Museum, Amsterdam
5.21
Neue Möbel, ed. by Gert Hatje, vol. 8. Stuttgart 1966, p. 133
5.22, 5.22.1 and 5.22.2
Studio De Lucchi, Milan
5.23
Focke Museum, Bremen
5.24
Vitra Design Museum, Weil am Rhein
5.26
Neue Möbel, ed. by Gert Hatje, vol. 3. Stuttgart 1955, p. 142
5.27
Rassegna, Il progetto del mobile in Francia, issue 26/2, 1919-1939. Bologna 1986, p. 56
5.28
Stedelijk Museum, Amsterdam
5.30
Photo: Kai Loges Photo Design, Kernen i. R.
XS Möbel für Kinder/Holzwerkstatt Biiraboom, Kernen i. R.
5.31
Neue Möbel. Ein internationaler Querschnitt von 1950 bis heute. Hrsg. von Klaus-Jürgen Sembach. Stuttgart 1982, p. 287

Chairs
All photographs Vitra Design Museum except the following:

6.18
Robert A. Wettstein, Zürich
6.12, 6.17, 6.19, 6.20
Thomas Dix, Grenzach-Whylen